EXPLORING

Color Photogr

I0607763

EXPLORING

Color Photography

ROBERT HIRSCH
Amarillo College

·

wcb
Wm. C. Brown Publishers
Dubuque, Iowa

Book Team

Editor *Meredith M. Morgan*
Developmental Editor *Raphael Kadushin*
Production Editor *Harry Halloran*
Designer *Mary K. Sailer*
Photo Research Editor *Mary Roussel*
Visuals Processor *Joyce E. Watters*

wcb group

Chairman of the Board *Wm. C. Brown*
President and Chief Executive Officer *Mark C. Falb*

wcb

Wm. C. Brown Publishers, College Division

President *G. Franklin Lewis*
Vice President, Editor-in-Chief *George Wm. Bergquist*
Vice President, Director of Production *Beverly Kolz*
Vice President, National Sales Manager *Bob McLaughlin*
Director of Marketing *Thomas E. Doran*
Marketing Communications Manager *Edward Bartell*
Marketing Information Systems Manager *Craig S. Marty*
Marketing Manager *Kathy Law Laube*
Production Editorial Manager *Colleen A. Yonda*
Production Editorial Manager *Julie A. Kennedy*
Publishing Services Manager *Karen J. Slaght*
Manager of Visuals and Design *Faye M. Schilling*

Cover photo © Roger Camp, "The Race, 1985", Cibachrome

Table of Contents photos: Page viii: © Roger Camp, "Yellow Snorkler, 1985", Cibachrome; Page ix: © Michael Stravato, "Untitled, 1986", Type C print 8" × 10"; Page x: © Barbara Kasten, "Architectural Site 6, July 14, 1986", (Pelli) Courtesy of John Weber Gallery, New York, NY, 30" × 40" Cibachrome; Page xi: © David Robinson, "NYC 7", 16" × 20", Cibachrome, Courtesy of J.J. Brookings Gallery, San Jose, CA; Page xii: © Linda Heiliger, "Coral Sky", Type C print, Courtesy of Jayne H. Baum Gallery, NY, NY; Page xiii: © Jerry Burchfield, "Untitled", Type C print, 11" × 14"

Interior illustrations by Barbara Wooten: Figures 1.6, 1.7, 1.8, 4.2, 4.3, 4.6, 4.7, 4.8, 4.9, 8.1, 9.1, 10.7, 10.11a, 10.11b, 12.1. Illustration concepts created by Barbara Wooten.

Copyright © 1989 by Wm. C. Brown Publishers. All rights reserved

Library of Congress Catalog Card Number: 87–73369

ISBN 0-697-06132-9

No part of this publication may be reproduced, stored in a retrieval system, or transmitted, in any form or by any means, electronic, mechanical, photocopying, recording, or otherwise, without the prior written permission of the publisher.

Printed in the United States of America by Wm. C. Brown Publishers
2460 Kerper Boulevard, Dubuque, IA 52001

10 9 8 7 6 5 4 3 2 1

• •

To my mom, Muriel Hirsch, for teaching me to read, and my dad, Edwin Hirsch, for introducing me to photography.

And to the memory of Ernest Schackleton and the crew of the *Endurance,* who have all provided me with insight into what true exploration is all about. "The qualities necessary to be an explorer are, in order of importance: optimism, patience, physical endurance, idealism, and courage. Optimism nullifies disappointment. Impatience means disaster. Physical endurance will not compensate for the first two moral or temperamental qualities."

—*Ernest Schackleton*
(1874–1922)
Explorer of the South Pole.

• •
•

Contents

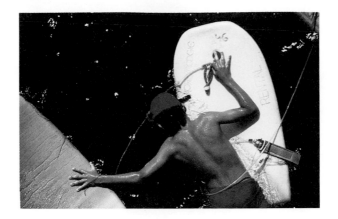

Contents

Contents

Contributing Photographers

The following photographers are
reproduced in this text.

Sandy Anson
David Arnold
Alicia Bailey
Betty Barnard
John Barnhart
Thomas Barrow
Tim Baskerville
Mark Berghash
Vin Borrelli
Drex Brooks
Gary Brotmeyer
Lawrie Brown
Jerry Burchfield
Larry Burrows
Roger Camp
Richard Colburn
Michele Cousins
Eileen Cowin
James Crable
Cathy C. Crowell
Willard R. Culver
Dean Dablow
Eduardo Del Valle
Pamela DeMarris
John Divola
Thom Dougherty
Jay Dunitz
Michael Eastman
Mitch Epstein
Dennis Farber
Richard Felix
Alida Fish
Jeff Fletcher
Bill Frazier
Harriet Gans
Laurence M. Gartel
Terry Gips
Audry Glasman
Gary Goldberg
Judith Golden
Mirta Gomez

Linda Adele Goodine
David Graham
Eva Roa Grotefend
Jim Haberman
Bob Harbison
Maggie Hasbrouck
Chuck Hassell
Linda Heiliger
Michael Herbert
Hans Hildenbrand
Rev. Levi L. Hill
George Hirose
Robert Hirsch
Rick McKee Hock
David Hockney
Bill Hoy
Scott Hyde
Steve Jenlk-Black
Len Jenshel
Rick E. Jurus
Kenneth Kaplowitz
Barbara Kasten
David Katzenst
Doug Keats
Robert Glenn Ketchum
Angie Klidzejs
Linda Kroff
Ellen Land-Weber
Cay Lang
Erik Lauritzen
David Lebe
David Levinthal
Helen Levitt
Linda Loper
Ann Lovett
Neil Lykas
Marcia McGlasson
Glen McKay
John Maggiotto
Paul Marlin
Ken Matsubara

James Clerk Maxwell
Lorrah Meares
Joel Meyerowitz
Catherine Miles
Kay Miller
Suzanne L. Mitchell
Lee Montgomery
Kim Mosley
Scott Mutter
Patrick Nagatani
Ellen Neal
Bea Nettles
Michael Northrup
Arthur Ollman
Ashley Parker Owens
Michael Peven
John Pfahl
Eliot Porter
Judith Preston
April Rapier
Leland Rice
Linda Murphy Robbennolt
Holly Roberts
David Robinson
Geno Rodriguez
Cindy Sherman
Sandy Skoglund
Leif Skoogfors
Jan Staller
Tom Steele
Michael Stravato
Martha Strawn
Andree Tracey
Marie Triller
Ragnars Veilands
Joseph Walsh
Curt Walters
Danny D. Weeks
William Wegman
Edwin Wisherd
Willie Ann Wright

Preface

This book has been expressly written to provide a stimulating introduction to the techniques, images, and history of color photography at the college level. It assumes that the reader has a basic working knowledge and understanding of black-and-white photography.

Technological changes in the field of color photography are taking place at a rapid rate. Equipment and products considered state of the art one day are discontinued and replaced the next. For this reason, the text is designed to provide the reader with a strong conceptual base from which aesthetic and technical explorations can be conducted.

The approach is pragmatic, explaining how theory relates directly to the practice of the making of color photographs. This text attempts to present the tools that are necessary for the elaboration of ideas with the use of photography. To be an explorer is to investigate the unknown for the purpose of discovering truth. Once truth is uncovered it is possible to gain understanding. Understanding can lead to creation. From creation the uncovering of meaning is made possible. This book offers a structured starting place for ideas and techniques of known exploration. It offers guided paths to get the reader involved with the spirit of discovery and to provide the means necessary to begin to express your visual voice. It is not designed to be the final authority. Ultimately, readers should be able to discard this guide book and make their own way.

The illustration program of this book has been put together after looking at thousands of images. This section gives an overview of the wide variety of approaches currently being employed by professionals, teachers, and students. It is important for people entering color work to be exposed to the many diverse aspects the medium has to offer. The photographs I have viewed reflect a contemporary trend by photographers to experiment and push the definitions and limits of what most people tend to think a color photograph is about. I believe that this is a healthy concern that will expand the boundaries of color photography.

I invite all readers of this first attempt to participate in the learning process by providing me with comments and suggestions about this book.

Thanks to all the people at Amarillo College and Wm. C. Brown who have offered their cooperation, time, and knowledge in getting this manuscript together; to all the artists that have contributed their work for consideration; to Barbara, for proofreading and the illustrations; to Harriet, for helping me through the real tough spots; and to all my students for their encouragement and participation in the process of creating this book.

In putting together the photographs that appear in the text, I owe a debt of thanks to Jayne Baum of the Jayne Baum Gallery, New York, New York; Timothy Duran of J.J. Brookings Gallery, San Jose, California; Steve Yates, Curator of Photography, Museum of Fine Arts, Santa Fe, New Mexico; and Jim Featherstone, former curator of the University Art Gallery, New Mexico State University, Las Cruces, New Mexico.

A word of caution: in many aspects of color photography you will be working with chemicals that can be hazardous to your health if they are not handled properly. To prevent problems from occurring with any process that you may be encountering, read all directions, precautions, and safety measures thoroughly before you begin to work. Wear thin rubber gloves and dispose of them after each use. Avoid getting any chemicals on your skin. If this should happen, flush the area with running tap water. Always work in a well-ventilated area. Avoid inhaling any chemical fumes. A charcoal mask can be worn when mixing chemicals or if you are sensitive to chemical irritants. Preventative common sense is all you should need to have a long, safe, healthy involvement with color photography. Have fun in your explorations.

Bob Hirsch
Canyon, Texas

Reviewers

Kenneth V. Crow
Olympic College

David L. DeVries
California State University–Fullerton

Jim Featherstone
New Mexico State University

Dan Guthrie
Ithaca College

Gregory T. Moore
Kent State University

Michael Peven
University of Arkansas–Fayetteville

Color Photography

The Quest for Color in Photography

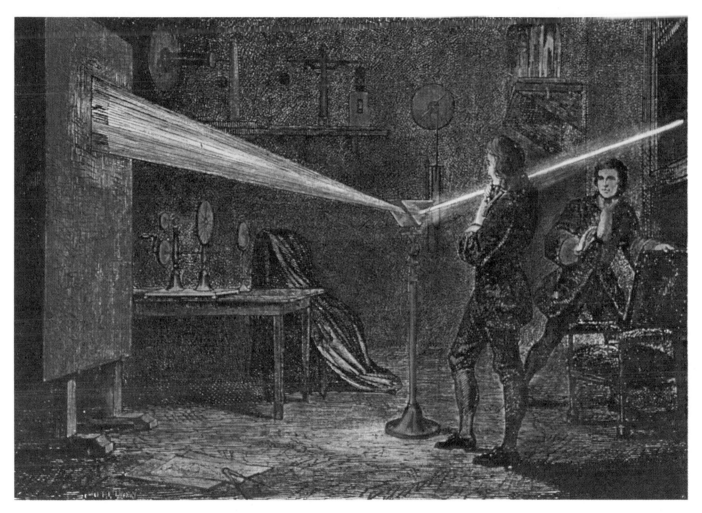

Historical Pictures Service, Chicago.

Figure 1.1
Isaac Newton's experiment proved that
colors are in white light, and that white light
is made up of the entire visible spectrum of
colors.

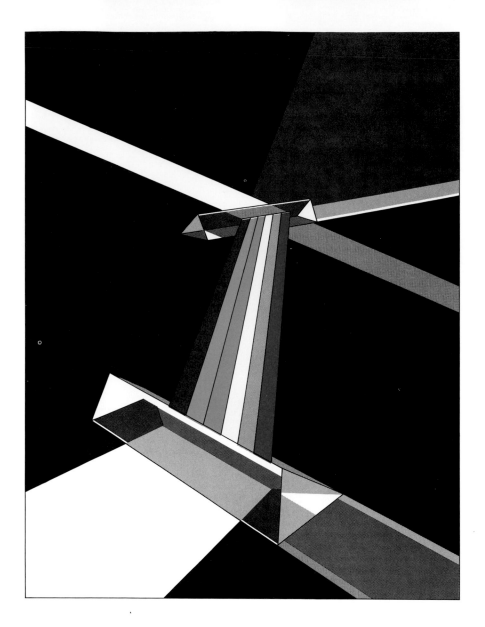

Newton's Light Experiment

In 1666, Isaac Newton of England demonstrated that light is the source of color. Newton passed a beam of sunlight through a glass prism, making the rainbow of colors that form the visible spectrum. He then passed the rainbow back through a second prism that converted all the hues back into white light (figure 1.1). From this experiment Newton determined that color is in the light, not in the glass prism, as had been previously thought, and that the light humans see as white light is actually a mixture of all the visible wavelengths of the spectrum.

A prism, like the one Newton used, separates the colors of light through the process of refraction. When light is refracted, each wavelength of light is bent to a different degree. This separates light into individual bands that make up the spectrum. It is the wavelength of the light that determines its visible color.

Figure 1.2
A red object appears to be red because it reflects red wavelengths of light while absorbing most of the other wavelengths of light.

Figure 1.3
A white object looks white because it reflects all wavelengths of light that strike it.

Separating Light

The colors of light are also separated by the surfaces of objects. We perceive the color of an object by responding to the particular wavelengths of light reflected back to our eyes from the surface of the object. For example, a red car looks red because it absorbs most of the light waves reaching it, but reflects back those of the red part of the spectrum (figure 1.2). An eggshell will appear white because it reflects all the wavelengths of light that reach it (figure 1.3).

If the light is filtered, it will change the color of any object that it falls upon. If the white eggshell is seen only by a red filtered light source, it will appear to be red. This occurs since red is the only wavelength that strikes the eggshell, and in turn, red is the only color reflected back from the eggshell (figure 1.4). Objects that transmit light, such as color slides, also absorb some of the colors of light. They have dyes that absorb specific wavelengths of light, while allowing others to pass through. We perceive only the colors that are transmitted, that is, that are allowed to pass through the slide.

Young's Theory

By 1802, Thomas Young, an English physician and early researcher in physics, proved that light travels in waves which have specific frequency and length. In 1807, Young advanced a theory of color vision which states that the human eye is sensitive to only three wavelengths of light: blue, green, and red. These three primary colors are blended by the brain to form all the other colors. Young's ideas later formed the basis of the additive theory of light: white light is made up of blue, green, and red light. All the remaining colors visible to the eye can be created by mixing two or more of these colors (see chapter 2, History of Color Photography). Young's theory has yet to be disproved, even though it does not seem to fully explain all the various phenomena concerning color vision (see Color Observations in chapter 4). It does continue to provide the most useful model to date that explains all the principal photographic processes in which color images have been produced.

Figure 1.4
If a white object is shown in only a single-filtered source of light, it will appear to be only that single color. If only one color strikes an object, that color is the only color that can be reflected back.

Figure 1.5

The top cut-away view of the human skull reveals how color images are believed to be formed in the brain.

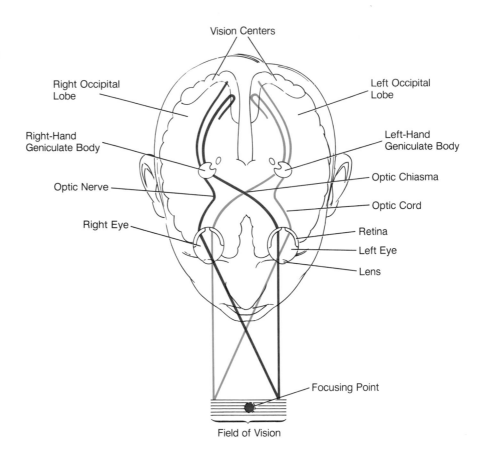

Vision Centers

Right Occipital Lobe

Left Occipital Lobe

Right-Hand Geniculate Body

Left-Hand Geniculate Body

Optic Nerve

Optic Chiasma

Optic Cord

Right Eye

Retina

Left Eye

Lens

Focusing Point

Field of Vision

How We See Color

It is rare for us to see pure color, that is, light composed solely of one wavelength. Almost all hues we see are a mixture of many wavelengths. Color vision combines both the sensory response of the eye and the interpretive response of the brain to the different wavelengths of the spectrum. Light enters the eye and travels through the cornea and passes through the iris, which acts as a variable aperture controlling the amount of light entering the eye. The now-formed image is focused by the lens onto a thin membrane at the back of the eye called the retina. The retina contains light sensitive cells called rods and cones, which create an image-receiving screen in the back of the eye. The physical information received by the rods and cones is sorted in the retina and translated into signals that are sent through the optic nerves to the nerve cells in the back of the brain. The optic nerves meet at the chiasma. Visual images from the right side of the brain go to the left and images from the left side of the brain go to the right (figure 1.5). This separation is essential for depth perception and three-dimensional vision.

Human beings can see a spectrum of about one thousand colors that range from red light, which travels in long wavelengths, through the midrange of orange, yellow, and green, to blue and violet, which have shorter wavelengths. The length of the light waves is determined by the distance from wave crest to wave crest. The difference between the longest and the shortest wavelengths is only about .00012 inch.

Chapter One

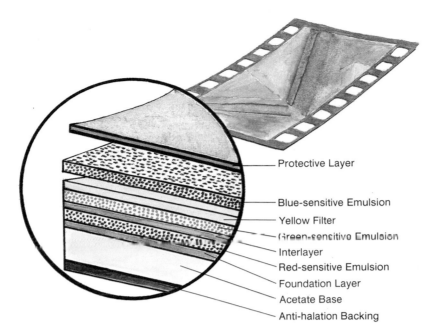

Figure 1.6
This enlarged cut-away view shows the construction of a typical contemporary, three-layered color film.

Protective Layer

Blue-sensitive Emulsion

Yellow Filter

Green-sensitive Emulsion

Interlayer

Red-sensitive Emulsion

Foundation Layer

Acetate Base

Anti-halation Backing

How the Brain Sees Color

This information is analyzed and interpreted in the brain. At this time, nobody has discovered the chemical and neurological reactions that actually let us perceive light or color. It is currently believed that the effects of light and color upon an individual are dependent upon their physical and psychological state, past personal experiences, memories, and preferences. It has been proven that when a group of people view a single specific color, their responses to it will vary considerably (see chapter 4). Although color can be defined objectively with scientific instruments, people apparently cannot. People see color subjectively.

Young's Theory Applied to Color Film

Current techniques for creating color photographs make use of Thomas Young's theory that almost any color we can see may be reproduced optically by combining only three basic colors of light: red, green, and blue. For example, all color films are generally made up of three emulsion layers which are supported by an acetate base (figure 1.6). Each emulsion layer is primarily sensitive to only one of the three additive primary colors. The top layer is sensitive to blue light and only records that color, the middle layer to green light, and the bottom layer to red light. All other colors are recorded on a combination of two or more of the layers.

How the Film Produces Color

During development each layer makes a different black-and-white image that corresponds to the amount of colored light that was recorded in each individual layer during the exposure (figure 1.7). The developer oxidizes and combines with the color chemical couplers in the emulsion to create the dyes. The blue-sensitive layer forms the yellow dye, the green-sensitive layer creates the magenta dye, and the red-sensitive layer makes the cyan dye. During the remaining stages of the process, the silver is removed from each of the three layers. This leaves an image created solely from the dyes in each of the three layers (figure 1.8). The film is then fixed, washed, and dried to produce a complete color image.

Figure 1.7
A representation of how color negative film produces an image. a. The original scene. b. How each layer of the film records the image. c. How each layer responds in processing. d. The final result used to make a color print.

•

(a) Original Scene

(b) After Exposure

Blue-sensitive Layer of the Emulsion

Green-sensitive Layer of the Emulsion

Red-sensitive Layer of the Emulsion

(c) After Processing

(d) Final Negative

Figure 1.8
Color film before and after processing.

•

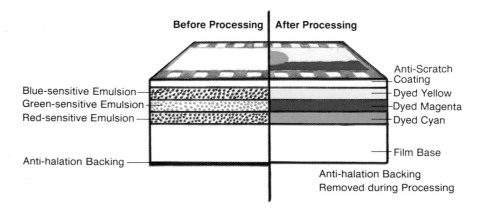

Before Processing | After Processing

Blue-sensitive Emulsion
Green-sensitive Emulsion
Red-sensitive Emulsion

Anti-halation Backing

Anti-Scratch Coating
Dyed Yellow
Dyed Magenta
Dyed Cyan

Film Base

Anti-halation Backing Removed during Processing

Chapter One

∴

A Concise and Select History of Color Photography

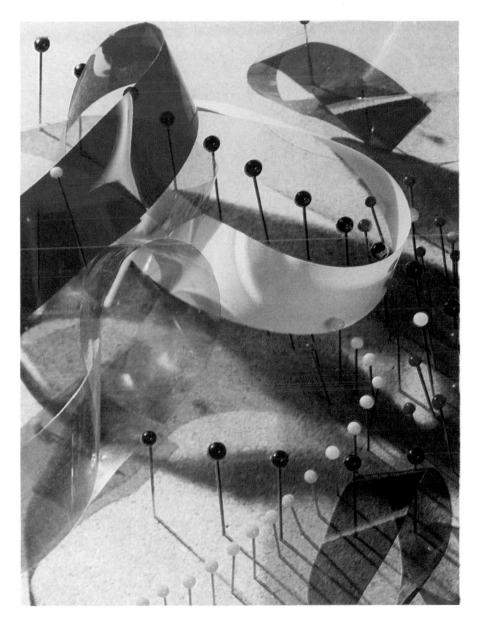

"Study with Pins and Ribbons 1937–38"
Laszlo Moholy-Nagy
34.9cm × 26.5cm,
Assembly (VIVEX Print),
International Museum of Photography at George
Eastman.

————
•

Figure 2.1
The first color photographs were black-and-white images that had been colored by hand.

Unidentified photographer, French, Female Nude, ca. 1858, Daguerreotype with applied color. © International Museum of Photography at George Eastman House

•

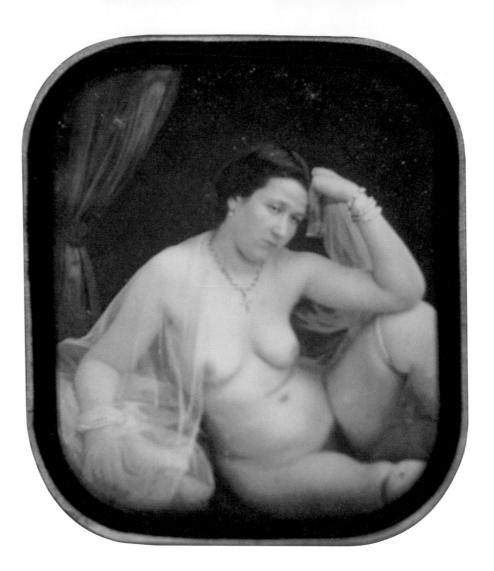

First Photographs

In 1839, Louis Jacques Mandé Daguerre made public the first practical photographic process called the Daguerreotype. It was a finely detailed, one-of-a-kind, direct positive image, produced through the action of light on a silver-coated copper plate. His photographs astonished and delighted, but people nevertheless complained that the images lacked color. Immediately, other interested parties began to seek a way to overcome this deficiency. Not surprisingly, the first colored photographs made their appearance that same year. They were black-and-white images that had been hand-colored (figure 2.1). It would take nearly a hundred years of research and development to perfect the rendition of color through purely photographic means.

First Experiments in Color

In 1840, Sir John Herschel, renowned British astronomer and also the originator of many seminal ideas in photography, reported being able to record blue, green, and red on silver chloride-coated paper. These three colors correspond to the rays of light cast on the paper by a prismed solar spectrum. Herschel's work suggested that photographs could be made directly from the action of light on a chemically sensitive surface. Herschel was unable,

Chapter Two

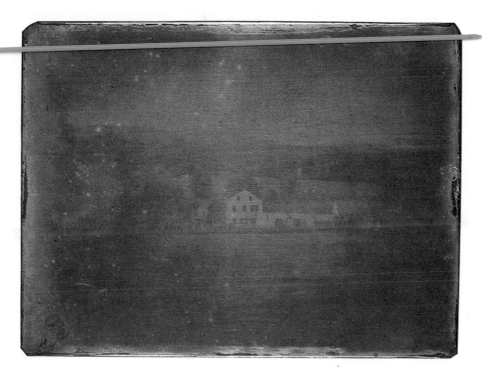

Figure 2.2
Levi Hill created a sensation in 1850 by announcing that he had discovered a way to make color photographs from nature. The photographic community waited in vain for Hill to publish repeatable instructions for his process. He was eventually dismissed as a faker.

Division of Photographic History, National Museum of American History. Hillotype, "Landscape with Farmhouse" Rev. Levi L. Hill 1851

however, to fix the colors on the coated paper. They could only be looked at very briefly under lamplight before they faded into blackness. Other experimenters attempted to record colors directly on Daguerreotypes. This was done through a process called Heliochromy, which did not make use of any filters or dyes. No Heliochromes are known to have produced any permanent recordings. Even the most stable of the early photographic color experiments faded within days when exposed to direct light.

A Secret Process

In 1850, Levi Hill, a Baptist minister from Westkill, New York, announced he was able to produce permanent color photographs (figure 2.2). Hill's announcement created quite a stir. Everyone was waiting to learn how the process worked. Six years later, Hill finally published his method by advance subscription, which netted him about $15,000. The account turned out to be a rambling tale of his life and experiments, but it did not contain any workable instructions for his secret process of making color photographs. Just before Hill's death in 1865, he still claimed to have made color photographs, but said it had occurred by accident. He revealed that he had spent the last fifteen years of his life attempting to repeat this accidental combination without success.

The First Color Photograph/The Additive Theory

The first true color photograph was made in 1861 by James Clerk Maxwell, a Scottish scientist. Maxwell used the additive theory developed by Thomas Young and refined by the German scientist, Hermann Helmholtz. The additive theory was based on the principle that all colors of light can be mixed optically by combining, in different proportions, the three primary colors of the spectrum—red, green, and blue. Just two primary colors can be mixed in varying proportions to produce many colors. For example, a mixture of the right proportion of green and red will produce yellow. When all three of these primary colors are combined in equal amounts the result is white light (figure 2.3).

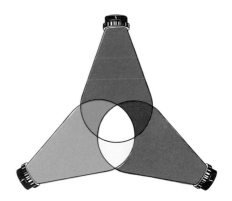

Figure 2.3
In the additive process separate colored beams of red, green, and blue light are mixed together in various proportions to create any color in the spectrum. When the three additive primaries are mixed in equal proportions, they appear as white light to the human eye.

Figure 2.4
James Clerk Maxwell made the first true
color photograph in 1861. Maxwell's success
proved the additive color theory and
provided a method for the creation of color
photographs.

James Clerk Maxwell, Tartan Ribbon, 1861.
© International Museum of Photography at George
Eastman House

When white light is passed through a primary-colored filter of red, green, or blue, the filter will transmit only that particular color of light and will absorb the other colors. A red filter will transmit red light, while absorbing all other colors, which are combinations of green and blue light.

James Maxwell's Color Photograph

Making use of the additive color theory, Maxwell had made three separate black-and-white negatives of a tartan plaid ribbon through three separate blue-violet, green, and red filters. Black-and-white positives were made from the three negatives. These positives were projected in register (the three images perfectly coinciding) onto a white screen, each positive from a different projector. Each slide was projected through the same colored filter that was used to make the original negative. For example, the green positive, originally photographed through the green filter, was projected through the green filter. When all three positives were simultaneously projected, each through the same colored filter from which the original negative was made, the result was a color photograph of the multicolored ribbon (figure 2.4). Maxwell's demonstration not only proved the additive color theory, but provided a method for producing color photographs.

A Mystery Solved

Later scientific investigation revealed that Maxwell's photographic emulsions were not properly sensitized; the experiment should not have worked. The emulsion was not sensitive to red and only slightly sensitive to green. It took scientists a century to figure out why Maxwell's experiment worked with an emulsion which was not sensitive to all the primary colors. It turned out that Maxwell's experiment succeeded because of two other deficiencies in the materials which cancelled out the effect of the nonsensitive emulsion. The red dye of the ribbon reflected ultraviolet light that was recorded on the red negative. His green filter was faulty and let some blue light strike the plate.

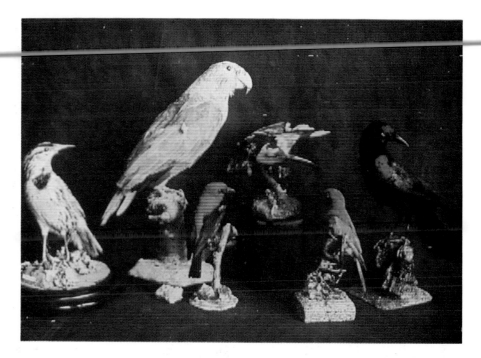

Figure 2.5
The Joly Color process, the first line-screen process for additive color photography, was introduced to the public in 1896. Although it had only a very limited success, it indicated that the additive method could become a commercially viable way for making color photographs.

Unidentified Photographer, Irish (?), Stuffed Birds, ca. 1895. © International Museum of Photography at George Eastman House.

·

Both of these defects corrected for the lack of sensitivity of the emulsion to red and green light. When done with properly sensitized panchromatic emulsions, sensitive to all the colors of the spectrum, Maxwell's method works perfectly. This proves his experiment was theoretically sound. However, the first true panchromatic emulsions, which had their sensitivity extended through the use of dyes, were not commercially available until the twentieth century.

Additive Screen Processes

In 1869, Louis Ducos du Hauron, a French scientist, published *Photography in Color*. Among the methods he proposed was one in which the additive theory could be used to make color photographs in an easier manner than the one Maxwell devised. A screen ruled with fine lines in the primary colors, red, green, and blue, acted as a filter to produce a color photograph with a single exposure, instead of the three exposures needed in Maxwell's experiment.

Joly Color

In 1894, Charles Jasper Joly, a Dublin physicist, patented the first line-screen process for additive color photographs, based upon Ducos du Hauron's idea. In this process, a glass screen that had transparent ruled lines of blue, green, and red, about two hundred per inch, was placed against the emulsion of an orthochromatic plate (not sensitive to red light). The exposure was made and the screen was removed. The plate was processed and contact-printed onto another plate to make a positive black-and-white transparency. This was placed in exact register with the same screen used to make the exposure. The final result was a limited-color photographic transparency that was viewed by transmitted light. This method was introduced in 1896 as the Joly Color process (figure 2.5). It enjoyed only a brief success, because it was expensive and the available emulsions were still not sensitive to the full range of the spectrum, thus the final image was not able to achieve the look of "natural" color. However, Joly's work indicated that the additive process could be a commercially practical way to make color photographs.

Figure 2.6
Autochrome was the first additive screen
process to achieve both aesthetic and
commercial success.

© Edwin Wisherd, Autochrome circa 1932 Courtesy of
Volkmar Wentzel Collection

Autochrome

In Lyon, France, a major breakthrough in the making of color photographs
was patented in 1904 by the inventors of the motion picture projector, Au-
guste and Louis Lumière. Autochrome was their improved and modified screen
process, which did not use colored lines as filters. In the Autochrome system,
a glass plate was dusted, in a random fashion, with equal amounts of micro-
scopic grains of potato starch that had been dyed with the primary colors
blue, green, and red. A fine black powder of coal dust was used to fill in any
spaces that would otherwise allow unfiltered light to pass through this filter
screen. A newly developed panchromatic emulsion, which greatly extended
the accuracy of recording the full range of colors in the visible spectrum, was
then applied to the plate. The exposure was made through the glass side of
the plate, with the dyed potato starch acting as tiny filters. The plate was
then developed, reexposed to light, and finally redeveloped to form a trans-
parency made up of tiny dots of the primary colors. The eye mixed the colors,
much like a pointillist painting, to make a color-positive image (figure 2.6).

Autochrome Characteristics

Autochrome was successfully used from 1907 to 1932, though it did have its
problems. Autochromes tended to be dark, due to the density of the potato
starch screen. Since the light had to travel through this dense screen, ex-
posure times were longer than with black-and-white films. Recommended
starting exposure time was 1 second at f/4 in direct sunlight at midday in the
summer and 6 seconds on a cloudy day. The randomly applied potato grains
tended to bunch up in places, creating blobs of color. Also, Autochromes
could be seen only in a viewer.

Figure 2.7
Dufaycolor, introduced in the 1920s, became the most popular of the additive process color films due to a faster emulsion time and an improved screen that provided more realistic colors.

© Willard R. Culver, Dufaycolor circa 1936 Courtesy of Volkmar Wentzel Collection

The advantages of this process, however, were numerous. Autochromes could be made with any regular camera, without needing additional photographic equipment to produce a color photograph; the image was made in one exposure, not three; the cost was not prohibitive; and while the colors were not accurate, they did produce a friendly, warm, soft, pastel image that was considered to be quite pleasing.

By the end of World War I magazines like *National Geographic* were using Autochromes to make color reproductions for the first time in their publications. Autochrome was the first color process to get beyond the novelty stage and to be commercially successful. It cracked a major aesthetic barrier because it was taken seriously for its picture-making potentialities. This enabled photographers to begin to explore the visual possibilities of making meaningful photographs with color.

Dufaycolor

Other additive screen processes followed on the heels of Autochrome. The Dioptichrome plate was made by the French firm of Louis Dufay, beginning about 1908. The process was improved and renamed Dufaycolor in the 1920s. Dufaycolor eventually became more popular than Autochrome because of the structure of its screen. The screen was a mosaic of alternating blue-dye and green-dye squares that were crossed at right angles by a pattern of parallel red-dye lines. This design allowed the use of a faster emulsion and offered greater color accuracy (figure 2.7). It was marketed until the 1940s. By this time, the quest for a simpler process that would provide more realistic and natural colors brought about technical discoveries which made all the additive screen processes obsolete.

Figure 2.8
Finlay Colour was the major competition to
Dufaycolor in the 1930s. All additive screen
processes, including these two, were
phased out with the perfection of
subtractive color materials in the later half of
that decade.

© Edwin Wisherd, Finlay Colour circa 1932 Courtesy of
Volkmar Wentzel Collection

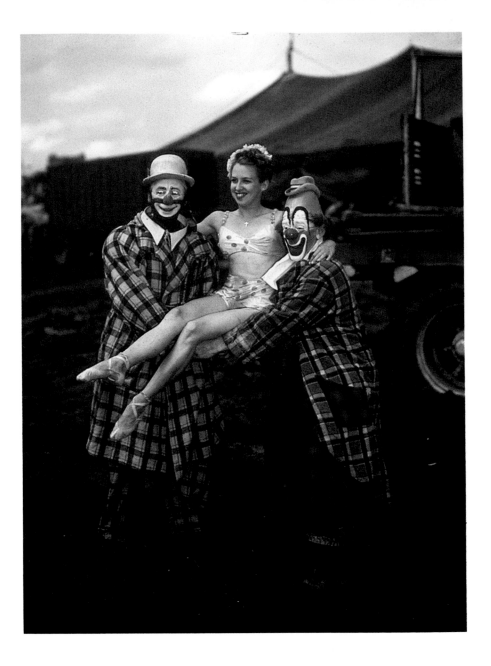

Finlay Colour

Finlay Colour was an additive screen process patented in 1906 by Clare L. Finlay of England and introduced in 1908 as the Thames Colour Screen. This screen was made up in a precise checkerboard fashion of red, green, and blue elements rather than the random mosaic pattern used in Autochrome. This separate screen could be used with any type of panchromatic film or plate to make a color photograph. In 1909, the Thames Colour Plate was released, containing an integral screen in which the screen and emulsion were combined to form a single plate. Both of these processes were abandoned after World War I, but improved versions were marketed under the name of Finlay Colour in 1929 and 1931 (figure 2.8). The Finlay Colour processes were to be the major rivals to Dufaycolor until the introduction of the subtractive materials in the mid-1930s.

Current Applications

Additive Enlargers

Today in color photography, the additive method is sometimes employed in the making of prints. It is in very limited use because the additive enlarger systems are more complex and expensive. To make a full color print with the additive process, the enlarger is used to make three separate exposures, one through each of the primary-colored filters. The blue filter is first used to control the amount of blue in the print, next the green filter is used to control the green content, lastly the red filter is used to control the red in the picture. Some people prefer this additive technique, also known as tricolor printing, because it is relatively easy to make adjustments in the filter pack, with each filter controlling its own color.

Television

The additive system is the perfect vehicle for color television since the set creates and emits the light forming the picture. The color television tube has three electron guns, each one corresponding to one of the additive primaries. These guns produce red, blue, or green phosphors on the screen to create different color combinations that form the image on the set.

The Subtractive Method

Louis Ducos du Hauron not only proposed a method for making color photographs with the additive process in *Photography in Color,* but he also suggested a method for making color photographs using the subtractive process.

How the Subtractive Method Works

The subtractive process operates by removing certain colors from white light while allowing others to pass. The modern subtractive primaries (magenta, yellow, and cyan) are the complementary colors of the three additive primaries (green, blue, and red). When white light is passed through one of the subtractive-colored filters it will transmit two of primaries and absorb (subtract) the other. Individually each subtractive filter transmits two-thirds of the spectrum while blocking one-third of it. For example, a magenta filter will pass red and blue, but will block green. When two filters are superimposed, they will subtract two primaries and transmit one. Magenta and yellow filters will block green and blue, allowing red to pass. When all three subtractive primaries overlap in equal amounts, they block all wavelengths and produce black. When they are mixed in varying proportions they are capable of making almost any color (figure 2.9)

Pigments

When working with pigments, as in painting, instead of light, the colors are also formed subtractively. The different colors of pigments absorb certain wavelengths of light and reflect others back for us to see. However, painters generally use red, blue, and yellow as their primary colors. These colors cannot be mixed from any other colors. These primary colors are used to make all their other colors. Red and yellow will make orange, red and blue make purple, and blue and yellow make green. Green, an additive primary, cannot be used as a primary color in painting because it consists of two colors, blue and yellow.

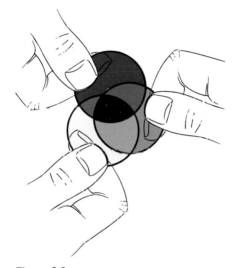

Figure 2.9
The subtractive process allows almost any color to be formed by removing certain colors from white light while permitting other colors to pass. The subtractive primary colors in photography are magenta, yellow, and cyan. They are the complementary colors of the additive primaries green, blue, and red. Black is produced when all three filters overlap.

———— •

Figure 2.10

In Louis Ducos du Hauron's Heliochrome process three separate negatives were made on black-and-white plates, using three separate subtractive filters. The negatives were used to make three positives, which were then superimposed to create a color photograph. This was the first successful use of the subtractive process in the making of color images.

Louis Ducos du Hauron, *Cityscape of Agen*, France, 1877. © International Museum of Photography at George Eastman House

Heliography

In Ducos du Hauron's patented subtractive method, known as Heliography, three separate negatives were made behind three separate subtractive filters. He used violet, green, and orange-red filters (the correct modern subtractive filters had not yet been established). Positives were made from these negatives and printed onto three sheets of light-sensitive bichromated gelatin. These positives contained carbon pigments of blue, red, and yellow, which Ducos du Hauron believed to be the complementary colors of the filters that were used to form the colors in the original exposure. When washed with hot water, the gelatin that was not affected by light in the original exposure was washed away. This left blue, red, and yellow carbon prints, which when superimposed together formed a color photograph called a Heliochrome (figure 2.10). Color prints or slides could be made with this process, depending upon whether the carbon prints were attached onto paper or glass.

Exposure Difficulties

Though the subtractive process proved to be practical, it plagued photographers with long exposure times. Ducos du Hauron reported typical daylight exposures of 1 to 2 seconds with the blue-violet filter, 2 to 3 minutes with the green filter, and 25 to 30 minutes behind the red one. If the light changed during the exposure process, the color balance would be incorrect in the final result. This problem was solved in 1893 when Frederic Eugene Ives perfected Ducos du Hauron's single-plate color camera.

Ives's invention, the Photochromoscope camera, made three separate negatives in succession on a single plate by using a revolving back that had blue-violet, green, and red filters. Positives were made by contact printing. The three positives were cut apart and placed on Ives's Kromskop viewer. This viewing system had the same type of colored filters as the camera and a system of mirrors that optically superimposed the three separations creating a color Kromogram. The completed color photograph could only be seen in this viewer (figure 2.11). While Ives's methods did work, they were complex, time-consuming, and expensive.

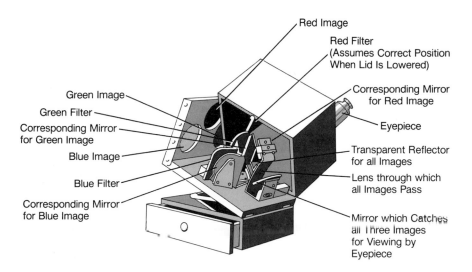

Green Image
Green Filter
Corresponding Mirror
for Green Image
Blue Image
Blue Filter
Corresponding Mirror
for Blue Image

Red Image
Red Filter
(Assumes Correct Position
When Lid Is Lowered)
Corresponding Mirror
for Red Image
Eyepiece
Transparent Reflector
for all Images
Lens through which
all Images Pass
Mirror which Catches
all Three Images
for Viewing by
Eyepiece

Figure 2.11
Frederic Eugene Ives's Kromskop viewer
was a complex and expensive viewing
system that optically superimposed three
Photochromoscope positives to make up a
color Kromogram.

Subtractive Film and Chromogenic Development

Between 1911 and 1914, Rudolf Fisher of Germany, working closely with Karl Schinzel of Austria, invented a color film that had the color-forming ingredients, known as color couplers, incorporated directly into it. This type of film, known as an integral tri-pack, was made up of three layers of emulsion, stacked on top of each other, with each layer being sensitive to either blue, green, or red.

Through a process known as chromogenic development, the color couplers in each layer of the emulsion form a dye image in complementary colors of the original subject. During chromogenic development, the dye image is made at the same time as the silver halide image is developed in the emulsion. The silver image is then bleached away, leaving only the dye, which is fixed to form the final image.

The problem with this tri-pack film was that unwanted migration of the dyes between the three layers could not be prevented, causing color inaccuracies in the completed image.

The discovery that color couplers could produce images by chromogenic development was a giant breakthrough that laid the foundation for most color processes in use today. Some black-and-white films also make use of this system to make various densities of black dye.

Kodachrome

In 1930 Leopold Godowsky, Jr. and Leopold Mannes, who had been experimenting with making color films in makeshift labs since they were teenagers, were hired by Kodak Research Laboratories. By 1935 they were able to overcome the many technical difficulties and produce the first truly successful integral, tri-pack, subtractive-color reversal film. This film was called Kodachrome and was first marketed as a 16mm movie film. It was said, only half jokingly, that it took God and Man (Godowsky and Mannes) to solve the problem of the color couplers' unwanted migration between emulsion layers. Their ingenious solution to this problem was to include the color couplers in separate developers during the processing of the film, rather than building the color couplers into the film emulsion itself. Unlike all other current color films, Kodachrome continues to be the only color film made without these color couplers in the film emulsion.

Figure 2.12
With Kodachrome began the modern era in color photography of accurate, reliable, and easy-to-use color films. The technical perfection of the color processes combined with artists' feeling for light and strong sense of composition have made color photography one of the major art forms of the twentieth century.

© Eliot Porter, "Apples, Maine 1942," Kodachrome Courtesy of Scheinbaum & Russek Gallery, Santa Fe, NM

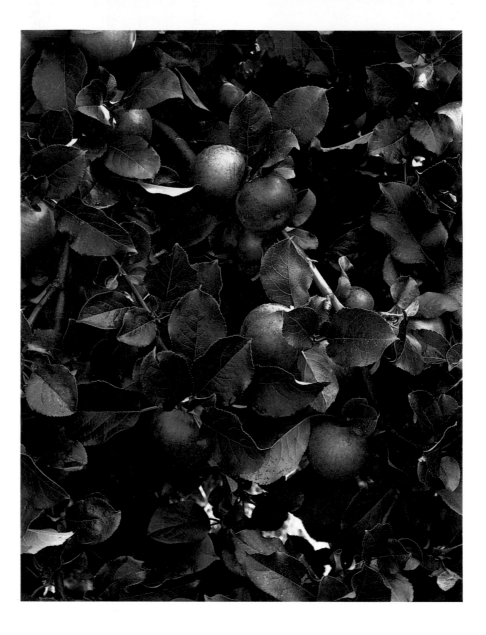

Exposure Problems Solved

In Kodachrome film only one exposure is needed to record a latent image of all three primary colors. The top of the emulsion is sensitive only to blue. Under this is a temporary yellow-dye filter that absorbs blue light, preventing it from affecting the emulsion below. This temporary yellow filter, which dissolves during processing, allows the green and red light to pass through and be recorded in the proper emulsions below.

The Kodachrome Process

Kodachrome is first developed into a negative, then through reversal processing into a positive. During the second development, the colors of the original subject are transformed into complementary dyes—cyan, magenta, and yellow—that will be used to form the final color image. Then the positive silver images are bleached away and the emulsion is fixed and washed. This leaves a positive color image that is made up only by subtractive-color dyes with no silver.

Chapter Two

In 1936 Kodachrome was marketed for the 35mm still photography market. Kodak was concerned that nobody would want a tiny slide that had to be held up to the light to be seen. In a brilliant move, Kodak had each processed slide returned in a 2″ × 2″ cardboard mount which could be projected onto a screen. The slide show, which had died out with the Victorian-era Magic Lantern exhibitions, was reborn.

Kodachrome was the first film to achieve the dream of an accurate, inexpensive, easy-to-use, and reliable method for making color photographs. The only drawback to Kodachrome is that its complex processing means that the photographer is unable to develop the film; it must be sent to a lab that has the necessary equipment. Its use and mastery by artists like Eliot Porter began the modern struggle to have color photography recognized as a legitimate art form (figure 2.12). In over the fifty years since its introduction, Kodachrome continues to be the unmatched standard in accuracy, rendition, contrast, and grain for all color films.

Chromogenic Slide Film

In 1936 Agfa released Agfacolor Neu film, which overcame the migration of the color couplers. This was done by making the color coupler molecules very big. In this manner, they would mix easily with the liquid emulsion during the manufacturing of the film. Once the gelatin that bound them together had set, the color coupler molecules would become trapped in the tiny spaces of the gelatin and would be unable to move. This was the first three-layer subtractive-color reversal film that had the color couplers built into the emulsion layers themselves and employed a single developer to make the positive image (figure 2.13). This simplified process allowed the photographer to process the film. Kodak countered with its own version of the Agfacolor process in 1940 with Ektachrome.

Chromogenic Negative Film

Agfa brought out a color negative film in 1939 from which positive color prints could be made directly on a special companion paper. Kodak followed suit in 1942 with Kodacolor. Kodacolor is considered to be the first subtractive-color negative film that completely solved the problem of the color couplers migrating from layer to layer in the emulsion.

Chromogenic Negative Development

The processing method used for Kodacolor is, with many improvements, the basis for all color negative film processes in use today (see chapter 6, Color Negative Film).

In this process, currently called C–41, a single developer produces a negative silver image and a corresponding dye image in all three layers of the emulsion at the same time. Bleach is used to remove all the silver, leaving only the dye. The film is fixed, washed, and dried, completing the process.

Kodacolor overcomes the limitation of each image being one-of-a-kind since any number of positive prints can be made from a color negative film.

When making prints from a chromogenic negative with the subtractive method, the light is filtered in the enlarger before it reaches the negative. Correct color balance can thus be achieved in a single exposure with a minimum of filtration. One of the three dye layers in the negative is usually left unfiltered. Thus, printing is simplified as it is not necessary to use more than two filters at one time to make a print. The subtractive method also enables pictures to be made directly from slides in a reversal printing process such as Cibachrome, Type R, and Dye Transfer.

Figure 2.13
Agfacolor—Neu film, released in 1936, was the first subtractive-color reversal film to have color couplers built into the emulsion. This development greatly simplified film processing and allowed photographers to personally develop their film.

© Hans Hildenbrand, Agfacolor Detail enlarged from 5″ × 7″ Courtesy of Volkmar Wentzel Collection

The Act of Seeing

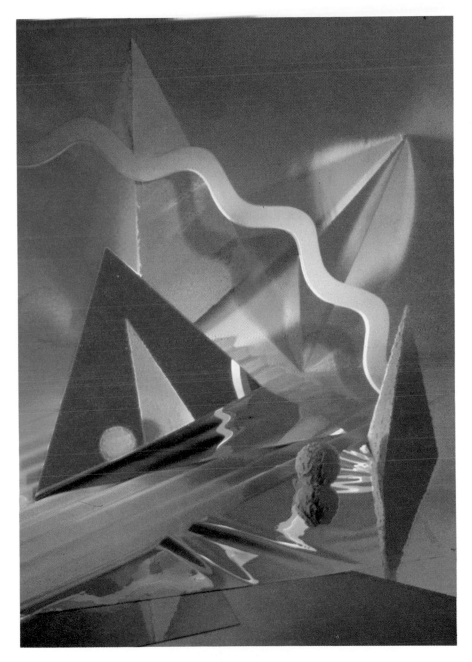

"Metaphase 5, 1986"
Barbara Kasten
Cibachrome,
Courtesy John Weber Gallery, NYC.

———
·

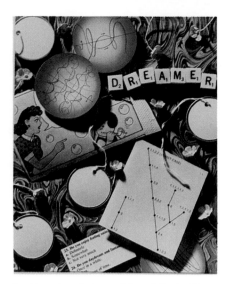

Looking at a photograph is not like looking out a window. It requires a system of thought processes to reach a decision. It is not a mysterious God-given gift, but a process that can be taught and mastered.

© Ann Lovett "The Innocents: Dreamer" 1985, 14" × 11" Type C print

How We See

Seeing is an act of perception. It helps us to ascertain, experience, learn, and understand. It is an individual experience that is conditioned by the traditions and standards of the culture in which we live.

Our western society has always been dependant upon literacy to function. It is necessary to be able to read in order to decipher messages that have been put into a written code or language.

When one begins to deal with pictures, another set of skills is needed to interpret the coded information. One must learn to become visually literate.

Visual Literacy

All literacy is based upon the quality of the reader's stored information. The more accessible information a person has on file, the wider the range of possible responses that person has to any situation that arises.

Some people are afraid to learn to read images. These people only accept the old ways and reject anything that is new, different, or unfamiliar. When people are able to overcome this fear and begin thinking on their own, learning becomes a joyful and invigorating experience. This adds to their storehouse of information that can be called upon when dealing with new situations, thereby increasing their range of responses.

Whatever type of communication is in use, the receiver must be able to understand the code. In the past, pictures showed something of known importance. Traditional picture-making used the act of seeing to identify subject matter. This is all many people expect and want of a picture maker. When something different or unexpected appears, they have no data or mechanism to deal with it. What we do not know or recognize tends to make us nervous and uneasy. This hostility manifests itself in the form of rejection, not only of the work, but of any new ideas as well.

Looking at a picture is not the same as looking out a window. It requires thinking, sorting, analyzing, and decision making. It is a developed system of thought that can be taught and learned.

Social Values

Society has not placed a high value upon learning the visual language. For many people art is simply something that is supposed to be pretty and recognizable. They have missed the picture maker's function within society as someone who can perceive, interpret, and offer a wider understanding of reality. Yet it is these same people who crave the products that these explorations often bring forth. People do not make fun of the scientist in the lab even if they do not understand what the scientist is doing because society has sanctioned the scientist's activities. The major difference between art and science is that the former is an intuitive approach to explain reality while the latter insists on an exact rational set of repeatable measurements. Science says there is only one right answer; art says there are many correct answers.

Visual Illiteracy

The value system of our culture reflects the scientific mode of thought; achievements have to be measured in terms of words and numbers. The educational system has been interested in teaching only the twenty-six symbols of our alphabet and the numerals 0 through 9. This teaching meets the needs of growing industrial nations, but demands change. Education should be a

Chapter Three

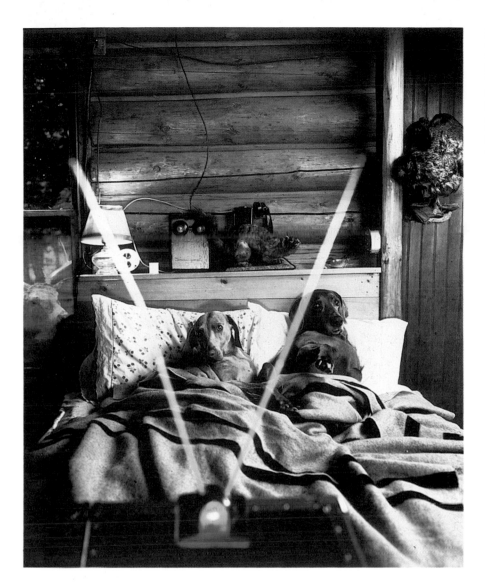

Photography can let the image maker comment and interact with society. The visually literate viewer can decode the image and make an intelligent response. This process can stimulate thought and action, bringing about changes in society and making life more meaningful.

William Wegman "Ray and Mrs. Luber in Bed Watching TV (Second Version) 1981" 20" × 24" Polaroid, Courtesy of Holly Solomon Gallery New York, NY

·———

process, not a product. Public education has ignored visual literacy and the price that has been paid is that many people do not have the skills necessary to understand all the messages that surround them in their environment. They lack the necessary data to go through a visual decision-making process. They have become "objects" that can easily be manipulated. They simply react to situations by either accepting them or rejecting them. They do not question anything. They have been removed from the process.

The picture maker is an active participant in this decision-making process. Image making offers the opportunities for the photographer to interact and comment on what is going on with society. The photographer's work can stimulate others to thought and action. The entire photographic process can make life deeper, richer, more varied, and more meaningful. This process is worth something, even if it cannot be measured in tangible terms.

Seeing is a personal endeavor of which the results depend on the viewers' ability to decode the messages that are received in a symbolic form. A broad, flexible response will show the viewer there is no hierarchy of subject matter. Keeping the mind open will enable one to uncover all the levels and possibilities of new materials and to view the familiar anew.

Pursuing the role of the picture maker as the "scout," riding out in front of the wagon train, making observations of unknown or hostile territory, and reporting back the findings to the group, requires a mastering of the basic ingredients of all image making. Understanding the basic design elements and how light affects objects is crucial in learning how to look at and make pictures.

Becoming visually literate is one small step a person can take in accepting responsibility for affirming their own values. Ultimately this could have widespread effects. As more people become visually educated, more aware of their surroundings, and are able to see the world for themselves, they can participate in making decisions that affect the manner in which the business of society is conducted.

What Are You—Visual or Haptic?

Have you ever wondered how and why photographers make pictures in a specific style or why viewers of photography react more strongly to certain pictures? This section will present some ideas on this subject, get you thinking about it, and let you draw your own conclusions.

The Work of Victor Lowenfeld

The initial work in discovering some of the separate ways that we acquaint ourselves with the environment was done by Victor Lowenfeld in 1939 while he was working with the partially blind. Lowenfeld found that some partially blind people would use their limited sight to examine objects when they worked with modeling clay. He noticed that other visually impaired people would not use their eyes but instead would use their sense of touch. These observations led Lowenfeld to conduct a study of people with normal vision in which he found they had the same tendencies.

The Creative Types: Visual and Haptic

Lowenfeld divided the creative types into two major classifications. The first group took an intellectual, literal, realistic, quantitative approach to things. He called this group "visual." The second type functioned in an intuitive, qualitative, expressionistic-subjective mode. He labeled these people "haptic." In his studies Lowenfeld found that 47 percent of the study subjects had clear visual tendencies, 23 percent had clear haptic tendencies, and 30 percent had mixed visual and haptic tendencies. Lowenfeld then set out to determine the major characteristics of each of the groups.

Characteristics of the Visual Type

He found that the visuals tend to produce whole representational images. They are concerned with "correct" proportions, colors, and measurements (figure 3.1). The visual realist likes to acquaint himself with his environment primarily through his eyes; the other senses play a secondary role.

Figure 3.1
Lowenfeld's "visual" types like to make representational images that deal with preserving the illusion of the outer world.

© David Graham "Best Co." 1981 Type C, Courtesy of Jayne H. Baum Gallery, New York, NY 20" × 24"

Visual Photographers

As a generalization, visual photographers prefer to preserve the illusion of the world. The visual-realist style is an unmanipulated objective mirror of the "actual" world. It is unobtrusive, and concerned with *what* is there. These people use the camera traditionally, tending to be observer/spectators; for them the camera is a recording device. They go for content rather than for form. The subject is always supreme. In their work they avoid extreme angles and photograph from eye level. Documentary work is the most obvious style. They usually attempt to preserve spatial continuity and favor a normal lens. Their style is more open, subtle, recessive, or informal, leaning towards the unobtrusive and the familiar.

Working Methods of Visual Photographers

The visual-realists like to print full-frame uncropped negatives. The code of the visual-realist is that of linear reality. Their pictures reflect concrete themes and often tell a story. The visual-realist uses the "straight" technique. The Zone System has become a favorite starting place with its emphasis on "correct" technique.

The picture is usually created at the moment the shutter is released (figure 3.2). Darkroom work is kept to a minimum. Few or no unusual techniques are employed except what is considered to be in keeping with the current tradition. They may not even do their own processing or printing. Visual-realists have used photography to match reality and have often used the work to produce motives for change in society. The work has enabled people to see places and things that they are not able to experience for themselves.

Figure 3.2
Lowenfeld's "haptic" types tend to incorporate themselves into their work. Emotional and personal values can determine the color and form of the final image, resulting in expressionistic works.

© Barbara Kasten "Architectural Site 6, July 14, 1986" (Pelli) Courtesy of John Weber Gallery, New York, NY 30" × 40" Cibachrome

Figure 3.3
The "visual" photographers' work often reflects concrete themes and tells a story. Documentary and journalistic work generally fit into the visual's way of seeing. This kind of work lets people see and experience actual things that they normally would not interact with.

© Larry Burrows "DMZ, 1966" 11" × 14" Dye Transfer Courtesy of Larry Burrows Collection & Laurence Miller Gallery, New York, NY

•

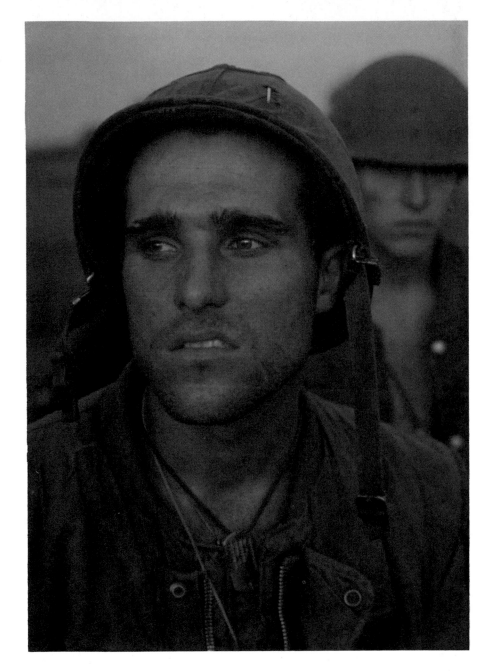

Characteristics of the Haptic Type

Lowenfeld found that the haptics were more kinesthetic. Haptic comes from the Greek word *haptos,* which means "laying hold of." The haptic is more concerned with his bodily sensations and subjective experiences. The haptic becomes part of the picture. Emotional and subjective values can determine the color and form of objects, rather than how and what they actually look like (figure 3.3).

Haptic Photographers
The haptic-expressionist photographers will often stylize and distort the subject. They participate actively in the photographic process and become part of the picture. The haptics, explorers of the inner self, are trying to liberate their inner vision instead of reproducing an image of the outer world. They are concerned with the subjective and more personal type of vision. Dealing with spiritual and psychological questions tends to restrict the audience appeal of the work.

Chapter Three

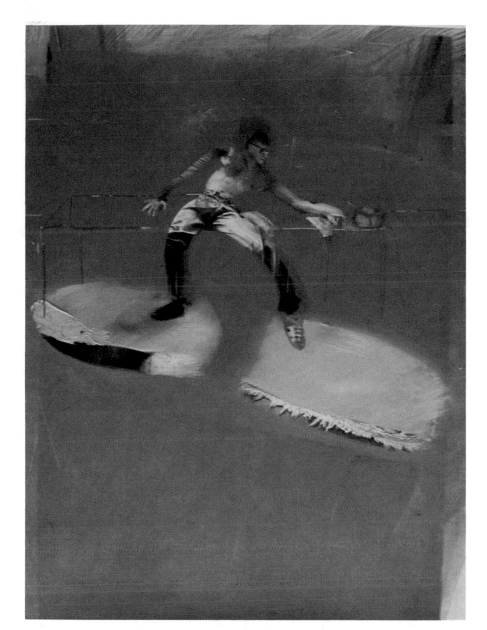

Figure 3.4
The "haptic" photographers actively become part of the photography process by distorting and stylizing the subject, frequently practicing postvisualization manipulation of the image to create a more intense response. Haptics tend to explore the inner self and their images deal with questions of a psychological and spiritual nature.

© Holly Roberts "Man With T.V." 20" × 16" Oil on silver print

•

The Haptic Photographers' Working Methods

The haptics are the ones who will break with ritual. Their style is more self-conscious and conspicuous, placing importance on the unfamiliar. The emphasis is on form. They will emphasize the essential nature rather than the physical nature of the subject.

The haptic-expressionists use the camera flamboyantly. It becomes a tool to offer comment on the subject at hand.

They will manipulate the image if it will heighten the response. They will move and rearrange the given reality to suit their needs. Many times, they will fragment real space, preferring a closer, more controlled shot.

The haptic will frequently practice postvisualization, seeing the darkroom as a creative lab to carry on visual research. Experimenting with different techniques and types of film and paper, their darkroom becomes a spot for contemplation, discovery, and observation (figure 3.4).

The haptics create their own mini-universe, saturating the image with visual clues and information, attempting to direct and lead the viewer around within the frame.

Photography's Visual Revolution

Photography has brought about a revolution in the arts. It initially freed painters and writers from having to describe objects and happenings, letting them move from outer matching to inner matching. It turned art toward the inner processes of creativity in expression, which helped lead to the development of abstract art. This has opened entirely new roads for the human mind to travel upon. The artist is now able to present the entire creative process for public participation.

Photography has been changing so rapidly that it is difficult for many people to keep up. Most still cling to the same ideas that were presented to them when they were children. This attitude has blocked the path of creativity and slowed the growth of photography. Experimentation in any field is necessary to keep it alive, growing, and expanding. The photographer should be encouraged to experiment for the pursuit of new knowledge.

As both a photographer and viewer of photographs, it is important to know that there is no fixed way of perceiving a subject, only different ways that a subject can be experienced. Photograph your experience of what is mentally and emotionally important, what is actively in your mind and what you care about during the process of picture making. When looking at other photographs, especially ones that are unfamiliar or you do not understand, attempt to envision the mental process that the photographer used to arrive at the final image. The visual photographers are concerned with the "what" and the haptics with the "how."

The Process of Rediscovery

Photography offers a rapid sequence of rediscovery. A new picture can alter the way we look at a past picture. Feel free to use whatever method is necessary to make your picture work, whether it is previsualization, postvisualization, a preprocess idea or an in-process discovery. In your work you do not think with your eyes, so give yourself the freedom to question the acceptance of any method of working. Make the darkroom a place and a time for exploration, not a situation to display your rote-memory abilities. Do not be inhibited to walk on the edge. Do not let someone else set your limits. Just because you have done something that was unexpected does not make it wrong. There are major discoveries waiting to be uncovered in photography. Keep your definition of photography broad and wide. There are no intrinsic standards to follow. If you are able to let your true values and concerns come through, you will be on the course that allows your best capabilities to come forward and be seen. Do not be awed by fashion, for it is no indication of awareness, knowledge, or truth. It is simply a way of being "with it." Talking about photography is just that, talking about photography. Words are not pictures. As a picture maker the ultimate goal should be making pictures.

. .

Assignment

Determine whether you possess the more general qualities of either the visual or the haptic way of image making. Choose a subject and photograph it in that manner. Next, turn that switch inside your brain and attempt to think in the opposite mode. Make a picture of the same subject that reveals these different concerns.

Figure 3.5
The color key reflects the present fundamental color concerns of the photographer. It is not constant, but varies depending upon the concerns, mood, and state of mind of the photographer.

© Harriet Gans "4FLS" 1986 16" × 20" Cibachrome

The Color Key and the Composition Key

How is the decision reached as to which colors are included in the picture? People have colors that they tend to favor. Notice the colors with which you chose to surround yourself. Observe the colors of your clothes or room because they are a good indication of your color key.

The Color Key

Your color key is a built-in automatic pilot. It will take over in situations when you do not have time to think. Everyone has it. It cannot be made; it has to be discovered.

The color key reveals the character of a person. It is not a constant; it changes. At one point it is possible to be seeing dark, moody hues; later it could be bright, happy, warm colors. It is all a balancing act that mirrors your inner state of mind. When the picture is composed, the framing establishes the relationship of the colors to one another. These decisions will affect how the colors are perceived. The colors selected are the ones that the photographer currently identifies with in a fundamental way (figure 3.5).

The Composition Key

The composition key is the internal sense of construction and order that is applied in putting the picture parts together. It cannot be forced. One's true sense of design and style is an ongoing developmental process. It is a rendition of yourself in terms of picture construction. You are it. It is incorporated into the work and is given back in the final image. Some common compositional keys to begin looking for are the triangle, circle, figure eight, and spiral along with the H, S, and W forms (figure 3.6).

Figure 3.6
The composition key is an internal sense of
design that the photographer uses to
structure the image. It reveals the
photographer's sense of design and visual
style. This sense is not fixed, however, but
an ongoing developmental process.

© Erik Lauritzen "Backlot, 1986" 14" × 17" Type C
print

·

Recognizing the Keys

Recognizing these keys is a way to make yourself more aware and a better
image maker. The good photographer can learn to make pictures even in bad
conditions. Being able to see that there is more than one side to any situation
will help make this happen. For example, one could say it is raining and not
go out to make a picture, or one could see that it is raining and make this an
opportunity to make the diffused, shadowless picture that has been in the
back of their mind. These keys are meant to offer a guide for understanding
how people visually think. They are not hard-and-fast rules for making pic-
tures. They should also point out that there is more than one way for people
to see things. When you learn how others are viewing the world, it is then
possible to see more for yourself.

Can you identify your personal color and composition key? Do not expect
to find it in every piece. It can be hidden. Doodles can often provide clues to
one's compositional key. If you are having trouble seeing these phenomena,
get together with another photographer and see if you can identify each others
"keys."

· ·
· ·

Assignment

Look through books and magazines and find a body of work by a photogra-
pher that has meaning for you. Notice the color and compositional devices
that this photographer uses in the work. Now make a photograph in the manner
of this photographer. Do not copy or replicate this photographer's work, but
take the essential ingredients and employ them to make your own photo-
graph. Next, compare the photograph that you have made with the work of
the photographer. Lastly, compare both photographs to your other work. What
similarities and differences in color and composition do you notice? What can
you see that you did not notice before making these comparisons?

Figure 3.7
An example of the figure-ground phenomenon. What do you see first? How can this type of ambiguity affect how the viewer might read and respond to an image? What role does contrast play in how you see this image?

•

Figure 3.8
If the figure and the ground are similar, the viewer can have trouble determining what the photographer thought was important to present. Complex compositions require careful and skillful handling so the viewer does not get lost within the photograph.

© Vin Borrelli "Workshop, Thompson, CT, 1987"
16" × 20" Type C print

•

Figure-Ground Relationships

What Is Figure-Ground?

Figure-ground is the relationship between the subject and the background. It also refers to the positive-negative space relationship within your picture. "Figure," in this case, is the meaningful content of your composition. "Ground" describes the background of the picture.

Figure 3.7 is a classic example of the figure-ground phenomenon. What do you see first? Can you discern a different figure-ground relationship? What do you think most people see first? Why? What does this tell you about the role of contrast?

Why Is This Important?

When the figure and the ground are similar, perception is difficult (figure 3.8). The viewer might have difficulty in determining what is important to see in the picture. It often occurs when the photographer attempts to show too much. The viewer's eyes wander all over, without coming to a point of attention. The composition lacks a climax, so the viewer loses interest and leaves the image. If you have to explain what you were trying to illustrate, there is a strong chance that your figure-ground relationship is weak.

Figure 3.9

A simple, straightforward composition with a limited number of colors is one way a photographer can strengthen figure-ground relationships.

© David Robinson "NYC 4" 16" × 20" Cibachrome, Courtesy of J. J. Brookings Gallery, San Jose, CA

What Can Be Done to Improve It?

When you observe a scene, determine exactly what interests you. Visualize how your content (figure) and background (ground) are going to appear in your final photograph. Put together a composition that will let the viewer see the visual relationships that attracted you to the scene. Be selective about what is included in the picture. Isolate the subject. Do not attempt to show "everything." Many times showing less will actually let the audience know more about the subject, as they do not have to sort through a multitude of visual chaos. Try limiting the number of colors until you gain more experience (figure 3.9). A color photograph does not have to have every color in the universe in it. Keep it simple and make it meaningful.

Assignment

Make two photographs of the same scene. Have one that shows a clearly definable figure-ground relationship of the scene. Have the other portray a weak figure-ground relationship. Then compare and contrast the two.

FOUR

∴

Thinking in Color

"New York City, 1971"
Helen Levitt
11″ × 14″, Dye Transfer,
Courtesy Laurence Miller Gallery, New York, NY.

———
•

Photography and Reality

Most people say they prefer color pictures to black-and-white pictures. They claim that color photographs are more "real" than black-and-white. This means that we tend to confuse color photography and reality to even a greater extent than black-and-white. Have you ever walked into someone's house and they point to the 8" × 10" color glossy on the piano and say, "There's Morty. He sure looks good, doesn't he?" We all know that isn't Morty, but we expect photography to duplicate our reality for us. This situation reveals an entire series of problems dealing with the construction of current color materials and our own powers of description and memory that the photographer and the audience face when working with color.

Standards in Color

In all the color processes, the final outcome hinges on how successful the synthetic dyes replicate a "natural" color balance. Each manufacturer makes their emulsions to emphasize different color balances. Certain colors are over-emphasized and in others their degree of brightness is exaggerated. While these colors may look good, they are not accurate and there is a loss in delicate and subdued colors. There is *no standard!* Some films tend to create a cool, neutral, or even detached look. They emphasize blue and green. Other films give a warm look, favoring red and yellow. These colors seem more intense and vivid. The warmness tends to draw people in and create more involvement.

This lack of a standard color balance is true of all color films, whether they are for making negatives or slides. The dyes simulate the look of reality, but they do not reproduce true colors. What you get is an interpretation of the scene. For this reason it becomes imperative for the photographer to personally work with many of the available materials in order to find one that agrees with his personal color sense. By learning the characteristics of films, the photographer will also know what film will work best in a given situation.

Talking about Color

Have you ever noticed how few words there are to describe colors in the English language? Some cultures have up to twenty words to distinguish slight differences within one color. Without the words for description, we have a very limited ability to see and distinguish subtle variations in color. Most people will simply say the car is red. This covers a great deal of territory. We go to a car dealer and they call it "candy apple red." Neither term is an accurate description and doesn't give another person much sense of what we are attempting to describe. These vague generalizations cause problems in translating what we see in pictures into words.

Color Description

Each color can be defined by three essential qualities. The first is hue, which is the name of the color, like blue or yellow. It gives the specific wavelength that is dominant in the color source. The second quality is saturation, or chroma, which indicates the apparent vividness or purity of a hue. The spectrum shows perfectly saturated hues (figure 4.1). The narrower the band of

The Electromagnetic Spectrum

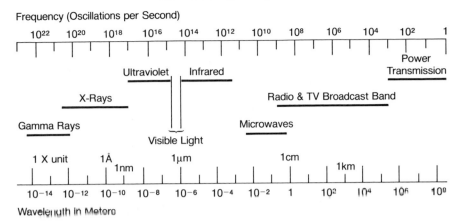

Frequency (Oscillations per Second)

Wavelength In Meters

The Visible Spectrum

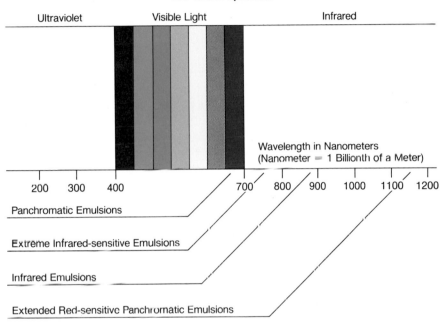

Wavelength in Nanometers
(Nanometer = 1 Billionth of a Meter)

Panchromatic Emulsions

Extreme Infrared-sensitive Emulsions

Infrared Emulsions

Extended Red-sensitive Panchromatic Emulsions

Figure 4.1
The complete spectrum is made up of all forms of electromagnetic energy. Only an extremely limited range of the entire spectrum, called the visual spectrum or white light, can be detected by the human eye. When white light is broken up into its various wavelengths the eye sees these wavelengths as separate colors.

wavelengths, the purer the color. Strong, vivid hues are referred to as saturated colors. Almost all colors we see are desaturated by a wider band of other wavelengths. When different wavelengths are present, the hue is said to be weaker or desaturated.

The third quality of color is luminance or brightness. Luminance deals with the appearance of lightness or darkness in a color. These terms are relative to the viewing conditions. They try to define color as it is seen in individual situations.

These terms can be applied to color description in any situation. Take as an example the specific hue, red, which has the longest wavelength of visible light. Mix it with a great deal of white light and it produces pink, which is

Figure 4.2
This is an example of color description for red. Notice how this hue's saturation and luminance have been altered, producing a wide variety of color effects.

·

desaturated red. Now paint this color on a building that is half in sunlight and half in shadow (figure 4.2). Each side of the building would have the same hue and saturation, but each side would have a different luminance. If a beam of sunlight strikes an object and makes a "hot spot," then that area is said to be desaturated since the color has been diluted with a large amount of white light. White is a hue with no saturation, but has a high luminance. Black contains no saturation and a very small amount of luminance.

Learning these three basic concepts will help the photographer to be better able to translate what has been seen by the eye into what has been recorded by the photographic materials. It also provides a common vocabulary of terms that we can employ in accurately discussing our work with others.

Color Relativity

Our perception of color is relative. Hue does not exist for the human eye without a reference. A room that is lit only by a red light will, after a time, appear to us as normal. Household tungsten lights are much warmer than daylight, yet we think color balance appears normal under these conditions. When a scene is photographed in tungsten light on a daylight color-balanced film it will be recorded with an orange-red cast.

Stare at a white wall through a red filter. In time, your eyes will stop seeing the color. Now place an object of a different color into this scene. The red will reappear along with the new color.

This point is important to remember when attempting to color balance prints. If you stare at the print too long, the color imbalances will appear correct. For this reason it is recommended that a standard reference, like the Kodak Color Print Viewing Filters with a piece of white paper, be used for determining color balance (see chapter 10, Printing Color Negatives).

The color luminance and saturation of an object within a scene will appear to change depending on the colors surrounding it. A simple experiment can be performed to see how luminance is relative. Cut two circles from a piece of colored paper. Take one of the circles and put it in the center of a bigger piece of black paper and the other on one of white (figure 4.3). The circle

Figure 4.3
The circles in this illustration are the same color. The circle on the right appears to have a greater luminance than the circle on the left because both color luminance and saturation are subjective and dependant upon the surrounding colors.

·

Chapter Four

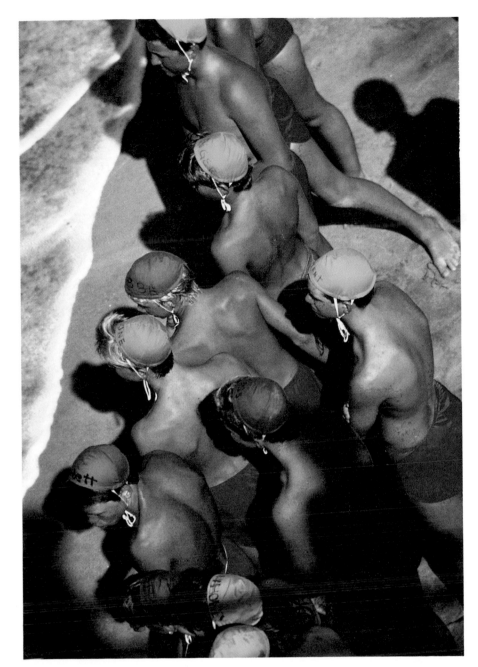

Figure 4.4
Color contrast is created when
complementary colors (opposite colors on
the color wheel) appear next to each other.
This presents the appearance of greater
contrast, even if the color intensity is the
same. The closer the colors are to each
other on the color wheel, the less color
contrast will be produced.

© Roger Camp "The Race, 1985" Cibachrome

upon the black paper will seem to have a greater luminance than the circle
upon the white paper, demonstrating how color luminance and saturation are
subjective and dependent upon the surrounding colors.

This phenomena, also called simultaneous contrast, will cause a color's
hue and brightness to change. For example, a gray circle will appear yel-
lowish upon a purple background, reddish upon a green background, and
orange upon a blue background.

Color Contrast

Color contrast happens when complementary colors, opposite colors on the
color wheel, appear next to each other in the picture (figure 4.4). Take blue
and put it next to yellow. The appearance of great contrast is given, even if
the color intensity is identical.

Figure 4.5
Color harmony depends on both the reflected light and the relationship of the colors to each other on the color wheel. The closer the colors are to each other on the color wheel, the more harmonious the color relationship appears. Harmonious colors create less color contrast. Preston created this image by making several prints from the same negative, then reversing the negative in the enlarger and making additional prints. These prints were then cut into two-inch strips and rearranged into the final image.

© Judith Preston "#6" 10" × 25" Type C prints

The human eye helps to create this impression. Every color is a different wavelength of light. Blue has the shortest wavelength and red the longest. When two primary colors appear next to one another, the eye cannot properly process the color responses. Thus, the colors appear to vibrate, creating contrast. Contrast is the major element that influences balance and movement in a composition. In color photography, unlike black-and-white, contrast does not depend solely upon light reflectance.

Color Harmony

Color harmony is a product of both reflected light and the relationship of the colors to each other on the color wheel. A low contrast picture will have colors which are next to one another on the color wheel (figure 4.5). These harmonious colors can have a great deal of difference in the amount of reflected light that is striking them and yet still not provide as much visual contrast as complementary colors with closer reflectance values.

In color photography contrast is the result of the amount of light being reflected, the colors present, and the colors' relationship on the color wheel. Complementary colors will create a higher contrast and more vibrancy. Harmonious colors make for a more placid scene with lower contrast.

Some Observations about Color

Color Memory

Josef Albers, who wrote *Interaction of Color,* discovered that people have a poor memory for color. Albers would ask an audience to visualize a familiar color, such as the red on the Coca-Cola logo. Then he would show different shades of red and ask the audience to pick which one was Coca-Cola red. There was always disagreement. To Albers this indicated that we have a short color memory span. Albers's book is good to read for gaining a deeper understanding of how color interacts with our perceptions.

Color Deceives

To begin to see and use color effectively, it is first necessary to recognize the fact that color continually deceives us. It is possible for one color to appear as two different colors. In figure 4.6 the two halves of the circle are the same color, yet the human eye does not see them both the same.

This tells us that one color can and does evoke many different readings depending upon the circumstances. This indicates that it is necessary to experience color through the process of trial and error. Patience, practice, and an open mind are needed to see the instability and relativity of color. Observation will reveal the discrepancy between the physical fact of color perception and its psychological effect. In any scene there is a constant interplay between the colors themselves and with the viewer and his or her perceptions of the colors.

Color Changes

Colors are in a continuous state of change, depending upon their relationship to their neighboring colors and lighting and compositional conditions. The following sections provide a series of visual examples that reveal the flux of color.

Subtraction of Color

Figure 4.7 is an example of making two colors appear the same. The two circles in the centers of the rectangles appear to be the same color. To get the best comparison, do not look from the center of one to the center of the other, but at a point midway between the two. The small, elongated semicircles at the top and bottom of the figure shows the actual colors of the circles in the rectangles. The circle on the white ground is an ocher yellow, while the one on the green ground is a dark ocher. This shows that any ground will subtract its own color from the hues that it possesses.

Experiments with light colors on light grounds indicate that the light ground will subtract its lightness in the same manner that hue absorbs its own color. The same is true for dark colors on a dark ground. This indicates that any diversion among colors in hue or in its light-dark relationship can either be visually reduced or obliterated on grounds of equal qualities.

The conclusion is that color differences are caused by two factors, hue and light, and in many instances by both at the same time.

After-image

Stare steadily at the marked center of the green circle in figure 4.8 for a minimum of thirty seconds, then rapidly shift the focus to the center of the white circle. Red or light red will appear instead of white. The red is the complementary color of green. This example reveals how color can appear differently from what it physically is.

Figure 4.6
The two halves of the circle are the same color, yet the human eye does not see them as the same color. This phenomenon is an example of color relativity.

Figure 4.7
The subtraction of color shows how two different colors can be made to look the same.

Figure 4.8
Look steadily at the circle on the left for thirty seconds, then look immediately at the circle on the right. Do you see the after-image? In an after-image a color can look different than it does in reality.

Figure 4.9
Stare steadily at the black inverted triangle on the left, then quickly shift your focus to the inverted triangle at the right. In the reversed after-image the white areas of the original will appear as blue and the blue areas as pale orange.

Eye Fatigue Why does this happen? Nobody knows for certain, but one theory is that the nerve endings of the human retina, the cones and the rods, are set up to receive any of the three primary colors, which in turn make up all colors. This theory states that by staring at green, the blue and yellow sensitive parts of the eye become fatigued, causing the complement, red, to be visible. When the eye quickly shifts to white, which is the combination of blue, red, and yellow, only red is seen, due to the fatigue. Thus red, which is the complement of green, is the color seen.

Reversed After-image

Stare at the blue figures with a black inverted triangle in the center in figure 4.9 for at least thirty seconds, then quickly shift your focus to the square on the right. Instead of seeing the after-image of the blue figures in their complement, orange, the leftover spaces will predominate, being seen in blue. This double illusion is called reversed after-image or contrast reversal.

The phenomena of after-image and reversed after-image show us that the human eye, even one that has been trained in color, is not a foolproof gauge against being deceived by color. The conclusion is that colors cannot be seen independently of their illusionary changes by the human eye.

Cooking with Color

Learning to work with color has many similarities with learning how to cook. Having a good recipe is no guarantee of success. One has to be constantly sampling, tasting, and making adjustments. The colors in a scene can be thought of as the ingredients that make up the picture; their arrangement and mixture will determine the final result. Two cooks can start off with the same ingredients and wind up with a completed dish that tastes quite different. Simply by making small changes in quantity, one of the ingredients will lose its identity while another will dominate. Cooking teaches that a successful meal involves more than reading a recipe. The same holds true for the photographer. Changes in color placement within a composition will cause shifts in dominance, which can alter the entire feeling or mood of the picture.

Color Is a Private Experience

Learning about color is a step-by-step process of observation and training that teaches the individual that seeing is a creative process involving the entire mind. What is ultimately learned is that color continues to be private, relative, elusive, and hard to define. Our perception of color is hardly ever as it actually appears in the physical world. There are no standard rules because of mutual influences colors have upon one another. We may know the actual wavelength of a certain color, but we hardly ever perceive what the color physically is. In photography this problem is compounded by the fact that the registration and sensitivity of the retina in the human eye is not the same as that of photographic materials. In the world of human vision, colors are busily interacting with each other and altering our perceptions of them. This interaction or interdependence keeps colors in an active, exciting state of flux.

Figure 4.10
By studying the work of master photographers it is possible to gain insight into their sensitive handling of color relationships.

© Eliot Porter "Waterfall, Hidden Passage, Glen Canyon, Utah 1962" Dye Transfer print. Courtesy of Scheinbaum & Russek Gallery, Santa Fe, NM

Assignment

Study the works of the visual masters of color to gain an artistic understanding of what they knew about color relationships and how they applied them (figure 4.10). This is not done to copy, compete, or revive the past. The aim of any study is to understand the past and create new work that reflects present-day concerns, directions, and ideas.

∴

Color Slide Film

"Car Remanufacturing, Allentown, PA"
Leif Skoogfors
Fujichrome 50 Film,
Leif Skoogfors/Woodfin Camp and Associates.

———
•

Characteristics of Slides

Advantages

Color slides, also known as transparencies, are positives that are made on reversal film. They are looked at by transmitted light that passes through the image only one time. Prints, on the other hand, are seen by light that is reflected from them. The light bounces off the base support of the print and passes through the image in the emulsion twice, coming and going. This effect doubles the density, which in turn reduces what can be seen within the print itself. Due to this effect, slides have certain advantages over prints made from negatives, including the sharpest grain structure, maximum color separation, the best color saturation, and more subtlety in color and detail.

The viewer can distinguish a wider tonal range since the slides are viewed by transmitted light. Slides are the choice for photographic reproduction, as printers can make color separations directly from them. The processing of slide film provides the user with a finished product without any additional steps, and since no printing is involved in producing the final image, slide film can be processed at home without a great deal of specialized equipment.

Since there is no double density effect with slide film, the range of tones between the highlight and shadow areas are not as critical as it is with negative film.

Disadvantages of Slides

Despite their good points, slides do have their disadvantages. They are small and hard to see; generally a projector and a screen are required for proper viewing. Since the final image is contained on the film base itself, each slide is unique and must be handled with care when they are being viewed to prevent damage. Both of these characteristics can make slides less convenient to use than prints.

Unlike negative film, slides can only be manipulated slightly through development to effectively alter the range of contrast because the color balance of the film is directly effected by development. The biggest disadvantage to someone who is learning to work in color is that there is no second chance to make corrections with slides as there is when making a print. Slide film has a much narrower exposure latitude than negative film. An exposure error of even a ½ f/stop can ruin the picture since both the color and density of the completed picture are determined by exposure. It is possible to make corrections by recopying the slide, but this adds contrast and takes away the initial advantages slide film has to begin with. In contrasty lighting, slide film can produce bleached out highlights and dark inky shadows. If a print is made from a slide, there are twice as many tonal reversals with corresponding color and tonal distortions to deal with as when working with negative film.

How Slide Film Works

Slide film makes a positive, rather than a negative image. The film uses the "tri-pack" structure, which is a sandwich of three gelatin layers that contain light-sensitive silver halides. During exposure, each layer will record one of the primary colors of light. White light, which is a mixture of blue, green, and red, will create a latent image on all three layers. Other colors formed by mixing the light will make latent images only in those areas that are sensitive to those colors. For instance, yellow, which is a mixture of green and red, will make a latent image only in the green and red layers. It will not be recorded by the blue layer. Imagine a large red ball. In the final picture, it will appear red because the dyes of the colors which are complementary to blue and green were formed in two layers of the film during development. When the slide is

Table 5.1
Kodak E-6 Process

Step	Time in Minutes*	Temperature (°F)**
The First Three Steps Must Be Carried Out in Total Darkness		
First developer	7*** (1) and (2)	100 +/− 0.5
Wash	2	92 to 102
Reversal bath	2	92 to 102
The Remaining Steps Can Be Carried Out in Room Light		
Color developer	6	100 +/− 0.5
Conditioner	2	92 to 102
Bleach	7	92 to 102
Fixer	4	92 to 102
Wash	6	92 to 102
Stabilizer	1	92 to 102
Dry	as needed	

* All steps include a ten-second drain time.

** For best results, keep all the temperatures as close to 100° F as possible.

*** Development time changes, depending on the number of rolls that have been processed. Check the capacity of the solutions with the instructions.

(1) Initial Agitation. For all solutions, tap tank on a 45-degree angle to dislodge any air bubbles. No further agitation is needed in the reversal bath, conditioner, or stabilizer.

(2) Additional Agitation. Subsequent agitation is required in all other solutions. After tapping the tank, agitate by slowly turning the tank upside down and then right side up for the first fifteen seconds. For the remaining time of each step, let the tank rest for twenty-five seconds and then agitate for five seconds.

viewed in white light, the blue and green are subtracted from the light, which leaves only red to be seen. Slide film, unlike negative film, has no color mask to correct inherent imperfections of the green-sensitive and red-sensitive layers of the film.

Processing

Time and temperature are critical to obtain correct color balance and density. The first step is similar to black-and-white processing. A silver-grain negative image is developed in each of the layers of the emulsion. The silver will appear where the film has been struck by light. White light will effect all three layers, while red, for example, will form silver only in the red-sensitive layer. No colored dye is formed during this stage of the process.

Next, the first development is halted and the film is "fogged" either through chemical action or exposure to light so that the silver grains can be formed throughout all layers of the emulsion.

During color development, two things happen simultaneously. The remaining silver is developed. This occurs where subtractive primary dyes are produced in the emulsion layers. These dyes will make up the final image. At this stage the film would look black because the film has metallic silver in all the emulsion layers and color dyes in many places.

To be able to see the dye-positive image, the film has to be bleached. The bleach changes all silver into silver halide crystals. The fixer then removes all the silver halides from the film, leaving only the dye-positive image. Some processes combine the bleach and the fix into one step.

The wash takes away the remaining fixer, then the stabilizer lets the film dry evenly and gives it protection from fading and discoloration.

This process is known as chromogenic development. Almost all the current color processes use this to produce the cyan, magenta, and yellow dyes in their three-layer emulsion structure.

Most of the contemporary color slide films can be developed in one standard process called E–6 (table. 5.1). To determine whether a film can be developed by this method, simply read the label on the film box or cassette.

Table 5.2
Starting Points for First Developer Time Compensation

Camera Exposure	First Developer Time in Minutes*
One stop overexposed	5
Normal exposure	7
One stop underexposed	9
Two stops underexposed	12 1/2

*Time based on first roll in fresh solutions.

Push Processing

Most E–6 process films can be exposed at different speeds and still produce acceptable results if the first developer time is adjusted to compensate (table 5.2). When film is push processed it can suffer a color balance shift, a change in contrast, and a decrease in exposure latitude.

Brands

Slide film is available in many brands and in different speed ranges. Each manufacturer uses its own dyes, yielding noticeable variations in the colors produced. Certain brands emphasize distinctive colors; others may have an overall cool (blue) or warm (red and yellow) bias. Brands will also differ in their contrast, grain structure, saturation, and overall sharpness. Since these characteristics cannot be compensated for during a secondary step like printing, it is important that the photographer choose a film whose bias will fit both the aesthetic and technical concerns of the situation.

The manufacturers have been busy making changes in almost every film currently on the market. For this reason, it is futile to attempt to describe the characteristics of each film because this information becomes rapidly outdated. The only way to keep up is to use the different films and evaluate the results for yourself. You can read test reports and talk with other photographers, but this is all hearsay. Choosing a film is a highly personal matter. Experience is the best guide. Try different films in noncritical situations to learn their strong and weak points. After some experimentation you will most likely discover that there is one type of film that you prefer. It is worth the time to work with one film and learn its personality, as this will be helpful in obtaining consistent and pleasing results.

Film Speed

Each brand offers a selection of different film speeds. The speed or light sensitivity of a film is determined from a set of procedures established by the International Standards Organization (ISO). Films can be divided into four basic categories based upon their speed: slow films have an ISO below 100, general-use films possess an ISO of between 100 and 200, fast films have an ISO of 200 to 400, and ultrafast films have an ISO of 400 or more.

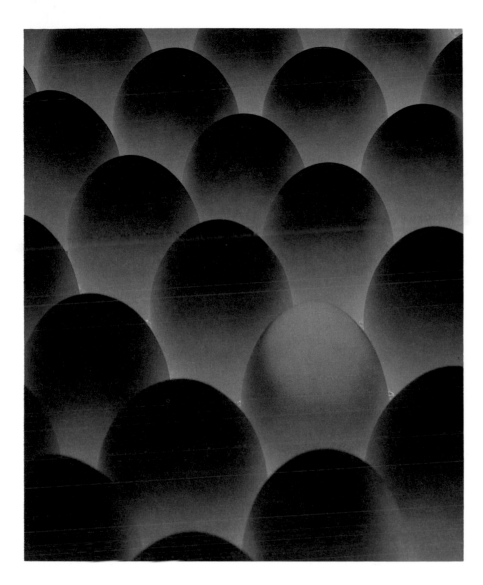

Hoy makes use of the subtlety of color that slide film can deliver. Slide film is an excellent choice when planning to reproduce work in a print medium.

© Bill Hoy "Hero Egg" 4″ × 5″ Ektachrome 1987

In general, the slower the film the greater the color saturation, the tighter the grain structure, and the better the color contrast, which will make the image appear to be sharper. Slower films also have less tolerance for exposure error. Faster films will look more grainy without as much color contrast or saturation. They have a greater ability to handle small exposure errors and some mixed lighting conditions. In low light conditions they will be able to capture a greater variation in hue and tone. With slide film an important guide is to expose for key highlight detail in the scene. Choose the film with care so that it will work for your situation. Try not to get into the position of making the film fit the circumstances.

Amateur and Professional Films Compared

Both amateur and professional films have similar color quality, grain characteristics, image stability, and sharpness. The main difference is in the color balance of the films. As all color film ages, the characteristics of its color balance change.

An amateur photographer typically buys a few rolls of film at a time. The film might remain in the camera at various temperatures for months before it is processed. Allowances for this type of use are built into the film during manufacture. For example, if a film's color balance shifts toward yellow as it ages, the color balance of the emulsion will be made in the complementary direction, blue, to compensate. This allows time for the film to be shipped, stocked, and sit in the camera. By the time the film is finally shot and processed its color balance should still be close to optimum.

Professional films are manufactured at their optimum point for accurate color balance and consistent speed. These films are designed for refrigerated storage by both the dealer and user. They should be processed immediately after exposure.

Lighting Conditions

The color performance of a film will vary depending upon the lighting conditions in which it is used. In open or deep shade, or in overcast daylight, the film may record the scene with a cool cast. A warming filter can be used to correct this.

Tungsten slide film is designed to be balanced with photo floodlights. Make certain that the film being used matches the light under which it is going to be exposed. Type A film is balanced for 3400°K bulbs. Type B film is balanced for 3200°K bulbs. Use filters to correct if necessary (see chapter 9 on filters and their use).

Special Processing

Most slide films, such as Agfachrome, Ektachrome, and Fujichrome, can be processed at most laboratories or by yourself. The quality of these laboratories varies tremendously. Check them out before giving them any important work to do. Some films, notably Kodachrome, have to be returned to the manufacturer or a major laboratory to be processed. This is because the dye couplers are not found in the emulsion of these films, but in the processing chemicals. The process is very exacting and is carried out by expensive machinery. Processing kits for Kodachrome are not available to the general public.

Color Negative Film and Prints

"Jaipur, Rajastman"
Mitch Epstein
20″ X 24″, Ektacolor print,
© Mitch Epstein

·

Characteristics

Color negative film is the first part of a flexible two-stage process for making prints on paper. The method is similar to that used for slide production, except that film is processed into a negative instead of a positive. This means that areas in the original that were dark will appear as light and colors will show as their complement (opposite) on the film.

Advantages

Color negative film is easier and quicker to process than transparencies. It is convenient because unlimited prints can be produced, once the additional printing equipment is acquired. Prints are easy to store, send, and display without the need of such additional equipment as a slide projector, screen, and darkened room. Prints allow intimate contact with the work, enabling the viewer time to become involved with the image. Negative films offer greater exposure latitude than slide films and they give the photographer another opportunity to interact with the work. Both the color saturation and density will increase with more exposure, the opposite of slide film. Negative film should be exposed to produce acceptable detail in the key shadow areas. When in doubt as to the proper exposure, it is usually best to slightly overexpose the film. The film has a wide latitude for overexposure and this can be corrected when the print is made. If the film is greatly underexposed, the result will be a weak, thin negative that will produce a flat print lacking in detail and color saturation (see section on exposure methods in chapter 7). Changing the color balance, contrast, density, and saturation is possible during the printing process, which can produce a final piece that is a more accurate reflection of the photographer's concerns.

Disadvantages

The major disadvantages are that more time and equipment are required to get the final image, and the quality of the obtainable color is not as high as slide film. If a normal print and a slide of the same scene are compared, the slide will have more brilliance, greater detail, deeper saturation, and more subtle color because the slide film itself is the final product and it is viewed by transmitted light. The negative requires a second step, printing, to get to the final image, resulting in a loss of quality because the print paper is viewed by reflected light. The paper absorbs some of the light, causing a loss of color and detail. If a print is the desired end product, the negative/positive process offers the most accurate color rendition. This is because the negative film contains a color mask that corrects deficiencies in the green- and red-sensitive layers of the film.

Construction of Negative Film

Think of color negative and reversal film like a sandwich that is constructed on a single piece of bread. The bread in this case is called the base. Three different silver halide emulsions that are sensitive to blue, green, and red light form what is called the tri-pack on this base.

Each emulsion layer is coupled to the potential dyes, magenta, yellow, and cyan, which are used to form the color image. These dyes are the complements of the green, blue, and red hues that made up the original scene. When the film is exposed, a latent image is created in each layer. As an example, red light will be recorded in the red-sensitive layer of the tri-pack, but it will not affect the other two layers.

Colors that are made up from more than one primary color will be recorded on several of the layers of the tri-pack. Black does not expose any of the emulsion but white light is recorded on all three layers.

Chromogenic Development of Negative Film

During the chromogenic development process both the full black silver image and the color dye image are formed simultaneously in the tri-pack. Next the film is bleached, removing the unwanted black silver image. This leaves the three layers of dye showing the scene in superimposed magenta, yellow, and cyan, each one being a complement and a negative of the green, blue, and red from the original scene. Now the film is fixed, during which the unexposed areas of the emulsions are made permanent. Washing then removes all the remaining unwanted chemicals. Finally it is stabilized for maximum life and dried. The final color negative will have an overall orange mask. This is needed to reduce contrast and maintain accurate color during the printing of the negative.

Most current negative films can be developed in the C–41 Process (table 6.1). To be sure that the film you are using is compatible in C–41, check the box or cassette.

Table 6.1
Kodak C–41 Process

Step	Time in Minutes*	Temperature (°F)**
The First Two Steps Must Be Carried Out in Total Darkness.		
Developer	3¼*** (1) and (2)	100 +/− 0.25
Bleach	6½	75 to 105
The Remaining Steps Can Be Carried Out in Room Light.		
Wash	3¼	75 to 105
Fixer	6½	75 to 105
Wash	3¼	75 to 105
Stabilizer	1½	75 to 105
Dry	As needed	

*All steps include a ten-second drain time.

**For best results, keep all temperatures as close to 100°F as possible.

***Development time changes depending on the number of rolls that have been processed. Check the capacity of the solutions with the instructions.

(1) Initial Agitation. For all solutions, tap the tank on a 45-degree angle to dislodge any air bubbles. No further agitation is needed in the stabilizer.

(2) Additional Agitation. Subsequent agitation is required in all other solutions. After tapping the tank, agitate by slowly turning the tank upside down and then right side up for the first thirty seconds. For the remaining time in the developer, let the tank rest for thirteen seconds and agitate for two seconds. Since the time in the developer is short, proper agitation is a must or uneven development will result. For the remaining time in the bleach and fixer, let the tank rest for twenty-five seconds and agitate for five seconds.

Negative film enables the photographer to interact with the photograph during the printing process. Alterations in the color balance, contrast, density, and saturation can be made to insure that the final print accurately reflects the concerns of the photographer.

© Len Jenshel "Hoh Rain Forest, Olympic National Park, Washington 1980" Type C print Courtesy of Laurence Miller Gallery, New York, NY

How the Print Process Works

A color print is made when light is projected through a color negative onto color printing paper. The light is filtered at some point before it reaches the paper. The paper, like the film, has a three-layered tri-pack emulsion composed of silver and dyes that are used to form the image. Each layer is sensitive to only one color of light which is complementary to the dyes found in the negative. When the print is made, the colors from the negative are reversed. For instance, a red ball would be recorded in the cyan layer of the negative. When light passes through the negative, only green and blue light will be transmitted. This exposes only the layers in the paper emulsion that are sensitive to green and blue light, releasing the complementary magenta and yellow dyes in the paper. The magenta and yellow dyes recreate the red ball from the original scene. Where there is clear film in all the emulsion layers, white light will produce a latent image in each of the layers of the print emulsion. This will produce black when the print is processed.

Chapter Six

Developing the Print

When the print is developed, each of the three layers of the exposed emulsion develops into a positive black-and-white silver image, which represents the third of the spectrum that it recorded (red, green, and blue). Wherever the silver is deposited, dyes that correspond to that color are formed. For example, where blue light strikes the paper, only the yellow layer of the tri-pack, which is complementary to blue, will be affected. The blue light forms a positive silver image and a directly corresponding yellow dye. After development, the paper contains the exposed tri-pack of positive silver and dyed images. Next the print is bleached. This converts the silver to silver halides, which the fix then removes. Usually the bleach and fix are combined so that this process takes place more or less at the same time. This leaves only a positive dyed image that is washed and then dried. Since the image is formed by dyes, these prints are called dye coupled or Type C prints.

The colors in the resulting image are those which are reflected back to the eye from the light falling on the print. An object that is red looks red because the yellow and magenta dyes in the print emulsion absorb the blue and green wavelengths from the light falling on it, reflecting back only the red.

Brands and Speed

Follow the same guidelines for film selection as outlined in the section on slide film in chapter 5. Exposing for key shadow detail is the basic starting guide with negative film. Beware of using a film with a higher speed than necessary for the conditions as this can result in the loss of highlight detail in the final print.

Type S and Type L Films

Some manufacturers design films specifically for different exposure situations. For example, Kodak's "Professional" color negative films come in two versions. Type S, for short exposures, is balanced for daylight and designed for an exposure time of 1/10 to 1/10,000 of a second. Type L, for long exposures, is balanced with tungsten light (3200°K) and for exposure times of 1/50 to 60 seconds. If exposure time and/or the color temperature of the light does not match the film, filters will be necessary to correct the color temperature. Small mismatches can be corrected when making the print.

Prints and Slides from the Same Film

There are special films like Kodak 5247/5294, motion picture film stocks, that can be processed to give both slides and prints from the same roll of film. It is generally okay for snapshooting, but it does not deliver the accurate quality that film designed for these specific purposes is capable of doing.

∴

Defining the Light
Exposure Methods and Techniques

"Girl and Cloud, Cap Hatien, Haiti"
David Katzenstein
16″ × 20″, Type C Print, 1981,
Courtesy of the Jayne H. Baum Gallery, New York,
NY.

·

Figure 7.1
A reflective light reading is made by pointing the light meter directly at the subject. A reflective reading measures the light that is bounced off or reflected from the subject. Most in-camera meters can only measure reflected light.

•

Figure 7.2
An incident light reading measures the light that falls on the subject. To make an incident reading, the photographer stands in front of the subject and points the meter at the camera or main light source. The meter is not pointed towards the subject. Many meters need a special attachment to read incident light.

•

A Starting Place

Without proper exposure, nothing is possible in photography. Exposure technique is the prerequisite to starting the process of transforming ideas into photographs. These exposure guidelines are offered as basic starting points for people in the learning stages of exposure control. They will produce acceptable exposures under a wide variety of conditions without an extensive amount of knowledge, testing, or frustration. As experience and confidence is gained, more advanced exposure and development procedures can be employed (see chapter 13 on the Zone System).

Determining the correct exposure with color materials is essentially the same as it is for black-and-white, except it is more critical. Slide film requires the greatest accuracy because the film itself is the final product; its exposure latitude is not wide, so small changes can produce dramatic results. In general, underexposure of slide film by up to a ½ f/stop will make for richer, more saturated color effect. With negative film, overexposure of up to a full f/stop will produce similar results. Good detail in key shadow areas is needed to print well. Negative film has a much wider exposure range, plus the printing stage allows for further corrections after initial exposure of the film.

Reflective and Incident Light

There are two fundamental ways of measuring the amount of light in a scene. Reflective light is metered as it bounces off the subject. This is accomplished by pointing the meter directly at the subject (figure 7.1). Reflected reading from low midtones and high shadows deliver good general results with negative film.

Incident light is measured as it falls upon the subject. The meter is not pointed at the subject, but toward the camera or main light source (figure 7.2). Incident readings work well with slide film, as does reflected reading of key highlights, if areas containing shadow detail are not visually critical. Most camera meters are capable of reading only reflected light. Attachments are available that fit over the front of the lens that will allow for incident reading with most thru-the-lens (TTL) metering systems.

Camera Meters

Camera meters are the device most people initially employ to make their exposure calculations. Now almost every contemporary 35mm SLR camera has a TTL metering system. The system will provide accurate results under even light and they are convenient, but it is up to the operator to make them perform to obtain the desired pictures. The more one knows about the camera's metering system, the greater the likelihood of using it to achieve the desired exposure. All meters are partially blind; they see only the middle gray of 18 percent reflectance as it appears on film. (See the tear-out 18% gray card at the back of the book that you can use to help determine the proper exposure.) The reflectance reading tells the photographer that if the object the meter is reading is a middle gray or averages out to be a middle gray, this is how the camera should be set for an average exposure. The meter is a tool that measures only the intensity of the light; it does not judge the quality of the light or the feeling and mood that the light produces upon the subject. The best exposure is not necessarily the one that the meter indicates is the correct exposure. The meter is a guide that reads the signs. It is up to the photographer to see, respond to, and interpret the light and decide what exposure will deliver the color, detail, feeling, and mood needed to express and convey the situation to the audience. Some basic metering guidelines are summarized in table 7.1.

Basic In-Camera Metering Systems

There are four basic metering systems currently in use (figure 7.3).

The Center-Weighted System

The center-weighted system has its light sensitive cell located in the back of the pentaprism, providing the center of the frame with the greatest amount of sensitivity to light. This sensitivity decreases toward the bottom and top of the frame.

The Overall System

In the overall system the cells read the entire frame as it is reflected from the shutter curtain or the film. It tends to provide a bias of sensitivity toward the center of the frame.

The Averaging System

The averaging system has two cells in the pentaprism that read different parts of the frame. Their readings are averaged together with a bias towards the center of the picture area.

The Spot System

The spot system measures light off a small zone in the center of the frame. It requires care and skill to make use of the spot. It must be pointed at crucial areas of detail in the picture to obtain proper results. Averaging is often employed when working with a spot meter. For instance, the light is measured in the key shadow and highlight areas, then these two readings are combined and averaged to get the exposure. When it is not practical for the photographer to get up close to measure the light on a subject, as with a distant landscape, a sporting event, or an animal in the wild, the spot meter has the advantage of being able to measure the light from any number of key areas of the scene from a distance.

Table 7.1
Some Basic Metering Guidelines

1. Check to see that the speed of the film matches the meter setting.
2. Perform a battery check before going out to take pictures.
3. For taking a reflected light reading, point the meter at the most visually important neutral toned item in the scene.
4. Get close to the main subject so that it fills the metering area. Avoid extremes of dark or light when selecting areas on which to base your general exposure.
5. If it is not possible to meter directly from the subject, place your hand in the same light as the subject and compensate the exposure by opening up one f/stop, or place the 18% gray card from the back of this book in the same type of light and meter off it.
6. In situations of extreme contrast and/or a wide tonal range, consider averaging the key highlight and shadow area or take a reading off an 18% gray card under the same quality of light.
7. For an incident reading, fit the light-diffusing dome over the cell and point the meter at the source of the light, so the meter is in the same lighting conditions as the subject in relationship to the camera position

Center-weighted System

Overall System

Averaging System

Spot System

Figure 7.3
How the four basic in-camera metering system patterns are set up to read light.

·

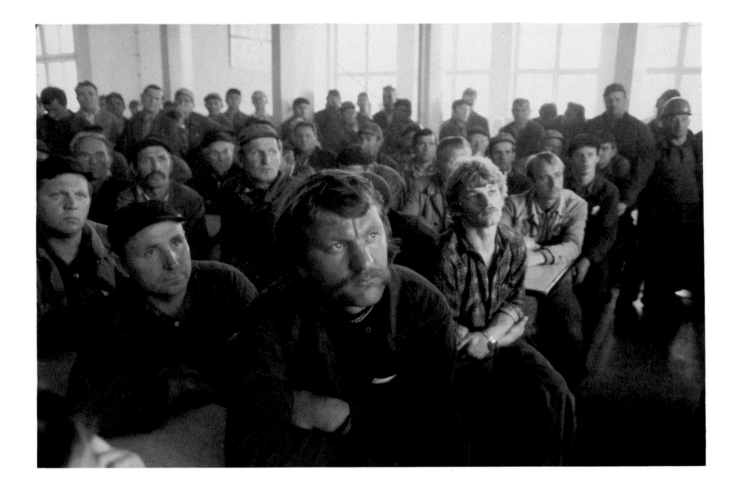

Figure 7.4
When a scene contains large amounts of light areas careful metering is necessary to prevent an underexposed photograph because the scene's overall brightness will fool the meter. This can produce a lack of detail in the key subject area.

© Leif Skoogfors "Shipyard Workers Discuss Strike, Gdynia, Poland 1981" Courtesy of Woodfin Camp & Associates

Common Metering Problems

Having a TTL metering system does not guarantee good exposures. Unusual lighting conditions can still easily fool the meter. The most common errors occur when the subject is not in the main area that the system is reading, if there is a very dark or light place in the metered area, if the quality of the light is not even and striking the subject from the front, or if the light is overly bright or dim. Knowing which type of metering system the camera uses will allow the photographer to frame the proper areas within the metered zone to get the desired outcome.

How the Meter Gets Fooled

Scenes containing large amounts of light areas, such as fog, sand, snow, or white walls, will give a meter reading that will cause underexposure because the meter is fooled by the overall brightness of the scene (figure 7.4). Additional exposure of between one to two f/stops will be needed to correct the meter error.

Scenes with a great deal of dark shadows will produce overexposure, this happens because the meter is designed to reproduce an 18% gray under all conditions. If the major tones are darker or lighter the exposure will not be accurate and must be corrected by the photographer. A reduction of one to two f/stops will be needed. An incident reading will perform well in these situations as it is unaffected by any tonal differences within the subject. Bracketing is a good idea in both these situations.

Bracketing

Bracketing is done by first making what is believed to be the correct exposure. Then make an exposure ½ f/stop under that exposure and finally one more exposure ½ f/stop over the original exposure, totaling three exposures of the scene. In tricky lighting situations, bracket two ½ f/stops in each direction (over- and underexposure) for a total of five exposures of the scene. With slide film it is often better to bracket in ⅓ f/stop as a more accurate exposure is needed than with negative film.

Do not be afraid to use a few more frames of film. Bracketing can help the photographer gain a basic understanding of the relationship between light and exposure. Analyze and learn from the results so next time a similar situation is encountered, bracketing will not be necessary.

Hand-Held Meters

When acquiring a hand-held meter be certain it can read both reflected and incident light. Incident light readings are accomplished by fitting a light diffusing attachment over the meter's cell. The meter can then be pointed at the light source rather than at the subject. Since it measures the light falling upon the subject and not the light reflected by the subject the incident reading is useful in contrasty light or when a scene has a large variation in tonal values.

Hand-held spot meters are also available. As with the in-camera spot system, the main danger of using the spot meter is it reads such a tiny area that taking a reading from the wrong place can easily throw off the entire exposure. For this reason the spot meter should be used with care until confidence and understanding of how and where to meter is gained. Some hand-held meters have attachments that allow them to make a spot reading.

Manual Override

Cameras that have fully automatic exposure systems without a manual override reduce the photographer's options. The machine decides how the picture should look, how much depth of field it should have, and whether to stop the action or to blur it. Learn to be the master of the machine, not its prisoner.

Batteries

Most in-camera meters are powered by small silver oxide, mercury, or lithium batteries. They all tend to fail without much warning, so carry spare batteries when you go out to photograph (see section on Batteries in chapter 16).

Figure 7.5

In diffused light colors appear to be muted and highlights and shadows are at a minimum. The brightness range of the scene will often remain within a range of three f/stops.

© Erik Lauritzen "Red Fence, Pittsburgh, PA 1985" 14" × 17" Type C print

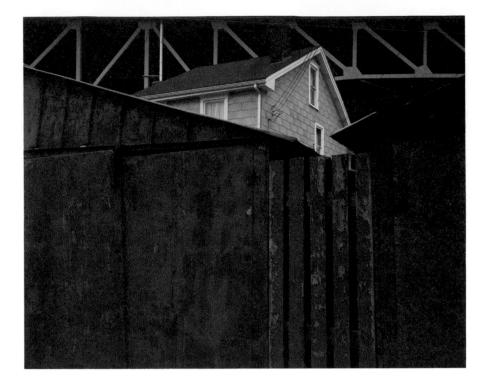

Basic Exposure Methods

The Brightness Range of the Subject

The brightness range of a subject (the difference in the number of f/stops between the key highlight and key shadow area of a scene) is one way to determine exposure. The brightness range method can be divided into four broad categories: diffused, even, or flat light; average bright daylight with no extreme highlights or shadows; brilliant, contrasty, direct sunlight; and dim light.

Diffused Light

Overcast type days offer an even, diffused quality of light (figure 7.5). Colors appear muted, quiet, and subdued. Both highlights and shadows are minimal. Whenever the scene is metered, the reading will usually remain within a range of three f/stops. The apparent brightness range and contrast can be increased through overexposure.

Average Daylight

In a scene of average bright daylight the colors look more saturated, the contrast is more distinct, the highlights are brighter, and the shadows are darker with good detail in both areas (figure 7.6). Meter reading from different parts of the scene may reveal a range of about seven f/stops. Care must be given to where meter readings are taken. If the subject is in direct sunlight and the meter in the shadow, overexposure of the subject will be the result.

Brilliant Sunlight

Brilliant, direct sunlight makes for the deepest color saturation while also producing conditions of maximum contrast (figure 7.7). The exposure range can be twelve f/stops or greater, which will stretch or surpass the film's ability to record the scene.

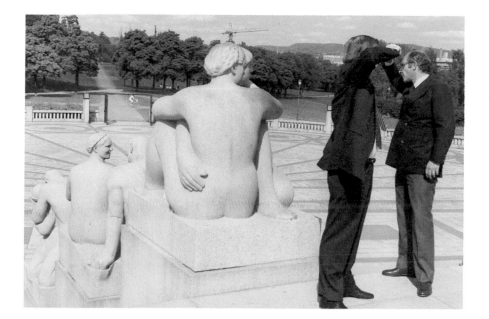

Figure 7.6
In average bright daylight contrast will be greater, colors will be more saturated, and there will be good detail in both key shadow and highlight areas. The brightness range will be about seven f/stops.

© Eduardo Del Valle & Mirta Gomez "Untitled, Oslo, Norway 1985" Type C print, 7½" × 11"

•

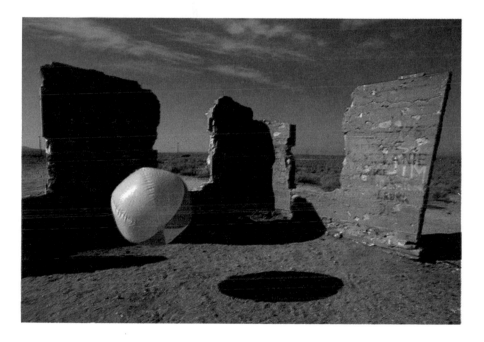

Figure 7.7
In brilliant sunlight contrast and color saturation are at their maximum. The exposure must be carefully thought out so the needed detail will be produced in the key subject areas. The brightness range can be twelve f/stops or more, surpassing the film's ability to record the scene.

© David Arnold from "Occasions: House Ruin, Mohave Desert"

•

These conditions make for black shadows and bright highlights. Color separation is at its greatest; white will appear its purest. Determining which areas to base the meter reading upon are critical for obtaining the desired results. These effects can be compounded when photographing reflections off glass, polished metal, or water. Selective exposure techniques like averaging, use of incident light, or spot reading may be needed (see Unusual Lighting Conditions section later in this chapter).

Figure 7.8
Dim light can strain a film's ability to record the necessary color and detail. Colors can appear monochromatic and the contrast range will often be extreme, with either not enough contrast or too much contrast. Artificial light sources can supply unusual and/or dramatic effects.

© Jan Staller "Taxi, New York City, 1985" Type C print 15" × 15" Courtesy of Jayne H. Baum Gallery, NY, NY

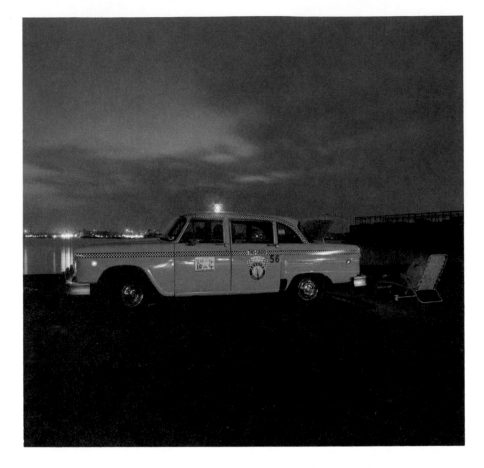

Figure 7.9
When exposing for the subject a reflective reading is made directly from the most important object in the scene. Proper detail will then be retained where it is needed and the meter will not be fooled by areas of bright light or deep shadow.

© John Divola "Flying/Falling 1986" Dye Transfer 18½" × 18½" Courtesy of Jayne H. Baum Gallery, New York, NY

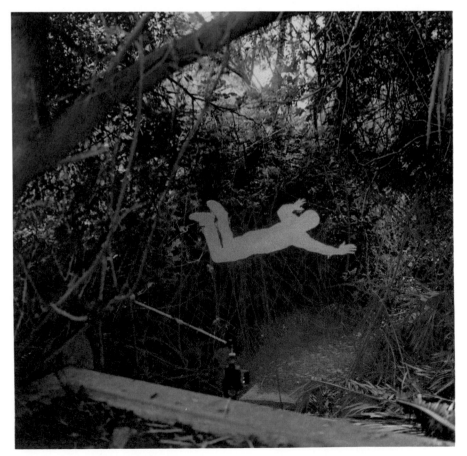

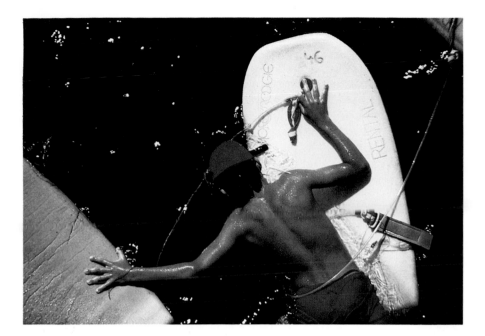

Figure 7.10
When a scene contains large amounts of dark and/or light areas, exposing for tonal variations is a way to arrive at the correct exposure. In this method, two light readings are made, one from the key shadow area and a second from the key highlight. These two readings are then averaged to obtain the proper exposure.

© Roger Camp "Yellow Snorkler, 1985" Cibachrome

Dim Light

Dim natural light taxes the film's ability to record the necessary color and detail of the scene (figure 7.8). Colors can be flat and monochromatic and contrast is often problematic. Contrast can be extreme when artificial light sources are included within the scene. Contrast can also be lacking with details, often being difficult to determine. Low levels of light mean long exposures, a tripod, or additional lighting are often required to make the picture.

Exposing for the Subject

Exposing for the subject is another way to determine proper exposure. When in doubt of where to take an exposure reading, decide what the subject is in the picture and take the reading from it (figure 7.9). For instance, when making a portrait, go up to the subject and take the meter reading directly from the face, open up one f/stop for Caucasion skin, and then return to the chosen camera position. With a landscape in diffused, even light, an overall meter reading can be made from the camera position. If the light is not diffused, the camera meter can be pointed up or down to emphasize either the sky or the ground. These readings can also be averaged.

Exposing for Tonal Variations

Exposing for tonal variations is another method that can be used in calculating the exposure. A scene that has large amounts of either dark or light tones can give incorrect information if the exposure is based on a single reading (figure 7.10). When making a picture of a general outdoor scene, the correct exposure can be achieved by taking two readings and then averaging them. For example, a landscape is going to be photographed, it is late in the day, the sky is brighter than the ground, and detail needs to be retained in both areas. First meter a critical highlight area (sky) in which detail is required. Pretend the reading is f/16 at 1/250 of a second. If the exposure was made at this setting, the sky would be rich and deep, but the ground detail would be lost and might appear simply as a vast black area. Now meter off a key area in the shadow area of the ground. Say it is f/5.6 at 1/250 of a second.

This would provide an excellent rendition of the ground, but the sky would be overexposed and appear white, completely desaturated of color, and with no discernible detail. To get an average reading, take the meter reading of the highlight (sky) and the shadow (ground) and halve the f/stop difference between the two readings. In this case, an average reading would be about f/8½ at 1/250 of a second. It is alright to set the aperture in between the click stops with most cameras. The final result will produce a compromise of the two situations, with acceptable detail and color saturation in each area.

When working with negative film, it is often possible to take the meter reading from the ground, let the sky overexpose, and correct by burning it in when a print is made.

If the subject that is being photographed is either a great deal darker or lighter than the background, averaging will not provide good results. If there is more than a five-f/stop range between the highlight and shadow areas, there will be an unacceptable loss of detail in both areas. In a case like this, let the background go or use additional lighting techniques like flash fill to compensate for the difference.

Basic Flash Fill

A basic flash fill technique involves first taking an available-light meter reading of the scene, basing the f/stop on your camera's flash synchronization speed. Now divide the exposure f/stop number into the guide number of your flash unit. The result is the number of feet you need to be from your subject. Shoot at the available-light meter reading with the flash at this distance. For example, the meter reads f/16 at a synchronization speed of 1/125. Your flash unit has a guide number (GN) of 80. Take 16 (f/16) and divide it into 80 (GN). The result is 5, the distance you need to be from the subject with an exposure of f/16 at 1/125. Many newer flash units can make automatic flash fill exposures. Flash fill can also be employed selectively to provide additional illumination or with filters to alter the color of specific areas in the scene (figure 7.11).

Unusual Lighting Conditions

Unusual lighting conditions will cause exposure problems: uneven light, light hitting the subject from a strange angle, backlight, glare and reflections, areas having large highlights, or shadows such as inside doorways and windows. The wide range of tones in such scenes is often greater than the film's ability to record them. The photographer must decide what is important to record and how to get it done.

Subject in Shadow

When the subject is in shadow, decide what is the most important area of the picture, which colors have the most interest, and what details need to be seen. If the subject is in shadow, take a reflected meter reading from the most important shadow region. This will provide the correct information for that key area. Other areas, mainly the highlights, will experience a loss of color saturation and detail due to overexposure, which can be corrected by burning in these areas when the print is made. At other times, there may be a key highlight striking the subject in shadow. The exposure can be made based on the highlight reading, letting the remainder of the subject fall into obscurity (figure 7.12).

Figure 7.11
Flash fill is a method of providing additional artificial light to illuminate the scene. Exposure is determined by three factors: the available light in the scene, the guide number, which indicates the power of the flash unit, and the distance between the subject and the flash unit.

© Richard Colburn "July 4th, Biwabik, MN, 1985" Type C print 18″ X 18″

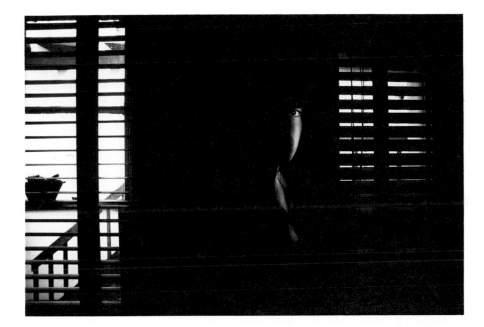

Figure 7.12
A proper exposure can be calculated when the subject is in shadow by taking a reflective reading from the key area in which detail needs to be retained. Other parts of the picture can experience loss of color saturation and detail.

© Roger Camp "Elaine, 1981, Balboa Park, CA," Cibachrome

•

Figure 7.13
When the subject is in bright light exposure can be determined by taking a reflective reading from the key highlight area, causing a loss of detail in the shadows. If this loss is not acceptable, try one of the alternative solutions. An incident light meter can often be used in this situation to provide an acceptable exposure.

© Roger Camp "The View from Carol's Window, 1981" Cibachrome

•

Subject in Bright Light

Should the main point of interest be in a bright area, take a reflected reading from the key highlight area or use an incident reading. A contrasty subject dealt with in this fashion will provide dramatic, rich, and saturated color along with good detail in these bright areas (figure 7.13). The shadows will lack detail and will not provide much visual information. Anything that is backlit will become a silhouette with no detail at all under these circumstances.

Alternative Solutions

If it is not acceptable to lose the details in the shadows, there are other alternatives. These alternatives include averaging the reflective reading, bracketing, using additional lighting techniques such as flash fill, or combining both a reflective and an incident reading. This last method is done by taking an incident reading directed toward the camera of the light striking the subject. This reading will not be affected by extreme highlights. Then take a reflected reading with the meter aimed at the key subject area. Now average the two and bracket for insurance.

Reciprocity

What is the Reciprocity Law? It's the theoretical relationship between the length of exposure and the intensity of light. It states that an increase in one will be balanced by a decrease in the other. For example, doubling the light intensity should be balanced exactly by halving the exposure time. In practical terms, this means that if you meter a scene and calculate the exposure to be f/8 at 1/250 of a second, you could obtain the same exposure by doubling your f/stop opening and cutting your exposure time in half. Thus, shooting at f/5.6 at 1/500 of a second should produce the same results as shooting at f/8 at 1/250. You could also double your exposure time and cut your f/stop in half, so that shooting at 1/125 of a second at f/11 is the same as shooting at 1/250 of a second at f/8. Table 7.2 shows some of the theoretical exposures that would work the same if your exposure was f/8 at 1/250 of a second.

Table 7.2
Theoretical Exposure Equivalents.
(Based on a Starting Exposure of f/8 at 1/250 of a Second)

f/stop	Time in Seconds
f/16	1/60
f/11	1/125
f/8*	1/250*
f/5.6	1/500
f/4	1/1000

* Starting Exposure

Reciprocity Failure

Like most humanly constructed laws, this one does not hold true in every situation. We have what is called reciprocity failure for both very long and very short exposures. Exposures at about 1/10 second or longer and those faster than 1/10,000 of a second begin to show the effects of reciprocity. At about 1 second or longer, the normal ratio of aperture and shutter speed will underexpose the film. Since only specialized cameras are capable of speeds higher than 1/10,000 of a second, most photographers do not need to worry about it. Some electronic flash units, when set on fractional power, can achieve exposures that are brief enough to cause reciprocity failure.

Reciprocity Failure and Its Effect on Color Materials

With black-and-white film we can simply increase the exposure time to compensate for the film's slow reaction time and avoid underexposure. The problem with color materials is that the three emulsions do not respond to the reciprocity effect in the same manner. This can produce a shift in the color balance of the film or paper. For this reason, it is important to keep the paper exposure range between 8 to 15 seconds, with ten seconds being the ideal. If you wish to correct for reciprocity failure, follow the exposure and filtering instructions provided with the film or paper. These are merely starting points and experimentation must be carried out to discover what will work best in a particular situation.

The problem with filtering is that by adding filters you will make the exposure even longer, which in turn can cause the reciprocity effect to be even more pronounced. When using a Single Lens Reflex (SLR) type camera the filters will add density which can make viewing and focusing more difficult in a dimly lit situation.

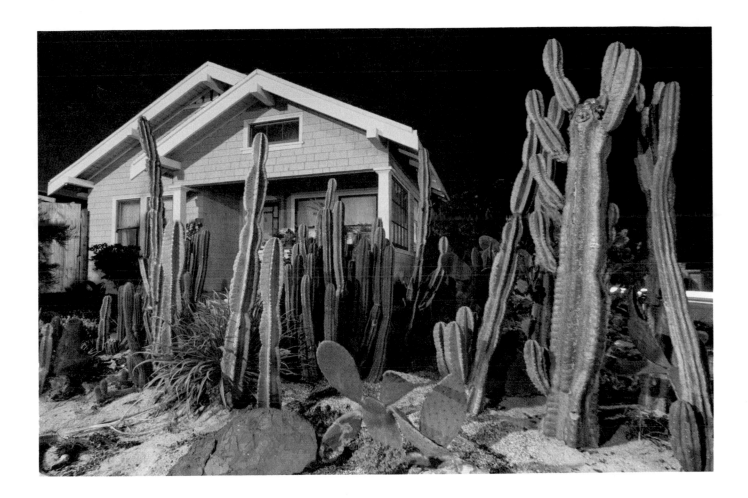

Common Reciprocity Failure Situations

Some typical times that you will run into reciprocity problems are before sunrise, after sunset, at night, and in dimly lit interiors. Fortunately, the quality of light at these different times tend to be strange. That is, there is no standard by which we can judge whether or not you have succeeded in producing an acceptable color balance. Accurate color does not always mean good color. At times like these you may want to take a chance that the combination of light and reciprocity shift will go in your favor to create an unusual color balance that will give your picture impact, which would be impossible to achieve in any other fashion (figure 7.14). Apply what you have learned from this experience to future situations.

Keep Making Photographs

Do not let reciprocity failure stop you from making pictures. Try some exposures with the recommended filters, some with nonrecommended filters, and others with no filters at all. Be sure to bracket your exposures to ensure that you will get acceptable results. Film is your cheapest resource. Do not be afraid to use it. If that extra roll produces a satisfying result, you won't be thinking of the extra time or expense; you will be happy that you produced something good. It is very difficult to be a photographer if you do not expose film. Do not expect every frame to produce a masterpiece. Ansel Adams is reported to have said he was happy if he could produce twelve good photographs in a year.

Figure 7.14
The color shifts that occur in long exposures are produced by the reciprocity failure of the film. Filters and additional exposure are needed for correction, but the unusual color balance can provide a startling visual impact.

© Arthur Ollman "Untitled, 1980"

∴

Color Temperature
Matching Film and Light

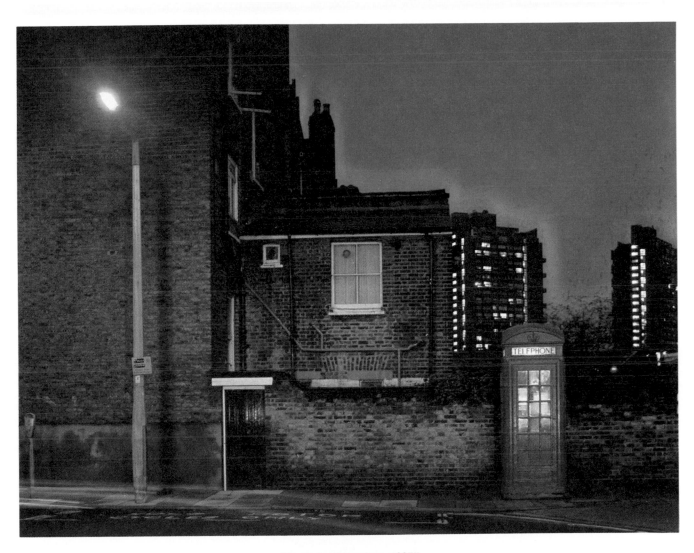

"Noelle's Phone Box, 1987"
20″ × 24″, Type C print,
© Neil Lukas.

·

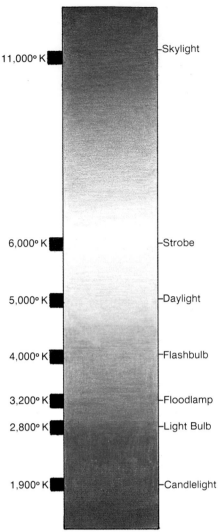

11,000° K — Skylight

6,000° K — Strobe

5,000° K — Daylight

4,000° K — Flashbulb

3,200° K — Floodlamp

2,800° K — Light Bulb

1,900° K — Candlelight

Figure 8.1
The Kelvin scale is how color temperature of
light is measured. The bluer the light, the
higher the Kelvin temperature. The chart
gives common illumination sources and their
approximate Kelvin temperature.

Color Temperature and the Kelvin Scale

The balance of the amount of colors that are contained in a continuous spectrum source of light, having all the visible wavelengths in various amounts, is measured as color temperature. Color temperature is expressed on the absolute (Kelvin) scale. The Kelvin scale starts at absolute zero, minus 273 degrees on the centigrade scale. The Kelvin temperature is determined by adding 273 to the number of degrees centigrade to which a black metal radiator would have to be heated to take on a certain color. A black body is used as a standard gauge since it does not reflect any light falling on it and only emits radiation when heat is applied to it. The Kelvin scale is to the color of light as the ISO scale is to the sensitivity of film (figure 8.1).

Our Sun: A Continuous Spectrum Source

Our sun radiates "white" light that is a continuous spectrum of all the visible wavelengths that are produced by the elements burning on the sun's surface. As these wavelengths are separated out by absorption and reflection we see them as color. The short wavelengths appear as blue, the long as red and all the other colors fall somewhere in between these boundaries.

The Color of Light

Although we think of daylight as being "white" it usually contains some color depending upon the time of day, the time of year, and the weather. Artificial light is rarely white. Our brain remembers how things are supposed to look and makes us believe that the light is white even if it isn't the case. It interprets the scene for us.

How Film Sees Color

Unfortunately, color film cannot yet do this. It simply records what is present. Each color film is designed to accurately record the quality of light for a certain manufactured "normal" color temperature. If you use a film that does not match the color temperature of the light, the picture will have an unnatural color cast to it.

Daylight Type Film

The most common color film is designed to give an accurate representation of a scene in daylight. At midday the Kelvin temperature of outdoor light is about 5500°K. Daylight films are designed to give faithful results at between 5200°K and 5800°K. Daylight has a predominately blue color content. If you make pictures at other times, like early morning or at sunset, the light will have less blue in it. When the color temperature drops below 5200°K, daylight film will begin to record the scene as warmer. The more you drop below 5200°K, the greater the color cast will be. In artificial tungsten light, daylight film will produce a warm orange-reddish-yellow cast.

In winter light, everything will appear slightly cooler or bluish. Light reflected off colored walls or passing through translucent objects will create a color cast that will influence the entire scene (figure 8.2).

Tungsten Film

Tungsten Type B film is color balanced at 3200°K. It is designed to be used with 250 to 500 watt photolamps or spots. Using tungsten film in daylight produces a blue cast. If you use it with a light source of a lower (redder) color temperature like a household bulb, the result will be yellower.

Chapter Eight

Figure 8.2
The color balance of any light source will be influenced by any translucent objects that it passes through or any colored surface from which it is reflected. This effect is known as color contamination.

© Kay Miller "Untitled, 1985" Type C print 8" × 10"

Filtering for Color Shifts If you do not want these shifts in color, then you must filter them out. You will get better results if you filter at the time of exposure, rather than attempting to correct the shifts later.

Negative Films

Negative film has a greater tolerance for mixed color temperatures (daylight and tungsten) than does slide film. Negative film also gives you two chances to make corrections: once at exposure and again when the print is made. Faster negative films, having a speed of 400 or more, can more accurately accommodate a greater variety in color temperature balance than slower films. They also work better in mixed light situations and with fluorescent "daylight" type tubes.

Figure 8.3
Colored filters or gels can be placed in front
of a flash or other light source to create
color changes within a scene. In this
photograph about seventy-five colored
flashes were combined with daylight. This
helps to lead the eye around and make
visual connections within the composition.

© Michael Northrup "Strobacolor Series: House Frame,
1984" Type C print 16″ × 20″

Slide Films

With slide film basically what is seen is what you get. You need to correct at
time of exposure or make corrections by filtering and recopying the slide. This
latter method will cause an increase in contrast and loss of detail.

Electronic Flash

Electronic flash has a color temperature equivalent to bright daylight, usually
about 5600°K to 6000°K. Each unit is different, some tending to be cooler
and bluer than others. Electronic flash also produces a great deal of ultraviolet
light that can appear as blue on color film. If your flash is putting out light that
is too cool for your taste, a yellow CC or CP filter of slight value, can be cut
and taped in front of the unit. Usually a filter with a value of 05 or 10 will get
the job done. Filters can be intentionally used to provide creative lighting
changes within a scene (figure 8.3). Flash can also be employed if you are
shooting daylight film in tungsten light. The flash can help to offset the tung-
sten light and maintain a more natural color balance.

Common Kelvin Temperatures

Table 8.1 provides the Kelvin temperatures for the common daylight and ar-
tificial sources.

Common Conversion Filters

Ultimately, if you are going to be involved in color photography you will need
to acquire color filters (table 8. 2). Do not rush out and simply buy a bunch
of filters. Instead, observe situations that you keep encountering that a filter
would help to solve. Base your purchases upon your own shooting experi-
ences and get the equipment that will let you make pictures that are more
pleasing to yourself.

Table 8.1

Common Light Sources and Their Approximate Color Temperatures

Daylight Sources*	Color Temperature (°K)
Skylight	12,000 to 18,000
Overcast sky	7000
Noon sun with clear sky (summer)	5000 to 7000
Noon sun with clear sky (winter)	5500 to 6000
Photographic daylight	5500
Noon sunlight (depends on time of year)	4900 to 5800
Average noon sunlight (Northern hemisphere)	5400
Sunlight at 30 degree altitude	4500
Sunlight at 20 degree altitude	4000
Sunlight at 10 degree altitude	3500
Sunrise and sunset	3000

Artificial Sources**	Color Temperature (°K)
Electronic flash	5500 to 6500
Blue-coated flashbulbs	5500 to 6000
White flame carbon arc	5000
Zirconium-filled clear flashbulbs (AG–1 & M3)	4200
Warm white fluorescent tubes	4000
Aluminum-filled clear flashbulbs (M2, 5 & 25)	3800
500-watt 3400 °K photolamp (photofloods)	3400
500-watt 3200 °K tungsten lamp (photolamps)	3200
100-watt household lamp	2900
75-watt household lamp	2800
40-watt household lamp	2650
Gaslight	200 to 2200
Candlelight	1900

*All daylight color temperatures depend on the time of day, season of the year, and the latitude and altitude of the location.

**The age and the amount of use of bulb, lamp, or tube will affect the color temperature.

Table 8.2

Basic Conversion Filters

To Change:	Wratten Filter No.	Filter Color
Daylight (5500°K) to 3200°K	85B	Amber
Daylight (5500°K) to 3400°K	85	Amber
Daylight (5500°K) to 3800°K	85C	Amber
Tungsten (4200°K) to 5500°K	80D	Blue
Tungsten (3800°K) to 5500°K	80C	Blue
Tungsten (3400°K) to 5500°K	80B	Blue
Tungsten (3200°K) to 5500°K	80A	Blue

Color Temperature Meters

The photographic color temperature of a light source can be measured by a color temperature meter. The most reliable and expensive meters compare the relative amounts of red, blue, and green energy in the light. They work well with incandescent light sources, but are not as accurate for measuring fluorescent light. This is because light sources, such as fluorescent light, that do not radiate color continuously and evenly throughout the spectrum cannot be given a color temperature. These discontinuous sources are assigned color temperatures on the basis of measurement with a color temperature meter and/or on their visual response to color films.

Fluorescent and Other Gas-Filled Lights

Characteristics of Fluorescent Light

A fluorescent light source consists of a gas discharge tube where the discharge radiation causes a phosphor coating on the inside of the tube to fluoresce. Although fluorescent light may appear to look like light from that of another artificial source it is not. Fluorescent light possesses both a discontinuous and unbalanced spectrum. The color of the light depends on the type of phosphor and gas used. It has peak outputs in the green and blue regions of the spectrum, valleys or deficiencies in red, gaps of other wavelengths, and its intensity varies as the gas moves in the tube. This makes it a discontinuous source, lacking the full range of wavelengths that are present in the visible spectrum. This makes them generally unsuitable for naturalistic color photography.

What Happens without a Filter?

If you photograph using daylight film under fluorescent light the resulting image will have a green cast. This is not generally attractive, especially if you are making pictures of people; they will have a green cast to their flesh. If this is not what you had in mind, corrective action will be required.

Corrective Actions that Can Be Taken
1. You can replace all the fluorescent lights with tungsten lights or with tubes that are designed to give off light closer to daylight. This is generally too expensive.
2. You can put plastic filters over the tubes that will make them closer to daylight. This isn't often practical.
3. If possible, shoot a fast daylight negative film that has a speed of 400 or more. This will give you two chances to make corrections. Once at the time of exposure and again when you make the print. The higher speed films have a greater tolerance for this type of light.
4. Use a fluorescent filter. They are available for both daylight and tungsten films and can be used with either slide or print film. These will generally make a big improvement (figure 8.4). If critical results are needed, you will have to run tests using CC filters to determine the exact filtration. It will usually be a combination of magenta and blue filters.
5. Match tubes to film. Certain tubes will photograph more naturally with specific films. For instance, Daylight and Color-Matching tubes will look more natural if you use a daylight-type film and filter. Warm White tubes are more suitable with tungsten films and filters.
6. Use an electronic flash as a fill light. This will help to offset some of the green cast and make the scene appear as our brain tells us it should be.

(a)

(b)

Figure 8.4
Scenes lit entirely by fluorescent lights are difficult to color correct. a. This photo was made by Stravato on a high-speed negative film with no filters. He attempted to color correct the image during printing, but it still contains an unnatural color cast. b. This picture was made on the same roll of daylight-balanced film with a fluorescent daylight filter. Notice how it has neutralized the color shift, especially in the white areas of the print.

© Michael Stravato "Ice Cream, 1987" Type C prints 11" × 14"

Mercury and Sodium Vapor Sources

Mercury and sodium vapor lights fit into the category of gas-filled lights. Being extremely deficient in many of the wavelengths that make up white light, they are difficult to impossible to correct for and require an extreme amount of filtration.

Figure 8.5
Try making photographs even if the film does not match the color temperature of the light. The mismatch can create enlivened and unexpected combinations, producing images with striking color balances and a sense of mystery.

© Tim Baskerville "Old Man Above Kelly's Cove, 1983"

•

Take a Chance

Do not be afraid to make pictures even if your film does not match the color temperature of the light. Sometimes you can get an evocative color mood piece when this mismatch occurs. Often the combination of different light sources will enliven and create surprise in your picture (figure 8.5). When in doubt, take it and see what it looks like. At worst you will learn what doesn't work for you. At best, you may have interacted with the unexpected and come away from the situation with something that is beautifully astonishing. If you are going to be a photographer, you have to make pictures. Use your film. It is your cheapest resource and provides you with a springboard for not only your current work, but future ideas as well. Be a visual explorer and see what you can discover.

∴

Filters

"Desire"
John Divola
18¾″ × 18½″, Dye Transfer Print, 1985,
Courtesy of the Jayne H. Baum Gallery, New York,
NY.

———

•

What Does a Filter Do?

A photographic filter is a transparent device that can alter the quality and quantity of light. It is placed in front of the camera or enlarging lens or in the path of the light falling upon the subject. Filters that go in front of the lens have to be of optical quality or they can degrade the image quality. Filters used in front of a light source or with a color enlarger do not have to be of optical quality, but they do have to be able to withstand high heat without becoming distorted or faded.

How Filters Work

Most filters are colored and work subtractively, absorbing the wavelengths of light of their complementary (opposite) color while transmitting wavelengths of their own color. Filters are normally uniform in color, but may differ in density (color strength). Since filters block some of the light, they generally require an exposure compensation known as the filter factor.

Filter Factor

A filter factor of 2X means that one additional f/stop of exposure is needed; 4X indicates two additional f/stops of exposure. Most thru-the-lens camera metering systems will give an accurate reading with a filter in place, otherwise the film speed can be adjusted to compensate. For example, if you are using a film with a speed of 100 and a filter with a 2X factor you change the film speed to 50. This will provide the film with one additional f/stop to compensate for the filter factor.

Dichroic Filters

Dichroic filters, like those found in many color enlargers, act by interference. A thin coating on the surface of the filter causes certain wavelengths to be reflected and thus canceled out, while permitting other wavelengths to pass through it.

How Filters Are Identified

Filters are described and identified in a variety of systems. The most widely used is the Kodak Wratten number system in which filters are simply identified with a number, such as 85B.

In color photography filters are employed to make changes in the color balance of the light that creates the image. The color of a light source is described in terms of its color temperature, measured in degrees Kelvin (°K). If the color temperature of the light does not match that of the film, the final image will contain a color cast. A color temperature meter can be used to provide a precise reading of the light source's Kelvin temperature when extremely accurate color correction is needed.

Match the Film to the Light

It is always best to match the light and the film with the correct filter at the time of exposure. Negative film will allow for some correction when the print is made, but slide film is unforgiving. For this reason, filtering at the moment of exposure is critical. Manufacturers have made it easier by supplying slide

film for daylight (5500°K), Type A (balanced for photo-flood lights at 3400°K), and Type B (balanced for studio lights at 3200°K). Type A and Type B film exposed in sunlight will produce a strong blue cast, while Daylight film exposed to artificial light will have a distinct red-orange-yellow cast.

There are about one hundred different correction filters available to deal with the range of color temperature encountered.

Filter Categories Used with Color Films

The following are general categories of filters that are commonly employed with color films (figure 9.1).

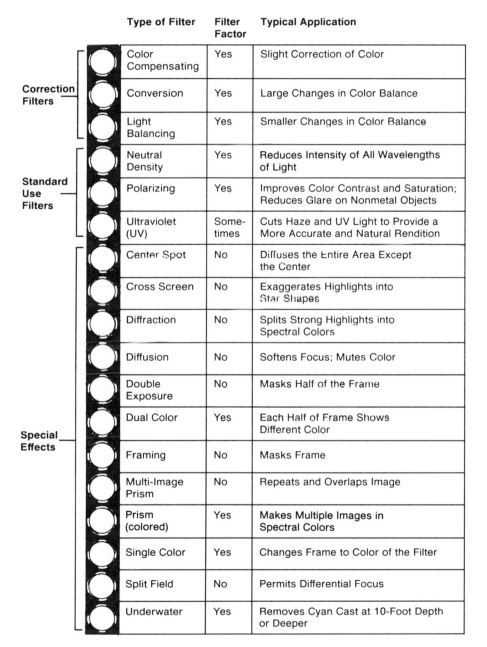

	Type of Filter	Filter Factor	Typical Application
Correction Filters	Color Compensating	Yes	Slight Correction of Color
	Conversion	Yes	Large Changes in Color Balance
	Light Balancing	Yes	Smaller Changes in Color Balance
Standard Use Filters	Neutral Density	Yes	Reduces Intensity of All Wavelengths of Light
	Polarizing	Yes	Improves Color Contrast and Saturation; Reduces Glare on Nonmetal Objects
	Ultraviolet (UV)	Sometimes	Cuts Haze and UV Light to Provide a More Accurate and Natural Rendition
Special Effects	Center Spot	No	Diffuses the Entire Area Except the Center
	Cross Screen	No	Exaggerates Highlights into Star Shapes
	Diffraction	No	Splits Strong Highlights into Spectral Colors
	Diffusion	No	Softens Focus; Mutes Color
	Double Exposure	No	Masks Half of the Frame
	Dual Color	Yes	Each Half of Frame Shows Different Color
	Framing	No	Masks Frame
	Multi-Image Prism	No	Repeats and Overlaps Image
	Prism (colored)	Yes	Makes Multiple Images in Spectral Colors
	Single Color	Yes	Changes Frame to Color of the Filter
	Split Field	No	Permits Differential Focus
	Underwater	Yes	Removes Cyan Cast at 10-Foot Depth or Deeper

Figure 9.1
Common filters and their typical applications in color photography.

Figure 9.2
Conversion filters are normally employed to
make large changes in color balance.
Generally, they are used to correct for a
mismatch of film type and illumination. Here
a filter has been purposely used to
selectively alter the color balance of the
scene.

© Erik Lauritzen "Palm, 1986" Type C print

Color Compensating Filters

Color compensating filters (CC) are used to make slight and precise correc-
tions in one or two colors of the light. CC filters will counteract small color
shifts and correct minor color casts. They are also employed to gain proper
balance when color printing. CC filters come in various densities of blue, cyan,
green, magenta, red, and yellow. Their density is indicated by numbers like
CC10B, which means 10 points of blue.

Conversion Filters

Conversion filters are used to make large changes in color balance. Generally
they are used to correct a mismatch of film type and illumination, but can be
employed to create a deliberate color shift (figure 9.2). They consist of 80

series (blue) and 85 series (amber) filters. The common 80 series filters are used with daylight film to color correct it with tungsten light. Use a 80A with daylight film and 3200°K or ordinary tungsten light. An 80B is used with 3400°K lights and an 80C with clear flashbulbs. The 85 filters correct tungsten film when it is used in daylight. Use an 85 filter with Type A film (3400°K) and a 85B with Type B film (3200°K).

Light Balancing Filters

Light balancing filters will make smaller changes in the color balance than conversion filters. They are used to match an artificial light source more closely with a tungsten film. Filters in the 81 series have a yellowish or amber color and will lower the color temperature of the light. Use an 81A filter to reduce excessive blue in aerial, marine, and snow scenes. It is also effective on overcast and rainy days or in open shade. Those filters in the 82 series possess a bluish color and will raise the color temperature of the light. An 82A filter is used to reduce the warm cast in early morning and late afternoon light.

Unnumbered filters are available to make general adjustments for the excessive blue-green cast of fluorescent lights. An FL-D filter is used with Daylight film and FL-B filter for Type B Tungsten film.

Neutral Density Filters

Neutral density filters (ND) are applied to reduce the intensity of the light by absorbing the same amount of all the wavelengths. They have an overall gray appearance and come in different densities that will cut the light by one, two, or four f/stops. They can be used to reduce the depth of field or to use a very high speed film in extremely bright light. They will not affect the color balance or tonal range of the scene.

Polarizing Filters

Normally light is made up of energy vibrating in all directions at right angles to the direction the light waves are traveling. When light is polarized the vibration is predominately in one plane at right angles to the direction the light is traveling. The polarizing filter is a device used to polarize the light in photography. It is usually a gray-brown color. They are used to eliminate reflections from nonmetallic surfaces like glass, tile, and water, and they can improve the color saturation by screening out the polarized part of the glare. This can make a clear blue sky appear deeper, richer, and have more contrast (figure 9.3). When using a polarizing filter focus first, turn the filter mount until the glare decreases and the colors look richer, then make the exposure.

Special Purpose Filters

Special purpose filters include ultraviolet, haze, and skylight filters. All of these absorb ultraviolet (UV) light, reducing the effects of scattered light which the film records as blue. This produces a more accurate and natural rendition on the film. Infrared filters that transmit infrared wavelengths are used with special infrared films.

Figure 9.3
The polarizing filter was used for this photo to deepen the color saturation of the sky, eliminate reflections from the painted pole, and create more contrast. These factors all help the eye to travel up the pole to the flag.

© Michael Stravato "Untitled, 1986" Type C print 8" × 10"

Special Effect Filters

Special effect filters are available to produce unusual visual effects. These include the following filters:

Center Spot—diffuses the entire area except the center.

Cross Screen—exaggerates highlights into star shapes.

Diffraction—takes strong highlights and splits them into spectral color bursts.

Diffusion—softens and mutes the image and color.

Double Exposure—masks half the frame at a time.

Dual Color—each half of the frame receives a different color cast.

Framing—masks the frame to form a black or colored shape.

Prism/Multi-Image—repeats and overlaps the image within the frame.

Prism/Colored—makes multiple images with spectrum-colored casts.

Split Field—allows differential focus within the frame.

Underwater—removes the cyan cast that appears at a depth of ten feet or more.

Filter Kits

Filter kits that come with a universal holder and color gelatin squares offer an inexpensive way to work with a variety of filters. It will also free you from having to use only manufactured materials. By using your ingenuity it is possible to create your own filters for artistic control of color.

∴

Printing Color Negatives

"World Trade Center, 1971"
Len Jenshel
16″ × 20″, Ektacolor print,
Courtesy Laurence Miller Gallery, New York, NY.

•

#11 Amber
Safelight

Opaque Piece of Paper that Acts as an
Aperature Control Device for the Penlight.

Figure 10.1
Since color paper is sensitive to a wider
range of wavelengths of light than black-
and-white paper, it requires a different
safelight in order not to fog the paper. A
small pocket-style flashlight, with an opaque
piece of paper wrapped around it to act as
an aperture control, can provide additional
light for setting up at the enlarging station.

•

Many people are afraid to try color printing. If you can make a successful
black-and-white print, you can make a successful color print as well. The
methods presented here are designed to teach the basic concepts and tech-
niques that are necessary to make a color print with a minimum of equipment.

There are always new methods appearing on the market. Once these
basic principals have been mastered, you will be ready to adapt to any future
changes in technology without trouble. There are some differences between
working in color and black-and-white that you will need to know.

Basic Equipment and Basic Ideas for Color Printing

The Safelight

The standard OC black-and-white safelight will fog color paper so a #13 filter
is used in the safelight when printing from negatives (slides are printed in
total darkness without a safelight). The #13 filter and safelight gives off enough
light in a group darkroom to prevent collisions and stumbling. The latest gen-
eration of LED (light-emitting diode) color safelights provide more light, but
many established darkrooms will not have them for some time.

A small pocket flashlight with a shade is a great help in getting about and
setting things up at your station (figure 10.1). For a modest investment, there
are mini-battery-powered safelights that can be worn around the neck.

Color materials are extremely sensitive to light, therefore use care when
pointing the flashlight or turning on any white-light source in the darkroom.
Do not turn on the enlarger light if the head is raised.

Multiple station darkrooms are a place of collective activity that requires
responsible behavior to protect the efforts of all concerned. If an individual
darkroom is available, printing can be done without a safelight and the paper
can be processed in a drum under full illumination.

A properly produced image from a color
negative will enable the viewer to fully
participate in the photographer's
presentation of the event.

© David Graham "Crashed Car, 1985" Type C print
Courtesy of Jayne H. Baum Gallery, New York, NY
20″ × 24″

•

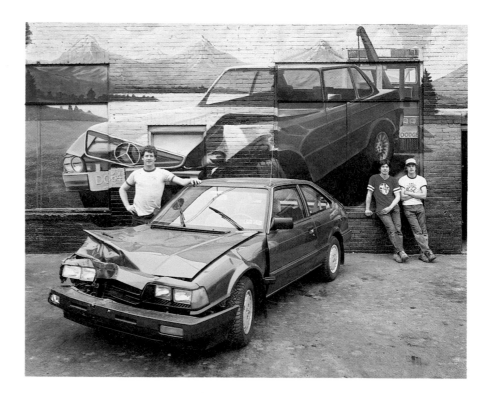

Chapter Ten

The Easel

Most easels are painted yellow by the manufacturer, which works well for black-and-white printing because the yellow color reflected onto the paper during exposure does not affect it. This is not the case with many color papers that can be sensitive to the reflected yellow light; the papers can be fogged by it. However, papers with opaque backings like Cibachrome A-ll are not affected by reflected color. The problem of paper being fogged by a yellow easel can be overcome by spray-painting the easel with a flat-black enamel (figure 10.2).

Figure 10.2
A photographic easel with adjustable blades allows making prints of various sizes with ease. The easel can be painted black to ensure the color paper is not fogged by color reflected by the easel during exposure.

The Enlarger

There are two basic types of enlargers, condenser and diffusion. The condenser style uses one or more condenser lenses to direct the light from the lamphouse into parallel rays as it goes through the negative. This system is widely used in black-and-white printing because of its ability to produce greater apparent sharpness and because it matches the standard black-and-white contrast grades of paper extremely well.

Diffusion Enlarger

In a diffusion enlarger (figure 10.3), which is commonly employed in making color prints, the light is mixed in a diffusing chamber. In this method the light reaching the negative is traveling in many directions (diffused) as it reaches the negative. The diffusion process insures the proper mixing of the filtered light, offers a suitable contrast for color printing, makes defects in the negative less noticeable, and will soften the final print.

Figure 10.3
A composite dichroic diffusion color enlarger. It is a self-contained system that features separate color filter controls, a color-corrected high intensity light source, a UV filter, heat absorbing glass, and a white light switch.

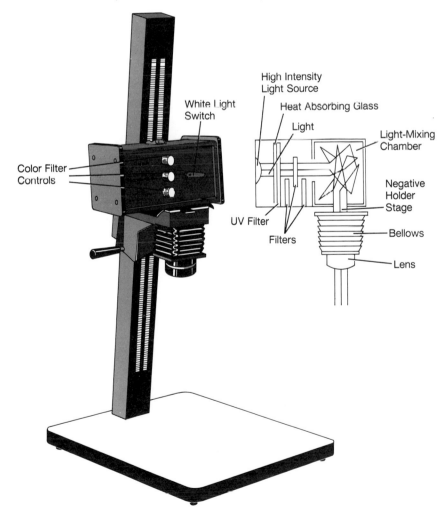

White Light Switch

Color Filter Controls

High Intensity Light Source

Heat Absorbing Glass

Light

Light-Mixing Chamber

Negative Holder Stage

UV Filter

Filters

Bellows

Lens

Both types offer advantages and disadvantages. When the opportunity presents itself, try out each type, compare, and see which is more suitable to your needs.

Dichroic Systems

The best color enlarging system is the dichroic color head, which is a self-contained system with filters, color-corrected high intensity light source, a UV (ultraviolet light) filter, heat-absorbing glass, and a white light switch. The dichroic color head contains filters with metallized dyes. These will enable the printer to work more accurately. The dichroic head also enables one to make moderate changes in the filter pack without affecting the printing time. Most dichroic systems are in diffusion-type enlargers.

Converting Black-and-White Enlargers

Many black-and-white enlargers can be converted to color by replacing the black-and white-head with a dichroic head. Less expensive systems are available, including the use of CP and CC filters.

CP Filters

CP (color print) filters can be used with enlargers that contain a filter drawer. The CP filters change the color of the light *before* it reaches the negative. They are only available in the subtractive primary colors and are not as optically pure as the CC filters, but they do cost less. The major advantage of the CP filters is they go above the lens, eliminating the focus and distortion problems associated with CC filters, which are located below the lens. A UV filter and heat-absorbing glass are needed with both CC and CP filters to protect the film and shield the paper from UV exposure. Both filters can be used with either condenser- or diffusion-type enlargers, but not with a cold-light enlarging head.

CC Filters

CC (color correction) filters work well for occasional use, but they are problematic and more expensive. CC filters are optically pure gelatin acetate filters which are placed in a filter holder *under* the enlarging lens. They are available in both additive and subtractive colors and in a wide range of densities. CC filters change the light after the image has been focused, which can cause problems in loss of image contrast, distortion of the picture, and a reduction in overall sharpness. Sparing and economic use of filters (i.e., one CC20 filter, not four CC05 filters) will help to alleviate these problems. Wear thin cotton gloves when using these filters in order to prevent the filters from getting dirty and scratched.

Voltage Stabilizer

Regardless of the type of enlarger or filter system, a voltage stabilizer (figure 10.4) will be needed. Some of the dichroic systems have a voltage stabilizer built in. Any changes in the voltage to the enlarger during exposure will produce changes in the color balance. To prevent this from occurring and to have consistent results, a voltage stabilizer is connected between the timer and the power outlet.

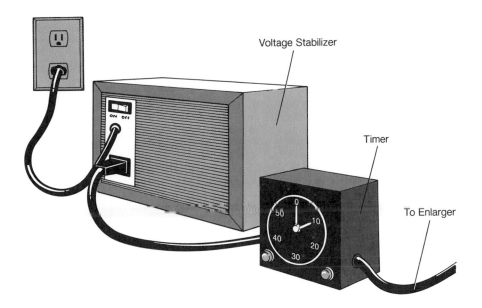

Voltage Stabilizer

Timer

To Enlarger

Figure 10.4
A voltage stabilizer is needed when making color prints as power fluctuations during exposure can produce changes in the light source's color. This can cause changes in the color balance of the print, making corrections and consistency hard to achieve.

Notebook

Keep a notebook to record final print information (figure 10.5). This will establish a basic starting point that will make it much easier to make a print when a similar situation occurs with a certain type of film. It also makes reprinting quicker. Information is commonly kept in columns under the following headings: subject, title or number of print, negative number, enlarger lens, enlarger height or size of the print, magenta filtration, yellow filtration, cyan filtration, exposure time in seconds, f/stop of the lens, and details concerning burning and dodging.

Each color enlarger will produce differences in time and filtration, but this information will help one to arrive at a final print with more ease. In a group darkroom, find an enlarger that you like and stick with it. Learn its quirks and ways so that you are comfortable working with it.

Figure 10.5
Keeping the final print information in a notebook establishes a basic starting point that can be referred to the next time a similar situation is encountered.

Temperature Control

Temperature control is necessary for most color processes. Being off by as little as one-half degree can cause a change in the color balance. Check your thermometer against one known to be accurate. The Kodak process thermometer makes an excellent reference as a standard of comparison. Corrections can be made if yours is off. If the standard reads 100 degrees and yours says 101 degrees, simply process at 101 degrees instead of 100 degrees based upon your thermometer's reading.

The cheapest method of temperature control is the water bath. Chemicals are put into cold or hot water until they reach operating temperature. The temperature must be maintained, requiring constant monitoring. This method makes accuracy and consistency difficult to maintain.

If you can afford it, buy a temperature control storage tank or make your own using a fish tank heater and an old soda pop cooler. The consistency of the results, plus their convenience, will offset the cost. If you are fortunate enough to work in a lab with an automatic print processor, the machine will take care of temperature control, replenishment rate, and processing.

Figure 10.6
A Cibachrome-style processing drum
mounted on a motorbase is a convenient
and inexpensive tool for making color prints.
The base of the paper is placed in contact
with the interior wall of the drum with the
emulsion side of the paper curling inward.

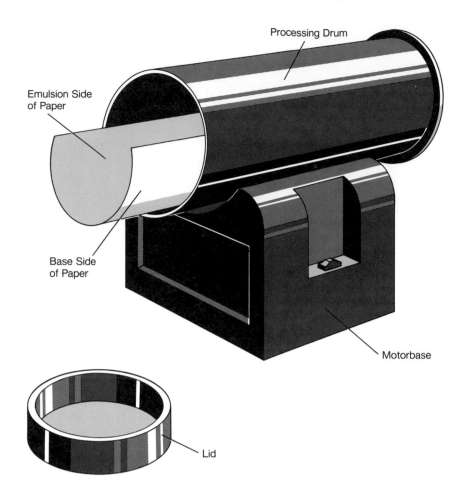

The Drum Processor

Drum processing (figure 10.6) is the best alternative to an automatic color print processor. Processing can be carried out in room light with a minimum amount of chemistry. A motorbase can aid in attaining proper agitation and consistency, which in turn will make printing easier, simpler, less costly, and more enjoyable. There are many types and styles of drums and bases available. Check them out and see which you prefer. The Cibachrome-style drum has no feet or big lips to get in the way and it rolls easily on a level surface. Drums are available from 8″ × 10″ to 16″ × 20″. More than one print can be processed at a time in a drum. For instance, the 16″ × 20″ model can do up to four 8″ × 10″ prints. Read the manufacturer's suggestions for use, processing times, and amounts of chemistry (see chapter 11, Printing Color Slides).

What to Photograph

Begin with a simple composition, shot on daylight-type negative film with a speed of about 100 in normal daylight outside conditions. Do not shoot under any type of artificial light, including flash. Be sure to include a human fleshtone by shooting someone with whom you are familiar and can refer back to if need be.

Chapter Ten

Photographing a gray card or color charts is not necessary, but it can be helpful for making objective decisions. It is necessary to remain objective, but keep in mind that color photography is highly interpretive and therefore subjective as well. There are no standard formulas for color balance that can be applied to every situation. It is either the color that you want and like or it isn't. It makes no difference how accurately you can render the gray card if the colors do not do what you have in mind.

It is not a math problem that is being solved, it is a visual one. There is more than one correct answer, but do not use this as an excuse for ignorance. One has to learn technique and be able to control it in order to master the craft of image making. Likewise, do not let equipment or technique get in the way of making photographs.

The Qualities of White Light

Principles of Subtractive Printing

White light is made up of blue, green, and red wavelengths, known as the additive primary colors. The three colors that are produced by mixtures of the paired additive primaries are cyan (blue-green), magenta, and yellow, called the subtractive primary colors. The subtractive method is the one we are going to be working with because it is the most widely used. Each subtractive primary represents white light minus one of the additive primaries (cyan equals white light minus red, magenta equals white light minus green, and yellow equals white light minus blue).

Subtractive primaries are the complements (opposites) of the additive primaries. Thus cyan is complementary to red, magenta is complementary to green, and yellow is complementary to blue. When you determine your filter combinations for printing, think of all the filters in terms of the subtractive colors. This means blue equals magenta plus cyan, green equals yellow plus cyan, and red equals yellow plus magenta.

Additive colors are converted to their subtractive equivalents in the following manner:

> 10 Red = 10 Magenta + 10 Yellow
>
> 20 Red = 20 Magenta + 20 Yellow

Filters of the same color are added and subtracted normally:

> 10 Magenta + 10 Magenta = 20 Magenta
>
> 30 Magenta − 10 Magenta = 20 Magenta

Neutral Density

Whether you work with the dichroic, CC filters, or CP filters, they all contain cyan, magenta, and yellow. Each of the three subtractive filters blocks out one of the three components of white light— blue, green, and red. If all three filters were used at once, not only would the color balance be changed, but some of all three would be eliminated. This also builds extra density which causes extended printing time. This effect is known as neutral density. The same color changes can usually be achieved without affecting the print density by using only two of the subtractive filters.

Figure 10.7
How white light is affected as it passes
through the subtractive primary color filters,
illustrating the basic principles of subtractive
color printing.

The general rule for printing color negatives is to use only the magenta and yellow filters. Leave the cyan set at zero. This will also eliminate one-third of the filter calculations and make printing faster and easier.

Figure 10.7 shows what happens as white light is passed through the different subtractive filters.

Chapter Ten

General Printing Procedures

These are the general steps for color printing:

1. Select a properly composed and exposed negative.
2. Clean the negative carefully. Use film cleaner and soft lint-free paper towels such as Photo-Wipes. If there are problems with dust or static, get a static brush. If you want to avoid radiation, get a static gun like a Zerostat that are sold in record stores. The static gun and a good sable brush will get the job done and will avoid unnecessary spotting of the print later. Using canned air can create more problems than it solves. The propellent can come flying out onto the negative, making a bigger mess than was already there.

 If the film has been improperly processed or handled and received a noticeable scratch, apply a liquid no-scratch substance such as Edwal's No-Scratch. Clean the negative and paint No-Scratch on the entire non-emulsion side. If the negative is badly scratched, paint it on both sides. This treatment will diffuse the image slightly. After printing, be sure to remove all the No-Scratch with film cleaner and Photo-Wipes. If you lose the little brushes that come with the No-Scratch, Q-Tips make a wonderful substitute.

3. Turn on the power to the enlarger.
4. Remove all filters from the light path. Many dichroic enlargers have a white light switch that will do this.
5. Open the enlarging lens to its maximum aperture. Having as much white light as possible makes composing and focusing easier because this has to be done through the orange mask of the negative film.
6. Set the enlarger height and focus using a focusing aid. Have a piece of scrap printing paper at least the same size as the print in the easel to focus upon. This will make composing possible on a black easel and insure the print will have maximum sharpness.
7. Place the starting filter pack, based upon past experience or the manufacturer's suggestion, into the enlarger. Forgetting to put the filters back into the enlarger after focusing and printing with white light will result in the print having an overall reddish-orange cast.
8. Set aperture at f/5.6.
9. Set timer for 10 seconds.
10. Place the unexposed paper, emulsion side up, in the easel. The emulsion side looks dark bluish-gray under the safelight. The paper will generally curl in the direction of the emulsion. Most paper is usually packed emulsion side up in the box. Many are packaged with only one piece of cardboard and it is facing the emulsion side of the paper. If the paper looks white under the enlarging light, you have probably printed on the wrong side; throw it away and start again. Printing and processing through the wrong side of the paper results in a fuzzy reversed image with an overall cyan cast.

 Take time. Do not worry about making a mistake. That is part of the learning process.

Making a Contact Print

Due to the orange mask of the color negative film, most people find it difficult to "read" what is in their negatives. The contact print provides the opportunity to see the negative in a print form. The contact print lets one see how they were thinking; it shows what was done right and wrong in the coverage of the subject, both aesthetically and technically; it lets the photographer see things that may have been missed in the examination of the negative; and it can point the direction toward the pursuit of an idea or improvement of a technique.

The Basic Procedure

To make a contact print:

1. Place a strip of paper, emulsion side up, under the enlarger. Make sure that the enlarger is high enough to let the light completely cover the paper of the full contact print evenly. When making an 8" × 10" contact print set the enlarger to the proper height used to make an 8" × 10" print. This will give a closer idea of the actual enlarging time for the finished print.
2. Place the film emulsion side down on top of the paper. Cover with a clean piece of glass or use a contact printing frame. If safelight conditions are dim or nonexistent, leave the negatives in their protective sleeves. Check the protective sleeves to make certain they do not affect the clarity and color balance of the contact print or the filter information from the contact may not be correct when it is applied to making the final print.
3. Set the starting filter pack.
4. The fat "L" can be used to determine correct exposure, following the method previously outlined in making the print. Some people do not like using the fat "L" for contact prints. Instead, a piece of cardboard is used to block the light and move it across the paper to create six separate exposure increments as in black-and-white printing (figure 10.9). Try exposing at f/8 in 3-second increments (3, 6, 9, 12, 15, and 18 seconds). If the entire test is too light open the lens to f/5.6. If it is too dark, stop the lens down to f/11 and repeat the procedure.
5. Process, dry, and evaluate.
6. Pick the area that has the best overall density. Recalibrate the time so it is in the 10-second exposure range. For example, if the best time was f/8 at 6 seconds, adjust the exposure so that the new exposure will be f/11 at 12 seconds. Make any changes in the filter pack based upon the information obtained in the area of best density.
7. Make a new contact print of the entire roll based on these changes.
8. Process, dry, and evaluate.

Reading the Contact Sheet

The information from the contact print should make it easier to choose the best negative to print. This information from the contact print will provide a good place to begin making enlargements. If the selection looks too magenta on the contact print, begin to correct for this by adding more magenta to the filter pack before making the first test. This step begins the way to making that perfect print even more rapidly. In general, the information obtained from an 8" × 10" contact print (exposure and filtration) can be applied as a starting place for the creation of the 8" × 10" enlargement.

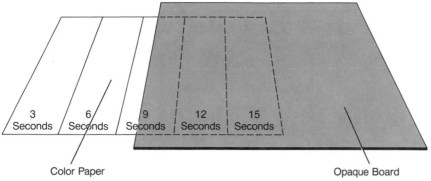

Color Paper Opaque Board

Figure 10.9
Some people do not like the fat "L" method
for determining exposure for a contact print
and instead use an opaque piece of board
to block the light. In this method, like in
black-and-white printing, the exposure time
is varied while the f/stop remains
unchanged. Once exposure is calculated, it
is adjusted so it is in the ten-second range
and any additional exposure changes are
made by adjusting the f/stop.

45°

White Piece
of Paper Print Viewing Filter

Color Print
to be
Corrected

Figure 10.10
Color print viewing filters are an effective
method to learn how to recognize all the
basic colors used in color printing and can
be employed to make visual corrections of
color prints. The correction method shown
here demonstrates one technique for
determining which color is in excess. Be
certain the light striking the correction filter
and the print is of equal intensity and
quality.

Evaluating the Print

Follow these steps when evaluating the print:

1. When possible, examine the print in lighting conditions similar to those
 that the finished print will be viewed under.
2. Is the exposure correct? First determine the best density because
 changes in it will affect the final color balance. Look carefully at sensitive
 areas like facial and neutral tones. This will help to determine which ex-
 posure will give proper treatment for what you have in mind.
3. After deciding what is the best density, determine which color is in excess.
 It is easier to see the incorrect color in a middle tone area. If there is a
 face in the picture, the whites of the eyes are often a key spot to make
 this determination. Avoid basing the color balance upon shadow areas
 and extreme highlights.
4. The most effective way to tell which color is in excess is by using the
 Kodak Color Print Viewing Filters (figure 10.10). One side of the filter set
 is designed for negative printing and the other side for positive (slide)
 printing. Use the appropriate side.

Methods for Using Viewing Filters

There are a number of different ways to use these filters. One or a combination of the following methods should be helpful in determining the color balance of the print.

Filters next to the Print

Under proper lighting conditions place a piece of white paper next to the area of the print to be examined. The filters have six colors to work with: magenta, red, and yellow (the warm colors) and blue, cyan, and green (the cool colors). Half of these can be immediately eliminated by deciding if the print is too warm or too cool. Then glance rapidly back and forth between the key area and the white piece of paper to see if the color in excess can be determined.

The white paper is a constant to avoid color memory (see color memory section in chapter 4). If this does not work, take the green filter and place it upon the white paper at a 45-degree angle so that the light passes through the green filter and strikes the white paper, giving it a green cast. Glance rapidly back and forth between the color that the filter casts onto the white paper and the key area being examined in the print in order to see if the color cast matches. If it does, excess color is green. If it does not, try the blue filter following the same procedure. If the blue does not match, try the cyan. If there is a problem deciding between green and blue, it is probably neither. It is most likely cyan, the combination of blue and green.

Printing experience has shown that cyan has been in excess more than either blue or green. Notice if one color appears regularly in excess in your printing and be on the lookout for it.

Now use the viewing filter to determine the amount of excess by judging which of the three filter strengths the color cast comes closest to. Is the excess slight (a 5-unit viewing filter), moderate (10 units), or considerable (20 units)? If the change is moderate, requiring a 10-unit viewing filter, make a ten-point correction in the filter pack.

In the older model of the print viewing filters each filter has an assigned value of twice what the current model is listed at, but the filters are the same. The older set will list a slight excess as 10 instead of the 5 that the current set is labeled with. When working with an older filter set changes dialed into the enlarger filter pack will be half the strength of those of the print viewing filters.

The dichroic head makes it possible to fine-tune a print with small changes in the filtration of two or three points. Moderate changes in filtration will not affect the print density with the dichroic head. When working with CC and CP filters changes in filtration must be compensated for by adjusting the exposure time. An increase in filtration will require an increase in exposure to maintain proper print density. Use manufacturer's suggestions until experience is gained.

Filters over the Print

Another method of making filter corrections with color print viewing filters involves looking at the print through the filter that is the complement (opposite) of the color that is in excess. In this method, flick the filter over the print looking through it at the key examination area. Keep the filters about six inches from the print surface. Do not put your eye directly against the filter as it will adapt to that color. Do not let the light that is illuminating the print pass through the filter on its way to the print. Whichever filter and density combination neutralizes the excess color and makes the print appear normal is the combination to base the corrections on. If the print looks too blue, it should appear correct through a yellow filter. Make the determination as rapidly as possible. Do not stare too long, as the brain's color memory will take over and fool you

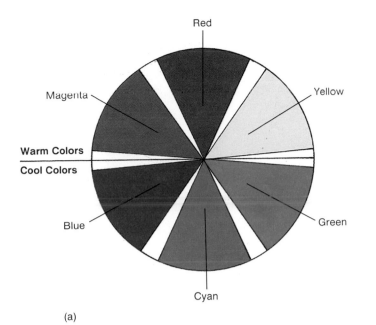

(a)

Figure 10.11
The basic rules for making changes in the filter pack. (*a.*) It is first determined from the color wheel if the print is a cool or warm color, then it is decided which color it is. Using the color print viewing filters, it is decided how much correction is needed. (*b.*) The chart is a reference to determine how much and which filters have to be used to make the desired correction.

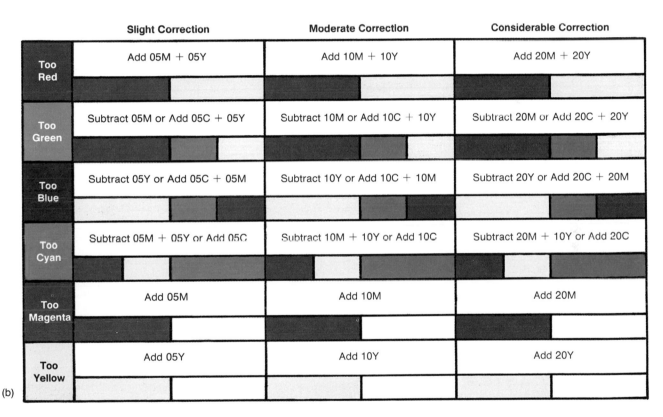

	Slight Correction	Moderate Correction	Considerable Correction
Too Red	Add 05M + 05Y	Add 10M + 10Y	Add 20M + 20Y
Too Green	Subtract 05M or Add 05C + 05Y	Subtract 10M or Add 10C + 10Y	Subtract 20M or Add 20C + 20Y
Too Blue	Subtract 05Y or Add 05C + 05M	Subtract 10Y or Add 10C + 10M	Subtract 20Y or Add 20C + 20M
Too Cyan	Subtract 05M + 05Y or Add 05C	Subtract 10M + 10Y or Add 10C	Subtract 20M + 10Y or Add 20C
Too Magenta	Add 05M	Add 10M	Add 20M
Too Yellow	Add 05Y	Add 10Y	Add 20Y

(b)

into thinking the scene is correct (an example of color adaptation). The brain knows how the scene is suppose to look and will attempt to make it look that way, even if it does not. When in doubt, go with your first judgment.

The Ring

The "ring-around" is a popular method of evaluation in which the print is compared against a series of standard selections. The ring will include a "correct" print along with a series of "incorrect" prints made from the same negative. This includes an under- and overexposed print and one print with each of the six colors printed in varying degrees of excess. The ring can be created from your own standard negative or purchased in a commercially prepared format.

Traditionally, the ring has been used because it seemed to be the most logical way to learn how to tell the differences in color balance. The problem that arises is that people do not necessarily learn to recognize color differences in a logical manner. Most people are able to learn just as rapidly by diving in and making a print. Making the ring is time-consuming and not particularly interesting. A person's ability to learn new information remains higher when that person continues to print from new and stimulating negatives. The ring can be of value to those working at home, alone, without someone with experience in color printing to act as a guide.

Ultimately, it makes no difference which method is used. Everyone sees things in their own way and in their own time. Try one of these methods out; if it does not work, try another. Discover which does the job for you. You may even come up with a better way.

Changing the Filter Pack

When modifying the pack (see fig. 10.11) a filter of the same color can be added, however it is more desirable to subtract a complementary filter. This is because the paper will respond better with a minimum of filters and will keep the exposure time in the ten-second range. In most cases use only the magenta and yellow filters. Leave the cyan set on zero. Do not have all three in the pack together as it will produce unwanted neutral density. Avoid extremes of exposure to prevent reciprocity failure.

Memorizing table 10.3 is helpful as this information is needed every time a change in the filter pack takes place. It provides the answers to the six most commonly asked questions in color printing.

Changes in Paper Emulsion

Each batch of color paper has different characteristics that will affect the exposure and filtration. Because of this the paper is given an emulsion number that is sometimes printed on the package. In order to avoid the problems associated with changing emulsions, try to buy paper in as large a quantity as is affordable. It is better to buy a one-hundred-sheet box of paper than four twenty-five-sheet packages that could have been made at four different times. Each time the emulsion number is changed it is usually necessary to correct the exposure and filter information. As the manufacture of color papers has improved, there is a less noticeable difference in color balance from emulsion to emulsion.

Burning and Dodging

Just as in black-and-white printing, burning in, giving the print more exposure, will make it darker and dodging, giving the print less exposure, will make it lighter. In color printing it is possible to not only change the density of a print, but the color balance of selected areas by burning and dodging. If you burn in an area with more yellow light, it will reduce the amount of yellow in that area. Too much burning and dodging can cause a color shift to take place in those areas.

A "dodger" can be made by cutting a piece of cardboard to the shape of the area that will be given less exposure and attaching it to a dowel, pencil, or wire with a piece of tape (figure 10.12). Keep the dodger moving during the exposure or an outline will appear on the print.

A "burning" tool can be produced by taking a piece of cardboard that is big enough to cover the entire print and cutting a hole in it to match the shape of the area to be given more exposure (figure 10.13). Keep it in constant motion during exposure to avoid the outline effect.

Table 10.3
Basic Subtractive Filtering Rules

To reduce magenta, add magenta filtration.

To reduce yellow, add yellow filtration.

To reduce red, add magenta and yellow filtration.

To reduce cyan, subtract magenta and yellow.

To reduce green, subtract magenta.

To reduce blue, subtract yellow.

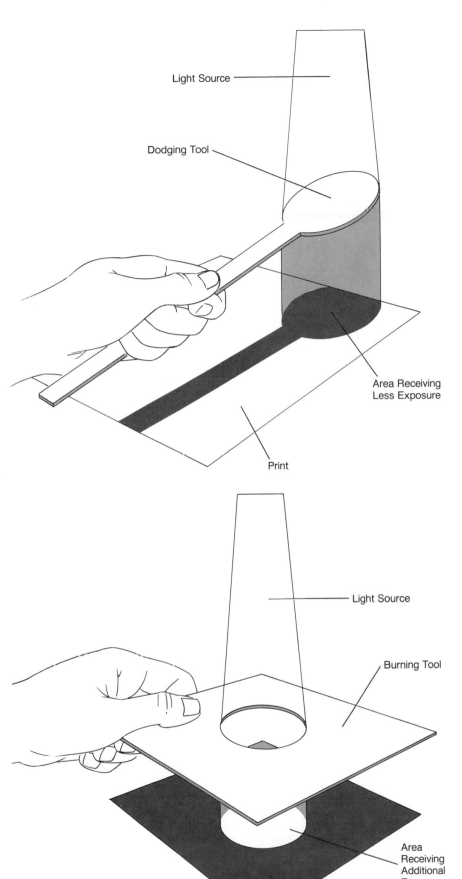

Light Source

Dodging Tool

Area Receiving
Less Exposure

Print

Figure 10.12
A "dodger" is employed to give an area of a
print less exposure. It is necessary to keep
the "dodger" in motion during exposure to
avoid creating an outline of the tool.

Light Source

Burning Tool

Area
Receiving
Additional
Exposure

Print

Figure 10.13
A "burning" tool is used to give an area of
the print more exposure. It also must be
kept in motion during exposure or the
burned-in area's density will not match the
rest of the print.

Save These Tools

After a while the collection of burning and dodging tools will meet most printing needs, saving construction time and speeding darkroom work. Some people do most of their burning and dodging with their fingers and hands. Others prefer to purchase commercially prepared tools. Do whatever works best for your needs.

Final Decisions and Cropping

Once the correct filter pack and exposure has been obtained, check the print for exact cropping. A handy way to determine whether the print has been cropped properly is to cut out a pair of "L"'s from a piece of white board. These "L"'s can be overlayed with one another on the print to determine the exact cropping of the final picture.

Look at the Print in a Mirror

If the print still does not look the way you wish, try an old painter's method for seeing the work in a different fashion: look at the print in a mirror. Reversing the image can let one momentarily forget the previsualized idea. It can provide the opportunity to see the work as a viewer might or in a totally different manner than before. This could provide the clue to the direction that needs to be taken to let the picture deliver its message to its future audience.

Storage

Paper keeps better under refrigeration. It can be frozen if it is not expected to be used for some time. Allow enough time for the paper to reach room temperature before printing or inconsistency will result. It takes a one-hundred sheet box of 8" X 10" paper about three hours to warm up.

Color Analyzers

What a Color Analyzer Does

Color analyzers are exposure meters for the darkroom that measure color in addition to brightness of a projected color image (figure 10.14). The information that it provides is used to help determine the correct exposure and filter pack of the print. To be of use, the analyzer must be programmed. This is done by finding the proper exposure and filtration for a standard reference negative, generally containing a gray card and/or average skin tone. This information becomes the standard from which the machine will base its decisions.

When a print is made from a new negative, a probe is used to read comparative areas like skin tone from the new negative. The machine then compares the information and tells what the difference is between the two. This data is then used to make adjustments in the exposure and filter pack to bring the new negative in line with the standard.

Figure 10.14
A color analyzer provides information that can be used to determine the correct exposure and filter pack.

Chapter Ten

What a Color Analyzer Cannot Do

An analyzer can be of beneficial use under certain conditions, but it can prove to be problematic for beginning people who want to master and understand the basic concepts and principles of color printing. It is my opinion that the analyzer leaves the photographer out of the fundamental creative visual process of achieving the vision of the perfect print. With the analyzer, one does not even have to know what filters are in the pack or how changes in the relationship of filters affect the print. Printing is a private, individualistic, subjective, and time-consuming activity. It requires the photographer to make visual decisions based upon the merits of each picture situation and not upon a predetermined machine response. At times it seems the analyzer mainly teaches the operator how to program and reprogram the machine. Some people become dependent upon this unnecessary piece of equipment. They use the machine's brain instead of their own to make the picture. For some beginners the analyzer offers the illusion of freedom, independence, and self-sufficiency. Once you have learned to make all the printing decisions visually, with your own eyes and mind, the possibilities are increased. This lets you do anything that you like to the print, anywhere, at any time.

Try and Compare

Like most anything else in photography, there are those who would offer a different opinion. When the opportunity presents itself, try an analyzer out and see what you think. They can be fun, but do not be seduced by pure technology. Make a judgment based upon your experience and actual needs. Until then, do not run out and purchase an analyzer for color printing.

There are other devices, like the visual color matrix, that are designed to help determine the correct filter pack. Although less expensive, these devices tend to be imprecise, providing at best a general ballpark starting place for the filter pack.

Following the methods outlined in this chapter, most people can make a correct color print from a properly exposed negative within three attempts (test strip, first print, second corrected print) while at the same time learning the basic concepts and principles of color print making.

Internegatives

A color print can be made directly from a slide using a separate positive-printing process (see chapter 11, Printing from Slides) or with a regular color negative print processing method by first making what is called an internegative (figure 10.15). One method of accomplishing this is through the use of one of the family of Kodak's Vericolor Internegative Films. These are available in 35mm 100-foot rolls and in sheets of 4" × 5", 5" × 7", and 8" × 10". All are tungsten-balanced (3200°K) films that can be processed in C-41 color negative chemicals. If the source of exposure is not 3200°K, use filters to correct it. Internegative films offer a long tonal range, excellent color separation, and do not have much trouble with reciprocity failure. These films can give the photographer more control over color and detail in the final print than is sometimes possible with a direct slide-to-print process (positive-to-positive). Development time can be altered by up to +/− 20 percent from normal to increase or decrease contrast without causing much of a color shift.

Figure 10.15
This image was originally made on slide film, then transferred onto internegative film that was intentionally overexposed by a half f/stop to obtain maximum color saturation. At times internegative film lets the photographer have more control over final print color and contrast than would be possible in a regular slide-to-print process.

© Martha Strawn "Images From India Portfolio: Untitled, 1986" Type C print 16" × 20"

Making Internegatives on 4″ × 5″ Film

Place a clean, properly exposed slide in the enlarger. Take a clean 4″ × 5″ sheet film holder and slide in a piece of plain white paper. Focus the image to the size required. Check to be certain that there are no light leaks or reflections coming from the enlarger that can fog the film. Close down the enlarging lens until the shadow values start to lose detail and merge together, usually at about f/11. In total darkness, remove the white piece of paper and replace it with a piece of film. Be careful not to move the holder. A tape marker can be used to indicate where the holder should go and can be felt in the dark. If the holder has been moved, put the dark slide in over the film, turn on the enlarger and reposition the holder. See the instruction sheets that come with each type of film for suggested exposure and filter starting points. When establishing a starting pack, a test strip can be made to determine proper exposure. Once this is established, make any future changes by either opening or closing the lens, as changes in time could alter the color balance.

Film is developed in a standard C-41 process, and it can be processed in a drum like a piece of paper. Use three ounces of each chemical for the 8″ × 10″ drum and increase the development time by 10 percent to 20 percent. Take the negative out of the drum for washing. If there is blue streak down the middle of the film, it indicates that the tank wall prevented the developer from washing away the antihalation dyes. This streak should wash out.

Kodak makes internegatives that will deliver acceptable results for most general daylight situations at a modest cost. For critical work, a custom internegative will probably be necessary.

Copying a Slide onto Negative Film

A slide can be copied onto color negative film with the use of a copying tube. The tube fits over the front of the camera lens and will hold one slide at a time. Point the camera at a bright light source that matches that color balance of the film being used, then focus and set the exposure. Use a camera that has through-the-lens metering because it will easily give the correct exposure. It would not hurt to bracket the exposures. Next, process film and print in regular manner.

Safety

All the chemicals involved in the color process are potentially dangerous and need to be treated with knowledge and respect. The following guidelines can help to insure a fun and safe color printing experience: read all directions and precautions before beginning to print; work in a well ventilated area; wear thin rubber gloves to avoid contact with chemicals; store mixed chemicals correctly; keep all materials out of the reach of children and pets; use safety caps if necessary; check your wiring and make sure everything is grounded; and install shock-proof outlets in the wet areas of your darkroom. If you have a question or problem about any photographic chemicals you can call the following numbers twenty-four hours a day:

Kodak, 716/722–5151
Ilford, 914/478–3131
Your local poison control.

The Center for Occupational Hazards, 5 Beekman Street, New York, N.Y. 10038 (212/227–6220) will answer questions concerning safety in artists' studios by letter or phone.

Overexposure: Health Hazards in Photography by Susan Shaw is an excellent book pertaining to all health aspects involving photographic processes. It is available from Friends of Photography, P.O. Box 500, Carmel, Calif. 93921.

∴

Making Prints from Color Slides

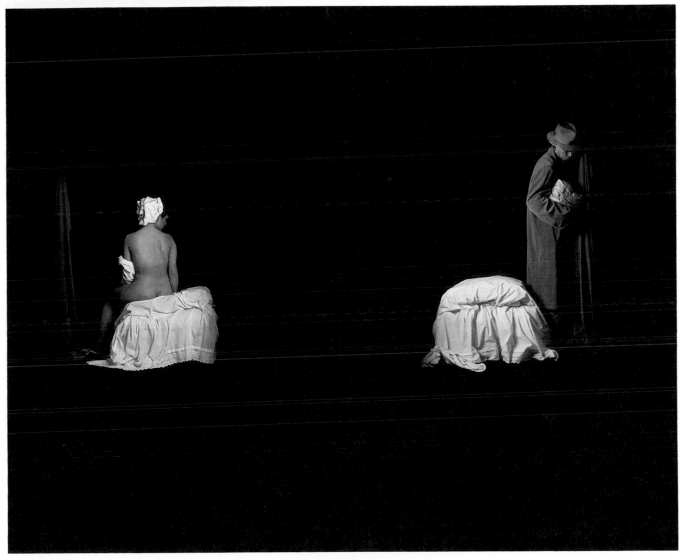

"Untitled"
Eileen Cowin
32" × 40", Cibachrome, 1987,
Courtesy of the Jayne H. Baum Gallery, New York,
NY.

·

A color negative delivers the most leeway in the creation of a print. Improvements in processing techniques now enable one to produce a high-quality print directly from a slide. There are advantages of slide film over negative film. First, processed transparency film produces a direct positive image to view. This makes it much easier to tell which slide has the preferred color and exposure without the need to make a contact sheet. Since there is no orange mask to get in the way, what you see is what you get. Next, slide material is capable of showing a wider range of tones than a negative, though this advantage is lost when a print is made from a slide. Lastly, a slide gives better results if the picture is to be reproduced using any type of photomechanical printing process—i.e., prints for publication.

The Processes

There are a number of companies that manufacture the materials for making prints from slides. Rapid changes in this area cause products to appear, change, and disappear in a short period of time. At the moment, there are two common processes in use that appear to be similar, but are not interchangeable.

The Chromogenic Process

The first process is the chromogenic system in which the colors are made by a chemical reaction with the developer. The Kodak Ektaprint R–3000 process with its Ektachrome 22 paper is an example of this process.

The Dye-Destruction Process

In the second process, known as the dye-destruction system, all the dyes are present in the emulsion. Processing destroys the dyes that are not needed to make the final image. Utocolor, a dye-destruction process introduced in 1909, was the first method for making prints from color slides. Gasparcolor, unveiled in 1933, was a movie film in which the subtractive color image was formed by bleaching out the unwanted dyes instead of forming them in the emulsion. The Cibachrome P–30 process and paper is based on the Gasparcolor process and can be used in a home darkroom.

There are other processes available. Each has its own strengths and weaknesses. Since there is such a great variety of processes with technical changes occurring with great frequency, it is most important to read the manufacturer's instructions *before* you begin to work.

Basic Reversal Printing Principles and Equipment

In the midst of all these technological transformations there are some basic principles that can be applied to reversal print making.

The "Ideal" Transparency

The most important is the selection of the "ideal" transparency since all the results will be based upon it. Generally, a slide with a greater-than-normal color saturation will produce superior results. This means a slide that has been slightly underexposed by ⅓ to ½ of an f/stop. A contrasty slide will be difficult to print, because the process itself will add more contrast to the finished print. A slide that might normally be considered a little flat will often print surprisingly well.

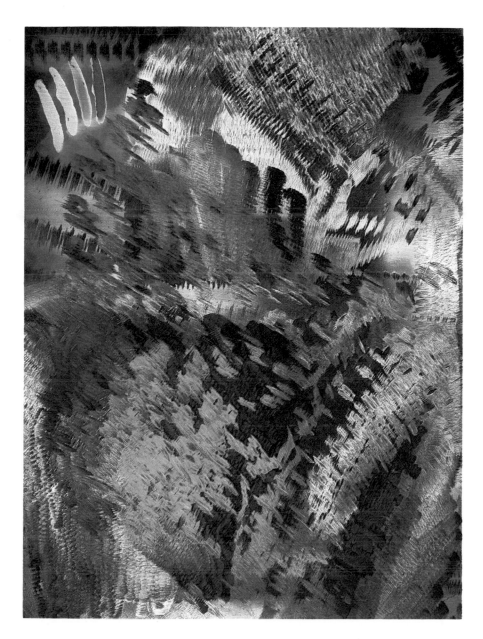

This image concentrates on the spectral qualities that can be created on sheets of stainless steel and titanium. Changes in the surface can be effected through the use of a torch, a wire brush, or an electric grinder. Alternations are also possible by wiring an insulated paintbrush to a DC converter and voltage regulator. The image is rendered with water and baking soda with changes in voltage altering the colors. Cibachrome offers a direct dramatic translation.

© Jay Dunitz "Pacific Light #25, 1985" Cibachrome 30" × 40" Courtesy of Jayne H. Baum Gallery, NY, NY

Lack of an Orange Mask

Since slides do not have the orange mask, which compensates for inade-quacies in the negative/positive system, expect to lose a certain amount of detail and subtlety in the tone and color of the reversal print.

No Safelight

The sensitivity of these materials is such that safelights cannot be used. The paper must be handled in total darkness until it is loaded in a drum, which is the easiest way to process these materials.

Determining the Emulsion Side of the Paper

It can be difficult to determine which is the emulsion side of the paper in total darkness. Here are four ways to tell which is the emulsion and which is the base side of the paper:

1. The paper has a tendency to curl with the emulsion on the outside of the curve.
2. Use the glow from a luminous timer dial or a strip of luminous tape on the darkroom wall. The paper will reflect light on the emulsion side. This will not fog the paper.
3. Cibachrome suggests rubbing both sides of the paper while holding it up to your ear. The emulsion side makes a different sound than the base side. If this method is used, be careful not to damage the paper and to have clean hands so as to not leave fingerprints.
4. If all else fails, cut an edge from a piece of the paper and look at it under white light to determine the emulsion side.

Keep a Record

Keep a written record of your lab work. Once the proper exposure and filtration for a type of film in a certain lighting situation (daylight, tungsten, mixed) is established, you are provided a basic starting filter pack the next time this situation is encountered. As in negative printing, the perfect print is best discovered through a visual process of trial and error. Different films, enlargers, lenses, and paper will all produce changes in the filter pack.

Use of Distilled Water

If the process being used requires the mixing of chemicals, use distilled water. The chemical and mineral composition of your local water source can affect the processing. This wild card can be dealt out of the deck before starting with the use of distilled water.

Temperature Control

If the process requires temperature control, warm the chemicals in their sealed bottles in a water bath. Clean glass baby food jars make good one-shot chemical containers. Put tape on the side and label a separate jar for each step. Make a mark on the side of the jar to indicate the proper amount of chemical needed for each step.

Safety

Wear thin rubber gloves when handling these chemicals, especially the bleach. Work in a well-ventilated area. Avoid breathing any chemical fumes. If you are sensitive to fumes, wear a protective mask. Use the neutralizing chemical or baking soda if the process requires it or run the risk of ruining your plumbing as well as the environment.

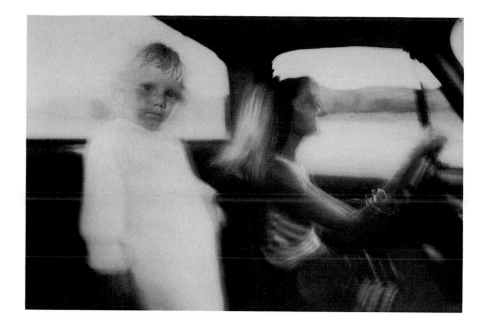

Glasman makes use of Cibachrome's bright colors and high contrast to produce large-scale prints for exhibition.

© Audrey Glasman "ED 4, 1984" Cibachrome 40" × 60" Courtesy of Timothy C. Duran & J. J. Brookings Gallery, San Jose, CA

Making a Print

To make a print, remove the slide from its mount and clean it carefully because dust spots will appear as black spots on the final print making spotting difficult. Now insert the slide into the negative carrier. In most of the processes the emulsion side goes down, but check the process instructions to be sure. Place the carrier into the enlarger and turn it on. Compose and focus the picture on a scrap piece of the same type of paper with which you are working. Unless the paper has an opaque backing, it can be fogged by an easel with a yellow base. Avoid this problem by spray painting your easel with flat black enamel or taping a piece of black paper securely to the easel base. If you have difficulty focusing on your target paper, remove all the filters from the pack to get white light. Be sure to return the filters to the pack before printing. Some enlargers have a white light switch that will do this automatically. Set the filtration according to past experience or the manufacturer's recommendations, then make a test strip of a key area, the same as you would for a print from a negative.

Response to Time and Filtration

One major difference in reversal papers is their response to time and filtration. You must be bolder in your changes to affect the print. Starting test strip times could be five, ten, twenty, and forty seconds at about f/8 or f/11.

When making filter corrections, there will be little difference in changes of three, five, or even ten points of a color. Leaps of twenty points at a time are not unusual.

Before processing, recheck the manufacturer's procedures and times.

Processing

It is easier to process in a drum since the steps can be carried out in white light, but tray processing also works fine with adequate ventilation.

Using the Drum

When using a processing drum, be sure it is clean and dry. When loading the drum, the exposed paper goes with the base of the paper against the wall of the drum, with the emulsion side curling inward upon itself. Be certain the lid is secure before turning on the white light. Process on a flat, even surface covered with a towel for good traction. A motorbase for the drum can be obtained to make processing easier if a great deal of printing is planned. The Cibachrome-style drum, with no legs sticking off the sides to get in the way, is the best for rolling on a flat surface.

General Preprocessing Procedures

Have all the chemicals warmed up to temperature and ready to go before exposing the paper. If tray processing, be certain to have enough chemicals to completely cover the entire print. Avoid contamination by always using the same bottles for the same solutions. Have a container ready to pour the used chemicals into for proper disposal. Check and maintain proper temperature or your results will be chaotic and not repeatable. Presoak the paper for 60 seconds in a water bath to help ensure even development. Drain times are considered to be part of the normal processing times. If the presoak is 60 seconds and it takes 10 seconds to drain the drum or tray, start to drain at 50 seconds.

Proper Agitation

When rolling the drum on a flat surface, make the pattern of agitation uneven during the first thirty seconds. Lift the drum up slightly on one side, roll it, and then lift it up on the other side.

Print Drying

Exercise care in handling a wet print because the emulsion is very soft and easy to damage. After processing, dry the print with a hand-held hair dryer or in an RC paper print dryer. Do not dry it in a regular dryer that was designed for fiber-based papers because this will melt the plastic coating on the print and leave quite a mess on the dryer.

Evaluation of the Print

For best results compare the test strip with the original slide or a similar slide of the same subject. Look at it in the same type of light that you expect to view your finished print. Pick the exposure that you like the best and check for color balance in key areas. If possible, look at a white or neutral area when deciding which color is in excess. Use the Color Print Viewing Filters on the side labeled prints from slides as a guide. The main thing to remember in printing from slides is that all the rules of negative printing must be turned around (Table 11.1). This could prove to be a bit confusing if you have been negative printing. Take a little extra time and think before you act. It could save time, money, and a great deal of anger. They don't call it reversal for nothing.

Table 11.1
Some Reversal Printing Rules

More exposure will give you a lighter print, not a darker one.

When looking at your test strip, keep in mind that the darkest strip has actually had the least amount of exposure.

To burn-in an area, give it less exposure.

To dodge-out an area, give it more exposure.

To make a print darker, give it less exposure.

To make a print lighter, give it more exposure.

Reversal Exposure Starting Points

Having determined the correct number of seconds required for exposure, make future exposure changes, whenever possible, using the aperture of the enlarging lens (Table 11.2). Changing the amount of seconds can affect the established color balance. This procedure can reduce the need of making additional corrections to the color pack.

Color Corrections

To remove the excess color cast from the print, remove that color from the filter pack. This means all the negative printing filter rules also apply in reverse. Depending upon the process, cyan filters may be employed. Be sure to have only two filters in the pack at once or unwanted neutral density will be produced. Refer to Table 11.3 to avoid confusion.

Work in units of about 10 for a slight change in color, 20 for a moderate change and 40 for a considerable effect. Generally, changes of 5 units or less are hardly noticeable in reversal printing. Be bolder with corrections than in negative printing. A general rule is to double the corrections in reversal printing, based upon your negative printing experience.

After making the appropriate changes, make a new test print and re-evaluate following the same procedures.

Table 11.2
Using the Aperture of the Enlarging Lens to Control Exposure

If the print is dark, open the aperture of the enlarging lens about one f/stop.

If it is slightly dark, open the enlarging lens about a half f/stop.

If the print is light, close the aperture of the enlarging lens about one f/stop.

If it is slightly light, close the enlarging lens about a half f/stop.

Table 11.3
Reversal Filter Pack Changes

Print Is Too:	Add	or	Subtract
Blue	Yellow		Cyan and magenta
Yellow	Magenta and cyan		Yellow
Green	Magenta		Cyan and yellow
Magenta	Cyan and yellow		Magenta
Cyan	Magenta and yellow		Cyan
Red	Cyan		Magenta and yellow

Cibachrome is a dye-destruction process in which the dyes are present in the emulsion of the paper, then processing destroys all dyes not needed to create the final image. Here it has been used to portray a humorous juxtaposition that can be created within photographic reality.

© Linda Murphy Robbennolt "Cookie 1985" Cibachrome 16" × 20"

Difficult-to-Print Slides

Masking

If you encounter a slide that is presenting difficulties in printing that cannot be corrected by burning, dodging, or with Cibachrome Low Contrast paper, especially if subtle detail must be retained, a contrast mask could offer the solution. Basically in this technique the original color slide (emulsion side up) is taped to a piece of frosted acetate and contact printed onto a piece of black-and-white film. After the film is processed, it is taped in register (emulsion side up) to the original color slide (emulsion side down). This sandwich is then printed following normal working procedures.

The effect of the mask is generally most evident by its ability to reduce excessive contrast in the highlight areas. An increase in detail of subtle color should be visible in the key shadow areas as well.

Internegatives

If you are not happy with the way that the slide has printed, an internegative can be made from the slide and printed as a regular negative (see Internegative section in chapter 10).

What to Shoot: Keeping It Simple

For first attempts at making prints from slides, work from a simplified transparency. Avoid the use of a lot of different colors. Make slides that show predominately one, two, and three colors. This does not mean that you make a picture with only one color in it; one color should be seen as having the greatest visual influence, authority, or force in the picture.

Next, make photographs that have uncluttered compositions. Emphasize shape; look for rectangles, circles, squares, triangles, and other geometric formations.

Start out using a daylight balanced film. Properly exposed warm-toned films like Kodachrome tend to print very easy with reversal papers. Once experience and confidence are gained, move ahead to more complex compositions and color arrangements.

Cibachrome: The Current Standard

There are many processes available for making prints directly from slides. Many color printers believe the dye-destruction process offers superior color, resolution and sharpness, greater dye stability, fewer processing steps, and easier-to-maintain processing temperatures. Since its introduction in 1963, Cibachrome has become the standard for the other processes to be compared and matched against. For this reason, the Cibachrome P–30 process is offered as a starting place for the making of prints from slides. It is not the only process. If you try it and find it is not to your satisfaction, use another process.

The Cibachrome P–30 Process

The Cibachrome P–30 process (Table 11.4) is carried out at 75° F (24° C) plus or minus 2° F. Follow all safety procedures. Avoid getting chemicals on your skin, and wear protective gloves, if necessary.

For making an 8″ × 10″ print with a Cibachrome drum, pour 2.5 ounces (75 ml) of each solution into a separate clean container and place them in a tray of water at 78° F. This will maintain a proper average processing temperature as it drifts in a downward direction, under normal room conditions.

Table 11.4
Review of Cibachrome P–30 Process

Review of the P–30 Process for Making an 8″ × 10″ Print at 75° F with 2.5 Ounces of Chemical per Step

1. Presoak	30–60 seconds
2. Develop	3 minutes
3. Rinse	30 seconds
4. Bleach	3–5 minutes
5. Rinse	15–30 seconds
6. Fix	3 minutes
7. Wash	3 minutes minimum
8. Dry	

It is important to be able to make a print directly from a slide. The image can then be viewed in a wider variety of surroundings. It also affords the photographer the opportunity to interact with the image and to make changes and corrections. In this print the combination of colors with a limited use of depth of field make a vibrant illusion in space.

© Lawrie Brown "35P, 1985" Cibachrome 16″ × 20″ Courtesy of J. J. Brookings Gallery, San Jose, CA.

•

The P–30 process can be replenished one time by adding 1.25 ounces (37 ml) of fresh chemical to an equal amount of used chemical. Temperature must be adjusted to maintain 75° F. Be careful to avoid contaminating the chemicals.

Steps in the Cibachrome Process

Follow these steps when using the Cibachrome process:

1. *In total darkness, place exposed paper in a clean and dry drum* Be certain the ends of the drum are securely attached. Now processing can take place in white light.
2. *Presoak* Stand the drum on end and pour water (75° F) into the funnel opening. The water will flow into the cap, but it will not come in contact with the paper until the drum is tipped over on its side. Set the timer for 1 minute and start it going. On a level surface immediately lay the drum on its side and begin rolling it rapidly back and forth, making more than one complete revolution each way. At the end of the minute, drain the water into a nonmetal container that will be used to dispose of all used chemicals.
3. *Developer* Following the same steps as the presoak, pour the developer into the top of the drum. Set the timer for 3 minutes and begin to process. During the first fifteen seconds agitation should be rapid, vigorous, and somewhat irregular to avoid creating a uniform pattern that can produce staining. At the end of the development time drain the used solution into a clean container for partial reuse.
4. *Rinse* Pour three ounces of water into the top of the drum. Agitate the water rinse for 30 seconds and drain into the disposal bucket.
5. *Bleach* Pour bleach into the top of the drum. Set the timer for a minimum of 3 minutes and begin agitating the bleach in the same manner as the developer. The bleaching time may be increased up to 5 minutes if highlights do not look clear. When bleaching is completed, drain the used solution into a clean container for partial reuse.
6. *Rinse* Pour three ounces of water into the top of the drum. Agitate the water for fifteen to thirty seconds and drain into the disposal bucket.

Cibachrome allows Rice to push and enliven the color saturation from the flat overcast light in Berlin. This permits an intriguing three-dimensional figurative relationship to develop with the graffiti on the Berlin Wall.

© Leland Rice "Detente, 1985–86" Cibachrome 28½" × 34" Courtesy of Rosamond Felsen Gallery, Los Angeles, CA

7. *Fix* Pour fixer into the top of the drum. Set the timer for three minutes and begin agitating the fixer in a gentle and uniform manner. At the completion of fixing drain the used solution into a clean container for partial reuse.

8. *Wash* Carefully remove the print from the drum as it is easy to damage the wet emulsion. Wash the print in a tray for at least 3 minutes in rapidly running clean water at 75° F.

9. *Dry* Remove surface water with a squeegee or clean chamois cloth. Drying can be accomplished in a number of ways: the print can be hung up, laid flat (emulsion side up) on a blotter or drying rack, dried in a print dryer designed for resin coated papers, or dried with a blow dryer. Prints must be completely dry before they are evaluated for proper color balance and exposure.

10. *Cleaning the Drum* After processing is complete, take the drum apart and thoroughly wash and dry all its components, inside and out, before processing the next print.

11. *Replenishment* To reuse the chemicals one time, save 1.25 ounces (37 ml) of each solution. Pour the remainder into a plastic, not metal, container. All the chemicals must be mixed together so that they can neutralize one another before they are discarded.

12. *Chemical Disposal* When the printing session is complete, add all the chemicals to the plastic container and then pour the mixture down the drain. Do not dispose of the chemicals individually.

Processing Problems

There are a number of common mistakes that occur when working with Cibachrome materials. The trouble-shooting guide (Table 11.5) and the manufacturer's instructions should help you to get back on the right track.

Table 11.5
Trouble-shooting Cibachrome

Print Problem	Possible Cause
Light flare	Paper fogged
Dark with red-orange cast	Exposed through back of print (lustre)
Black with no image	Exposed through back of print (glossy)
Irregular color streaks	Wet drum
Blue border/gray highlights	Developer contaminated
Orange cast/blacks bluish	Developer contaminated with fixer
Uneven tones/gray areas	Not enough chemicals used
Flat contrast and dark	Development time too short
No blacks and light	Development time too long
Dull and milky	Bleach time too short
Gray highlights	Bleach exhausted
	Bleach too cold
	Bleach time too short
Black with faint image	Bleach defective
Brown-red borders	Bleach carried over into fixer
Dark, dull fogged	Print fixed before it was bleached
Flat and yellow	Print not fixed
Yellow edges	Lack of agitation
Pink-magenta borders	Overagitation
Reticulation	Inconsistent temperatures

∴

Instant Processes
The Polaroid System

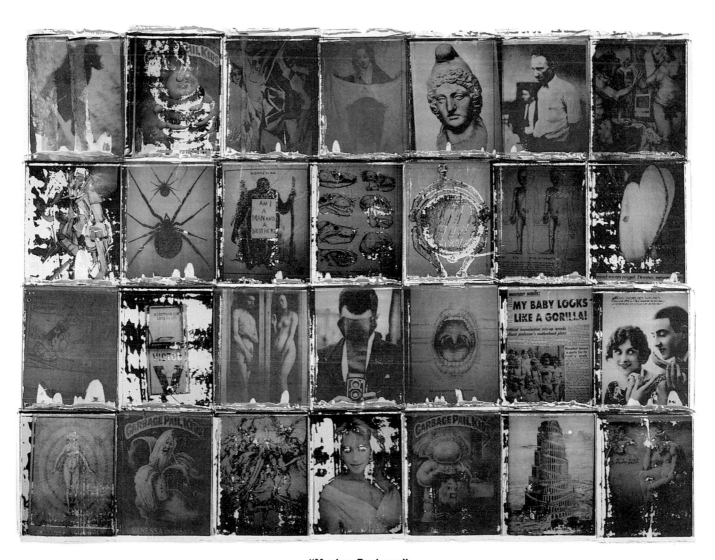

"Monkey Business"
Rick McKee Hock
40″ X 56″, Polacolor Transfer on Paper, 1987,
Courtesy of the Jayne H. Baum Gallery, New York,
NY.

•

Modern Instant Photography

Modern instant photography began in 1948 with the marketing of Edwin Land's first Polaroid process. The first full-color instant film, Polacolor, was introduced in 1963. This revolutionary product was a diffusion transfer, peel-apart color print film that developed itself and produced a color print in sixty seconds (see the Diffusion Transfer Process section later in this chapter). It was an immediate success with both amateur and professional photographers.

It Is Not What You Think

Most people associate instant films with Sunday afternoon family snapshots. Do not be fooled by instant films' innocent faces. It is possible to make beautiful, intimate, and unique color photographs with these films. They are convenient, fast, and can provide immediate feedback in any shooting situation. Professional photographers routinely use Polaroid to check composition, lighting, and the working order of their equipment. The information gained from the Polaroid can help make corrections and create a stronger image. Polaroids are also great icebreakers when photographing people as they are a familiar and nonthreatening object of our culture. The prints make wonderful presents to provide your sitter with at the completion of any picture-making session. Don't underestimate the Polaroid's potential. It is fun to work with and it is always a thrill watching the image come up. The artistic use of the material helped it gain acceptance as a valid medium.

Polaroid SX-70

In 1972 the Polaroid SX-70 system was introduced. It is a color diffusion transfer process that is self-developing in natural light and is the basis for almost all self-processing instant photography materials. SX-70 and its heirs are the dream-come-true vision of Dr. Edwin Land's one-step instant pictures at your fingertips. SX-70, Time-Zero Supercolor, and Polaroid 600 are all integral color-positive films designed for use with either a Polaroid camera or special film back. They are not compatible with a conventional camera.

Polaroid is not just for Sunday afternoon snapshooting. The use of materials should reflect the concerns of the photographer. Do not underestimate Polaroid's potential.

© Ken Matsubara "Untitled, 1987" Polaroid Spectra print Courtesy of J. J. Brookings Gallery, San Jose, CA

Chapter Twelve

The Spectra System

The Spectra System, introduced in 1986, is a fully automatic camera and picture system with some manual overrides. Its film has a speed of 600 and the overall picture size is 4″ × 4¹⁄₁₆″. It produces an image area of 3⁹⁄₁₆″ × 2⁷⁄₈″, which is larger and more rectangular than the SX–70. The image appears seconds after exposure by diffusion-transfer subtractive color chemistry, which is very similar to the SX–70 process.

Diffusion Transfer: The Polaroid Process

The Polaroid SX–70 and Spectra development processes use the diffusion transfer method (figure 12.1). After the shutter is pressed, the motor drive, which is powered by a battery in each film pack, automatically ejects the film through a set of rollers that break a pod of reagent located at the bottom of each piece of film. Development is then automatic and requires no timing.

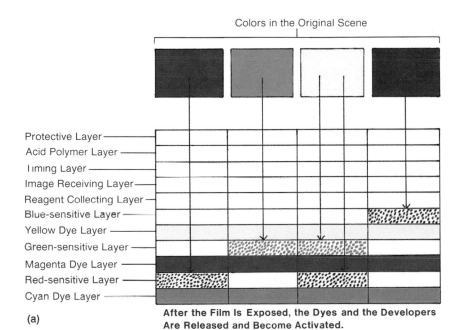

Colors in the Original Scene

Protective Layer
Acid Polymer Layer
Timing Layer
Image Receiving Layer
Reagent Collecting Layer
Blue-sensitive Layer
Yellow Dye Layer
Green-sensitive Layer
Magenta Dye Layer
Red-sensitive Layer
Cyan Dye Layer

(a)

After the Film Is Exposed, the Dyes and the Developers Are Released and Become Activated.

Figure 12.1
Typical diffusion transfer process: (a.) Film exposure; dye developers begin to diffuse upward. (b.) The exposed silver blocks upward diffusion of corresponding dyes. For example, the exposed blue-sensitive layer blocks the yellow dye. (c.) The dyes not restrained by the silver continue diffusing upward to form the image.

(b)

Exposed Silver Blocks Upward Diffusion of Corresponding Dyes. For Example, Exposed Blue-sensitive Layer Blocks Yellow Dye.

(c)

Dyes Not Restrained by Silver Continue to Diffuse Upward to Form the Image.

The best results are obtained at about 70° F. If it is colder, the color balance can shift to the cool direction. This can be compensated by putting the film inside your shirt to keep it warm while it is developing. Development can take place in daylight because the light-sensitive negative is protected by opaque dyes in the reagent. Both the positive and negative images are contained within each sheet of film.

As the picture forms, a number of things occur at once. First the silver halides are reduced to metallic silver in the exposed areas of each of the three additive primary light-sensitive layers. As this happens, the complementary subtractive primary dye developers move through the layers of the negative and the opaque reagent to form a white background for the picture. Now the dye developers are prevented from moving up to the positive image area by the developing silver. This layer will now only pass certain colors through. For example, the blue layer will block the yellow dyes, but not the cyan and magenta. Within a few minutes all the dyes that have not been blocked will have traveled through the white opaque layer and will become visible. The process automatically completes and stabilizes itself resulting in a completed dry print.

Color Balance

These films have a daylight color balance, but the film can be exposed under any light source by placing CC filters in front of the lens of the camera. It is also possible to correct for differences in color balance from one pack of film to another with the CC filters.

Levinthal creates a world in miniature by placing this world on a screen through a video camera and then recording scenes from it on Polaroid SX-70 film.

© David Levinthal "Modern Romance, 1985" Polaroid SX-70 print

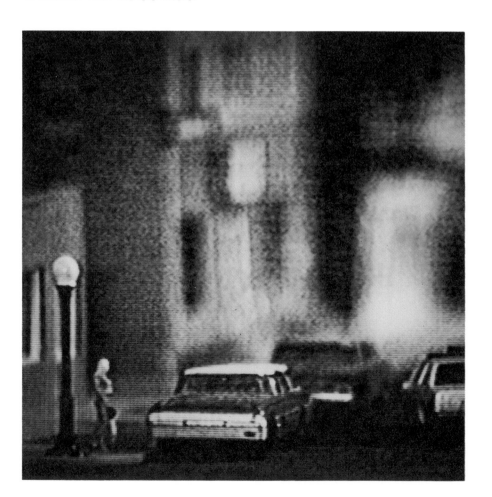

Exposure

Exposure is automatically determined by the Polaroid camera. This can be controlled to a limited degree by adjusting the exposure wheel on the camera to either the darker or lighter setting.

Storage

Store film in its sealed box. Keep it cool and dry. For prolonged life, this film can be refrigerated, but do not freeze. Let film warm up to room temperature before use.

Instant Manipulation

The dyes beneath the print's plastic coating are malleable both during and after development. Altering the print as the image is developing lets one interact with the picture during part of the process that is supposed to be automatic with no human intervention. Any type of stylus can be used to push and pull the dyes under the plastic covering. Pencils, dowels, coins—anything that can apply pressure directly to the print surface is worth giving a try. The secret of a good manipulation is knowing when to stop. Do not get carried away. Avoid creating more chaos, we already have enough of it in this world. Make some extra pictures to play and loosen up with before you get down to business.

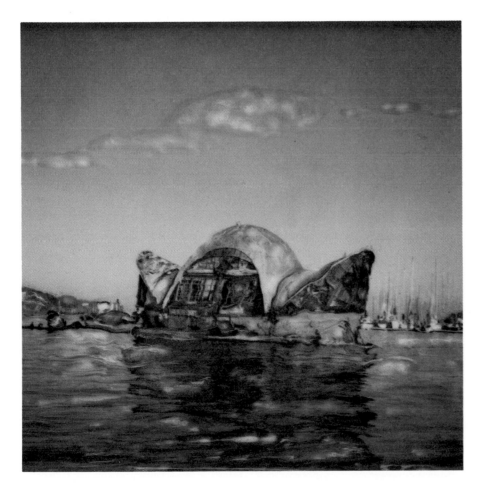

The manipulation of Polaroid material gives the photographer an opportunity to determine the final outcome and statement of the work, from which the manufacturer had attempted to exclude the product user. McKay has copied the original SX-70 print of this shot onto negative film in order to be able to make it larger and to create additional prints.

© Glenn McKay "House Boat, Sausalito, CA" 16" × 16" Type C print

Getting Started

If you have never attempted this process, try photographing a still life or a scene that is repeatable. Make a number of exposures. Let one remain un-manipulated. Have the stylus ready to begin drawing, digging, and pushing directly on the plastic surface. Start on the background and light colored areas before tackling the more detailed aspects of the picture. Wherever pressure is applied, it will loosen the dyes and bring to the surface a bit of white reflective pigment that is under the picture. Rubbing on dark colors tends to turn these colors a gray-white. Consider leaving a dark area to create contrast and juxtaposition with the altered part of the image. Compositions that are predominately one color don't offer as much opportunity to alter. Look for a picture that can provide a variety of shapes and tones for experimentation. As for color relationships, the film responds strongly to blue, green, and red. Take your time. Be gentle. Do not rush. It is okay to be subtle. The entire print does not have to be manipulated. The final picture will be textured with bumps and waves. Do not forget it is fine to ignore all this and just jump in and see what can be discovered.

Later Manipulations

It is possible to wait a couple of hours after you have shot to begin alterations. It will be necessary to soften the dyes again. This is done with the application of heat. A home hand iron works great. Hair and print dryers, hot plates, and dry mount presses will work too. But be careful; too much heat will cause the plastic surface to bubble, buckle, or crack. If you do not want these effects, cover the picture with some clean smooth sheets of paper. Then apply low heat for a few seconds at a time until the dyes soften.

Reentering the Process

The manipulation lets the photographer reenter into part of the photographic process from which they had been excluded. It gives the photographer more freedom of choice in determining the final outcome of the picture and increases the options. Avenues for subjective feeling are now able to enter into an automatic technical process. The artist can build more time into the picture. Instead of 1/125 second of time, the photographer can continue to be involved with the image for longer blocks of time. This can give the photograph more life and involve the viewer for longer periods of time.

Copies

Since these images are one-of-a-kind and small (SX–70s are about 3¼″ × 3¼″ and Spectras about 4″ × 3″) they can be copied onto conventional film to make more prints or enlargements.

Polachrome

Polachrome, introduced in 1983, is the first Polaroid instant film that has been designed to be used with a standard 35mm camera. It is a diffusion transfer, additive-color, line-screen, positive-transparency film similar to the type introduced by Charles Joly in 1894. A screen is formed on one side of the film by alternating lines of red, green, and blue. When you make your exposure the light passes through these colored lines, which act like color separation filters for the single layer of high resolution panchromatic black-and-white emulsion. The film is developed in a manual or automatic Polaroid AutoProcessor, in

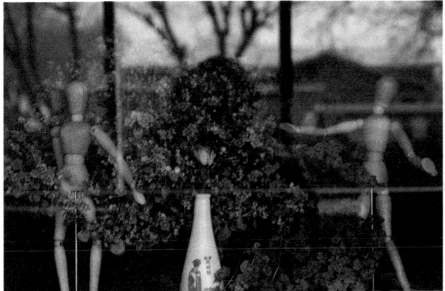

Polachrome is a diffusion transfer, additive-color, line-screen, positive-transparency film. It has its own distinctive look that has been compared to that of the early Autochrome process. While it may not be suitable in all situations, it has a wide range of possible applications.

© Robert Hirsch "Untitled, 1984" Polachrome

which the film is wound onto a spool and then back inside the processor. It is a dry process. The chemicals that are required for development come with each roll of film. Both the exposed film and chemical pod are placed into the processor when you are ready to develop. Polaroid also makes High Contrast Polachrome that provides more highly saturated colors than regular Polachrome.

The Process

During development both a negative and a positive black-and-white image are produced in a silver diffusion process. Then the negative and other processing layers are removed. What remains is a black-and-white positive that is filtered by the color screen. Thus, the final transparency is created by the additive process of blending light and not by the subtractive method.

The entire development process can be carried out in minutes at normal room temperature. You do not need any power source with the manual processor or a darkroom. There are no chemicals to mix and nothing to wash. The film comes out dry and ready to mount.

Characteristics

Polachrome does have some points that are different than conventional slide material that you should be aware of before you make use of it. The surface of Polachrome is more fragile than conventional film and requires greater care in mounting and handling. If you have a camera that has an OTF (off-the-film) meter, it may give faulty exposures due to the different reflectance of this film. Read the precautions enclosed with the film. When projecting these slides use a flat-field lens and avoid lenticular screens which might make a moiré pattern. Prints made from this material that are 8″ × 10″ or larger may reveal the filter screen lines of the film if you examine the print closely. This can also be quite evident if the transparencies are reproduced photomechanically or when photographing off of a TV screen. For these reasons, Polachrome is not generally recommended for either of these kinds of work. You may find that the color balance of this film is not suitable for all applications; it is different than most of the E–6 process films. They often have the look of the early Autochrome process. Try a roll and see.

General Information

Meter Setting

Start at a film speed of 40. Do not be afraid to alter the speed rating if the results are to your liking.

Color Balance

This film is designed for a daylight color balance (5500°K). With a tungsten color balance (3200–3400°K) use a Wratten 80A or 80B filter.

Reciprocity Failure

For a 1-second exposure, increase your exposure ⅔ f/stop; at 10 seconds, increase 1 f/stop.

Resolution

In low humidity, film curl may cause a loss of sharpness. Use a smaller aperture to compensate.

Film Rewinding

Do *not* rewind film completely back into the cartridge. Leave the leader or tongue of the film out of the cartridge. If you forget and rewind the film completely, use the film extractor provided with the AutoProcessor to fish out the film leader. You will need the leader to process the film.

Processing

Make sure the film cartridge and processing pack contain the same type and number of exposures. The film is available in twelve and thirty-six exposures. Best results are obtained at 70° F for 60 seconds. Film can be processed between 60° and 85° F. Changes in time and/or temperature can produce color shifts and changes in density. For more exact processing procedures see the instructions with the AutoProcessor. They are clear and easy to follow.

Storage

Keep the film and processing pack in temperatures below 70° F. Refrigerate both, if possible, for longer life and stability but do *not* freeze. Let the film and pack warm up before use.

Polaroid and the View Camera

Polaroid makes possible the rapid use of color materials for larger format cameras. Polacolor is a family of color print materials, available in 3¼″ × 4¼″ and 4″ × 5″ sizes. It is designed to be exposed in with a Polaroid filmholder instead of the camera's regular filmholder. The Polacolor films are balanced for daylight and will produce a print in sixty seconds. Changes in time and/ or temperature will alter the outcome of the final print. An increase in temperature will make the colors appear warmer while decreasing it produces cooler hues. Extending the development time can increase color saturation and overall contrast. A drop in development time can flatten or mute the colors while reducing contrast. Filtering at the time of exposure is necessary to alter or control the color in the final picture.

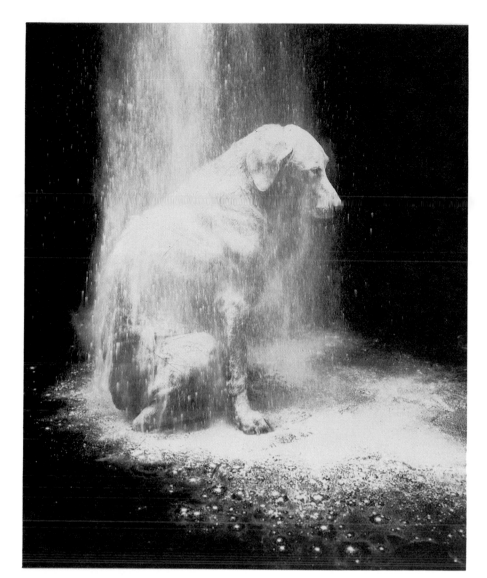

Figure 12.2
Polaroid materials have helped to broaden those making contributions to the field of photography. Artists like Wegman, who was not trained in photographic processes, have been able to participate within the medium, often bringing a fresh point of view that has helped widen the photographic audience.

© William Wegman "Dusted, 1982" Polaroid 20" × 24"
Courtesy of Holly Solomon Gallery, New York, NY

Larger Format Polaroid Materials

Polaroid also makes a group of print and slide materials for use with an 8" × 10" view camera. It requires its own special Polaroid filmholder and processor for development. Color materials are available for other special uses like the Polaroid 20" × 24" cameras which can be rented from Polaroid (figure 12.2).

Technical Assistance and Additional Information

Polaroid provides toll-free telephone technical assistance at 800/343–5000, Monday through Friday, 9 A.M. to 6 P.M. (Eastern time). Polaroid also offers *Polaroid 35mm Instant Slide System: A User's Manual* by Lester Lefkowitz, which provides in-depth technical information, and *Instant Projects,* which contains a wealth of ideas and information on using their instant materials.

Zone System for Color

"Reuss Arch and Amphitheater"
Eliot Porter
Dye-transfer print,
Courtesy of Scheinbaum and Russek Gallery, Santa
Fe, NM.

———

·

Using the Zone System for color photography is about the same as it is for black-and-white. The photographer has to learn the zones, be able to previsualize the scene, and place the exposures. The big difference is that there is less flexibility in processing color because it is necessary to maintain the color balance between all three layers of the emulsion or the film will be subject to color shifts and crossovers. Another difference is that contrast is determined not only by light reflectance, but by the colors themselves.

The film speed test is one more option that gives you control over your camera and chemical processes. It can help to achieve the results that you are after and put you in the driver's seat. Do not be a passenger who is merely along for the ride; be the one who determines the ultimate destination of your work. Increase your learning and you will increase your expression.

The Zone System and Slide Materials

Exposure is everything with slides, as the film is the final product. If a mistake is made, such as overexposure or underexposure of the film, it cannot be readily corrected in the secondary process of printing. What is true for negatives is the opposite for positives (slides). With negatives, the area most controlled by exposure is the shadow areas. With slides it is the other way around. The areas of least density in the image are the ones that are the most controlled by exposure. The highlights are the areas of slide film that are most affected by exposure. In using the Zone System method for exposure control, meter off of the important previsualized highlight and then open up the lens to the required number of stops for proper zone placement. All other tones will then fall relative to the placed zone. The darker values will show up as long as the highlight is metered and placed correctly.

Finding Your Correct Film Speed with Slides

Your personal film speed will be discovered upon a correct rendering of the highlights. The zone used for this test is Zone VII. The characteristics of Zone VII (the lightest textured highlight) include blonde hair, cloudy bright skies, very light skin, white painted textured wood, average snow, light gray concrete, and white or very bright clothes.

Zone VIII actually has less density, but it is so close to clear film that it can be difficult to visually distinguish it as a separate tone. It is the last zone with any detail in it. Zone VIII subjects include smooth white painted wood, a piece of white paper, a white sheet in sunlight, and snow entirely in shade or under overcast skies. Zone VIII contains extremely delicate values. It is easy to lose the sense of space and volume in very light objects. When seen beside Zone II or III it may seem to feel and be sensed as a pure white without texture.

Test Procedures

For this test, use a standard Zone VII value like a white painted brick wall, a textured white fence, or a textured white sweater. Make the test with your most commonly used camera body and lens and set the meter to the manufacturer's suggested film speed. Take the meter reading and place it in Zone VII. This is done by opening up two f/stops or their shutter speed equivalents. Remember the meter is programmed to read at Zone V (18 percent reflectance value). Then make a series of exposures, bracketing in half f/stops, three stops more and three stops less than the starting film speed. Next, develop the film following normal procedures. Mount and label all thirteen exposures, then project them in the slide projector that you most commonly use.

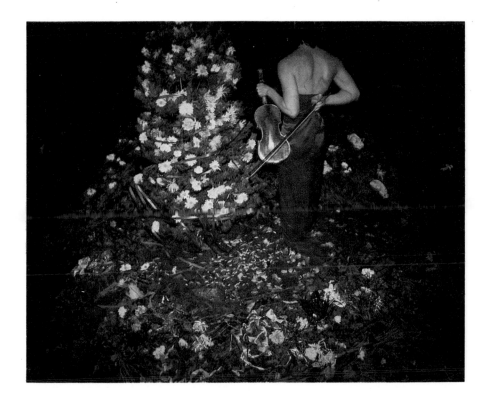

The Zone System gives the photographer more control of materials. This increases flexibility, which permits the photographer to more easily make statements.

© Linda Adele Goodine "Dawn, 1986" Cibachrome 30" × 40" Courtesy of Res Nova Gallery, New Orleans, LA
•

Look for the slide that shows the best Zone VII value that is possessing the right amount of texture with correct color, and is not too dark. This exposure will indicate your correct film speed.

Slide Film Speed Observations

Slide films generally seem to have a more accurate manufacturer's film speed rating than do negative films. The slower films are usually very close and you may even want to test them in ⅓ f/stop intervals, two full f/stops in both directions. Medium-speed slide films tend to run from right-on to ⅓ to ½ f/stops too slow. High-speed films can be off by ½ to one full f/stop. Usually most people will raise the film speed from the given speed. It gives a richer and fuller color saturation with a little underexposure. With slide film it is imperative that you meter with the utmost accuracy. When in doubt, give it less exposure rather than more. Do not be afraid to use some film. Bracket and be certain you have what you need and want.

Highlight Previsualization

Once you have determined your proper film speed, correct exposure entails previsualizing the highlights only. Pick out the most important highlight area, meter it, and place it in the previsualized zone that you want it to appear. You do not have to bother to meter the contrast range between the highlights and shadows. If you are in the same light as the subject being photographed, the correct exposure can be determined by metering off of an 18% gray card or simply metering the palm of your hand (if you are Caucasian) in the brightest light in the scene and then place it in Zone VI by opening up one f/stop. The contrast of the image, just as with color negative film, will be largely a matter of the relationship of the colors that are in the scene being photographed.

Working with Negative Film

The biggest technical obstacle most people encounter when working with color film is obtaining the correct exposure. It is more critical than in black-and-white photography because the exposure not only determines the density, but also the color saturation. Exposure techniques are basically the same as in black-and-white. It does no good, however, to meter the proper areas and make the right decisions if the film speed is not agreeing with your working procedures. If you have not been having any exposure troubles, leave well enough alone. There is no reason to run a test when you could be out making photographs. If you have had problems with exposure, especially underexposed negatives, run a test and establish your personal film speed. If your exposures are still erratic, it indicates either a mechanical problem or the need to review your basic exposure methods.

Custom Film Speed

The speed of the film that is recommended by the manufacturer is simply a starting point; it has not been engraved in stone. It is determined under laboratory conditions and does not take into consideration your personal lens, camera body, exposure techniques, the subject, and the quality of light. You can easily customize the speed of the film to make it perform for your personal style and taste. The film speed test recommended here is based upon the principles of the Zone System, but all your results are determined visually, not through the use of a densitometer.

Processing Negative Film

At this time all the major color negative films can be processed in Kodak's C–41 process. This is not only convenient, but also necessary. Attaining the correct balance of color dyes in the negative has not been an easy task. Standardization within the industry has made this less difficult. Even though it is possible to develop many different types of film in a common process, your results will vary widely. This is because each film has its own personality that is based around its response to different colors. You will need to try a variety of films and even different types of C–41 processes until you come up with a combination that matches your personal color sensibilities.

Exposing for the Shadows: Zone III

Color negatives, same as black-and-white, are exposed for proper detail in the shadow areas. Adequate detail in a Zone III area is generally considered to indicate proper exposure. Zone III indicates "average dark materials." This includes black clothes and leather. In the print, proper exposure will show adequate detail in the creases and folds of these areas. Form and texture are revealed, and the feeling of darkness is retained.

Film Speed Tests

A Simple Exposure Test

The simplest exposure test is one in which you find a Zone III valve (subject), then meter and place it using a variety of different film speeds (bracketing). The film is developed and examined with a loupe to determine which exposure will give the proper detail in Zone III. This provides the proper film speed.

A Controlled Test

Here is an easy and controlled method that provides more accurate results. On a clear day in direct sunlight photograph a color density chart and gray card like the one in the the the back of this book. Make the test with the camera body and lens you use most often. Set the film speed according to the manufacturer's starting point. Take all meter reading off of the gray card only. This way there is no need to change exposure for different zone placement. Make an exposure at this given speed. Then make a series of different exposures by bracketing in ½ f/stop increments two full f/stops in both directions.

As an example, say you set your film speed at 400 and determined that your exposure is f/8 at 1/250. You would make your exposure at this setting, then four exposures in the minus direction and four in the plus direction. Leave your shutter speed at 1/250 for all exposures. Table 13.1 gives you the f/stops you would need to expose at and their corresponding film speed.

Visually Determining the Correct Exposure

After making the exposures, process the film following normal procedures. Next place the film in slide mounts with each frame labeled according to its film speed, then project them in order beginning with the highest film speed. Pay close attention to the black-and-white density scale on the page photographed. As you look at the negatives, you should notice more of the steps becoming distinct as the speed of the film drops. Your correct exposure will show visible separation for all the steps in the scale.

What If You Cannot Decide?

What often happens is that you can narrow down your choice between two frames and then cannot decide which one is correct. If this occurs, choose the one that has more exposure. Color negatives do not suffer as much from overexposure as black-and-white negatives. Overexposing by even as much as two f/stops will not make a negative unprintable. Since the final print is made up from layers of dyes and not silver particles, overexposure will not create additional grain. It will build contrast, but the only protection against loss of detail in the shadow areas is overexposure. Color saturation is controlled directly by exposure. Underexposure will cause a loss of saturation that cannot be corrected for during printing. Underexposure will cause colors to look flat and washed-out.

The "No Time" Approach

If you do not have the time to test a new film, the guidelines in Table 13.2 are offered as starting film speeds for negative film. Table 13.3 recommends starting speeds for slide film.

When in Doubt

With color negative film, when in doubt give it *more* exposure. However, give color slide film *less* exposure.

Table 13.1
Film Speed Test Exposures Based on a Starting Film Speed of 400 with an Exposure of F/8 at 1/250 of a Second

f/stop	Film Speed
f/16	1600
f/11 1/2	1200
f/11	800
f/8 1/2	600
f/8*	400*
f/5.0 1/2	000
f/5.6	200
f/4 1/2	150
f/4	100

*Starting exposure

Table 13.2
The "No Time" Modified Film Speed for Negative Materials

Starting Speed	Modified Speed
100	50–80
200	100–125
400	200–250

Table 13.3
The "No Time" Modified Film Speed for Slide Materials

Starting Speed	Modified Speed
50	64–80
100	125–150
400	450–500

Contrast Control

With color negative films there are two important considerations that determine the contrast. The first is that contrast is produced from the colors themselves in the original scene. Complementary colors (opposite each other on the color wheel) will produce more contrast than harmonious colors (next to each other on the color wheel). This factor can only be controlled at the time of exposure.

Brightness Range

The second factor in contrast control of color negatives is the overall range of light reflectance between the previsualized shadow and highlight areas. This is the same as with black-and-white. It can be changed by modifying the development time. Unlike black-and-white, the development time cannot be changed as much because it will effect the color balance which is finalized during development. It is possible to adjust the contrast by one zone of contraction or expansion without color shifts or crossovers.

Table 13.4 suggests development times for Kodak's C–41 process in fresh developer for the first roll of film.

Table 13.4
Suggested Starting Development Times in Kodak's C–41

Contrast of Scene	Development Time*
N − 1	2 minutes 40 seconds
Normal	3 minutes 15 seconds
N +1	4 minutes

* All times based on first roll in fresh developer.

The Zone System can help the photographer to master the skills that are needed in the photographic process. As confidence is gained less energy is needed on technique, freeing more personal resources to be applied to the creation of new ideas and photographs.

© Cay Lang "Mother and Child V, 1987" Polacolor 20" × 24"

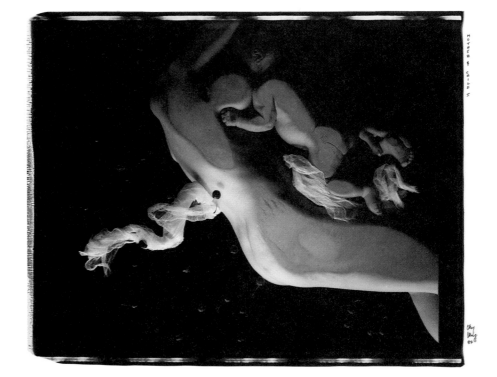

Chapter Thirteen

What Is "N"?

For those of you who are not well acquainted with the Zone System, "N" stands for normal. N minus 1 (N −1) is used when you have a higher than normal range of contrast and wish to reduce it. N plus 1 (N +1) is used when you have a scene with lower than normal contrast and want to increase it.

Paper and Contrast Control

It is also possible to increase the contrast of the final print by using a higher contrast paper, like Kodak's "Ektacolor Plus." By combining the higher contrast paper with an N+1 development, you can increase the contrast to a true N+1 to an N+1½.

The Zone System and Its Physical Equivalents

Table 13.5 lists the basic zones and their physical equivalents.

Table 13.5
Zone System Values and Their Physical Equivalents

Low Values

Zone Zero: the blackest black that a print can be made to yield. Doorways and windows opening into unlit rooms.

Zone I: The first discernable tone above total black. When seen next to a high key zone it will be sensed as total black. Twilight shadows.

Zone II: First discernable evidence of texture, deep tonalities which represent the darkest part of the picture in which a sense of space and volume is needed.

Zone III: Average dark materials and low values showing adequate texture. Black hair, fur, and clothes in which a sense of detail is needed.

Middle Values

Zone IV: Average dark foliage, dark stone, or open shadow in landscape. Normal shadow value for Caucasian skin portraits in sunlight. Also brown hair and new blue jeans.

Zone V: 18% Gray Neutral Test Card (inside the back cover of this book). Most black skin, dark skin, or sunburnt caucasian skin, average weathered wood, grass in sunlight, gray stone.

Zone VI: Average Caucasian skin value in sunlight, diffuse skylight, or artificial light. Light stone, shadows on snow in sunlit landscapes.

High Values

Zone VII: Very light skin, light gray objects; average snow with acute side lighting

Zone VIII: Whites with texture and delicate values; textured snow; highlights on Caucasian skin.

Zone IX: White without texture approaching pure white, similar to Zone I in its slight tonality without texture.

Zone X: Pure white of the printing paper base, specular glare or light sources in the picture area.

∴

Presentation and Preservation

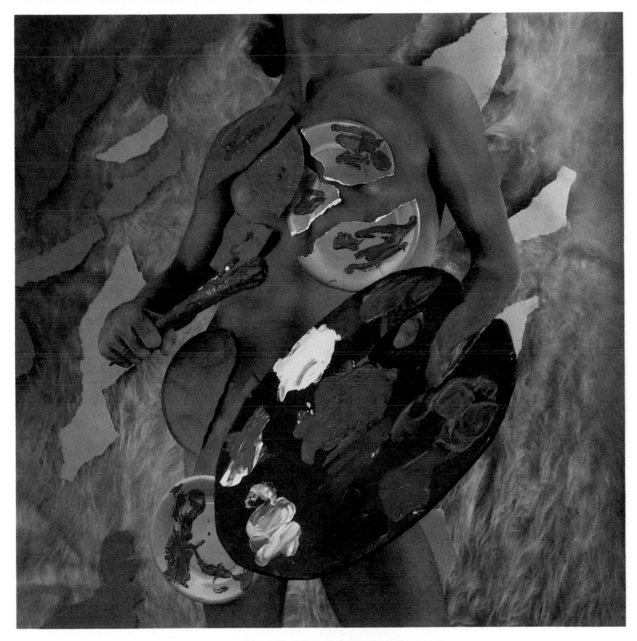

"St. Julian, Patron Saint of Art Dealers"
Geno Rodriguez
30″ × 30″, Cibachrome, 1986,
Courtesy of the Jayne H. Baum Gallery, New York,
NY.

·

Spotting

Spotting is usually carried out before the photograph is matted or mounted. Good working techniques should keep spotting to a minimum. In color both the density and color balance of the area that is being spotted has to be matched. To make this task as easy as possible, the following materials are needed (figure 14.1):

1. Color-spotting dyes are made by a variety of companies including Kodak, Dr. Martin's, Jobo, and Retouch Methods. Some people prefer to use good quality tube-type watercolors such as Windsor-Newton or Grumbacher. Spotone black-and-white materials can also be useful.
2. Sable brush with a good point, size number O or smaller.
3. Mixing palette. Enamel or plastic watercolor palettes work well. Some people prefer to mix on a piece of paper, clear acetate, or glass.
4. Container of clean water.
5. A couple sheets of white paper.
6. Paper towels.
7. Cotton glove.
8. Good light source.

How to Spot Color

Follow these procedures when spotting a color print:

1. Put the print on a smooth, clean, and well-lit surface. Place a clean sheet of white paper over the print, leaving the area to be spotted visible. A window can be cut in the paper to spot through, offering additional protection to the print. Put the cotton glove on the nonspotting hand. This will prevent the print from getting fingerprints and hand oil on it. Our bodies also contain and give off sulphur which can stain the print. The paper will provide a neutral viewing surface which will help act as a visual guide in matching the color balance.
2. Place small amounts of the color dyes that will be used onto the palette.
3. Wet the brush in the water. Draw a line with it on a paper towel to get rid of the excess water and to make a fine point.
4. Dab the brush into the dye. Draw a line on a separate sheet of white paper to see if the color matches. Compare the line with the area to be spotted. Blend with other colors, including black and white until the color matches.
5. Once the correct color balance has been achieved, draw a line with the mixed dye on the paper towel to remove any excess dye and water. With an almost dry brush apply the color to the print. Dab it on in a series of dots. This will help to match the grain structure that forms the image. Do not paint it in, as this will be noticeable as the print is made from points, not lines (figure 14.2). Make one pass using this dot method. There should be some areas of white still visible in between the dots. Let it dry for a minute. Make another pass with the dot technique, filling in some more of the spot. Let it dry and see if it matches. Repeat if necessary, but do not apply too much dye.
6. When finished spotting, wash the brush with warm water and soap. Rinse completely and carefully repoint the brush between the thumb and index finger.

A blob, a line, or an area that is too dark will draw as much attention to the eye as the spot. Take time and be subtle. Do not overdo it. This is not like painting a brick wall with a roller.

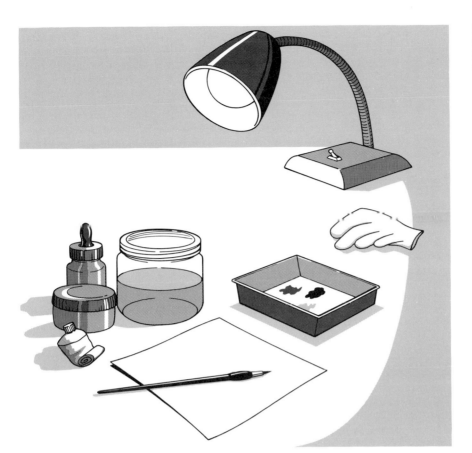

Figure 14.1
Some basic materials for spotting of color photographs.

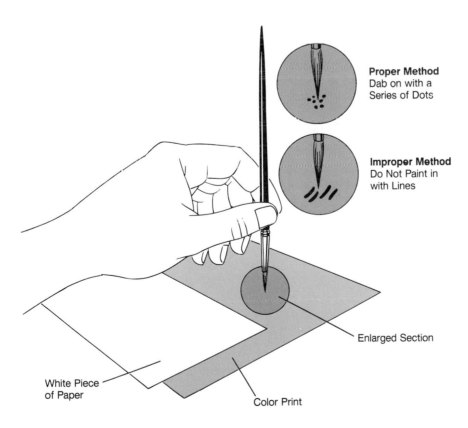

Proper Method
Dab on with a
Series of Dots

Improper Method
Do Not Paint in
with Lines

Figure 14.2
The method for properly spotting a print: A well-pointed brush containing the properly matched color dye is dabbed onto the print. A white piece of paper reveals the area to be spotted while protecting the remainder of the photograph.

Enlarged Section

White Piece
of Paper

Color Print

Proper spotting shows that the photographer knows and cares that craftsmanship plays an important part in the total effect the photograph will have on the viewer.

© David Graham "Piano, Hot Springs, Arkansas, 1985" 20" × 24" Type C print Courtesy of Jayne H. Baum Gallery, New York, NY

·

Dealing with Mistakes

If there is too much dye on the print, quickly remove it by letting a piece of paper towel absorb it. Do not rub or smear it.

If the color does not come out correctly or if too much dye is absorbed, attempt to remove the spot with a drop of 5-percent solution of ammonia and water. Apply it with a clean brush. Let it sit on the spot for about sixty seconds, then absorb it with a piece of paper towel. Let it dry before attempting to start spotting there again. If this does not work, let the spot dry and cover it with white dye and start over.

Spray Lacquers

After the dyes have dried, there may be a difference in reflectance between the spotted areas and the rest of the print, especially with glossy paper. If this is noticeable, spray the picture with a print lacquer which will create even reflectance over the entire photograph. They are available in glossy and mat finishes. Read manufacturer's instructions for proper application and handling of these materials.

Spotting Prints from Slides

When spotting prints from slides, the major difference is that the dust spots will appear as black, not white. These black spots have to be covered with white before spotting them. Small black spots can be removed by etching the surface of the print with a sharp pointed blade, such as a #11 X-Acto, until the speck is gone. This must be done with great care so that the surface of the print does not become too rough as to make it visually objectionable. Color should be applied with an extremely dry brush only. Lacquer spray will probably be needed in both cases to eliminate the differences in reflectance between the spotted and nonspotted areas of the picture.

Dry Mounting

There are a number of methods that can be employed for showing completed photographs. Dry mounting is the most common way to present the finished print for display. It is a fast method to obtain print flatness which will reduce surface reflections and give the work more apparent depth.

The Dry Mounting Process

Dry mounting tissue is coated with adhesive that becomes sticky when it is heated. This molten adhesive will penetrate into the fibers of the print and mounting board and form a bond. It is best to use a tacking iron and a dry mount press to successfully carry out the operation. A home iron is not recommended because it can create a series of unnecessary complications.

When mounting a resin-coated (RC) print be certain that the dry-mounting tissue has been designed to be used with RC paper or the print may blister and melt. Use four-ply mounting board so that the print will not bend. Keep the color selection simple. Use an off-white or a very light gray-colored board. The board should not call attention to itself or compete with the picture. To obtain maximum print life, use a museum quality board that is 100 percent rag and is pH neutral. Regular board contains impurities that in time can interact and damage the print.

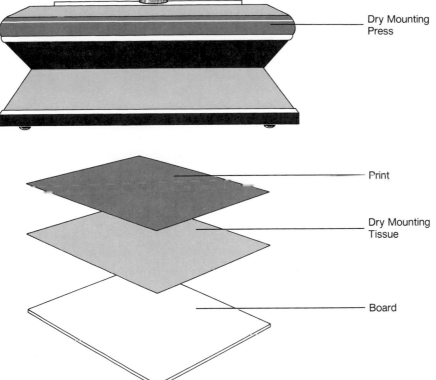

Dry Mounting Press

Figure 14.3
The basic materials for dry mounting a photograph. Double-check the temperature setting to ensure the photograph is not damaged during the dry mounting process.

Print

Dry Mounting Tissue

Board

Tacking Iron

Dry Mounting Steps

Use these steps in the dry mounting process (necessary materials are in figure 14.3):

1. Turn on the tacking iron and dry mount press. Let them reach operating temperature. Check the dry mount tissue package for the exact temperature as it varies from product to product. The temperature will be lower than that of fiber-based black-and-white paper. Using a temperature that is higher than recommended will damage the resin coating of the print.

2. Make sure all materials and working surfaces are clean and level. Wipe all materials with a smooth cloth. Any dirt will create a raised mark between the print and the board.

3. Predry the board and non-RC prints. Place a clean piece of paper on top of the board and prints in the press for about thirty seconds to remove any moisture. Remove materials from the press and let them cool.

4. Place the print face down with a sheet of mounting tissue at least the same size as the print on top of it. Take the hot tacking iron and touch it against the tissue in the center of the print. This should be enough to just keep the print and the tissue together. Do not tack at the corners.

5. Trim the print and tissue together to the desired size. Use a rotary trimmer, a sharp paper cutter, or a mat knife with a straight edge.

6. Position the print on the board. The standard print position has equal distance on both sides and about 20 percent more space on the bottom than at the top. If there is not more space at the bottom, the print appears to visually sink or look bottom heavy when displayed on a wall. Carefully make the measurements using a good metal ruler and mark the board in pencil to get a perfect alignment. Use a good metal ruler.

7. Align the print and tissue, face up, on the board according to the pencil marks. Raise one corner of the print and with the iron, tack that corner of the tissue to the board. Next tack the opposite corner. Now do the remaining two. The tissue must be flat or it will wrinkle.

8. Put this sandwich of print, tissue, and board with a cover sheet of clean paper on top into the press. Make sure it is at the proper operating temperature for the materials. Close and lock the press and heat for about thirty to forty-five seconds. Check the product for exact times.

9. Remove the sandwich and place it on a level surface under a weight to cool.

Dry Mounting Problems

Problems faced with dry mounting include:

1. Ease of ruining a finished print with dry mounting through accident and/or material failure.

2. After the print has been dry mounted, changes in heat and humidity, especially if the prints are shipped, can cause the print to wrinkle or come unstuck from the board. This happens because the print and the board do not expand and contract at the same rate. Since they are attached and the board is stronger, the print suffers the consequences.

3. The adhesives in the tissue can have adverse effects on the print, causing it to deteriorate.

4. If the print is dropped face down it is offered no protection and the print surface can be damaged.

5. If the board is damaged in any way there is a problem. Dry mounting is not water soluble. This means it is almost impossible to get the print released undamaged from the dry mount for any reason. This makes replacement of a damaged board extremely difficult.

The Overmat

An overmat is a board with a window cut in it, placed over a print that has been attached to a backing board. The raised border around the print protects the print surface from being easily scratched. If the overmat is damaged or soiled for any reason, it can be replaced without affecting the print. A mat can be cut with a hand mat cutter such as a Dexter or Logan, which requires some practice. Almost anyone can cut a mat with a machine such as the C & H mat cutter. For those who have but an occasional need of a mat, have a local frame shop make one for you.

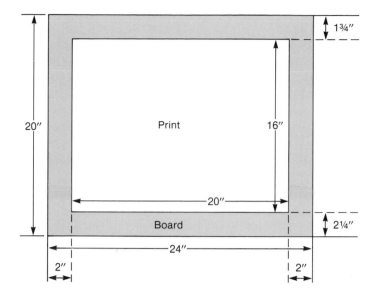

Figure 14.4
The dimensions of a window-type overmat for a 16″ X 20″ print on a 20″ X 24″ board. More space is usually left on the bottom of the mat than at the top to keep the print from appearing to visually sink on the board. The side borders are generally of equal dimensions.

How to Make an Overmat

Making an overmat includes the following steps:

1. Measure the picture exactly. Decide on precise cropping. If the picture is not going to be cropped, measure about 1/16 to 1/8 of an inch into the picture area on all sides if you do not want the border to be seen.

2. Decide on the overall mat size. Leave enough space. Do not crowd the print on the board. Give it some neutral room so that the viewer can take it in without feeling cramped.

 Generally, the minimum size board for an 8″ X 10″ print is 11″ X 14″. For an 11″ X 14″ print, use a 16″ X 20″ board. Many people try to standardize their sizes. This avoids the all too commonplace, hodge-podge effect that can be created if there are twenty pictures to display and each one is a slightly different size. When the proper size has been decided upon, cut two boards, one for the overmat and the other for the backing board. Some people cut the backing board slightly smaller (1/8″) than the front. This way there is no danger of it sticking out under the overmat.

3. In figuring the window opening it is helpful to make a diagram (figure 14.4) with all the information on it. To calculate the side border measurement, subtract the horizonal image measurement from the horizontal mat dimension and divide by two. This will give even side borders. To obtain the top and bottom borders, subtract the vertical picture measurement from the vertical mat dimension and divide by two. Then, to prevent the print from visually sinking, subtract about 20–25 percent of the top dimension and add it to the bottom figure.

4. Carefully transfer the measurements to the back of the mat board. Use a T square to make sure the lines are straight. Check all the figures once the lines have been laid out in pencil.

5. Put a new blade in the mat cutter. The C & H cutter uses a single edge razor blade with a crimp in the top. Slide the blade into the slot and adjust it so that it extends far enough to cut through the board. Hand tighten only, using the threaded knob at the end of the bolt.

6. Line the markings up with the mat cutter so that it cuts inside the line. Be sure to check that the angle of the blade is cutting at 45 degrees in the ''out'' direction for all the cuts, in order to avoid having one cut with the bevel going in and the other with it going out. It helps to practice on some scrap board before doing the real thing. When ready, line up the top left corner and make a smooth, nonstop straight cut. Make all the cuts in the same direction. Cut one side of the board and then turn it around and cut the opposite side until all four cuts have been made. With the C & H mat cutter, start the cut a little ahead of where your measurement lines intersect and proceed to cut a little beyond where they end. With some practice, this will let the window come right out with no ragged edges. If you cannot get the hang of it and continue making overcuts, simply stop short of the corners. Then go back with a single edge razor blade and finish the cut. Be sure to angle the blade to agree with the angle of the cut. Sand any rough spots with very fine sandpaper. Erase the guidelines so that the pencil marks will not get on the print.

7. Hinge the overmat to the backing board with a piece of gummed linen tape (figure 14.5). The mat will now open and close like a book with the tape acting as a hinge.

8. Place the print on the backing board and adjust it until it appears properly in the window. Hold it in place with print-positioning clips or a clean smooth weight with felt on the bottom.

9. Use photo corners to hold the print to the backing board. They will be hidden by the overmat and make it easy to slip the print in and out of the mat for any reason (figure 14.5).

Figure 14.5
The construction of a typical hinged window mat. The use of photo corners facilitate removing the photograph from the mat without harming the print.

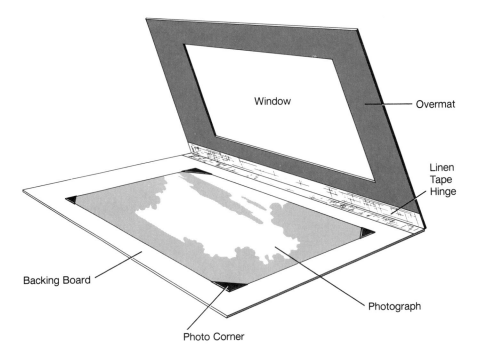

Window

Overmat

Linen
Tape
Hinge

Backing Board

Photograph

Photo Corner

Getting Supplies

Light Impressions, Inc., is the largest and oldest supplier of archival materials for photographic use at present. They sell clear polyester archival self-adhering mounting corners that are good for prints up to 11″ × 14″. For larger prints they sell acid-free Permalife paper photo corners that are attached to the backing board with acid-free linen tape. To get their catalog of supplies and books write or call: Light Impressions, 439 Monroe Avenue, P.O. Box 940, Rochester, N.Y. 14603, 800/828–6216.

Floating the Print

Some prints do not look good matted or mounted. The board interferes with the workings of the space within the picture. In cases like this "float" the picture.

How to Float the Photograph

Here are the steps in floating a print:

1. Decide on the final picture size.
2. Trim the print to these dimensions.
3. Cut a backing board or a piece of Artcor or Fome-Cor to the same size as the print. Artcor and Fome-Cor are of archival quality, they will not chemically interact with the picture, and they are cheaper than good board.
4. Have a piece of plexiglass cut to size.
5. Put the sandwich of plexiglass, print, and board together with a frameless device such as Swiss Corner clips and it is ready.

Prints made for public exhibition must possess the highest level of overall craftsmanship in technique and presentation. Here, Sherman's widely shown work has been credited with expressing the Postmodernism concerns of the 1980s. The work is ambiguous and self-conscious. It has been called a nonliteral imitation of the world of film and television that surrounds western culture.

© Cindy Sherman "Untitled, #119, 1983" Type C print 17½″ × 36″ Courtesy of Metro Pictures, New York, NY

Print Preservation

Materials That Will Damage the Print

There are other methods that can be used to display finished prints. Whichever method is decided to be appropriate for the work, avoid having any of the following materials in contact with the print as they are harmful to photographs and can cause damage over a period of time: cellophane tape, white glues, rubber cement, and "magnetic" albums with adhesive-coated pages and plastic covers. Do not write on prints with ball point pen or water-soluble markers as they tend to bleed through and stain the print.

Print Storage

Color prints should be stored in a cool, dark area with a relative humidity of about 25–50 percent. Avoid exposure to direct sunlight, as ultraviolet light in the sun's rays will cause the dyes to fade faster. Archival storage boxes offer the best protection for your prints. Use desiccants (a substance that will absorb moisture) if you live in an area of high humidity. Keep photographs away from all types of atmospheric pollutants, adhesives, and paints. Check the storage area periodically to make sure there has been no infestation of bugs or microorganisms.

Cold Storage

Freezing still offers the greatest stability for negatives and prints. Kodak even makes cold storage envelopes designed for freezing processed film. With billions of pictures now being made every year, deciding what is worth saving should be given some thought.

Color Print Life

In the past, it was common to have color print dyes fade within ten years. Kodak claims that its latest paper will last at least one hundred years in a photo album without extended exposure to light.

Additional Information

For more information about matting, framing, storage, archival processing, and print preservation, get a copy of either *The Life of a Photograph* by Keefe and Inch, Focal Press (1984), and/or *Caring for Photographs/Revised Edition,* Time-Life Books (1982).

Copy Slides

Making Copy Slides

Making slides of your prints or pictures from books for a presentation is relatively simple. The pictures to be copied can be positioned vertically on a wall or laid on any convenient flat surface. The camera can be tripod-mounted or hand-held, depending on the light source and film sensitivity. Camera movement must be avoided to produce sharp slides.

Be sure the camera back is parallel to the print surface and the lighting is uniform. Avoid shadows falling across the picture. Good results can be obtained most easily by using a daylight color slide film and shooting the pictures outside in sunlight, avoiding shadows which can create an unwanted color cast.

Figure 14.6
When copying work, two lights should be set up at equal distances on each side of the camera at 45-degree angles to the work being copied. Meter from a gray card, not off the surface of the work being copied. Make sure the film and the light sources have the same color temperature.

If copying is done indoors, a tungsten-type film should be used with artificial lighting. Be certain that the film matches the color balance of the lights that are being used. Two lights should be placed at equal distances on either side of the tripod mounted camera at a 45-degree angle to the picture being copied (figure 14.6).

Indoors or out, take a meter reading from a standard neutral gray card, such as the one inside the back cover of this book, for the most accurate results. Let the gray card fill the frame. Metering off of the picture itself will produce inconstant exposures. Try to let the image fill as much of the frame as possible, without chopping off any of it.

Only those slides that have been accurately exposed should be used. Generally, it is important to choose a group of images that form a cohesive group when viewed together and that reflect the visual concerns of the photographer's presentation.

Slide Presentation

Slides must be well presented. This means the photographer's name, the slide's title and size (with height before width), and date the image was made, and the type of process should be clearly printed on each slide with the top of the image indicated (figure 14.7). A red dot is often used to indicate how the slide should be placed in a carousel type tray (the dot should be placed so it is visible in the notch of the tray). This way a viewer will have no difficulty determining the correct way to view the slide.

Masking Slides
Mask out any areas of the slides that should not be seen when it is projected by using black photographic tape or chartpak tape. Place the tape on the nonemulsion side (shiny side) of the film. Use only one layer of tape or it may get stuck in the projector.

Avoid a Bad Reception
Slides that are not properly exposed, correctly labeled, or neatly presented will not receive a favorable welcome at a competition, gallery, school, or job interview. Slides are at best an imperfect way to view anyone's work, therefore give the slides your best effort so that they can present an accurate approximation of the colors, mood, and tone in your work.

Figure 14.7
Slides must be well presented to have a chance of receiving a fair reception. Each slide should be clearly labeled with the name of the photographer, title of the piece, its size with height before width, the date of the image, and the type of process that was used. The top of the photograph should be identified so a stranger will know how to view the image.

How to Ship Slides

Ship slides in transparent polyethylene pages. Do not send loose slides. Have your name and return address on the slide page. Use a stiff backing board in the envelope so that the slides cannot be easily bent. Send them in first class mail. Include any appropriate support materials such as your resumé, exhibition list, and a statement concerning the work. Enclose return postage and a self-addressed shipping label to help guarantee the return of your materials.

Problem Solving

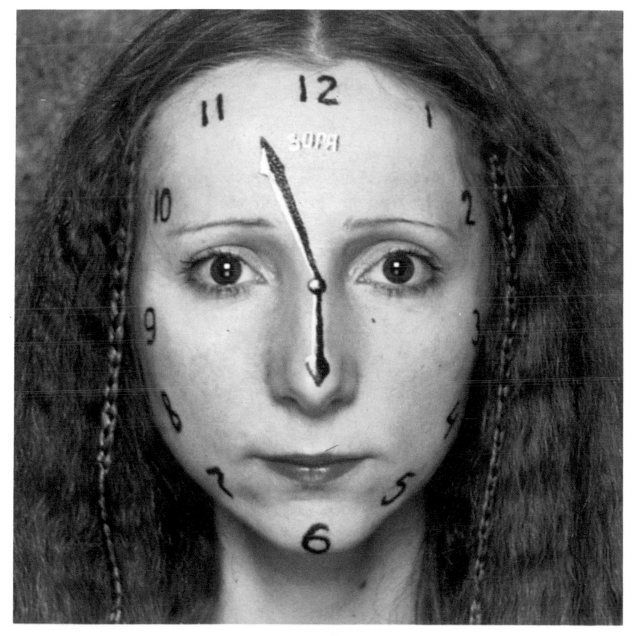

"A Clock; Time as a SURFACE of Life"
Gerlovina/Berghash/Gerlovin
printed 19″ × 19″, C-Print,
Courtesy of Marcuse Pfeifer Gallery, New York, NY.

⸺
·

Becoming More Aware

Getting ideas to solve problems means becoming more aware. This is accomplished by asking questions and taking on the responsibility of gaining knowledge, which requires self-discipline. It is necessary to believe in your own creativeness. Consider information from all sources. Do not attempt to limit your response to only the rational part of the brain; let your feelings enter into the process. Be prepared to break with habit and take chances. Listen to yourself, as well as to others, to get satisfaction.

Dealing with Fear

The major block to getting new ideas is fear. Fear takes on endless forms: fear of being wrong, of being seen as a jerk, or of changing the way in which something has been done in the past. Fear can be a reluctance to deal with the unknown or brought about by a lack of preparation. Apprehension deters creative development by misdirecting or restraining energy. It is okay to make mistakes; do not insist that everything be absolutely perfect. Students are not expected to be experts, so take advantage of this situation. Learning involves doing, therefore make that extra negative; make one more print to see what happens. You are the one who will benefit.

The Problem-Solving Process

Getting ideas means finding ways to solve problems. The process is a continuous circle of events (figure 15.1) that includes situation analysis, problem definition, idea formation and selection, putting that idea into operation, and evaluating and accepting the results.

Acceptance

Acceptance is to take on the problem as a challenge and a responsibility by saying yes to involvement, and committing your time and resources to solve the problem. It is like signing a contract which indicates the intention to take charge and see the project through to completion. We can either accept things the way that they are ("I do not know how to do this in color photography") or we can take on the responsibility for change ("I am going to learn how to do this").

Analysis

Analysis involves studying the problem and determining its essential features and feelings. It includes taking the problem apart, doing research to discover all its ingredients, and working out their relationship to the whole. This is the time to question everything and to generate all the possibilities that are available.

Definition

Definition is getting to the main issues and clarifying the goals to be reached. Ask yourself, "What is the 'real' problem?" Do not get sidetracked by the symptoms of the problem. One must decide where problems may lie and narrow down the information uncovered. This state defines the direction in which the action will be taken in order to solve the problem.

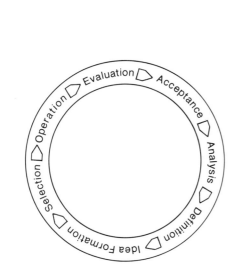

Figure 15.1
The problem-solving process is a continuous circle of responsible thinking.

Chapter Fifteen

Frazier used drawing, painting, sculpture, and xerography to make an illusory image that has the qualities of the actual site when viewed through the camera. The final construction is photographed, completing the process of deferring the reality presented in the image. The construction is destroyed after this process is completed.

© Bill Frazier "Souvenir from Extinct Civilizations: Pont du Gard, France 1985" Type C print 15" × 15"

Idea Formation

Idea formation provides ways of reaching the stated goal. Do not fall in love with one idea or assume the answer is known before this process is started. Put together all the solutions that have been considered, and keep an open mind to the alternatives.

Selection

Selection is the process of choosing from all the idea options that have been discovered. Now is the time to decide which way is best to reach the stated destination. Keep a back-up idea in case a detour is encountered. Do not be afraid to experiment, to take chances, to try something that has not been done previously.

Implementation

Implementation is putting the plan into action. The process of doing is as important as the final product. Do not seek perfection because it is impossible and the goal will not be reached. If the selected idea is not working out, be flexible and attempt something else.

Bring plenty of film. Do not be afraid to shoot. Use the film as an artist would employ a sketchbook. Film is the starting place for your visual ideas. Keep thinking. Do not worry if every picture is not a masterpiece. Do not be concerned about making a mistake; it will be dealt with in the next step of the process. Keep working.

Evaluation

During evaluation the course of action is reviewed. These questions are asked: What was done? What worked? What didn't work? Why did or didn't it work? What could be done to make the picture stronger? Pinpoint the source of any dissatisfaction. If the result does not meet the goals, it is time to do a "re-shoot."

Do not hold onto only one idea. Absolutist beliefs can be crippling to creative problem solving. A large part of learning involves how to deal with failure. We learn more from our failures than from our successes. Picasso said, "Even the great artists have failures."

Results

A successful solution is one that fits both the problem and the problem-solver. To make this happen, one must be prepared to jump in, take the chances, and become a part of the process called photography.

The successful problem-solver keeps a record of what has been done and how it was accomplished. This is knowledge, repeatable results gained from experience.

Problem-solving means coming to grips with the true nature of the situation. Simplistic solutions to problems offer the wrong answers for the lazy and the unthinking. Be skeptical of anyone who claims to have all the answers. Some people take a course in photography believing that techniques will make them photographers; this is not the case. To be a photographer, one must learn to think a situation through to a satisfying conclusion based upon personal experiences and needs.

∴

The Subject Is Light

"Taconic Parkway"
Robert Ketchum
30″ × 40″, Cibachrome,
J J Brookings Gallery, San Jose, CA.

⎯⎯⎯
•

Good Light

The definition of "good light" depends solely upon the photographer's intent. Have you ever encountered a scene that you knew should make a good photograph, yet the results were disappointing? There is a strong possibility that it was photographed at a time of day that did not let the light reveal the fundamental aspects that were important and attracted you to the scene in the first place. Try photographing the scene again at a different time of day.

What the Camera Does

Your ability to function as a creative photographer depends upon your knowledge in making your equipment work for you. A camera is merely a recording device and it will not reproduce a scene or an experience without your guidance at every stage of the process. The camera can isolate a scene; it can reduce it to two dimensions. It will freeze a slice of time and set it into a frame.

It doesn't record the sequence of events that led up to the moment that the shutter clicked nor your private emotional response to what was happening. These are items you must learn to incorporate into your pictures if you expect to make photographs instead of snapshots. The camera does not discriminate in what it sees and records, but you can, and must, to create successful images.

The Time of Day and Types of Light

Every photographer is familiar with the old Kodak adage, "Take pictures after ten in the morning and before two in the afternoon." By breaking this "rule" you can come up with some astonishing results. The day follows a predictable cycle of light that will influence your images.

Light is the key ingredient that is shared by every photograph. Before anything else, every photograph is about light. Light determines the look of every photograph you make. If the light does not reveal the perceived nature of the subject, the picture will not communicate your ideas to the viewer. Begin to recognize the characteristics and qualities that light possesses throughout the day and learn to incorporate them into the composition for a complete visual statement.

The Cycle of Light and Its Basic Characteristics

Before Sunrise

In the earliest hours of the day, our world is essentially black-and-white. The light exhibits a cool, almost shadowless quality and colors are muted. Up to the moment of sunrise, colors remain flat and opalescent. The intensity of the colors grows as the sun rises. Artificial lights can appear as accents and create contrast (figure 16.1).

Morning

As soon as the sun is up, the light changes dramatically. Since the sun is low and must penetrate a great amount of the atmosphere, the light that gets through is much warmer in color than it will be later in the day. The shadows can look blue due to the fact they lack high brilliant sunlight, because of the great amount of blue from the overhead sky, and because of simultaneous contrast (see Color Observations in chapter 4). As the sun rises, the color of light becomes warmer (red-orange). By midmorning the light begins to lose its warm color and starts to appear clear and white (figure 16.2).

Figure 16.1
Before sunrise our world is basically black-and-white with colors that tend to be cool and muted. Colors that do appear are often from artificial sources of light.

© Michael Stravato "Dawn, I-40, Looking East, Amarillo, TX. 1986" Kodachrome

Figure 16.2
Meyerowitz uses both the quality of morning light and a high level camera view to diminish human importance in this scene. A vast sense of space becomes the subject. The angle and color of the beach leads the eye into the water where the light striking the ripples of the waves takes us to the horizon where the sea and sky blend into infinity.

© Joel Meyerowitz "Long Nook Beach, 1983"

Figure 16.3
At midday the light is its purist white. Colors stand out strongly, contrast is at its peak, and shadows are deep and dark.

© David Robinson "NYC 7" 16" × 20" Cibachrome
Courtesy of J. J. Brookings Gallery, San Jose, CA

Figure 16.4
In the late afternoon, as the sun makes its way back to the horizon, the light starts to warm up again. Surface textures can be strongly rendered in this type of light. Shadows will lengthen and become bluer. Visual contrast can be seen as the sun continues to illuminate the earth while the sky begins to darken.

© David Arnold "House Ruin, Ryolite, NV" Cibachrome 13½" × 19½"

Figure 16.5
In the evening, after sunset, there is still plenty of light in the sky. Its quality is soft, making contrast and shadows minimal. These natural effects can be played off artificial light sources to create contrast and add interest.

© Jan Staller "Galaxy, 1985" Type C print 15" × 15"
Courtesy of Jayne H. Baum Gallery, NY, NY

Midday

The higher the sun climbs in the sky, the greater the contrast between colors. At noon the light is white. Colors stand out strongly, each in its own hue. The shadows are black and deep. Contrast is at its peak. Subjects can appear to look like three dimensional cut-outs. At noon the light may be considered to be harsh, stark, or crisp (figure 16.3).

Late Afternoon

As the sun drops to the horizon, the light begins to warm up again. It is a gradual process and should be observed carefully. On clear evenings objects can take on an unearthly glow. Look for an increase in red. The shadows will lengthen and will become bluer. Surfaces are strongly textured. An increasing amount of detail is revealed as the sun gets lower (figure 16.4).

Evening

After sunset there is still a great amount of light in the sky. Often the sunset colors are reflected from the clouds. Just as at dawn, the light is very soft and contrast and shadow are at a minimum. Look for the glowing pink and violet colors as they gradually disappear and the earth becomes a pattern of blacks and grays (figure 16.5).

Night

The world after the sun has set is seen by artificial light and reflected light from the moon. The light is generally harsh and contrast is extreme. Photographing under these conditions usually requires a tripod, brace, or a very steady hand. Since an increase in exposure can lead to reciprocity failure and possible color shift, use filters if correction is desired. Combinations of artificial light and long exposure can create a surreal atmosphere (figure 16.6).

Figure 16.6
At night our world is seen either by reflected moonlight or by artificial sources. Making photographs under these conditions entails long exposure times. A tripod is usually required and reciprocity failure is a definite possibility. Long exposures can combine with the ambient sources of light and movement of objects within the scene to create a surreal view of the earth.

© Tim Baskerville "Giant Camera 1983"

Assignment

Time of Day/Type of Light Pictures

Use any of the standard daylight color slide film (E–6 process) that has a film speed of about 100. Photograph at least two of the following suggestions. It is not enough to just show the differences of the quality of light at the different times of the day. Make a picture that has a strong composition and says something to the viewer.

1. Photograph an object at six different times of the day, in six different locations.
2. Photograph an object at six different times of day in the same location.
3. Make a photograph at a different location at six different times of the day. Do not add anything to the scene. Work with what is given.

The Seasons

The position of the sun varies depending upon the time of year. This will have a great impact on both the quality and quantity of the light. Learn to recognize these characteristics and look for ways to go with and against the flow of the season to obtain the best possible photograph.

Winter means a diminished number of daylight hours. Bare trees, pale skies, fog, ice, rain, sleet, and snow all produce the type of light that creates muted and subtle colors. Spring brings on an increase in the amount of daylight and the introduction of more colors. Summer light offers the world at its peak of color. Harsh summer light can offer a host of contrast and exposure problems for the photographer to deal with. Fall is a period of transition that provides tremendous opportunities to show the changes that take place in color.

The Weather and Color Materials

There is no such thing as bad weather for making photographs (figure 16.7). Fog gives pearly, opalescent, muted tones. Storms can add drama and mystery. Rain mutes some colors and enriches others while creating glossy surfaces with brilliant reflections. Dust will soften and diffuse color and line. Bad weather conditions often provide an excellent opportunity to create pictures full of atmosphere and interest. With a few precautions to yourself and equipment, you need not be just a fair weather photographer.

Fog and Mist

Fog and mist will diffuse the light and tend to provide monochromatic compositions (figure 16.8). The light can tend toward the cool side (blue). If this is not acceptable, use an 81A warming filter, or photograph in the early morning or late afternoon when there is the chance to catch some warm-colored light. If the sun is going in and out of the clouds, wait for a moment when a shaft of light breaks through the clouds. This can create drama and break up the two-dimensional flatness that these cloudy scenes often produce.

Since the light is scattered both colors and contrasts are made softer and more subtle. If you want to have a sense of depth in the mist, try not to fill your frame completely with it. Attempt to offset it with a dark area. To capture mist, expose for the highlights or use an incident light meter. Bracketing is crucial.

Figure 16.7
There is no such thing as bad weather for making photographs, provided the photographer is prepared and waiting to take advantage of the right moment.

© Michael Stravato "Sky Diver, 1986"

Chapter Sixteen

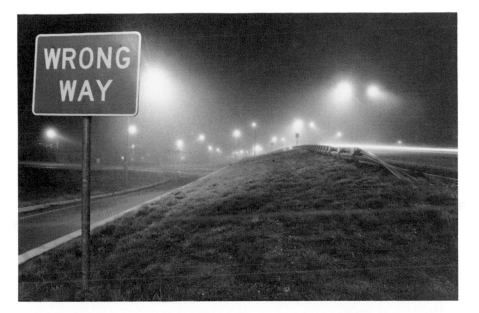

Figure 16.8
Fog and mist diffuse the light and tend to make monochromatic color schemes. The addition of a warm-colored object can break up this two-dimensional effect. In this instance, the red sign was illuminated by flash fill to make its visual impact even stronger.

© Michael Stravato "Wrong Way, 1987" Type C print 11" × 14"

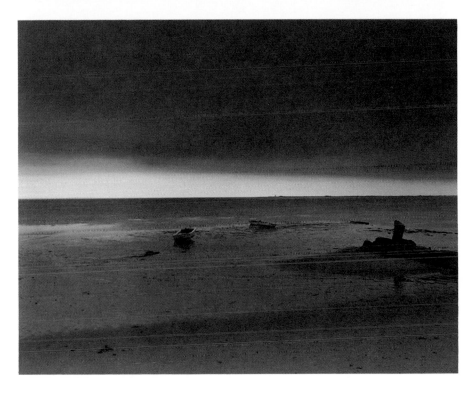

Figure 16.9
Meyerowitz has taken advantage of a morning storm to create depth and drama. The diffused light softens color and detail while the warm color of the sand in the foreground supplies color contrast and balance with the sky. The subtle use of reflections provides an additional visual spark.

© Joel Meyerowitz "Bay/Sky, 1980"

In fog, take a reading from your hand in light similar to that which is on your subject. Then overexpose by a half f/stop or a full f/stop depending upon how intense the fog happens to be. Film is your cheapest resource; don't be afraid to use it.

Rain

Rain tends to mute and soften color and contrast, while bringing reflections into play (figure 16.9). Include a warm accent if contrast or depth is desired. The shutter speed is important in the rain. The faster the speed, the more distinct the raindrops will appear. At speeds below 1/60 of a second, the drops will blur. Long exposures will seem to make them disappear. Experiment with

Figure 16.10
Snow can portray an unworldly stillness and
beauty. Snow will reflect any predominate
color within the scene. Care is needed
during exposure as the great amount of
reflected light will fool the meter into
underexposing the film. Keep battery-
powered equipment as warm as possible
when not in use to avoid electrical
slowdowns or failures.

© Jan Staller "Electric Totem Pole, 1985" Type C print
15″ × 15″ Courtesy of Jayne H. Baum Gallery, New
York, NY

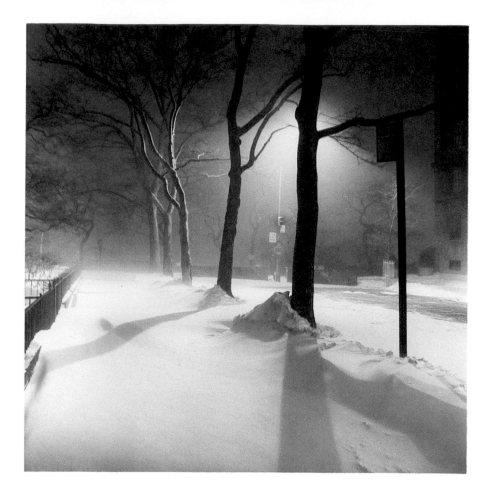

different shutter speeds to see what you can achieve. Keep your camera in
a plastic bag with a hole for the lens. Use a UV filter to keep the front of the
lens dry. Keep the camera inside your jacket when it is not being used.

Dampness

When working in a situation that is constantly wet, get a waterproof bag to
hold your equipment. There are inexpensive plastic bag-cases now available
at camping stores that will allow one to photograph in wet conditions without
worrying about ruining the camera. Carry a bandanna to wipe off any excess
moisture.

Before going out into any unusual weather conditions be certain to check
how many frames are remaining on the roll. If there are only a few left, reload
while everything is still dry and familiar.

Snow

Snow will reflect any predominate color (figure 16.10). Blue casts and shadows
are the most common in daylight situations. Use a UV filter to help neutralize
this effect. If this proves insufficient, try a yellow 81A or even an 81 filter. This
technique will also work well in higher elevations where the color temperature
of the light is higher (bluer).

Figure 16.11
Snow can be made to appear or disappear, depending upon the exposure's shutter speed. To capture the effect of falling snowflakes, a flash can be fired from the center of the camera. The light will reflect off of the flakes, making them highly visible.

© Curt Walters "Christmas Indian" Type C print 16" × 20"

Brightly lit snow scenes tend to fool the meter because there is so much reflected light. The meter will think there is more light than there actually is, telling you to close the lens down too far, producing underexposed negatives. Avoid this by taking an incident light reading and then overexpose between a half and one f/stop to get shadow detail. If this is not possible, use your hand. Fill the metering area with it, being careful not to get your shadow in it. Next open the lens up one f/stop from the indicated reading. To bring out the rich texture of snow, photograph when the sun is low on the horizon. Bracket when in doubt and learn which exposure works the best.

Snow Effects

Slow shutter speeds can make snow appear as streaks. Fast speeds will arrest the action of the flakes. Flash can also be employed. For falling snow, fire the flash from the center of the camera. The snow will reflect the light back, producing flare and/or spots (figure 16.11). The snowflakes can be eliminated by using a synchronization cord and holding the flash at arm's length off to one side of the camera. This will stop the snow and provide a scene comparable to the ones produced inside one of those plastic bubbles that are shaken to make it snow. Try setting the camera on a tripod, use a lens opening of f/8 or smaller plus a shutter speed of 1/8 of a second or longer and fire the flash during the exposure. This will stop the action of some of the falling snow while letting the rest of it appear blurred. Bracket the exposures until enough experience is obtained to determine what will deliver the type of results you are after.

Dust

Dust can be a bitingly painful experience to the photographer and equipment. Use a UV filter, plastic bag, and lens hood to protect the camera. Use the same shutter speed guide for snow in helping to determine how the dust is

Figure 16.12
Dust can produce spectacular colors in the
atmosphere. Here the photographer has
exaggerated the effects by exposing slide
film, then processing it to make the negative
from which the print was made.

© Danny D. Weeks "Untitled, 1985" Type C print
8" × 10"

to appear. Dust in the sky can produce amazing atmospheric affects (figure 16.12). If turbulence is to be shown, expose for the highlights. This will cause the shadows to go dark and the clouds will stand out from the sky. A polarizing filter may be used to darken the sky and increase color saturation. If detail is needed in the foreground, meter one-third sky and two-thirds ground with the camera meter and bracket one f/stop in either direction.

Heat

Heat will often be accompanied by glare, haze, high contrast, and reflection. These factors can reduce clarity and color saturation, but if handled properly can make colors appear to stand out (figure 16.13). In extremely bright situations, a neutral density filter may be needed to cut down the amount of light that is striking the film.

Do not point the camera directly into the sun except for brief periods of time. The lens can act as a magnifying glass and ruin the shutter and light meter. Store the camera and film in a cool place. Heat and humidity can ruin the color balance of the film before it is even processed. Refrigerate the film whenever possible both before and after exposure. Let the film reach room temperature before shooting to avoid condensation and color shift. Avoid carrying unnecessary equipment if you are going to be doing a good deal of walking in the heat. Do not forget a hat and sunscreen.

Cold

When using an electronic camera or flash, check the batteries before going out and carry spares. At temperatures of 20° F or less, there is the danger of all battery powered equipment becoming sluggish. If a battery powered shutter is off by 1/1000 of a second, it is not a problem if you are not shooting at above 1/125 of a second. If you were attempting to stop the action of a skier speeding downhill at 1/1000 of a second, the exposure would be off by one f/stop. In cold conditions, make use of the mid- and slow range of shutter speeds whenever possible to avoid this problem (figure 16.14).

Figure 16.13
Heat is usually accompanied by bright light,
glare, and high contrast. Careful
consideration of these factors can make
them work within the composition. Attempt
to keep film out of extreme heat and/or
humidity when it is not being used, as it can
have an adverse effect on its color balance.

© Richard Colburn "July 4th, Mtn. Iron, MN 1986" Type
C print 18" × 18"

Figure 16.14
Do not be afraid to get out and make
photographs in cold weather, but protect
yourself and your equipment. Carry extra
batteries and rewind the film carefully to
avoid producing static on the film.

© Drex Brooks "Doran Lee, Juntura, OR, 1986" Type C
print 12" × 18"

Cold-Weather Lubrication

Manual shutters will also slow down in the cold as the viscosity of the lubricants thicken as the temperature drops. A camera can be relubricated with special cold-weather lubricants if one was going to be doing a great deal of work in extremely cold conditions. These must be replaced when the camera is returned to use in normal conditions. Most cameras will perform well in cold weather as long as they are not kept out in the elements longer than necessary.

Cold-Weather Protection

When bringing a camera in from the cold, let it warm up before using it inside to avoid condensation which could damage its working gear. Do not take a camera that has condensation out into the cold until the condensation has evaporated or it may freeze, causing the camera to cease operating and ruining the inner components. Do not breathe on the lens outside to clean it because it might freeze on it. Wear thin gloves so that your skin does not have to come in contact with the cold metal but allows you to operate the camera with ease.

Batteries

Silver oxide batteries work well if the camera is used often. For the occasional user, lithium batteries have a longer shelf life. Keep spare batteries warm by retaining them next to your body. If the batteries appear to have expired, do not throw them away until they have been given time to warm up and tested again. Both types of batteries seem to work as well in the cold. It is a good idea to change batteries about once a year so that you do not experience a power failure as you are about to make your next masterpiece.

Static

Since static can occur anytime it is cold and dry, static can become the photographers' bane. Rapidly winding or rewinding the film can produce a static charge inside the camera. You will not know this has happened until the film is processed and discover a lightning storm of static across the pictures. Take it easy and go slowly. Do not rewind the film as fast as possible. Do not use the motor drive or auto rewind if possible in these conditions. This will help to prevent these indiscriminate lightning flashes from plaguing you.

∴

Color and the Visual Language of Design

"Carnival Queen"
Mitch Epstein
20″ × 24″, Ektacolor print,
© Mitch Epstein

·

Figure 17.1
A photograph is nothing more than some light-sensitive emulsion on a surface. Jenik-Black creates his multiple photograms by cutting out graphic shapes from illustration board and arranging them on unexposed paper. He then makes a series of twenty to forty exposures, varying the placement of the shapes, exposure times, and filter pack.

© Steve Jenik-Black "Naked Truth, Fact #4, 1986" Cibachrome 20" × 24"

Seeing Is Thinking

Seeing is thinking. Thinking involves putting together random pieces of our private experience into an orderly manner. Seeing is not a unique God-given talent; it is a discipline that can be learned and mastered.

We like what is familiar to us and tend to back away from anything unfamiliar. Becoming more visually literate makes us more flexible. Some people think photography is only for recording and categorizing objects. For them the photograph is like a window through which a scene is viewed or a mirror that reflects back a concrete reality. A photograph is nothing more than some light sensitive emulsion on a surface. It is possible that it shows us something recognizable, but maybe it only shows us lines, shapes, and colors (figure 17.1).

What Is a Good Photograph?

How do you make a good photograph? This is the question that everyone wants answered. There is no answer to this question now. This book offers a number of ideas that may be of help, but they might get in the way. It is a good question, even if we do not have "the" answer. Keep looking. The search will probably reveal there is no single answer, but many.

Discovering What You Have To Say

The first and most important step, in determining what makes a good photograph, is emptying the mind of all images that have been bombarding us on television, magazines, newspapers, movies, or home computers. These all belong to someone else. Throw them away. Next, toss out the idea that we know what a good photograph is. We know what is familiar; that a good photograph is suppose to be centered, focused, the subject is clearly identifiable, it is right side up, it is 8" X 10", it has color (unless it is "old," then it is black-and-white), the people are looking into the camera and are smiling, it was taken at eye level, it isn't too cluttered, it isn't too sparse. It is just right. And we have seen it a million times before. It is known, safe, and totally boring. Throw all these preconceived ideas into the dumpster where they belong and start fresh.

Making a Photograph That Communicates

A photograph is a picture that goes beyond a snapshot; it communicates your experience to another. A photograph has its own history—past, present, and future—and does not require any outside support, it can stand alone, as a statement. A photograph should be able to state something in a way that would be impossible to do in another medium.

Photography is a matter of order and harmony. The photographer battles the physical laws of universal entropy by attempting to control disorder within the photograph. The arrangement of objects within the pictorial space determines the success of the photograph. Order is good composition, which as Edward Weston said, "is the strongest way of seeing" the subject. The basis of composition is design.

Design includes all the visual elements that make up a composition. Visual design is the organization of materials and forms in a certain way to fulfill a specific purpose. Design begins with the organization of parts into a coherent whole. A good photograph is an extension of the part of the photographer that will create a response in the viewer. If the intentions are communicated successfully, the design of the photograph must be considered effective.

Putting It All Together

Anything that is touched by light can be photographed. Since it appears so easy, when starting out in photography, many people tend to try and say too much in their pictures. They often overcrowd the confines of their visual space with too much information. This can create a visual chaos in which the idea and motivation behind the pictures becomes lost.

When making photographs for this section work simply and subtractively. A painter starts with nothing. Through the process of addition, the picture comes into being. A photographer, on the other hand, begins with everything. The photographic process is one of subtraction. The photographer must decide what to leave out of the picture.

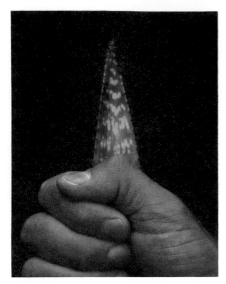

Figure 17.2
A photographer starts with everything when putting together a composition, so selectivity becomes critical. Through the use of subtractive composition the photographer eliminates all unneeded objects in the scene. A good photographer is like a magician who makes all undesired items before the camera disappear, leaving only those necessary to create the illusion.

© Michael Herbert "Untitled," Cibachrome 16" × 20"

In the act of photography, *selectivity* is everything. Use *subtractive composing* by going directly for what you want to include in the picture and subtracting all that is not required (figure 17.2). This subtractive method of putting the picture together can help the photographer to learn the basic vocabulary that produces the image. A good photographer is like a magician that knows how to make all the unwanted objects on stage disappear, leaving only the necessary items to create a striking illusion. For this reason it is necessary for the photographer to have a *point of departure*.

If you pick up the camera and go out to do something deliberate and specific, the possibility of encountering the significant and the useful is greater than standing on the corner hoping and waiting for something to occur. Do not be like the photographer described by George Bernard Shaw, who, like a codfish, lays a million eggs in the hope that one might hatch. Have a specific direction, but remain flexible and open to the unexpected. A work that continues to say something visually over a long period of time has what is called *staying power*. It usually takes years to cultivate this ability. It has almost nothing to do with the technical matters and means of producing a photograph, for the truth is how we feel about something. When this feeling is found in the picture, something of significance is expressed. For many things that we see, there are no words. "If we understood the enigmas of life, there would be no need for art."— Albert Camus

The Photographer's Special License

When you go out with a camera dangling around your neck, society gives you a certain license; learn to use it. If you went to a football game and started crawling around on the ground like a snake, people would at least find you strange. They may even become alarmed. You could be arrested and hauled off in a straight jacket, labeled as an unfit member of the group.

Now imagine the same scene, only this time you have a camera around your neck. People's responses are different if they see the camera. In this case, they will identify you by the camera and will dismiss your behavior by saying, "Oh, it's that crazy photographer," or "Look at that photographer trying to 'get' a picture." They may even come over and offer suggestions or give technical advice so that your pictures may "come out." Everyone thinks that they are photographers. Use this license to your advantage. Most people will cooperate if you know how to approach them. You can get people to be in your picture, to get out of your picture, to hold equipment, or just leave you alone. It all depends on the attitude that you project. Remember, everyone knows that photographers are all at least a little bit crazy. Put this conception to your use.

The Language of Vision

The language of vision uses light, color, shape, texture, line, pattern, similarity, contrast, and movement. Through these devices it is possible to make photographs that alter and enlarge our ideas of what is worth looking at and what we have the right to observe and make pictures of. Photography can transform any object and make it part of our experience by changing it into something that can fit into your hand to be studied later at your convenience.

The Vocabulary of Vision

The following categories are offered to provide the basic vocabulary that is needed to communicate in the photographic language.

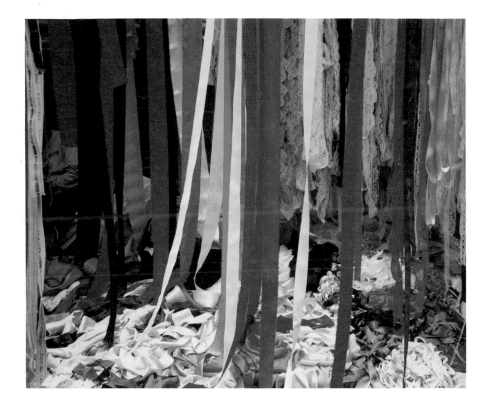

Figure 17.3
Line generally creates shape and indicates directional movement. Goldberg's vibrant color arrangement provides a strong juxtaposition with the sense of softness associated with lace.

© Gary Goldberg "Fabric and Lace, Merida, Mexico 1985" Cibachrome 16" × 20"

Line

Line carves out areas of space on either side of it. Any line, except one that is perfectly straight, creates a shape. Closing a line creates a shape. Lines can be majestic, flowing, or undulating. Lines can be used as a symbolic or an abstract concept. They can show you contour, form, pattern, texture, directional movement, and emphasis (figure 17.3).

Line, per se, does not exist in nature. It is a human creation, an abstraction invented for the simplification of visual statements for the purpose of symbolizing ideas. Nature contains mass (three-dimensional form) which is portrayed in photography by the use of line as contour (a line that creates a boundary which separates an area of space from its background).

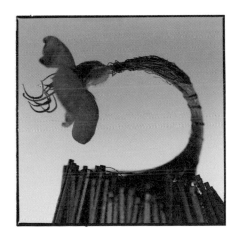

Figure 17.4
Shape is formed by a closed line. This is an area that has a specific character defined by an outline, contrast, color value, or texture with the surrounding area.

© Cay Lang "Innocent the Third, 1983–86" Type C print 20" × 20"

Shape

Shape is created by closed line; an area having a specific character defined by an outline, contrast, color value, or texture with the surrounding area (figure 17.4). There are four basic shapes:

1. Geometric shapes include the square, triangle, rectangle, and circle;
2. Natural shapes imitate things in the natural world: human, animal, and plant;
3. Abstract shapes are natural shapes that have been distorted in a certain way so that they are reduced to their essence. The source of the shape is recognizable, but it has been transformed into something different. This is usually done by simplification, the omission of all nonessential elements;
4. Nonobjective shapes do not relate to anything in the natural world. Usually, we cannot put specific names on them. They are for the eyes, not the intellect. They represent the subjective, not the rational.

Figure 17.5
Pfahl makes use of pictorial space to set up
an illusion that does not agree with our
assumptions of reality.

© John Pfahl "Six Oranges, 1975" Courtesy of Janet
Borden, Inc.

Space

Space is an area for you to manipulate in order to create form (figure 17.5).
There are two kinds of space:

Actual space is the two-dimensional area enclosed by the borders of the
camera's viewfinder and the surface on which the image later appears. Three-
dimensional spaces are inside and around or within an object;

Pictorial space is the illusionary sense of depth that we see in two-
dimensional work like photography. It can vary from appearing perfectly flat
to receding into infinity.

Texture

Generally, smooth textures tend to create cool sensations and rough textures
make for warm sensations. Texture and pattern are intertwined. A pattern on
a piece of cloth gives us a visual sense of texture, letting us feel the differ-
ences in the surface with our eyes, even though it doesn't exist to the touch.
Texture offers changing sensations either by hand or eye.

Artists have purposefully introduced three-dimensional texture into media
that was once considered to be exclusively two-dimensional. In this century,
the Cubists integrated other materials like newspapers and sand into their
paintings. This technique is now known as collage, meaning "to paste" in
French. Since then other artists have added three-dimensional objects into
their work. These works are known as constructions. They are the textural
element taken to the limit. The two kinds of texture that we will need to be
familiar with are tactile texture and light texture.

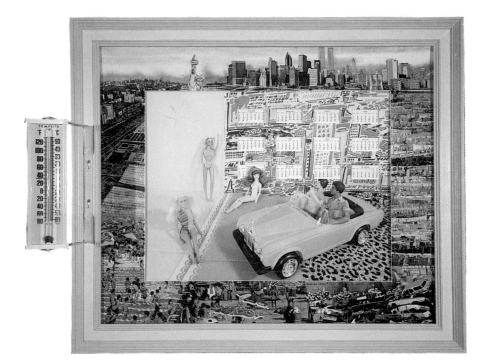

Figure 17.6
Texture in photography is usually an illusion produced by the eye. It is an illusion on a two-dimensional surface caused by variations in intensity of the light. Klidzej's satirical pieces have three-dimensional objects incorporated into the work. This type of work is known as photo-construction. Texture here possesses a physical tactile quality that can be felt in the surface of the work.

© Angie Klidzejs "American Dream #22, 1985" Mixed Media 23⅛" × 27¼"

Figure 17.7
The changing sensation of texture and depth has been created by variations of light and dark plus the relationship of the colors to one another.

© Lawrie Brown "21P, 1985" Cibachrome 16" × 20" Courtesy of J. J. Brookings Gallery, San Jose, CA

Tactile is a term that refers to actual changes in a surface that can be felt (figure 17.6). They can be rough, smooth, hard, soft, wet, or dry. They possess three-dimensional characteristics;

Variations in light and dark produce visual texture, which is two-dimensional. This illusion is produced by the eye. The relationship of color placement within the composition and the use of depth of field can also determine the sense of viusal texture (figure 17.7).

Figure 17.8
Pattern is an interplay between shape, color, and space that forms a recognizable, repetitive, and/or identifiable unit. It usually acts as a unifying compositional device. Multiple exposures have been used here to emphasize the repetition of the pattern with the interplay created within the space of the faces.

© Kenneth Kaplowitz "Untitled"

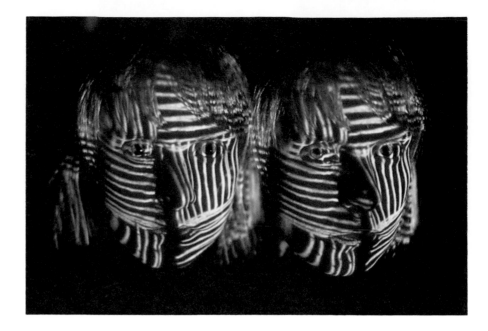

Pattern

Pattern is the unifying quality of an object. It is an interplay between shape, color, and space that forms a recognizable, repetitive, and/or identifiable unit (figure 17.8). Pattern can unify the composition, establish a balance among diverse elements, or create a sense of rhythm and movement.

The major difference between texture and pattern is degree. Do not get them confused. Pattern can possess visual texture but not all texture contains a pattern. A single board will have texture, but an entire row of boards will create a pattern. Pattern can be found in the repetition of design. In this case no single feature dominates. Its distinctive look is made possible by its repetitive quality. This form of pattern generally serves well as a background.

Surprises are possible when working with pattern. When elements are placed in repetition with other elements over a large area, they create new elements that may not be foreseen. These are often the result of negative space (the space around the design or playing through it). The shapes created by the interplay of the negative space become interesting themselves. Within the pattern these new shapes become apparent and begin to dominate so that the space or spaces can be the predominating visual factor.

Unity and Variety

A composition devoid of any unifying element will usually seem either haphazard or chaotic. A totally unified composition without variety will nearly always be boring. Unity and variety are visual twins. Unity is the control of variety, but variety provides visual interest within unity (figure 17.9).

The ideal composition is usually one that will have a balance between these two qualities, diverse elements held together by some unifying device.

The repetition of shape, pattern, or size plus the harmony of color and texture are visual ways of creating unity. The more complex the composition, the greater the need for a unifying device. Variety can be introduced through

Figure 17.9
The additional application of color and shape provide a balance of unity and variety that tie together the diverse elements of this humorous composition.

© Kim Mosley "Tar Pit, 1981" Acrylic, thread on Cibachrome 6½" × 9¼"

the use of size, color, and texture, but in photography contrast is the major control—light against dark, large against small, smooth against rough, hard against soft. Dramatic lighting is one way to emphasize these contrasts.

Balance

Balance is the visual equilibrium of the objects in a composition (figure 17.10). Some categories of balance:

Symmetrical, bilateral, or two-sided balance If you draw a line through the center of this type of composition, both sides will be an equal mirror image. Symmetrical balance tends to be calm, dignified, and stable;

Asymmetrical balance Will have equal visual weight, but the forms will be disposed unevenly. Asymmetrical balance is active, dynamic, and exciting;

Radial balance Occurs when a number of elements point outward from a central hub, like spokes of a bike wheel. Radial balance can be explosive, imply directional movement, and indicate infinity;

Balance through color The weight of a color can become the focal point in a picture. Warm colors (red, magenta, yellow) tend to advance or have more visual weight than the cool colors (blue, green, cyan). The majority of landscape is composed of cool colors. Warm colors appear mainly as accents (flowers and birds). A small amount of red can be equal to a large area of blue or green. Much of the landscape in the American West is an exception. There are few trees and the predominant colors are the warm earth tones. The amount of cool color is often determined by the amount of sky that is included. The time of day will also affect the amount of cool and warm colors, as the color temperature of the light changes;

Texture An area of texture can balance a large area of smooth surfaces.

Figure 17.10
Balance refers to the visual equilibrium of the objects within a composition. Balance can be achieved through the color by making its weight the focal point of the photograph. Divola makes use of a small amount of red to offset large areas of blue and green, drawing the viewer in the scene.

© John Divola "House, 1986" Dye Transfer 18½" × 18½" Courtesy of Jayne H. Baum Gallery, NY, NY

Figure 17.11
Emphasis provides a visual climax for the composition. The red lips create emphasis as they stand out against the photograph's overall whiteness.

© Eduardo Del Valle and Mirta Gomez "Leyza, Miami, FL, 1986" Type C print 7½" × 11"

Emphasis

Most photographs must have a focal point or points. There must be some element that attracts the eye and acts as a climax for the composition (figure 17.11). Without this, your eye tends to wander and is never satisfied. Focal devices to keep in mind are isolation, light, direction, height and angle, position, color, and size.

Rhythm

Rhythm is the visual flow accomplished by repetition, which can be evenly spaced points of emphasis (figure 17.12). It acts as a unifying device.

Proportion

Proportion deals with the size relationships within a composition (figure 17.13). Shapes are proportional to the area that they occupy within the composition. An example could be seen in making a portrait. If the circle formed by the head is two inches in diameter on a four-inch background, it will be more disproportional than if it were placed on a ten-inch background.

Correct proportion is generally based on what society considers to be real or normal. Just because something is disproportionate does not make it bad. On the contrary, it is often attention-getting and unique. Because of this, photographers will deliberately change the proportions in a composition to create impact. The position of the camera and the distance of the subject from the lens are the easiest ways to distort proportion.

Figure 17.12
Rhythm is created here by the repetition of shape and color at regular intervals.

© Lee Montgomery "Candy, 1984" Type C print
8" × 10"

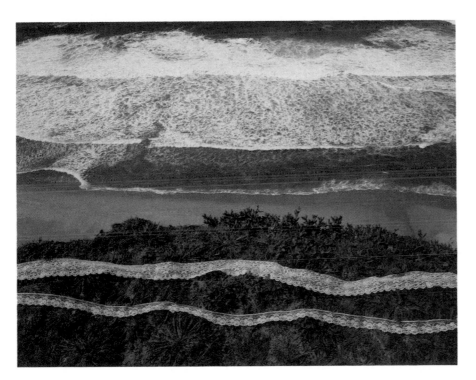

Figure 17.13
Proportion deals with the size relationships within a composition. Pfahl has deliberately changed the proportions in this photograph to create visual impact. The simplest way to distort proportion is by controlling the position of the camera and the distance of the subject from the lens.

© John Pfahl "Wave, Lave, Lace, 1978" Courtesy of Janet Dorden, Inc.

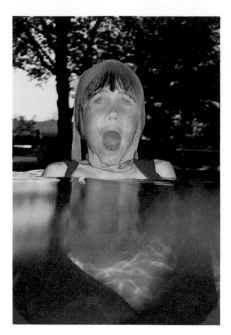

Figure 17.14
Scale indicates size in comparison to a constant standard. By showing something to be larger or smaller than normal, the audience is made to see and think about that object in a new way.

© Pamela DeMarris "Becoming A Woman" Type C print 20" × 24"

—————

.

Scale

Scale indicates size in comparison to a constant standard, the size something "ought to be" (figure 17.14). By showing objects to be larger or smaller than normal, the viewer is made to see the form in a new way. This encourages the audience to come to terms with it on a new level. Taking the familiar and making it unfamiliar can allow the viewer to see things that were once not visible.

Symbolism

We communicate through the use of symbols all the time. A symbol is anything that stands for something else. Usually a symbol is a simplified image that, because of certain associations in the viewer's mind, represents a more complex idea or system (figure 17.15).

Lines that form letters, words, or musical notes are symbols. *A photograph is a symbol.* A photograph of a person is not that person, but the representation of them. It stands for the person, which makes it a symbol.

Symbolism is a great power for the photographer. It permits the communication of enormously complicated, often abstract ideas with just a few lines or shapes. Symbols are the shorthand of the artist. Photography is a sign language. Learn to recognize and use the signs to your advantage.

The following categories of symbols are offered to get you thinking about what they can represent. Symbols are not absolute terms. They all have multiple readings. Make a list of your personal symbols and their meaning.

Some Basic Categories of Symbols

Figure 17.16 shows some of the following types of symbols:

1. Cosmic symbols such as yin and yang (yin: feminine, dark, cold, wetness; yang: masculine, light, heat, dryness), the zodiac (stands for the forces that are believed to govern the universe), and the four humors within the body that control the personality (blood, phlegm, choler (bile), and melancholy).

2. Magical symbols like the Christmas tree, which originated in Rome as a fertility symbol, an emblem of plenty with fruits and nuts decorating it. Cave painting was used to help insure a successful hunt. Tribal masks were employed for getting the desired results in battle, love, and the search for food. Masks let the wearers both disguise themselves and represent things of importance. This allows people the freedom to act out situations according to the desires of their inner fantasies.

3. Cultural symbols are mythological or religious concepts that have been changed and incorporated by a culture into becoming symbolic for a cultural event. St. Nicholas, a tall serious fellow, is now a fat, jolly, and highly commercialized Santa Claus.

4. Religious symbols. The cross, the Star of David, and the Buddha stand for the ideas behind the religion such as faith, generosity, forgiveness, hope, love, virtue, and the quest for enlightenment.

5. Traditional patterns have been woven into the visual arts for thousands of years. While the pattern remains the same, its context and meaning are altered by the group that makes use of it. The swastika is a good example of how this works. It has been used as an ornament by the American Indians since prehistoric times. It has appeared as a symbol through the old world of China, Crete, Egypt, and Persia. In our time, it's meaning has been totally perverted, from one of well-being to that of death when the German Nazi party adopted it as the official emblem of the Third Reich.

Chapter Seventeen

Figure 17.15
The collaborative efforts of Nagatani and Tracey put to use powerful symbols to create a scene with humor that manifests certain concerns and fears in contemporary society.

© Patrick Nagatani and Andree Tracey "Alamogordo Blues, 1986" Polaroid 20" × 24" ER Land Prints (Diptych) 24" × 40" Courtesy of Jayne H. Baum Gallery, New York, NY

Figure 17.16
Haberman blends together a number of categories of symbols that permit the humorous communication of abstract and complicated ideas within a visual framework.

© Jim Haberman From the American Scenes Portfolio: "Christmas, 1985" 16" × 20"

6. Status symbols indicate exact status or station in life of the owner: wedding rings, military insignia, coats of arms, cars, and clothes.

7. Patriotic and political symbols in the United States include the Statue of Liberty, the bald eagle, the flag, political parties (elephant and donkey), and Uncle Sam, which at a glance provide a wealth of information and express certain concerns.

8. Commercial symbols dispense information and/or advertise a service or product to be sold. Examples include three balls symbolizing the pawnbroker, the red-and-white pole signifying the barbershop, international road signs, and redesigned logos (Bell Telephone, National Broadcasting Company, and Shell Oil).

Figure 17.17
Crable breaks away from the traditional rectangle or square viewing frame of the photograph. He offers the viewer a circular motif along with a spiral-type configuration in order to express the cosmic and unworldly concerns obtained in this work.

© James Crable "East Wing, National Gallery of Art, Washington, D.C., 1987" Type C prints 26" diameter. Courtesy of J. J. Brookings Gallery, San Jose, CA

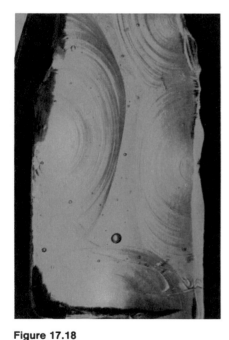

Figure 17.18
The color blue is intensely played off of the overwhelming sensuality of the image. It symbolically adds innocence and spirituality to the situation. This enables the viewer to deal with this in a manner that is not licentious.

© Eva Roa Grotefend "Untitled, 1987" Type C print 8" × 10"

9. Psychological symbols offer a system for investigating the conscious and unconscious processes of the human mind. Sigmund Freud's "The Interpretation of Dreams," and Carl Jung's "Man and His Symbols," are two watershed works that deal with these ideas. Filmmakers like Ingmar Bergman and Francis Ford Coppola have emphasized the psychological side of human nature in their works.

10. Personal symbolism. The artist creates a symbol to meet his or her particular needs. Some photographers whose works reflect these concerns include Man Ray, Lazslo Moholy-Nagy, Barbara Morgan, and Jerry Ullesmann.

Shapes and General Symbolic Associations

Shapes can also have symbolic meaning. These include:

The circle is associated with heaven, intellect, thought, the sun, unity, perfection, eternity, wholeness, oneness, and the celestial realm (figure 17.17).

The triangle can stand for communication between heaven and earth, fire, the number three, the trinity, aspiration, movement, upward, return to origins, sight, and light.

The square may represent firmness, stability, or the number four.

The rectangle often denotes the most rational and most secure. It is used in grounding concrete objects.

The spiral can illustrate the evolution of the universe, orbit, growth, deepening, cosmic motion, the relationship between unity and multiplicity, spirit, water, continuing ascent or descent.

The maze delineates the endless search or a state of bewilderment or confusion.

Color Associations—Some Traditional Effects and Symbolism

Along with shapes, color has symbolic associations that have come down through ages in Western cultures.

Red portrays sunrise, birth, blood, fire, emotion, wounds, death, passion, anger, excitement, heat, physical stimulation, and strengthening.

Orange shows fire, pride, and ambition.

Yellow indicates the sun, light, intuition, illumination, air, intellect, royalty and luminosity.

Green depicts the Earth, fertility, sensation, vegetation, water, nature, sympathy, adaptability, growth.

Blue signifies sky, thinking, the day, the sea, height, depth, heaven, innocence, truth, psychic ability, and spirituality (figure 17.18).

Violet marks nostalgia, memory, and advanced spirituality.

Common Symbols and Some Possible Associations

Consider these symbols and how their meanings can be used in your work.

Air symbolizes activity, the male principle, creativity, breath, light, freedom, liberty, and movement (fig. 17.18).

Fire represents the ability to transform, love, life, health, control, spiritual energy, regeneration, the sun, God, and passion.

Water denotes feminine qualities, life, and the flow.

The Earth suggests feminine qualities, receptiveness, solidity, and mother.

Ascent indicates height, transcendence, inward journeying, and increasing intensity.

Descent shows unconsciousness, potentialities of being, and animal nature.

Duality suggests opposites, complements, and pairing.

Unity signifies spirit, oneness, wholeness, centering, transcendence, harmony, revelation, supreme power, completeness in itself, light, and the divinity.

Centering depicts thought, unity, timelessness, spacelessness, paradise, the creator, infinity, and neutralizing opposites.

The cross portrays the tree of life, axis of the world, ladder, struggle, martyrdom, and orientation in space (fig. 17.9).

The Dark illustrates the time before existence, chaos, and the shadow world.

Light stands for the spirit, morality, all, creative force, the direction East, and spiritual thought.

Mountains demonstrate height, mass, loftiness, the center of the world, ambition, and goals.

A lake represents mystery, depth, and unconsciousness.

The moon presents the feminine and fruitfulness.

An eye illustrates understanding, intelligence, the sacred fire, and creativeness.

The sun indicates the hero, knowledge, the divine, fire, the creative and life force, brightness, splendor, awakening, healing, and wholeness.

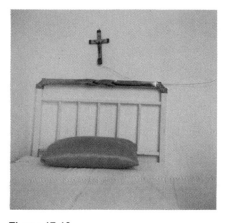

Figure 17.19
The simple composition and sparing use of color add to the power of association that the symbol of the cross can elicit.

© Drex Brooks "Samos, Greece, 1980" Type C print 13½" X 13½"

Working Applications with Color

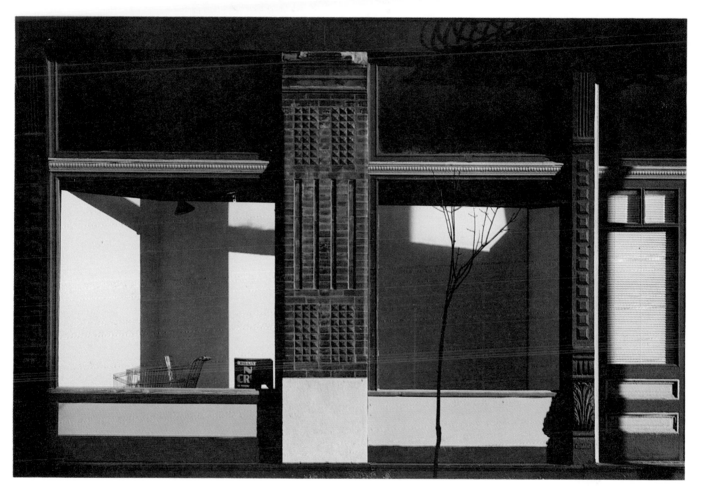

"Positively No Credit"
Michael Eastman
8″ × 10″, Vericolor Negative,
Courtesy Michael Eastman.

———
•

Figure 18.1
The forethought used by Lang in
determining the camera vantage point and
her selection of the broken vase contributes
to the control of all visual elements within
the photograph.

© Cay Lang "Gilda, 1983–86" Type C print 20" × 20"

The Angle of View

The angle of view, or vantage point, is one of the most important basic compositional devices that any photographer has to work with in determining how the image is going to be presented. It is such an elementary ingredient that it is often taken for granted and forgotten. The angle of view lets the photographer control balance, content, light, perspective, and scale within the composition. In color photography it will also determine the saturation of the hues and whether or not they form color contrast or harmony (figure 18.1).

Breaking the Eye Level Habit

Many people simply raise the camera to eye level and push the button. A photographer will explore the visual possibilities of the scene, attempting to find a way in which to present the subject in accordance with the desired outcome.

Altering the camera position does not cost anything or require any additional equipment, yet it can transform a subject and allow it to be presented in a new or different fashion. It can give the viewer more information or let the subject be seen in a way that was not possible before. It is the difference between seeing and sleepwalking through a scene.

Most of time we simply sleepwalk through life because it is so familiar. We walk down a hall without seeing the hall because we have done it a thousand times before. We are merely somnambulists, reorienting ourselves. We know what to expect; everything is in check and in place. There is no opportunity for surprise; no chance for the unexpected to enter.

To see you must be awake, aware, and open. When seeing, you are letting things happen and not relying on past expectations and cliches to get you through the situation.

Seeing is being conscious of color and space. The more one looks, the more one can penetrate the subject and then one is able to see even more.

Methods of Working

Select a subject and proceed to discover how angle and light will affect the final outcome. Here is a suggested method of approach:

Begin with a conventional horizontal shot at eye level, metering from the subject. Walk around the subject. Crouch down, lay down, stand on tiptoes, find a point that will raise the angle of view above the subject. Notice how the direction of light will either hide or reveal aspects of the subject. Move in closer to the subject and then get farther back than the original position. Now make a shot at a lower angle than the original eye level view. Try getting the camera right on the ground. Look through the camera; move and twist around and see what happens to the subject. When it looks good, make another picture.

Begin thinking about changing the exposure. What will happen if you expose for highlights? What about depth of field? Will a small, medium, or large f/stop help to create visual impact? How is the mood altered? All kinds of questions like these should be running through the photographer's head at this stage as part of the decision-making process. Answering them will require independent visual thinking. Try not to compete with fellow students. Competition tends to lead to copying of ideas and style. Copying means no longer discovering anything for yourself. Watch out for envy as it can also take away from one's own direction. The best pictures tend to be those that are made from the heart as well as the mind.

Make a vertical shot. Decide whether to emphasize the foreground or background. How will this decision affect the viewers' relationship with the subject?

Get behind the subject and make a picture from that point of view. How is this different from the front view? What is gained and what is lost by presenting this point of view?

If possible, make a picture from above the subject. How does this change the sense of space within the composition?

Change the lens that you have been using. See what changes occur in the points of emphasis and spatial relationships due to depth of field.

Move in close. Look for details that will reveal the essence of the entire subject and photograph them. This method of simplification should speak directly and plainly to the viewer.

Move back. Make an image that shows the subject in relationship to its environment.

Now do something really crazy. Using your instincts, make some pictures of the subject without looking into the camera. This can be a very freeing experience and can present composition arrangements that your conscious mind had been unable to think of using.

Do not be shy. If there is a problem of being unable to approach the subject from these diverse points of view, work with an inanimate object or a close friend. Choose a location or time of day when there will not be other people around to make you feel overly self-conscious or inhibited.

The camera is society's license to approach the unapproachable in a manner that would not otherwise be deemed acceptable in a normal social situation; use it to make the strongest possible statement.

Figure 18.2
In color photography contrast is not only determined by the difference between the dark and light areas of the scene but also by the relationships of the colors in the scene. Complementary colors like blue and yellow form the strongest color contrasts.

© Dean Dablow "Yellow Paint Spill, 1981" Type C print 11″ × 14″

Contrast with Color

In black-and-white photography contrast is created by the difference between the darkest and lightest areas of the picture. When working with color materials, the intensity and the relationships of one color to another play a vital role in creating contrast.

Complementary Colors

Complementary colors, opposite each other on the color wheel, make the most contrast (figure 18.2). The combinations of blue against yellow, green against magenta, and red against cyan form the strongest color contrasts.

It is thought that complementary colors create such contrast because of fatigue in the rods and cones of the retina. This is because each of these wavelengths can not be accommodated by the human eye at the same time. Think of it as a zoom lens that is going back and forth between its minimum and maximum focal lengths, while attempting to maintain critical focus. This is what the eye tries to do with complementary colors.

Cool and Warm Colors

Cool and warm colors can be used in creating contrast (figure 18.3). Warm colors tend to advance and are called active colors. The cool colors tend to recede and are generally more passive. Dark colors against light ones will produce contrast too. Desaturated colors played next to a saturated one makes for contrast. Pastel colors can provide contrast if there is enough separation between the colors on the color wheel.

Figure 18.3
Warm and cool colors can be used to create contrast in color. Warm colors are active and tend to advance in visual space while cool colors are more passive and tend to recede. Matsubara makes use of this here as the yellow stairs appear to stand out from the background in this scene.

© Ken Matsubara "Untitled," Polaroid Spectra Print
Courtesy of J. J. Brookings Gallery, San Jose, CA

Creating Color Contrast

Color contrast can be employed in the following ways:

It can emphasize the subject if photographed against a complementary background. Areas of contrasting colors can make for a visual restlessness which can give a sense of movement within the scene. Active and passive colors can flatten the visual space which can bring patterns to the forefront. Warm and cool colors can be used to produce a sense of balance within the picture. Dynamic tension can be built by placing active colors next to each other in the composition.

Assignment

Make a photograph that incorporates one of the following color contrast effects:

1. *Complementary contrast* Make use of colors that are opposite one another on the color wheel, like a yellow building against a blue sky.

2. *Active and passive contrast* Use a warm color against a cool one. The proper proportions of each are critical in making this work.

3. *Primary contrast* The juxtaposition of two primary colors can make for a bright, vibrant, and strong sense of feeling.

4. *Passive contrast* A quite, easy, restful mood can be achieved by using a neutral background as a staging area. A simple dark backdrop can be employed to offset a light area, which will slow down the visual dynamics of the picture.

5. *Complex contrast* Complex contrast uses many contrasting primary colors and requires careful handling or the point of emphasis can become confused or lost in an array of colors. With the proper treatment, the multicolored use of contrast can cause tremendous visual excitement and provide a strong interplay of the objects within a composition as well as connecting seemingly diverse elements.

Figure 18.4
Land-Weber made use of the evenness of
light and the limited depth of field that a
copy machine produces to create a
harmonic color relationship in this print, with
a limited palette of colors.

© Ellen Land-Weber "Untitled, 1984" 3M Color Process
15½" × 20"

Color Harmony

Harmonic colors are closely grouped together on the color wheel and present
a limited group of colors (figure 18.4). Any quarter section of the color wheel
is considered to show color harmony. The simplest harmonic compositions
contain only two colors that are desaturated in appearance. The absence of
any complementary colors make it easier to see the subtle differences in these
adjacent hues. Evenness in light and tone can help to bring out the harmonic
color relationship. Saturated colors that may be technically close to each other
on the color wheel can still produce much contrast and interfere with the har-
mony.

Color harmony is found everywhere in nature. Passive colors tend to be
peaceful and harmonize more easily than the warm active hues.

Harmony is Subjective

Harmony is a subjective matter and its effectiveness depends upon the colors
involved, the situation, and the effect that the photographer wants to pro-
duce. The actual visual effects depends on the colors themselves. Blue and
violet are adjacent to each other on the color wheel, therefore by literal def-
inition in harmony, but the effect that is created tends to be visually subdued.
Go to the other side of the wheel and take orange and yellow. These two
colors harmonize in an animated fashion.

Harmonic effects can be reinforced through the linkage of colors. This is
accomplished by repeating and weaving the harmonic colors throughout the
composition. This will place importance upon patterns and shapes within the
picture. Soft unsaturated colors in diffused light have been a traditional way
of creating harmonious relationships of colors. Special attention in framing
the picture is necessary. Be aware of exactly what is in all corners of the frame.
Eliminate any hue that can interfere with the fragile interplay of the closely
related colors.

In an urban manmade environment there is a great possibility of encountering discordant, unharmonious colors. This happens when contrasting colors are placed next to each other in such a way as to create a jarring or even unpleasant combination to view. Care in the use of light, the angle of view, and the right mixture and proportions of these discordant colors can introduce balance and vitality into a flat or static composition.

Methods to Create Harmony

Basic techniques to orchestrate a mood of unison include using a slight amount of filtration in front of the lens that matches the cast of the color of the light in the scene and desaturating the hues through the use of diffused light or using a soft filter in front of the lens. Differences in diverse colors can be deemphasized by incorporating neutral areas which make for balance within the picture. Both contrasting and harmonic colors can be linked together by working with the basic design elements like repeating patterns and shapes. Look for common qualities in balance, rhythm, texture, and tone to unite the colors.

• •
• •

Assignment

Make a harmonic color picture from one of the following areas:

1. Color harmony as found in nature. Pay close attention to the compositional location of the horizon line. Make a landscape that does not follow the tradition compositional rule of thirds. Photograph a scene with little or no sky. Make a skyscape with little or no foreground. Be on the look-out for symmetry in nature. One way to get repetition is to include reflections. This can be especially useful when there is some water in the picture. If the harmony produced by cool colors is too uninviting or stand-offish, try and add a small area of a muted complementary color. This can draw warmth and interest back into the scene. Be on the look-out for a detail from the landscape that can provide what you are after in a simplified and condensed manner. Showing less can let the viewer see more.

2. Urban color harmony. Find a place where people have consciously made a deliberate effort to blend the manmade creations into an entire overall scheme. Flat lighting can be used to play down the differences in the various color combinations within an urban setting. Smooth, early morning light can be employed for the same effect. Try to avoid the visual hustle and bustle that tends to bring forth visual chaos. Finding scenes of calmness and stillness within a busy cityscape will help to achieve harmony.

3. Still life is a perfect vehicle for creating a working color harmony. The photographer can assume total responsibility for controlling the arrangement of the objects, the background, the quality of light, and the camera position to ensure a harmonic composition. The sparing subtle use of filters can enhance the mood of harmony.

4. Portraits in harmony can be created by simplifying the background, selecting clothes and props to go with the subject, and using neutral colors and similar shapes. Soft directional lighting can minimize complementary colors. Placing tracing paper in front of any light source is a simple and inexpensive way to diffuse the light and gain control. A bare bulb flash can be valuable in a situation of this nature.

Figure 18.5
Dominant color compositions are created
when the colors become the subject of the
photograph. The visual experience does not
come from identifying a recognizable object
but from how color relationships are used to
express emotion and mood. It is a subjective
visual experience rather than an objective
one. Color is used to express what cannot
be expressed in words.

© Jay Dunitz "Kroeber Series #8" Cibachrome
40" × 40" Courtesy Jayne H. Baum Gallery, NY, NY

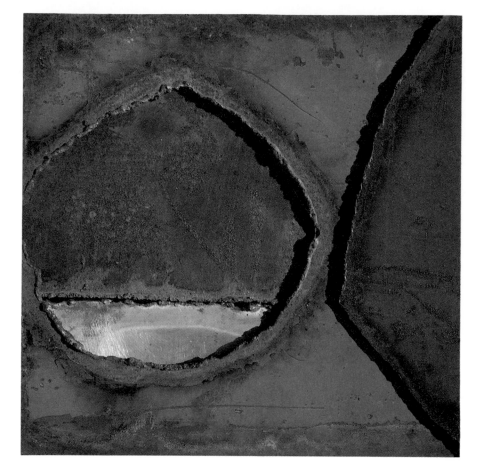

Dominant Color

Dominant color occurs when the subject of the picture becomes color itself
(figure 18.5). Painting movements such as abstract expressionism, color-field
painting, and op art have explored different visual experiences that are cre-
ated through the interplay of color. Works that make use of this method tend
to use color itself to express emotions or mood. The color relationships can
affect all the ingredients that make up a picture. Colors can be used to create
calm or tension. They can make the illusion of depth or make things appear
flat.

Simplicity

When putting together a composition keep things simple. Beware of incor-
porating too many colors into the picture. This can create visual confusion as
the different colors will be in competition to dominate. Let one hue clearly
predominate. The proportions of the colors in the scene will determine which
is the strongest. A small area of a warm color like red can balance and dom-
inate a much greater area of cool color like green.

Dominance may be achieved with a small area of a bright color against
a field of flat color. A large area of subdued color can also be dominant. The
value of a hue is a relative quality and changes from situation to situation (see
Color Description/Luminance in chapter 4).

Maintaining a Strong Composition

The dominant color must retain a working arrangement with the main point of interest in the picture. If color is not the subject itself, then it should reinforce and enhance the subject. Don't let the two clash or the viewer may have a difficult time determining what the purpose of the picture is. Don't send conflicting or confusing messages to the audience. Be straightforward and provide a well-marked visual path for the eye. Strong colors attract attention. Do something with it once you have it.

Shape becomes important. Use tight, controlled framing to make strong graphic effects. Get close and eliminate the nonessentials. A neutral or even black background can make the color stand out.

Assignment

Plan and execute a photograph that demonstrates the understanding of dominant color.

Isolated Use of Color

The energy and the visual spark of a hue depends more upon its placement within a scene than in the size of the area which it occupies (figure 18.6). Imagine a scene of cool harmonious colors that are even, smooth and unified. Now add a dot of red. Pow! It surprises the eye and instantly becomes the point of emphasis. Its solitariness stands out as a point of beauty. Its individuality introduces needed variety into the picture space.

Most colors have the greatest luminance when they appear against a neutral setting. Warm colors will step forward, adding depth and sparkle into a picture that was flat. Take an overcast or dusty day in which everything looks and feels of the same dimension. Add a small amount of a warm hue and contrast, depth, drama, emphasis, and variety appear out of this sameness. Do not underestimate the power a single individual color can have on the entire composition.

Advanced Planning

Often getting this single color in the right place at the right time requires the photographer to be ready in advance. Anticipating the moment will greatly increase the likelihood of this happening. Coordinating the light, background, and proportion of the isolated color means the photographer needs to feel confident and comfortable with the equipment and techniques being used. Practice and readiness are the prerequisites that let the picture maker take advantage of chance.

Check the situation out carefully. Ask in advance, "Which lens will be needed to get the correct proportion of that single color into the composition?" Be ready to improvise. If the lens that is needed is not available, will getting closer or further away make it work? Approach each new situation with openness that will allow adapting and accommodating the subject without becoming static or hackneyed.

Figure 18.6
Divola's use of isolated color adds contrast, drama, and depth while visually using color to call attention to the subject.

© John Divola "Wolf, 1986" Dye Transfer 18½" × 18½"
Courtesy of Jayne H. Baum Gallery, NY, NY

Working Plan

Getting the right amount of a unified color background is generally one of the first items necessary to catch this touch of color in the picture. Next comes the actual placement of that hue. Third is being sure of having the correct exposure.

For example, a monochromatic sky is the backdrop and the spot of warm color is located on ground level in the shadow area. There are a number of exposure possibilities available depending upon the desired outcome. If detail is to be retained in both areas, take a meter reading from the sky and one from the foreground and average them together. If the sky is f/8 and the ground is f/4, the exposure for that situation would be f/5.6. If detail in the foreground area is critical, expose for the key shadow area by getting in close or tilting the camera meter down so as not to include the sky. If the light is similar where you are standing, meter off of your hand. The sky will receive more exposure than necessary. If this is not corrected for during development, the sky can be burned-in by giving it more exposure when the print is being created.

Movement makes for visual excitement. It can be produced by placing the camera on a tripod and using a slow shutter speed to introduce a warm object in motion against a static monochrome setting.

. .

Assignment

Use one of these suggestions to make a photograph that relies on an isolated color to achieve its effect.

Monochrome

Some people think that in order to have a good color photo, it must include every hue in the spectrum. Often reducing the number of colors in the composition will create more of an effect than assaulting the viewer with the rainbow.

What Is Monochrome?

A narrow definition of a monochromatic photograph would mean one that uses only a single hue from any part of the spectrum. In a broader sense it can indicate a photograph that creates the total effect of one color, even though there are other hues present (figure 18.7).

When putting together a monochrome picture, the photographer can call into play knowledge, judgments, and understanding of composition that has been developed in black-and-white photography.

The Subjective Nature of Monochrome

Monochromatic photographs can create powerful moods. It simplifies the composition so that we tend to react more subjectively and less rationally. The photograph is not taken so much as a document to be read for information but as an event that elicits a sense of time and place. It can alter the normal flow of time and flatten the sense of visual space.

Figure 18.7
The monochromatic use of color by Mitchell flattens the visual space and alters the feeling of photographic time. We read the photograph not as a document for specific facts but as an event to be interpreted in a subjective manner.

© Suzanne L. Mitchell "Daytime Drama, 1983"
16" × 20" Type C print

Color Contamination

When dealing with a monochromatic image, beware of what is referred to as environmental color contamination. This occurs when a colored object within the scene reflects its color onto other items within the picture area. Color contamination can be in the form of a bright plaid shirt the photographer is wearing that reflects back onto the subject. Oftentimes objects within the composition will spill their color onto their neighbor. This is most noticeable when working with white items. It is possible for a white object to make another white object appear to be an off-white. Careful observation of the scene and the arrangement and selection of objects to be photographed is the best way to deal with this problem.

Exposure

Exposure is critical to maintain the fragile color and atmosphere. Monochromes need not lack contrast. Subdued colors and harmonious colors can be employed to give monochromatic impressions.

Aerial Perspective

Colors in distant scenes are muted by the atmospheric scattering of light, so tones appear progressively paler as the landscape recedes. This is known as aerial perspective. The blending and softening of colors in this condition can help to create a monotone rendition of a scene.

Assignment
Where to Begin

Make a photographic image that makes use of the monochromatic color concepts to create its visual power. The following situations offer starting places for monochromatic pictures in which both the color and detail is simplified: early morning, late in the day, storms, rain droplets, dust, pollution, smoke, iced or steamed windows, plus scenes that contain diffused light and lower than average contrast. Other techniques that can be employed to mute colors include deliberate defocusing, moving the camera while the shutter is open, soft-focus methods such as a diffusion or soft focus screen, and the use of filters.

Perspective

Perspective allows the artist to give two-dimensional work the illusion of the third dimension and furnishes depth (figure 18.8). Light and shadow begin to provide depth, but the actual illusion that one item in the composition is closer to the front than the other is brought about through the use of perspective.

Basic Types of Perspective Control

The following are seven basic types of perspective control commonly used in photography:

Aerial perspective is the effect in which colors and tones become blurred, faded, and indistinct with distance due to atmospheric diffusion. The colors in the foreground are brighter, sharper, warmer, and have a darker value than those that are farther away. There is a proportional decrease in luminance and warmth with distance which can be reduced with UV and/or a warming filter such as the 81A and 81B;

Diminishing scale creates depth by using the fact that we assume that the farther an object is from the viewer the smaller it seems. By composing with something large in the foreground and something smaller in the middle or background the picture maker can add to the feeling of depth. It is also possible to trick the viewer's sense of depth by reversing this order;

Position makes the visual assumption that objects, when placed in a higher position within the picture, are farther back in space than those toward the bottom of the frame. The same rules as those in diminishing scale apply to position;

Linear perspective happens when parallel lines or planes gradually converge in the distance. As they recede, they seem to meet at a point on the horizon line and disappear. This is called the vanishing point;

Two-point linear perspective can be achieved by photographing the subject from an oblique angle (an angle that is not a right angle; it is neither parallel or perpendicular to a given line or plane). This is most easily seen in a subject that has vertical parallel lines like a building. When it is viewed from a corner, two walls of the building will seem to recede toward two vanishing points rather than one. The closer the corner of the building is to the center of your composition, the more of a sense of depth, distance, and space will be attained. If the building is placed in one of the corners of the frame it will flatten one of the walls while making the other look steep;

Figure 18.8
Linear perspective is revealed by Crable's use of camera placement plus repetition to create the illusion of depth, distance, and space. The neutral color scheme is broken up with accents of warm colors to create contrast.

© James Crable "Empire State Plaza, Albany, NY, 1985" Type C prints 28″ × 28″ Courtesy of J. J. Brookings Gallery, San Jose, CA

Overlapping perspective occurs when one shape in the picture is placed in front of another, partially obscuring what is behind it. This is a good compositional device to indicate depth;

Selective focus is another method open to photographers to create the illusion of depth. To the eye a critically focused object set off by an unsharp object will appear to be on a different plane. Employing the maximum lens opening is a way to separate the foreground from the middle ground and background. Since the depth of field is extremely limited, whatever is focused upon will appear sharp, while the detail in the remainder of the picture will be destroyed. Using a longer than normal focal length lens will reduce the amount of depth of field at any given f/stop. The longer the focal length of the lens, the less depth of field it will have at any given aperture.

Limiting depth can be accomplished visually by incorporating a strong sense of pattern into the composition, which will tend to flatten the sense of space in the picture.

Converging Lines

A common problem photographers run into in dealing with perspective is converging vertical lines. For example, when trying to make a picture of the entire front of a tall building, it is possible that the camera may have to be slightly tilted to take it all in, or that a wide angle lens is necessary; both of these will cause the vertical lines to converge. Convergence can be visually pleasing as it emphasizes a sense of height.

If you need to maintain correct perspective and keep the verticals parallel and straight, a perspective control shift lens is required on a 35mm camera. On a larger format camera raising the front or tilting the rear will allow perspective correction. It is possible to minimize this effect by moving farther away from the building and using a longer focal length lens. This is often not possible in a cramped urban setting. If negative film is being used, there is one course of action still available. In the printing stage, it is possible to tilt the easel upward to correct the converging verticals. If the enlarger permits, tilt the lens stage as well to maintain image sharpness. Use a steady prop to make sure the easel does not move, focus in the middle of the picture after the easel is in position, and use the smallest lens opening possible to get maximum depth of focus.

. .

Assignment

Make a photograph that deals with at least one of the uses of perspective covered in this chapter.

Subdued Color

Subdued color photographs are generally dark, possess a uniform tonality, and contain unsaturated hues with large shadow areas and at least one bright highlight. In some cases, certain colors will appear more saturated due to the fact that they are set against a dark backdrop. The low tonal range of these compositions can be used to induce drama, mystery, sensuality, and the element of the unknown (figure 18.9).

Figure 18.9
The feeling of a pleasant mystery is woven by Heiliger's subdued use of color. The diffused, even light combines with the subtle rose color of the wall and the soft wispy sky to elicit this response.

© Linda Heiliger "Coral Sky" Type C print Courtesy of Jayne H. Baum Gallery, NY, NY

Chapter Eighteen

Working Techniques

Some working techniques to consider:

Use light that will strike the subject at a low angle.

Exposing for the highlights, which will let the shadows be dark and deep. Bracket the exposures until you are able to judge what the final effect will be.

Minimize background detail by using a higher shutter speed and a larger lens opening.

Let the subject block out part of the main source of illumination. This produces a rim lighting effect, which will also reduce the overall color contrast and tonal range.

Have a dark, simple uncluttered background.

Select the major color scheme of dark hues.

Work with a diffused or weak source of illumination. This will often occur naturally in fog, mist, or storms. This effect also reduces the scene's tonal range.

Use a diffusion filter. If you do not have one, improvise with a stocking or a piece of cloth.

Assignment

Make use of at least one of these ideas to produce a photograph that relies on subdued color for its impact.

Favorite and Unfavorite Colors

Everyone seems to respond positively to certain colors and negatively to others. This also applies to combinations of colors. Think about what colors are most often included in your own work. Do these colors appear regularly in other areas of your life (in the colors of the clothes that you wear or in how you have decorated your living quarters)? Which colors do not make many appearances in your work? Are these colors also avoided in other aspects of your life?

Picture Ideas

Possible pictures to shoot with favorite and unfavorite colors include:

Making one picture that emphasizes your favorite color or combination of colors. What are the qualities of these colors that are appealing to you?;

Making another picture that deals with colors that you have an aversion to. What is it about these colors that puts you off?;

Changing the color of a known object through the use of light or paint at the time of exposure or through the use of an unnatural filter pack when printing.

Figure 18.10
By altering the color of a familiar object, Brown makes the viewer do a visual double take. This reveals how important an object's color can be in relation to the reaction it creates in the audience.

© Lawrie Brown "White Rice, 1982" Type C print with thread Courtesy of J. J. Brookings Gallery, San Jose, CA

Overcoming Color Bias

After making these pictures, look at them and see what associations are created for you from these colors. What effect is created by changing the natural color of an object (figure 18.10)? It is possible, by working with a color that one dislikes, to see that something beautiful and meaningful can still be created (figure 18.11). This teaches us that our preferences and dislikes in color and in life often result from prejudices, which are a manifestation of fear caused by inexperience, lack of insight, and the failure to think for oneself. Do you really hate the color orange or was it your mother's least favorite color? Question yourself about these things. Keep your possibilities open so that you can achieve your full potential.

Pairs of Contrast

Use color to make pictures that express pairs of contrast. The object of prime visual importance is not only the actual subject matter in the scene but the colors that make up the scene. It is the colors themselves that should be used to express the ideas of contrast (figure 18.11).

Counterpoints

Consider these counterpoints: happy and sad; old and young; large and small; bright and dull; fast and slow; evil and good; calm and stormy; peaceful and warlike; hate and love; and apathy and decisiveness.

Assignment

Make a photograph that deals with the use of pairs or counterpoints (such as those listed in the previous section) as its major theme.

Reaction to Counterpoints

What are your reactions to these pairs of color contrasts? Are they what you expected? When shown to an audience, do the reactions to the color associations seem to be consistent or do they vary widely from person to person? What does this tell you about the nature of color response?

Figure 18.11
Stravato expresses pairs of contrast by use of counterpoint expressions on the faces as well as the warm and cool complementary colors of yellow and blue.

© Michael Stravato "Happy/Sad, 1987" Type C print 11" × 14"

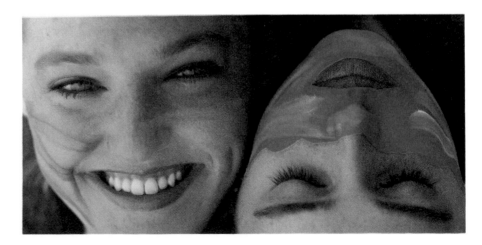

Chapter Eighteen

∴

The Interaction of Color, Movement, Space, and Time

"Standard Oil Building with Corinthian Top"
Scott Mutter
12″ × 9″,
J J Brookings Gallery, San Jose, CA.

·

The Flow of Time

When most of us think of a photograph, we think of a tiny slice of time, removed from the flow of life with a frame around it. Everything is still; nothing moves. That brief instant of time is there for examination. Convention has come to dictate that everything be presented like evidence at a trial, clear and sharp. "The more readable the detail, the better the picture," is a photographic maxim that has been the standard of a picture's worth for many people.

Control of Photographic Time through the Camera

This section will call into question these basic photographic axioms. By turning the shutter to a slower speed, one can increase the amount of time encompassed by the photograph. When the amount of time incorporated into the image is increased, more events become involved in the structure of the composition. This extended play of light on the film can have spectacular results. As light is recorded over a period of time a new fascination with color emerges as the hues swim together and blend into new visual possibilities. When the amount of time in an event is likewise decreased from what it is normally expected to be, a new way of seeing and experiencing is presented to the viewer.

Breaking Away from 1/125

The simplest way to begin to break away from the standard 1/125 of a second mentality is by working with the different methods of dealing with motion. The following are offered as starting points.

Stop Action

Stopping the action of an event can be achieved by using a fast shutter speed or flash in conjunction with a high-speed film. Consider freezing motion when it offers the viewer the opportunity to see something that happens too quickly for the eye to fully comprehend (figure 19.1). It also offers a way to stop an event at a critical point of the action for further analysis and study.

Figure 19.1
Stop-action photography lets the viewer have the time to study and analyze an event that occurs too rapidly for the eye to normally comprehend. Hirose makes use of hand-applied color to further control and heighten the mood of the situation.

© George Hirose "Ticker Tape, NYC, 1984" Hand colored silver print 16″ × 20″

Chapter Nineteen

Anticipation and timing are crucial to capture the climax of an event. Whenever possible, watch and study the action before shooting. Become familiar with how the event takes place. When shooting a stop-action photo select the appropriate vantage point and lens, then preset both the exposure and focus, taking care to use the smallest aperture to attain maximum depth of field. A wide angle lens will allow more room for error because it has more depth of field at any given aperture than a normal or telephoto lens.

The telephoto lens can be used to isolate the action. A minimum depth of field will separate the subject from the background. Prefocusing becomes critical, because any inaccuracy will result in the subject being out of focus.

The shutter speed needed to stop motion depends upon the speed of the subject and its direction and distance from the camera (Table 19.1). The nearer the subject or the longer the lens, the higher the shutter speed will need to be. A subject moving across the frame will require a higher shutter speed than one approaching head-on or at the peak of its action.

Dim Light and Flash

In dim light, flash rather than shutter speed, can be used to stop action. The speed of the movement to be stopped is dependant upon the duration of the flash. A normal flash unit will usually give the equivalent speed of between 1/250 to 1/500 of a second. Fractional power setting can supply much faster times, up to 1/10,000 of a second.

The Blur

The blur interjects the suggestion of movement into the picture (figure 19.2). Determine what shutter speed is needed to stop the subjects movement in relation to the camera position. A slower shutter speed will cause more blur and consequently more contrast between the moving and static areas. This can isolate a static subject from its surroundings. Consider which details are crucial, and need to be retained. Decide whether it will be more effective to blur the background or the subject.

Table 19.1
Shutter Speeds Needed to Stop Action Parallel to the Camera

1/125 of a second: most everyday human activities, moving streams and rivers, tree in a slight wind.

1/250 of a second: running animals and people, birds in flight, kids playing, balloons and kites, swimmers, waves.

1/500 of a second: car at 30 mph, bicyclists, motorcyclists, baseball, football, tennis.

1/1000 of a second: car at 70 mph, jet airplanes taking off, skiers, speedboats, high-speed trains.

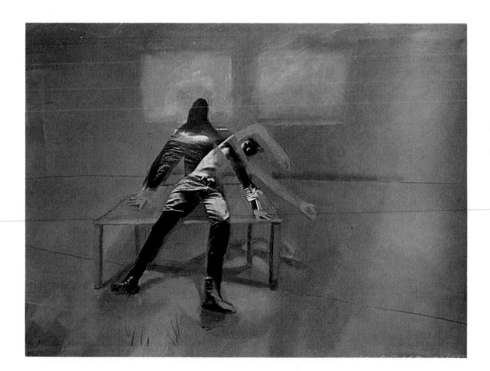

Figure 19.2
The blur lets the photographer interject the suggestion of movement into the photograph. Robert's hand coloring sets the mood, eliminates the unnecessary, and supplies additional items in time and space that were not included at the time of exposure.

© Holly Roberts "Bob Dreaming" Oil on silver print 16" × 20"

The Pan Shot

The camera can be intentionally moved to create a blur. One of the most effective ways to convey lateral movement, while freezing the subject and blurring the background, is the pan shot. Ranger finder-style cameras are easier to use for this because, unlike a single-lens reflex camera, they contain no moving mirror to black out the viewfinder during exposure. With practice, most any camera can be used with success.

Start out with a subject whose movement and speed are consistent. To accomplish the pan shot, use a slow film, holding the camera comfortably in the horizontal position. Prefocus on the spot that the subject will cross and set the needed shutter speed. For example, 1/15 of a second can be used to pan a vehicle moving at 30 mph and 1/30 of a second for 60 mph. Correlate the aperture with the speed, using the smallest aperture to get maximum depth of field. Frame the subject as soon as possible. Do not tighten up or hold the camera with a death grip; stay loose. Make the pan clean and smooth by following the subject with your entire body, not just with the camera. Gently release the shutter as the subject fills the frame and continue to follow through with the motion. Generally, take care not to crowd the subject. Leave it some space to keep moving unless containment is the object. After this is mastered, try incorporating some variations such as panning faster or slower than the object in motion. Further motion effects can be created by using the slow shutter speed and intentionally moving the camera in nonparallel directions from the subject.

Many random elements enter into these situations that involve long exposures. It becomes a deliberate combination of intent and chance. With practice, it is possible to get an idea of what the final outcome will look like. The unpredictability of these situations adds to their fascination.

Moving the Film

Film movement can achieve the effect of blending colors in motion. Put the camera on a tripod and hand crank the film past the shutter during exposure using a speed of 1/8 of a second or slower (figure 19.3).

Equipment Movement

Equipment-induced movement can provide an exaggerated sense of motion. Consider the following ideas:

Use a wide angle lens (24mm or wider). This will produce dramatic feeling of motion when employed to photograph movement at close range and at a low angle. The exaggerated sense of perspective created by this lens produces distortion which causes background detail to appear smaller than normal, thereby loosing visual importance. Conversely, foreground objects will seem larger and more prominent;

A multi-image prism that fits in front of the lens is another possibility. Its use requires care because it has been overused by dull people who have employed the prism in an attempt to couch their ineptitude in gimmickry. All these ideas can be abused by the unthinking. When a piece of equipment is used in place of an idea, the result is a gimmick. When a photographer has to resort to gimmicks, control of the situation has been lost. Whenever equipment is used to strengthen and support an idea, the picture maker is working with a technique;

Figure 19.3
Jurus's strip photograph blends the subject
and colors, achieving the effect of motion in
a method that relies upon a unique aspect
of camera vision. Jurus built his own linear
strip camera with a slit shutter to make this
image. The film was exposed by cranking it
past the slit. In this case the exposure time
was about five seconds.

© Rick E. Jurus "Zing, TA, TA" Type C print 3¼" × 10"

The zoom lens has become one of the most popular pieces of equipment available to photographers today. It falls into the same danger category as the prism. When used as a tool, the zoom lens can extend the range of photographic vision. Most commonly used is the zoom during exposure to create the illusion of motion. In this method blurred streaks of color come out of the center of the picture. It is a way to give a stationary subject the feeling of momentum. Put the camera on a tripod, set the lens to its longest focal length and focus on the critical area of the subject. Start at 1/15 of a second and then make a series of exposures using even longer times. Be sure to change the aperture to compensate for changes in speed. Zoom back to the shortest focal length as the shutter is tripped. Be prepared to make a number of attempts. Write down the exposure information so that you will know which combination produced each picture. Do not depend on your memory. Part of any learning experience is the ability to use the acquired skill in future applications. It helps to practice the zooming technique with no film in the camera until the operation becomes second nature. Once the basic method has been mastered, it can be combined with other techniques;

The pan zoom technique requires the photographer to pan with the subject while zooming and releasing the shutter. The camera needs to be on a tripod with a pan head. One hand is used to zoom while the other works the panning handle and shutter. A cable release is helpful or an assistant to fire the shutter at your instruction;

The tilt zoom technique needs a tripod with a head that can both pan and tilt. Follow the same basic zoom procedure, but use longer exposure times (start at one second). Try tilting the camera during the zoom while the exposure is being made. After you have this mastered try working the pan into this array of moves. The long exposures will give the photographer the opportunity to concentrate on this variety of camera moves.

Free-Form Camera Movement

Colored sources of illumination at dusk and after dark give the photographer the chance to weave line and pattern into a still composition. With a stationary light source, try using slow shutter speeds (starting at 1/8 of a second) while moving the camera in your hand. Start by making simple geometric movements with the camera while visualizing the effect of the blending and overlapping of color and line. If the camera being used is a SLR, try to sight above the viewfinder or to not look at all, going by feel and instinct. Using a wide angle lens should make this easier. If the camera is jerked and waved about too much the resulting color patterns and lines may become confusing.

Figure 19.4
The five-minute-long exposure in
Baskerville's piece introduces movement
into the composition. The unrealistic color
was achieved by exposing the rocks in the
foreground with a red flashlight and the
waves with a yellow flashlight, turning the
ordinary into the surreal.

© Tim Baskerville "Sutro Ruins, 1981"

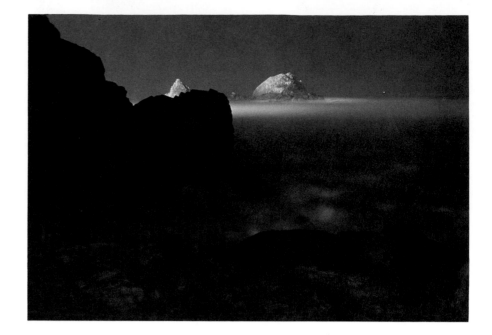

Moving lights can put color and motion into a static environment. With
the camera on a tripod using small apertures, make exposures at ten, twenty,
thirty, or more seconds. Try not to include bright nonmoving lights as they
will become extremely overexposed and appear as areas with no discernible
detail.

Extended Time Exposures

Long exposures can be made over a period of time with the camera attached
to a tripod and the lens set to a small aperture (figure 19.4). A slow film can
be used to make the exposure longer. To make an even longer exposure, use
neutral density filters in front of the lens. Avoid bright static sources of light.
Events like wind and passing lights will introduce motion. Reciprocity failure
will cause a shift in the color balance.

Rephotography

Rephotography is when a photographer returns to a subject that had been
previously photographed and attempts to make the exact picture again to
show how time has altered the original scene. The original photograph and
the new one are usually displayed next to each other to make comparison
easy.

In another form of rephotography, the photographer returns to the same
subject over a period of time (figure 19.5). Examples of this would range from
making a picture of yourself every day for a week to Alfred Stieglitz's pho-
tographs of Georgia O'Keefe that span decades. The relationship of the pho-
tographer and the subject is pursued over a period of time. The results should
represent the wide range of visual possibilities that can be produced from
this combination due to changes in feeling, light, and mood.

Multiple Exposure

Making more than one exposure on a single frame of film offers another avenue
of exploration (figure 19.6). Try it out in a controlled situation with a black
background. Light the set up, mount the camera on a tripod, and prefocus
and calculate the exposure based upon the number of exposures planned.

Chapter Nineteen

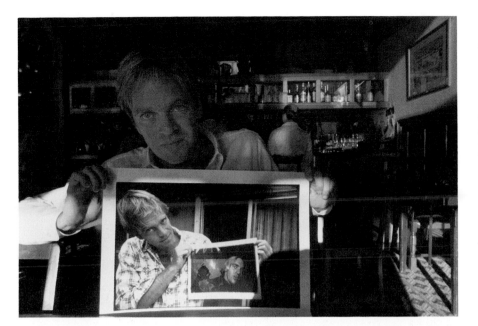

Figure 19.5
Rephotography lets the photographer explore the relationship between the subject and time. Veilands has interacted with this subject during three separate five-year periods. By incorporating the two previous photographs into this piece, a portrait representing a time period of fifteen years emerges.

© Ragnars Veilands "Thom Lochen Through Time and Space" Type C print

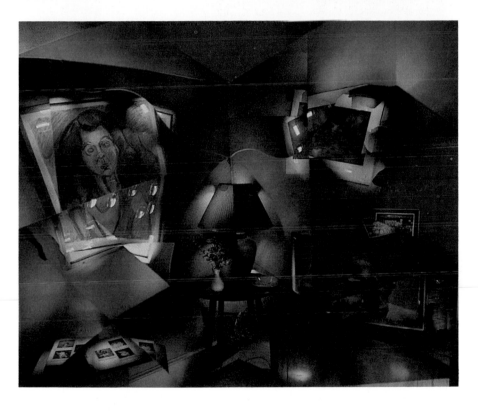

Figure 19.6
Northrup's multiple-exposed images are made possible by cutting out a "stencil/puzzle" from a piece of board and attaching it to a piece of glass in front of the camera. Pieces are removed one at a time and an exposure made for each piece. This alters the sense of time and space as objects are moved from exposure to exposure.

© Michael Northrup "Strobacolor Series. Gort, Klatu Borrada Nikto, 1986" Type C print 16" × 20"

A good starting point is to divide the exposure by the number of planned exposures. For example, if the normal exposure is f/11 at 1/4 of a second, two exposures would be f/11 at 1/8 of a second each. A camera with automatic exposure control can do the same thing by multiplying the speed of the film by the number of exposures and then resetting the meter to that new speed.

Try varying the amount of exposure time. This can give both blurred and sharp images as well as images of different intensity within one picture. Repeated firing of a flash will provide multiple exposures when the camera shutter is left open on the "T" or "B" setting. Move the subject or the camera to avoid getting an image build-up at one place on the film.

Figure 19.7
Meares uses a flashlight, a penlight, and a
strobe with colored gels to paint the
composition with light, resulting in a
dynamic sense of fantastical movement.

© Lorrah Meares "Configuration For A Lovecall"

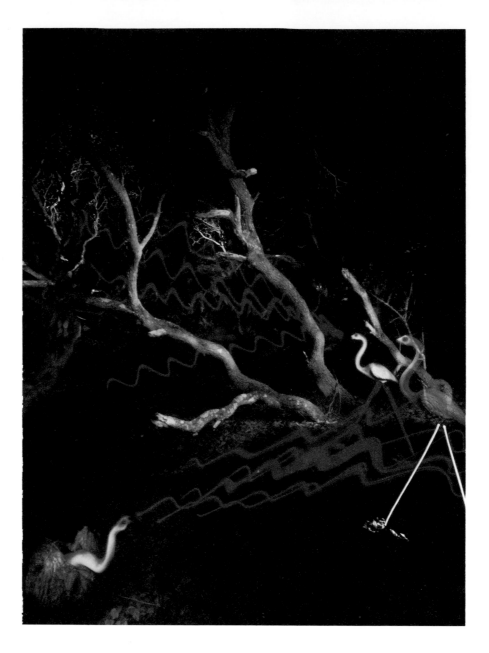

Painting with Light

Using light as a paintbrush requires setting the camera on a tripod with a
medium to small lens aperture (figure 19.7). Start with a subject against a
simple backdrop in a dark room. Prefocus the camera, then use a small pocket
flashlight with a blind to control the amount and direction of the light. Leave
the lens open (use the "T" setting or the "B" setting with a locking cable
release). By wearing dark clothes, the photographer can quickly walk around
within the picture drawing with the light without being recorded by the film.
Imagine how the light is being recorded. Since the final effect is difficult to
anticipate, be prepared to make a series of exposures. Vary the hand ges-
tures used with the light source to see what effect will be created.

Postvisualization

The darkroom offers the photographer a postexposure opportunity to expand and induce movement and time into a still scene. Application of these postvisualization methods can break the photographic idea that time is a mirror rendering the appearance of nature into the hands of man. These techniques let the photographer increase the possible modes of interaction with the work. These techniques include the interaction between positive and negative space, and interaction between different aspects of the same event, the interaction between static structure and movement, and interaction between the viewer and the object being viewed. Be ready to experiment and rely upon intuition.

Moving the Easel

When moving the easel, prepare to print in the normal fashion. Calculate the proper exposure, giving the print 75 percent of that figure. Make a second exposure of the remaining 25 percent and move the easel during this time. This ratio may be altered to achieve different results. The easel may be tilted during the exposure or the paper can be curled and waved outside of the easel for additional effects. The easel can be placed on a device like a "lazy Susan" and spun to create circular motion.

Moving the Fine Focus

Moving the fine focus control on the enlarger is a method to expand the picture. Give the print two-thirds of its required normal exposure time. For the remaining one-third exposure time, move the fine focus adjustment on the enlarger. To give yourself more time to manipulate the fine focus control stop the lens down and increase the exposure time. The outcome will be determined by how fast the fine focus control is moved, how long it is left at any one point, and the proportion of normal exposure to moving exposure.

Painting the Print with Light

Painting the print with light can be accomplished with a small penlight fitted with a handmade opaque blinder. The blinder acts as an aperture to control the amount of light. If this is done during the development stage of the print it will produce a partial Sabbattier effect. Different transparent filters can be placed in front of the flashlight to alter the color effects. This technique can often be effective when combined with other methods, including the masking of specific portions of the image (figure 19.8).

Multiple Exposure Using One Negative

Exposing one negative a number of separate times onto a single piece of printing paper can vastly alter the perception of time within the picture. Many variations are conceivable.

Reduce the size of the picture and print it a number of times on a single piece of paper. Let parts of each picture overlap to form new images.

Vary the size of the picture as it is printed on the paper.

Change the exposure times in order to create a variety of densities.

Print the full frame on part of the paper and then print different parts from the negative onto the paper.

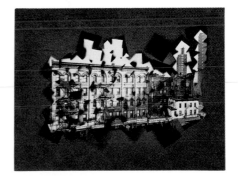

Figure 19.8
This print was painted with light during the exposure phase of processing. Masking was used to control the areas that were struck by light and color was added later with an airbrush.

© Robert Hirsch "View From Thom's Studio, 1986"
Airbrushed silver print 16" × 20"

Figure 19.9
Crowell's combination of a regular color print with a photogram combines the rich colors of the flowers with the blackness of the photograms. This produces a finished image that possesses the illusion of floating in deep space.

© Cathy C. Crowell "Iris #6, 1982" Type C print 16" × 20"

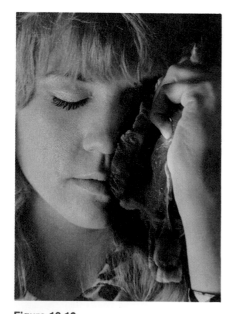

Figure 19.10
Stravato's colors emphasize the mood and add contrast to this piece through the use of two separate exposures with two different filter packs.

© Michael Stravato "Untitled, 1987" Type C print 11" × 14"

Combination Printing

Printing more than one negative on a single piece of paper jettisons the traditional picture vision and embraces a far more complex image of reality. This is done by switching negatives in the enlarger or by moving the paper to another enlarger and easel that has a different negative setup for projection. Opaque printing masks are used to block out different parts of the paper in order to control the areas of exposure.

Combination printing can also involve combining a negative with a photogram or varying the exposure time of different parts of the print (figure 19.9). Determine the proper exposure and give a percentage of it to the paper, then mask certain areas and give the remainder of the exposure.

Multiple Filter Packs

Making use of more than one filter pack can transform the picture's sense of time (figure 19.10). Start with a negative that contains a basically monochromatic color scheme and simple linear composition. Print one area of the picture with the normal filter pack while holding back the exposure on another part of the print. Now change the filter pack.

Consider working with complementary colors. Print in the area that was dodged out during the first exposure while holding back that part of the print that was already exposed.

The Cinematic Mode

The cinematic mode of picture making, in which each new frame implies a new episode or another step, modifies the way photographic time is perceived. It is concerned with the interaction between the objects of the composition. The space between objects can become part of the same structure as the objects. Forms actually reverse themselves.

Cinematic Sequence

The vitality of movement can be conveyed through the use of traditional still pictures linked together to form a cinematic sequence of events. This group of pictures is designed to function, not individually, but as a group (figure 19.11). The sequence must be able to provide information that a single image would be incapable of doing. A sequence can tell a story, present new information over an extended period of time, or supply a different point of view.

The Matrix-Grid

The grid can be used as a device to lead the viewer through the details and visual relationships of a scene. Get a few packs of Polaroid SX–70 film. Photograph a person or object so that the pictures have to be combined to make a complete statement (figure 19.12). The pictures do not have to be made from one frozen vantage point, but rather from a general point of view. It is possible to incorporate a number of variations of the subject into one single statement.

This type of picture invites the audience to spend time looking at it because the sense of time is fluid; it cannot be taken in all at once. The viewer must take many separate glimpses and build them up into a continuous experience, much like the way we see the actual world around us.

Figure 19.11
In this cinematic sequence Walsh has designed the single images to function as a group. Made at that special time of day, just after sunset, the soft residue of ambient skylight is balanced against the harsh artificial lights of the world at night.

© Joseph Walsh "Untitled, 1986" Type C print

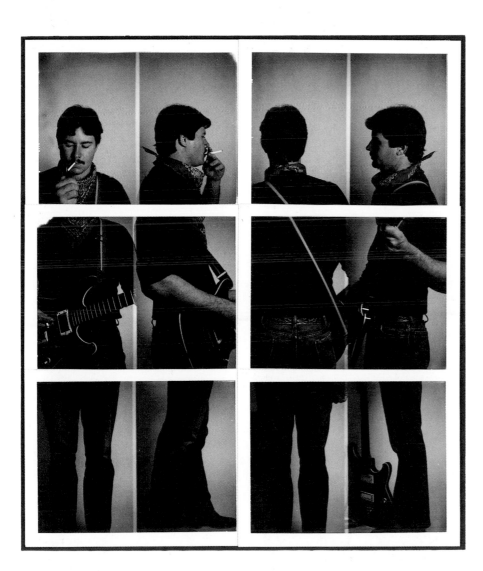

Figure 19.12
Steele's matrix-grid portrait supplies the viewer with additional information that could not be contained in a traditional print. The sense of time becomes more built up and fluid, inviting the audience to spend more time looking at the image.

© Tom Steele "Tracey II, 1986" Polaroid prints

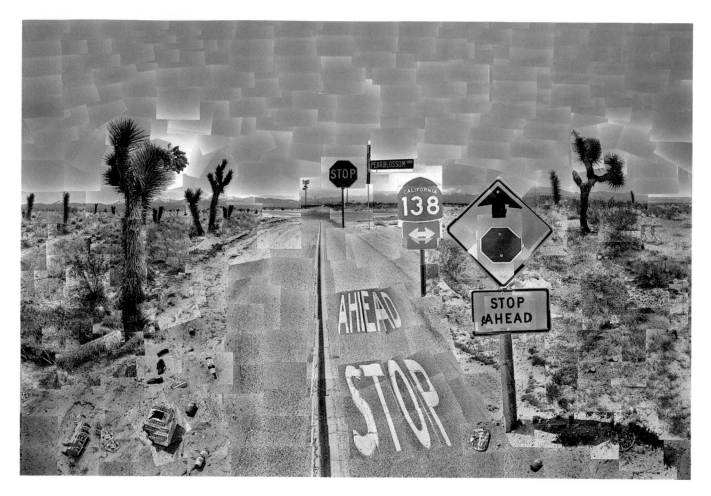

Figure 19.13
An incredible painterly sense of time, space, and place is woven by Hockney's masterful application of the "many make one" method. Exposing 650 rolls over a nine-day period, Hockney used about one thousand single images to create the final composition.

© David Hockney "Pearblossom Hwy., 11–18th April 1986" (2nd version) Photographic Collage, 78" × 111"

•

Many Make One

"Many make one" describes the visual process of photographing a scene in numerous individual parts and then fitting these single pieces of time together to create one image (figure 19.13). The single pictures of the original scene are not made from a specific vantage point but a general one. This encompasses different points of view over an extended period of time.

The focus may also be shifted to emphasize important elements of each single frame. Have the film processed and printed. Take all the prints and spread them out on a big piece of mat board. Begin to build an entire image out of the many components. It is okay to overlap pictures, discard others, have open spaces and unusual angles. Try not to crop the single pictures, because a standard size seems to act as a good unifying device. When the arrangement is satisfactory, attach the prints to the board. They do not have to be flush.

This method of picture making can expand the sense of space and time that is often lost in a ordinary photograph. It breaks down the edges of a regular photograph. It expands the frame beyond the conventional four perpendicular edges and can bring the viewer right into the picture.

Contact Sheet Sequence

The contact sheet sequence is a modified technique of using many single contact size images to make a statement. Pick a scene and imagine an invisible grid pattern in front of it. Photograph that scene using this invisible pattern as a guide. Process the film, then arrange the negatives into the desired order based upon your grid pattern, and contact print them to form a complete image.

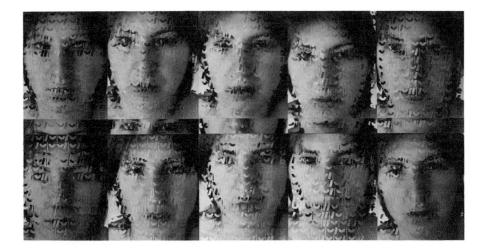

Figure 19.14
The joiner technique is employed by Kroff
for this installation piece. The work is formed
from fifteen separate images that are joined
together to make the final work.

© Linda Kroff "U/UU//, 1987" Type C prints 52" × 96"

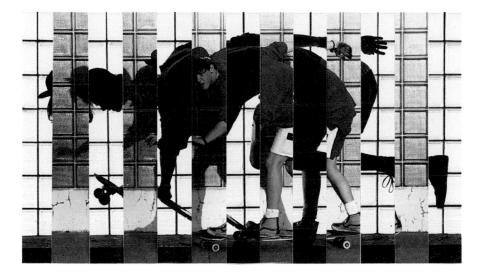

Figure 19.15
Marlin's slices of time play the subject off its
shadow and use variations in print density
to achieve an overall effect of depth and
motion.

© Paul Marlin "Vision Quest, 1987" Type C prints

Joiners

Joiners are created when a number of separate images of a scene are com-
bined to make a whole (figure 19.14). The subject can be divided into sepa-
rate visual components that are photographed individually. Each part provides
information about the subject that could not have been included if the subject
was shot in a single frame. These additional exposures should alter how the
subject is perceived. This includes its relative position in time and space,
changes in vantage point, angle, and variations in subject to camera dis-
tance. Single prints are made, laid out on a mat board, arranged, fitted, or
trimmed, and attached into place.

Slices of Time

Slices of time occur when a single scene is photographed a number of sep-
arate times to show the visual changes that can occur over a period of time
(figure 19.15). Intentional alterations in light and placement of objects can be
made each time the scene is rephotographed. Make the prints and then cut
each one into slices of the same size. This will act as a unifying element.

With practice the pieces may be cut into a variety of different sizes and
shapes. Keep each cut picture separate. Select one of the pictures to be the
master print. Arrange it on a mat board and begin to combine the slices from
the other prints into the single master print. When complete, attach the slices
to the board.

Figure 19.16

Farber's work challenges our perceptions and prejudices about what a photograph can be and do for the viewer. The layering effect between the paint and the photographic image juxtapose illusion and reality through the process of obscuring and revealing the scene.

© Dennis Farber "Ritual Observance, 1986" Type C print with paint 27" × 38" Private collection

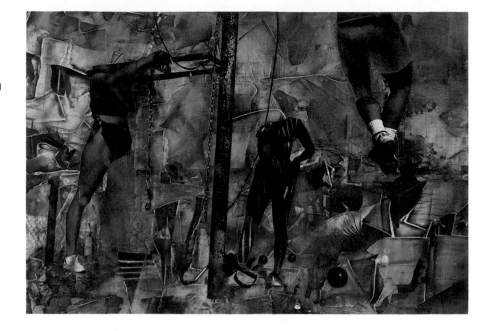

Figure 19.17

Klidzej's collage technique began with the scratching of Latvian symbols into the negative that was then printed and hand-colored. Additional items were collaged and sewn onto the surface of the image, providing a commentary on our contemporary gods of money, power, and territory.

© Angie Klidzejs "Colorful Character #13, 1982/83" Mixed Media 16¼" × 20¼" × 1¾"

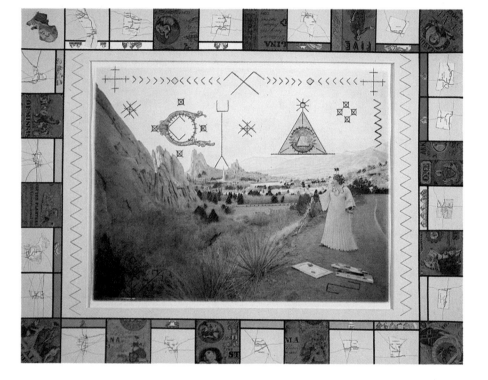

Composite Pictures

Composite photographs occur when visual elements from various sources and mediums are intertwined, then cut out or pasted on a common support material and rephotographed to obtain the final image. If it is not rephotographed, it is considered to be a montage.

Pictures of astonishing paradox can be produced using this method (figure 19.16).

Photographic Collage

A photographic collage is made when cut or torn pieces from one or more photographs are pasted together, often with three-dimensional objects, to produce the final picture. It is not rephotographed (figure 19.17). In this technique no attempt is made to hide the fact that it is an assemblage.

Three-Dimensional Photographs

Three-dimensional photographs can be made by emphasizing one attribute of a subject—color, pattern, shape, or texture—by having it physically come off the flat picture surface (figure 19.18). This exaggeration in time and space calls attention to that aspect of the subject while deemphasizing its other qualities.

Penetrating the Photographic Mirror

Being able to understand this type of nontraditional photographic time means continuing to penetrate the mirror of reality. Whenever traveling into the unknown one can hope to be rewarded with understanding. Ironically, the information that is brought with you may prove to be invalid in new circumstances. Be prepared to expand your previous concepts of how reality is composed.

Many times the most important aspects of a scene are hidden because of their familiarity and simplicity and our own lack of knowledge. When an urban dweller drives by a field with cattle in it, the urban person sees a field with cattle in it. When a farmer drives by the same field he sees something entirely different. The farmer can identify the types of cows, know what kind of condition they are in, what is planted in the field, and how it is growing. Both are viewing the same scene, but the farmer's broader knowledge and understanding of what is there allows him to read more of the visual clues that are in the scene. This provides the farmer with a richer and more accurate account of the scene.

By expanding our picture making endeavors we create new ways to look at the world and enlarge our understanding of its complex system of interaction.

Figure 19.18
Photography, painting, and sculpture are combined in Felix's hieroglyphic imagery as concave and convex screens. The screens are designed to follow the overall contours or feelings of the work as it was photographed. Paint is then applied along the perimeter of the screen and sometimes on the image itself. This work is a prototype designed to be placed on aluminum, allowing more flexibility in the angles of the work.

© Richard Felix "Lil Newspaper Rock, 1987" Shaped and painted Type C paper Courtesy of J. J. Brookings Gallery, San Jose, CA

Reflecting on Color and Photography

"A Lot Of Me"
John Maggiotto
15″ × 30″, Cibachrome, 1981,
Courtesy of the Jayne H. Baum Gallery, New York,
NY.

⎯⎯⎯⎯
·

Figure 20.1
Sherman's use of self-portraits reveal her secret ambitions, dreams, fantasies, and hopes within the framework of a media-image-saturated society. This work also shows the fun of dressing up and playacting before the camera.

© Cindy Sherman "Untitled (#131), 1983" Courtesy of Metro Pictures, New York, NY Type C print 34¾" × 16½"

Self-Portraits

Since the German artist Albrecht Dürer (1471–1528), artists have expressed many inner concerns through self-portraits. They have shown awareness of their own appearance and traits, producing evidence that will probably outlive them, that they once existed. The picture remains to show others how they once appeared and will gaze back at the viewer in another time. Self-portraits can show oneself as you are or may reveal an ambition to be something other or more than yourself (figure 20.1). These pictures oftentimes reveal the secret self.

Making a Self-Portrait

With these ideas in mind, make a self-portrait. The photograph should express a self-awareness and reveal something that is important for the viewer to know about you. A good way to reacquaint yourself with yourself is to sit down in front of a mirror, alone, without any outside distractions. After studying your image in the mirror, get a pencil and paper and make a series of contour drawings. To make a contour drawing look into the mirror and draw what you see and feel without looking at the paper until you are finished. Based on what you learned from making the contour drawing, make a photographic portrait of yourself.

Portrait of Another Person

Next, make a photographic portrait of someone you know following these same guidelines. This photograph should present information to the viewer that shows something important about this person's character (figure 20.2).

Portrait of an Object

Finally, compose a photographic portrait of an object that will tell your audience something about your feelings and relationship towards it (figure 20.3).

Technical Considerations

Camera Any.

Lens What will best fit the situation.

Film Daylight balanced color film.

Image size Print the full frame of your negative, don't force it to fit the standard 5" × 7" or 8" × 10" sizes. Make the size of your print fit the concerns of the subject. Don't try and fit them into an arbitrary size.

Point of view At least this one time, break with tradition and make some photographs that are not at eye level.

Light Make all your pictures using daylight as your only source of illumination. Do not use any artificial light, including flash.

Ideas Make Photographs

Think before starting to make this series of images. Develop an idea and let it lead you through the process. Edmund Carpenter said, "Technique cannot conceal that meaningless quality everywhere characteristic of art without belief." Techniques mastered can help one to speak, but some of the greatest thoughts have been expressed by the simplest means. Do not be a technicolor equipment gearhead. It is ideas, not equipment, that create powerful photographs.

Figure 20.2
Postvisualization methods, like those
employed by Golden, can be incorporated
into the portrait of another person. This can
both heighten and present additional
information to the viewer about the person's
character.

© Judith Golden ''Datura, 1987'' Mixed media
Cibachrome 24'' × 20''

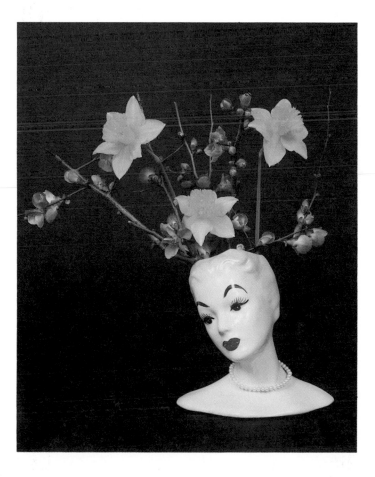

Figure 20.3
Goldberg's feelings are made clear in his
portrait of an object with the use of a simple
color scheme against a black background.
This releases the subject from the confines
of this world and lets it float in its own
universe.

© Gary Goldberg ''Vase, Face, Flowers, 1983'' Polacolor
8'' × 10''

Figure 20.4
Neal has visually conveyed the attributes of eating a hot dog in a warm, funny manner.

© Ellen Neal "Untitled, 1985" Type C print 8" × 10"

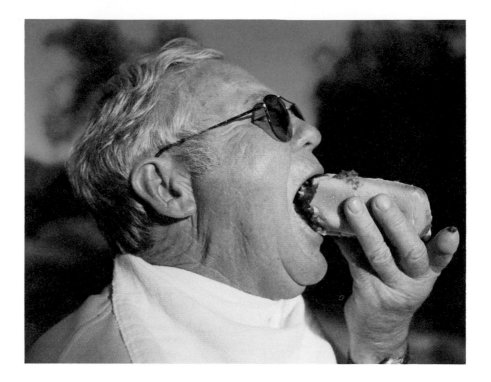

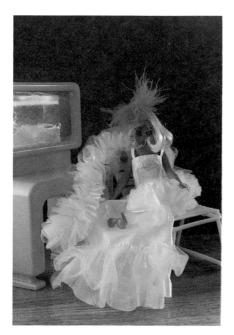

Figure 20.5
Miller has not only disguised the hot dog, but has also been able to change some of its connotations by camouflaging it within a different set of symbols.

© Kay Miller "Untitled, 1985" Type C print 8" × 10"

Truth and Illusion: What Is a Hot Dog?

In 1986 Americans consumed an average of eighty hot dogs per person. It is clearly a national passion.

Our government has been contacted by aliens from another planet. They communicate only through pictures. They have no spoken or written language. They want to know only one thing: What is a hot dog? The president does not know if the aliens' intentions are peaceful or warlike. The president calls on you to solve the dilemma.

Your job is to make two pictures for astronauts to take with them to the aliens. The first one must convey everything that is known about the hot dog (figure 20.4). Make a list of everything that enters your mind when you think of hot dogs (taste, texture, color, mustard, bun, baseball, beer, phallic object).

The other picture must not reveal anything about the true nature of the hot dog. It must be shown, but its true identity has to be hidden, disguised, or camouflaged (figure 20.5).

Depending upon how the astronauts view these aliens, they will determine which picture will be delivered. The fate of mankind on the planet Earth now hinges on your ability to show and to hide and to tell the truth or lie.

Photographic Reality

The photograph has become a major part of our decision-making process. Its inherent ability to transcribe external reality enables it to present what appears to be an accurate and unbiased validation of a scene. While photography is expert at expressing events, it also subtly interprets events by constantly interacting and integrating with the current values of the society-at-large. In reality, the so-called impartial lens allows every conceivable distortion of reality to take place (figure 20.6).

What questions does this raise in your mind about the role of the photographer, the use of the picture, and the subjective nature of the medium? Can you think of any other instances where pictures play this role?

Figure 20.6
Photographic reality permits the photographer to interact with the subject and interject into it, thereby being able to change and interpret reality. Pfahl demonstrates how the so-called impartial lens allows all sorts of distortions of reality to occur.

© John Pfahl "Shed With Blue Dotted Lines, 1975" Courtesy of Janet Borden, Inc.

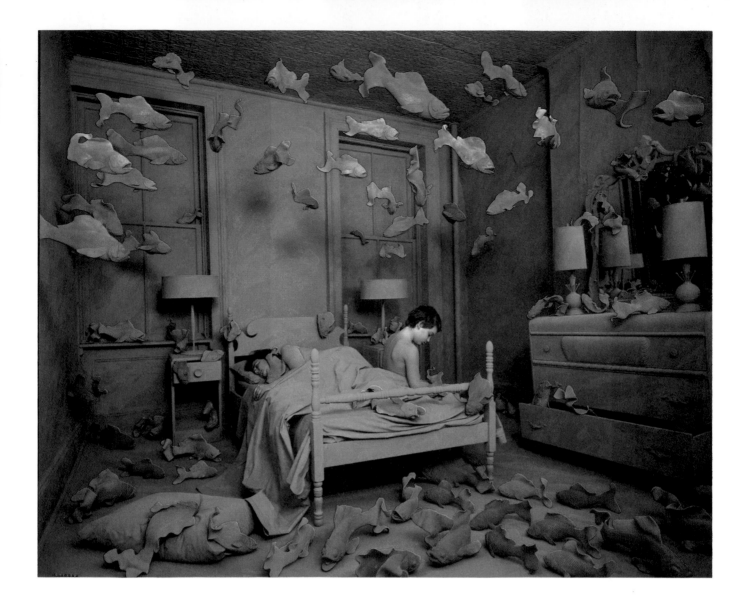

Figure 20.7
Some things that concern photographers do not exist in the natural world. Skoglund constructs fantasies for the purpose of being photographed. She uses color contrast to emphasize her inner, private concerns.

© Sandy Skoglund "Revenge of the Goldfish, 1981" 30" × 40" Courtesy of Castelli Graphics, New York, NY

•

What is Important?: Internal Color Events

Photography in Everyday Life

Photography has become the most important medium that tells people about their world. It has replaced painting as the prime communicator of human emotion. Photography is with us in our daily lives through television, magazines, newspapers, movies, and videos. It reaches out in all directions, even encompassing those who do not want to be touched. Most people still seem to only think of photography for it's documentary abilities. For this project use the camera to probe the inner realities of your mind rather than the outer reality of the street.

Chapter Twenty

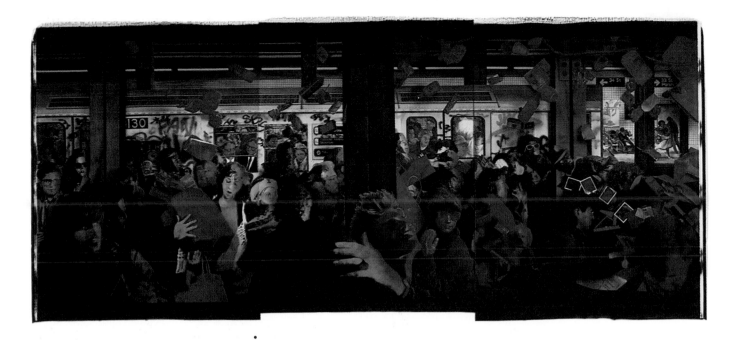

Assignment

Make a photograph that uses the power of color to deal with each of the following themes:

1. *Produce a picture of something that bothers you or that you find disturbing* Use your fears or neuroses for a chance at development and growth. Consider these possibilities: Can your pictures be used to confront something that makes you unhappy? Is it possible for the act of photography to lead to a new understanding of this situation? Can a picture increase your knowledge of the world? Does picture-making cause you to change your attitudes about something? Do not be like the dog that runs in circles chasing it's own tail. Use the picture-making experience to break out of your habits and routines and *see.*

2. *Construct a photo of an inner fantasy* (figure 20.7) Let your creative energy spring from yourself. Your own ideas and experiences communicated directly to another are always more important, instructive, and powerful than the secondhand imitation of someone else's style. Let it out in your image-making. Keeping all this inside can make you aggressive, crabby, irritable, or depressed. People can become intolerable when they cannot be creative. Bring forth yourself.

3. *Construct a photograph or a series of photographs that recall an important aspect of a memorable dream* It is okay to set things up to be photographed. You are the director. Do not take what is given if it is not what you want. Take charge. Do it your way and do it right.

4. *Fabricate your own environment* (figure 20.8) Alter existing objects, rooms, space, and light of an environment for the sole purpose of photographing the manipulated event.

Figure 20.8
The fabrication of an environment in order to photograph it allows the team of Nagatani and Tracey to densely pack recognizable symbols from our society into a controlled situation that permits elaborate commentary from the artists.

© Patrick Nagatani and Andree Tracey "34th & Chambers, 1985" Polaroid 20" × 24" ER Land Prints (Triptych) 24" × 60" Courtesy of Jayne H. Baum Gallery, NY, NY

Figure 20.9
Hasbrouck combines words and
photographs to create an intellectual
juxtaposition between these two forms of
communication. This permits the expression
of ideas that would not be possible if each
were used separately.

© Maggie Hasbrouck ''Ability to See, 1986'' 30'' × 40''

Words and Photographs

Regardless of which theme you chose to work with, include a written state-
ment about your experience. The words may be included in your picture. You
can write on the photo if you wish or you can include a text that goes with it
(figure 20.9). What do you notice happening when you combine pictures and
text? Does one overwhelm the other? Try to strike a balance where both play
off of one another. Use your words as support, not a crutch. Let them supply
information that will enhance your imagery.

Differences in Films

Shoot a different brand of film than you have used before and then answer
the following questions: What differences do you notice when you compare
this film to what you had previously used? Look at the color balance. Is it
warmer or cooler? Is the color saturation similar? What about the contrast? Is
it higher or lower? Is the grain pattern and structure the same? Compare flesh,
neutral, and white tones to see how they differ. Which film do you prefer? How
come? Is there a time when you would prefer to use one of these films instead
of the other? Why is this?

Chapter Twenty

∴

Color Ideas in Practice

"Garden Series #31, 1985"
David Lebe
16″ × 20″, photogram, painted silver print,
Collection: Albin O. Kuhn Library & Gallery,
University of Maryland Baltimore County.

———
•

Litho Film and Color

Litho films offer the photographer a wide array of possibilities in altering and enhancing their vision. Here are some of the basic methods that can be applied in the making of color photographs.

Bas-Relief

Bas-relief is a technique that creates the illusion of the third dimension in a two-dimensional photograph by emphasizing the shadow areas of the picture. The effect is achieved by placing a normal continuous-tone negative in contact with, but slightly out of register, with a high-contrast positive of the same negative. Variation in the registration method will alter the intensity of the effect. The negative and positive are then placed into the enlarger together and printed with a single exposure onto a piece of color paper.

The tonal range can be sharply reduced to produce extremes in the highlight and shadow areas. The final print will be a simplified version of the original scene; there will be no subtle details. The image will be graphic. Line and shape become the key compositional elements. Colors will appear bold, bright, and striking. Be visually dynamic in the selection of the composition.

Litho Production Materials

The production of both positive and negative lithos from the original through the use of both contact printing and projection printing will be done to make the final pictures. It is possible to work from either a negative or a slide. The following materials will be utilized: An original continuous-tone color negative, 2 clean pieces of 11″ × 14″ glass, color paper, litho film such as Kodak's Kodalith film, litho developer like Kodak's Kodalith Developer A & B, and a red ortho safelight filter (1A).

What to Do

All darkroom procedures with litho film must be carried out under a red 1A filter. With the exception of the developing and washing of the film, the darkroom procedures are the same as regular black-and-white printing. Mix all chemicals beforehand and allow them to reach an operating temperature of between 68°–72° F. Process in trays that are a little bigger than the film size being used.

Chemicals

Start readying the chemicals by preparing a working solution of litho developer by following the manufacturer's mixing directions. Make sure that there is enough solution to cover the film completely. Next, make up a tray of stop-bath, then prepare a tray of paper-strength fixer. Have a deep tray for washing. Finally, mix a tray of wetting agent, such as Kodak's Photo-Flo mixed with distilled water.

Making the Contact Positive

When the chemicals are prepared and at operating temperature set the enlarger to 8″ × 10″ print height, then over a clean opaque surface, place the clean negative on top of an unexposed piece of litho film, emulsion to emulsion. The lighter-colored side of the litho film is the emulsion side. The dull side of the negative is its emulsion side. Put a clean piece of glass over this entire sandwich. Dust creates pinholes that have to be retouched.

Set enlarger lens to f/11 and make a test strip. The exposure time should be similar to the time used for making an 8″ × 10″ proof sheet. White light, without any filters, is used to expose the litho film.

Develop the litho film by sliding it into the developer emulsion side up. Agitate the tray by lifting one corner and setting it back down. Lift another corner and repeat. Complete development takes two minutes and forty-five seconds. The dark areas should be totally opaque. Develop by visual inspection under the safelight and pull the film when the density appears correct. Do not develop for too short a time as it will produce streaks and pinholes in the opaque areas. If the image comes up too rapidly reduce the exposure time and try again. If the density is too light after two minutes thirty seconds, increase the exposure time.

When the development is complete lift the film out by one corner and slip it into the tray containing a working solution of stop bath. Agitate the film gently for about ten to fifteen seconds in the stop bath. Lift the film out, drain it, and put it into the tray of fixer.

In the fixer, agitate the film constantly and gently. In about sixty seconds the image will start to clear. Note how long it takes for this to occur. The total fixing time will be about twice the clearing time.

Rinse the film off, then inspect it in white light for proper exposure and processing. Do not attempt to judge it under the red safelight, as it will appear darker in the developer than in white light. If everything looks good continue to the next step. If not, decide what the trouble is and redo the process.

Wash the film for at least five minutes. To preserve the film for a longer time, use a hypo eliminator and then wash the film again for at least ten minutes. Handle wet film with care to avoid scratches.

After washing use a wetting agent mixed with distilled water for at least thirty seconds.

Hang the film by one corner in a dust-free place to dry. Excess water can be removed with a Photo-Wipe on the nonemulsion side. This will help to get rid of crud, streaks, and watermarks and will speed up the drying time.

After the film is dry, make a contact positive based on test information. Burning and dodging can be employed.

Retouching

Opaque can be applied with a spotting brush to retouch litho film. Any place that opaque is applied the light will be blocked. The opaque will eliminate dust spots, pinholes, scratches, and any unwanted details by simply painting over them. Work on the base side of the film. Opaque is water soluble and can be removed with a damp Photo-Wipe if a mistake is made. Litho film is versatile and can also be collaged, drawn on, scraped, and scratched to make an image.

Making a Litho Projection Positive

While the litho contact positive is drying, make an 8″ × 10″ positive from the same original negative using the following procedures:

Place a clean negative in the carrier and put it into the enlarger, which should already be set to the 8″ × 10″ format. Then focus and set the enlarger lens to f/11 and make a test strip. The exposure time should be close to the time used to make the positive litho contact. Repeat the processing procedures and evaluate.

Now proceed to make an 8″ × 10″ projection positive based on the test information.

Making Litho Contact Negatives

To make a litho contact negative take the dried litho positive contact and place it, emulsion to emulsion, with an unexposed piece of litho film on a clean opaque surface and cover with glass. Repeat the processing steps.

Take the dried 8″ × 10″ litho positive and repeat the previous steps.

At this point you will have an original color negative, a contact litho positive, a contact litho negative, an 8″ × 10″ litho projection positive, and an 8″ × 10″ litho negative.

.˙.

Assignment

This series of lithos can now be applied to changing the original image in various ways. Make the following color prints using a combination of the negatives and positives that now have made:

1. *A straight-print from the original continuous-tone color negative* This will act as the standard of comparison for the rest of the prints that will be made using the lithos.

2. *A bas-relief print* (figure 21.1) On a light table place the litho contact positive with the original negative. Carefully arrange the two just slightly out of register, so they do not exactly coincide. When a pleasing registration is obtained, tape the two pieces of film together. Put this sandwich into the negative carrier and place it into the enlarger. Make a color print following normal working steps.

3. *A high-contrast bas-relief print* (figure 21.2) Arrange the 8″ × 10″ litho negative and positive slightly out of register and tape them together. On a clean opaque surface, lay the film sandwich on top of an unexposed sheet of color paper. Make a test print to determine the correct exposure, then make the final print.

4. *A high-contrast black-and-white negative or positive* (figure 21.3 and figure 21.4) Make a contact print using the 8″ × 10″ litho negative. Adjust the filter pack to make three prints that have entirely different color balances. Record the filter pack information so that you will know how to alter colors with black-and-white film. Some typical filter packs and the colors that they will produce are:

 150Y = purple

 150M = yellow-green

 150C = sepia

 150C + 60Y = red

 150C + 60Y = yellow-brown.

5. A high-contrast black-and-white positive (figure 21.5). Follow the same procedure as for producing print number 4.

6. Carbo print hues (optional process). To produce colors that have a flat tonal range, like a copy of an old Fortune magazine, make two black-and-white positives from the negative. Sandwich all three together and make a print.

Chapter Twenty-One

Figure 21.1
The bas-relief effect is achieved by McGlasson's combination of a color negative and a black-and-white negative.

© Marcia McGlasson "Helium Monument, Amarillo, Texas 1985" Type C print 8" × 10"

•

Figure 21.2
This strange illusion between subject and shadow was made by printing a high-contrast litho positive and negative onto color paper.

© Bob Harbison "Wonderland Park, Amarillo, TX 1985" Type C print 8" × 10"

•

Figure 21.3
Hassell flashed his color paper briefly to colored light, then he printed this litho positive using a different filter pack combination.

© Chuck Hassell "Untitled, 1987" Type C print 8" × 10"

•

Figure 21.4
This image was created by printing a high-contrast litho negative on color paper.

© Linda Loper "Under Construction, 1985" Type C print 8" × 10"

•

Figure 21.5
Color, line, and shape are emphasized through the combining of a color negative with a black-and-white positive.

© John Barnhart "Untitled, 1987" Type C print 8" × 10"

•

Making Black-and-White Prints from Color Negatives

The time will come when you will need to make a black-and-white print from one of your color negatives. Maybe one of your pictures is going to be reproduced in the local newspaper, or a client may want a black-and-white print from a job that you had done in color. You may make a photograph in which the composition appears strong, but the colors do not work well together. It could be that the picture may work better in black-and-white, rather than in color. In certain situations, shades of gray communicate better than colors.

Basic Problems

There are some basic problems that need to be overcome to make a good black-and-white print from a color negative. If you simply attempt to print a color negative on regular black-and-white (blue-sensitive) paper, there will be a loss of contrast. The colors from the negative will not be reproduced in the correct shades of gray. Most commonly, reds will print too dark, which will be noticeable in the skin tones of the print, and the blues will appear too light, revealed in the tonality of the sky. Such a print will not look natural.

Overcoming the Problems

Here are some of the ways to overcome these problems. You could make a color-corrected black-and-white negative on panchromatic film, but this is a difficult and time-consuming process.

The standard solution is to use a panchromatic enlarging paper that is sensitive to green and red as well as to blue light. Kodak's Panalure is a paper that has been designed with this purpose in mind.

Panalure Paper

Panalure is currently available in three forms:

Panalure paper, fiber-based, single-weight, warm black tone in a glossy (F) surface. This is the most commonly used paper; Panalure Portrait paper, fiber-based, double-weight, brown-black tone in only a lustre (E) surface; and Panalure II RC, a resin-coated base, medium-weight, developer-in-emulsion, warm black tone in a glossy (F) surface. This paper has been designed primarily for machine development in an activator-stabilization processor.

Working with Panalure Paper

Safelight Conditions

Since Panalure paper is panchromatic (sensitive to all the colors of the visible spectrum), it should not be handled under a standard black-and-white safelight. The regular #13 color safelight is recommended with all three of these papers. If you do not have a #13 safelight, simply do not use a safelight.

Development

All three papers can be developed in a normal black-and-white developer like one part Dektol to two parts water or one part Selectol to one part water. Normal development temperature is 68° F. Standard development time for Dektol is one and one-half minutes. Selectol's development time is two minutes. Both have a useful range of one to three minutes in the developer. All the tones produced will be warm blacks. All processing procedures are the same as for any regular black-and-white paper. Since there is only one printing grade, the easiest way to control contrast is by choice of developer and how it is mixed. To increase the print contrast, use Dektol mixed equally with water or even use Dektol straight. If this is not high enough contrast, increase the temperature of the developer as high as 90° F and make the print using a condenser-type enlarger. To decrease print contrast, use one part Dektol to three or four parts water. If this does not do it, switch to one part Selectol or Selectol Soft to one or two parts water and print using a diffusion or cold-light type enlarger.

Panalure paper can be toned with such warm toners as Kodak's Sepia and Brown toner.

Use of Filters

Normally exposures will be made using only white light. On a color enlarger start out with all the filters set on zero. You can use enlarging or CC filters during exposure of the Panalure paper to change the gray tonal values in the final print. The filters will work in the same manner as if they were used on a camera with black-and-white film. If you want to make a gray tone lighter use a filter of the same color as the photographed object.

For example, if you made a picture of a yellow flower and wanted the gray tonal value of the yellow to be lighter in the final print, you would add yellow filtration. If you would like to make a gray tonal value darker, use the filter of the complementary color of the subject photographed. To make the yellow flower darker, add blue filtration.

Color Paper and Black-and-White Prints

What if you live in a small town and nobody happens to have any type of Panalure paper on hand and you need a black-and-white print? There is a way. If you are already making color prints, you have a panchromatic paper in your possession. The standard color negative papers are panchromatic. It is possible, by altering the development process, to make a black-and-white print on color paper. There will generally be a loss of image contrast and quality when compared with Panalure paper.

What to Do

Expose the color paper normally, like making a regular color print. Instead of processing it in the color process, process it in a standard black-and-white process. Use undiluted Dektol as the prints made in this manner tend to be flat. No color developer is used. Dektol will process the metallic silver and the fixer will remove the unexposed and undeveloped silver halides. Do not use bleach/fix because it will remove all the silver.

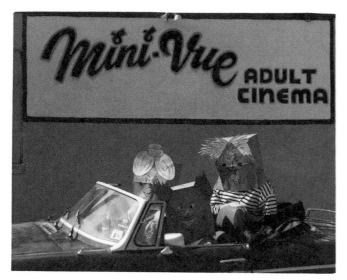

Figure 21.6
A normal well-crafted color print. Compare it with figures 21.7–21.9 to see how it translates into a black-and-white image.

© Paul Marlin "The Bagheads, 1987" Type C print
8" × 10"

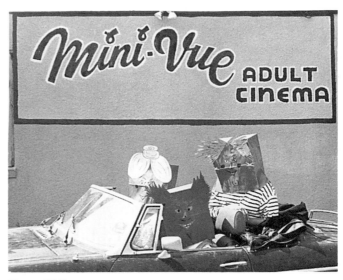

Figure 21.7
This figure offers an excellent translation of the color print. This print was made on Panalure paper, a panchromatic paper sensitive to green and red light in addition to blue light. This provides an accurate tonal rendition of all colors into shades of gray.

© Paul Marlin "The Bagheads #2, 1987" Panalure print 8" × 10"

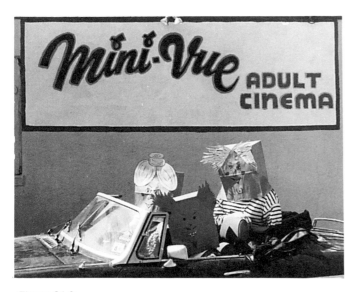

Figure 21.8
This print was made on a normal fiber black-and-white paper that is sensitive to blue light. There is a reduction in the tonal range and the colors are not reproduced in the correct shades of gray. Notice how the outline around the sign letters comes up looking white.

© Paul Marlin "The Bagheads #3, 1987" Silver print
8" × 10"

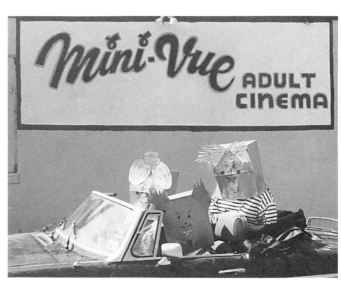

Figure 21.9
This photograph was made on color paper that was processed in a normal black-and-white process. There is a noticeable loss of image quality and contrast when compared with the Panalure print. It will get by in an emergency and will produce an acceptable halftone for reproduction purposes.

© Paul Marlin "The Bagheads #4, 1987" Type C print
8" × 10"

Assignment

For this project, make the following prints from a single negative:

1. Perfect color print (figure 21.6).
2. Panalure print; use filters if necessary (figure 21.7).
3. Print on regular black-and-white paper (figure 21.8).
4. Color paper processed in black-and-white chemistry (figure 21.9).

When you have completed all four prints, compare the three black-and-white prints to the original color print and see which one works best. Pay close attention to the red and blue colors to see which offers the best translation. Learn all you can about the different ways that the photographic processes can be put to work for your picture ideas. There is no telling when you might need one or where it might lead you. Photography can be an end unto itself, and technique can provide the means to that end.

Postcards

The postcard format, about 3 1/4" X 5 1/2", first appeared in Europe in 1869. In America at the turn of this century rural free delivery, reduced rates for cards, small hand-held cameras, and the new postcard-size printing papers contributed to making the postcard immensely popular. Before the rise in technology led to telephones and mass-circulation picture magazines, postcards were a fun and inexpensive way for people to keep in touch.

Folk Art Communicates

The postcard form and style is in the folk art genre. It throws to the winds all the sacred rules of picture-making. Many cards possess an amazing sense of irreverent good humor in how the subject is depicted. Originally the postcard was of a highly personal nature. People went to the local photographer's studio and had their own cards made that dealt with subjects that were of current importance in their lives. Portraits were popular and included all members of the family from the new baby to the dog. These were then sent to friends and relatives. At present most postcards are commercially printed and mass circulated. They serve primarily as documentation, offering evidence that shows you were in a certain place, at a certain time, and this is what you saw. Being able to write a message on the back makes it more personal. It is a form of simple communication that is quick, cheap, educational, and often entertaining. Today postcards are often used by photographers to announce the opening of an exhibition of their work (figure 21.10).

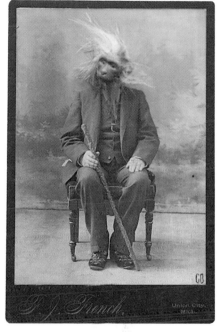

Figure 21.10
This Cabinet-style photograph, the standard for studio portraits from about 1866 to World War I, was hand-altered by Brotmeyer to form a new image. The Cabinet-style size (about 6" X 4") made it ideal to be reproduced as a postcard announcing his photography show.

© Gary Brotmeyer "Fotografia Misteriosa #1 (Dyer Hakim of Mery) 1986" Photo-collage with ceramic, hair & paint 6" X 4" Courtesy of Laurence Miller Gallery, NY, NY

Assignment
Making Your Own Postcards

Create your own postcards following these requirements:

1. 3 1/2" X 5 1/2" in size.
2. Photograph on one side, leaving the other side blank.
3. On the nonpicture side, divide the space in half vertically with the word "postcard."
4. To the right of the word postcard, address the card to the receiver and put on the correct postage.
5. On the left-hand side of the word postcard, in the upper left-hand corner, write a title or description to go with the photograph.
6. Below this write a message for the receiver.
7. Beneath the message, give the photo credit: the copyright symbol, the year, and the name of the photographer.
8. Mail the completed card.

Color Pinhole Photographs

Go into a dark room and make a small round hole in the window shade that looks out onto a bright outside scene. Hold a piece of translucent paper six to twelve inches from the hole and you will see what is outside. As far back as the ancient Greeks, many people have left evidence that they were aware of this phenomenon. Note: The image will be upside down, the same as in our eyes. Our brain turns it right-side-up.

Birth of the Camera

The *camera obscura* (Latin for darkroom) is based on this phenomenon. By the sixteenth century the camera obscura were in common use by painters, who would trace scenes from them. In 1658, Daniello Barbaro placed a lens on the camera obscura. It was this device that helped to work out the understandings and uses of perspective, which had been baffling artists, scientists, and scholars for centuries. Daguerre's camera was a simple camera obscura with a lens.

How Does the Camera Work?

An optical image is made up by what is known as tiny circles of confusion. Technically, the circle of confusion is the size of the largest circle with an open center which the eye cannot distinguish from a dot, a circle with a filled-in center. It is the major factor that determines the sharpness of an image and the limiting factor of depth of field. When these circles are small enough to form an image they are called "points" and the image is considered to be in focus. The pinhole camera has infinite depth of field, because it creates circles of confusion that are about the same size as the pinhole all over the inside of the camera. This means that these tiny circles of confusion are small enough to be considered points of focus with enough resolution to become a coherent image. If you add a lens, it will make smaller points of focus and the image will be sharper and more coherent.

Chapter Twenty-One

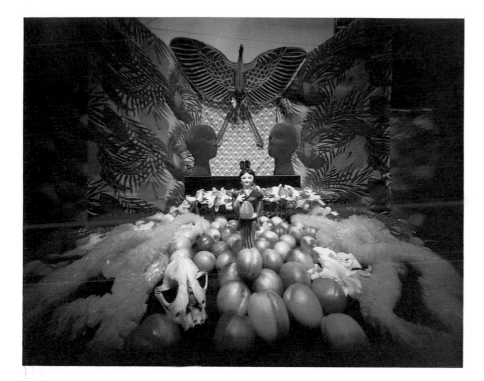

Wright's direct exposure of Cibachrome material produces a one-of-a-kind pinhole photograph. Filters are placed over the pinhole to make color corrections. Exposure time can run between three to six minutes.

© Willie Anne Wright "Our Lady of the Nectarines for San Francisco" Cibachrome

Materials to Build a Pinhole Camera

These items are needed to make a pinhole camera:

1. A sheet of stiff matboard or illustration board at least 1/16" thick. One side of the board should be black. This will be the inside of the camera. The black will help to reduce internal reflection.
2. A sharp X-Acto (Number 11 blade is good) or mat knife.
3. A 2" × 2" piece of brass shim or aluminum. An offset plate, obtained from a printer, is ideal. You can also use an aluminum pie pan or TV dinner tray.
4. Glue. Any household white or clear glue is fine.
5. A steel-edged or plain straight-edged ruler will deliver a far more accurate and close cut than a cheap wooden or plastic ruler.
6. A Number 10 or Number 12 sewing needle.
7. A small fine file or Number 0000 sandpaper.
8. A ballpoint pen.
9. Black photographic pressure tape or black electrician's tape.
10. A changing bag (optional).
11. A black-and-white single-weight, fiber-based enlarging paper.
12. Polaroid SX–70 film and camera for color pictures.
13. The blueprint of an adjustable focal-length pinhole camera provided in figure 21.11.
14. A 35mm camera can be converted into a pinhole camera. Cover a UV filter with black (opaque) construction paper with a good pinhole in the center. Place it on a 35mm camera and it becomes a pinhole camera.

For this image Fletcher constructed a special pinhole camera designed to make color separations through the use of a 47B, 61, and 29 color filter set. In this procedure three separate exposures are made, one through each filter, and later combined to make the final photograph. The lag in exposure time introduces color changes and movement.

© Jeff Fletcher "Untitled" Type C print

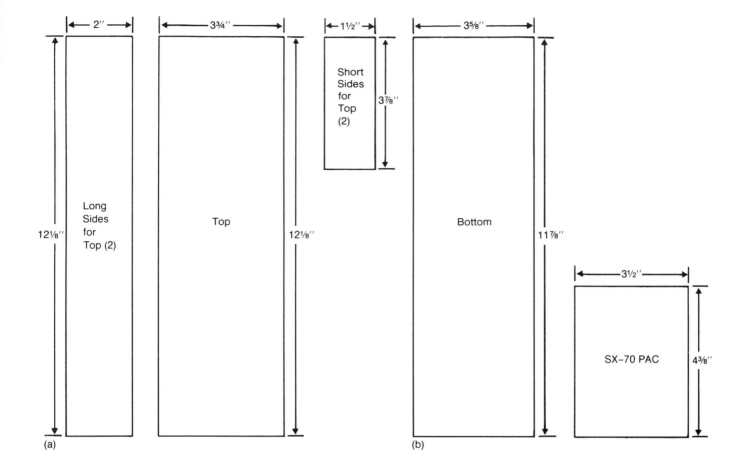

Figure 21.11
Blueprints for an adjustable focal-length pinhole camera, capable of using a Polaroid SX-70 film pack. Note that some of the parts need to be cut out in duplicate to assemble the camera. Figure 21.11d shows the completed pinhole camera that resembles a shoebox.

.

Variable Focal-Length Pinhole

The adjustable focal-length camera should be built to the dimensions given in the blueprint in figure 21.11 if you plan to shoot any Polaroid SX–70 film. You can use the SX–70 pack as a movable focal plane or make one out of cardboard. If you make one, be sure to glue on an upside-down set of cardboard steps to hold the paper flat during exposure.

Pinhole Camera Construction

Following the blueprint in figure 21.11, lay out the dimensions on the board. Carefully cut out all the pieces using a sharp knife and a straight edge. Sand any rough areas. Now proceed to the next two sections, making the pinhole and the shutter. After this is done, glue all the pieces together. Do not rush; allow the glue to dry. Finally, use the black tape to make all the seams light tight. Mark both the right and left sides of your camera clearly in the number of inches the focal point is from the pinhole. This is to give you more accurate and repeatable results. The closer to the pinhole, the wider the angle of view and the shorter the exposure will be.

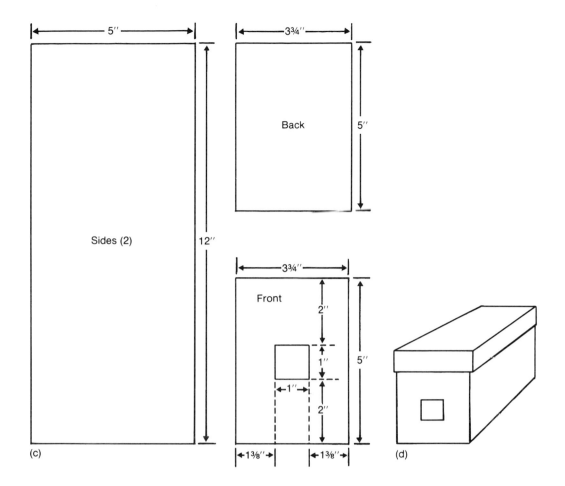

Making the Pinhole

Do not stab a hole in the metal; gently drill it with the needle on one side and then the other. Sand or file. Repeat until the hole is as perfectly round and free from defects as possible. With aluminum you can increase image sharpness by thinning the metal around the pinhole. This can be done by placing the metal on a book and punching it lightly in the center with a ball-point pen and then smoothing the back with a file. Then make the hole with the needle.

Now find the center of the front end of the camera. Cut a square opening equal to half the diameter of the metal pinhole material and glue or tape it into place.

The Shutter

You can create a simple shutter by making a sliding door in front of the pinhole with some thin board, or save the piece you cut out of the center of the camera front for the pinhole. Darken the sides with a marker and use a piece of tape to build thickness and to act as a handle. This will create a trapdoor-type shutter. Another option is to simply use the black plastic top from a film container and hold it in place with your hand or tape. Aluminum foil and tape will also work.

Table 21.1

Standard Needle Sizes and Their Diameters

Needle Number	Diameter
4	.036 inches
5	.031 inches
6	.029 inches
7	.026 inches
8	.023 inches
9	.020 inches
10	.018 inches
12	.016 inches
13	.013 inches

Exposure

If you know the needle number you can figure out what the f/stop will be, based on the focal length. A light meter can be used to give a ball park exposure figure provided you know the speed of the light-sensitive material being exposed.

The Aperture Formula

The f/stop is a simple ratio expressing the relation of the size of the opening that emits light, the pinhole, to the distance from the opening to film plane (Table 21.1). Therefore, a one-inch opening and a seven-inch focal length gives a ratio of 1:7, or a f/stop of f/7. So, a Number 10 needle makes a pinhole diameter of .018 inches with a five-inch focal length, would make an f/stop of f/277, which can be rounded off to f/280 (.018 divided into 500 is 277777).

Starting Exposure Times

Outdoor exposure times will run between one to fifteen seconds, depending on quality of light and the focal length. Trial and error will provide a starting point for acceptable exposure.

Getting the Hang of It

If you have never worked with a pinhole camera, begin by exposing black-and-white photographic paper. Process the paper following standard black-and-white procedures. If it is too light, give it more exposure; if it is too dark, give it less exposure. When you get a good negative, dry it and make a contact print. After experience is gained it is possible to expose any type of photographic material in the pinhole camera.

• •

Assignments

Make the following pinhole pictures:

1. *A portrait of one person that makes a statement about that person* Go beyond a pinhole mug shot.
2. *A group portrait of two or more people* This compounds the problems of composition and technical limitations.
3. *An architectural study (portrait of a building)* Show how this building is unique and what made you stop and photograph it.
4. *An object from nature* Show the life force at work.
5. *A manmade object* Show why it is important to you.
6. *A self-portrait* Tell something about yourself.

In the course of creating these six pinhole pictures, change the focal length. Have a minimum of one wide angle view, one normal view, and one telephoto view. List the focal length and other exposure information on back of every print.

Chapter Twenty-One

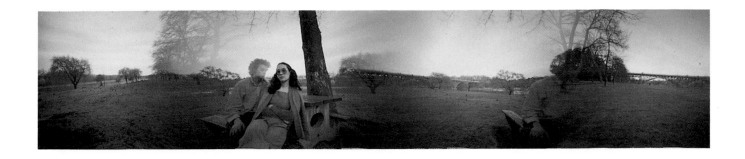

SX–70 Film Exposure

Having mastered the basics of the pinhole camera, you will be ready to start with color materials. SX–70 film offers a quick entrance with color. SX–70 follows the same basic rules as color slide film. If the print is too light, it means it has been given too much light, so cut back on the exposure. Should it be too dark, this indicates it was not given enough light. To correct this, increase the exposure time.

SX–70 Filtration

With the SX–70 film prints are often too "cool" looking. They have either a blue or cyan cast. This can be corrected by using the Kodak plastic color-compensating filters. To make the print warmer, use yellow or magenta and yellow filters to correct. Twenty points of filtration is a good starting place. Use yellow to reduce blue and magenta plus yellow to reduce cyan.

You can also use the color filters to experiment in purposely altering the color to change the mood or feeling of a scene. Filters will create added density, and you may have to increase the exposure time.

What next? Go on and expose color negative material, Cibachrome paper, or even modify the camera to take a Polaroid 4" × 5" back.

Additional Source Material

For more detailed information read *The Hole Thing—A Manual of Pinhole Photography* by Jim Shull, Morgan & Morgan, 1974; *How to Make and Use a Pinhole Camera,* Eastman Kodak Publication #AA–5, 1973; or *101 Experiments in Photography* by Zakia and Todd, Morgan & Morgan, 1969; or contact Eric Renner at the Pinhole Resource Center, Star Route 15, Box 1655, San Lorenzo, N.M., 88057.

Photograms

A photogram is a cameraless image created by placing a two- or three-dimensional object on top of light-sensitive material, then exposing the entire set-up to light. After development the image will reveal no exposure effects where an opaque object was in touch with the emulsion. Instead, it will produce an outline of the object.

To achieve this panorama Lebe made a camera that had four pinholes on a curved plane. An exposure was made through each of the pinholes on 2½" slide film and contact printed onto Cibachrome paper.

© David Lebe "Fairmount Park, 1974" Cibachrome 2¼" × 11½"

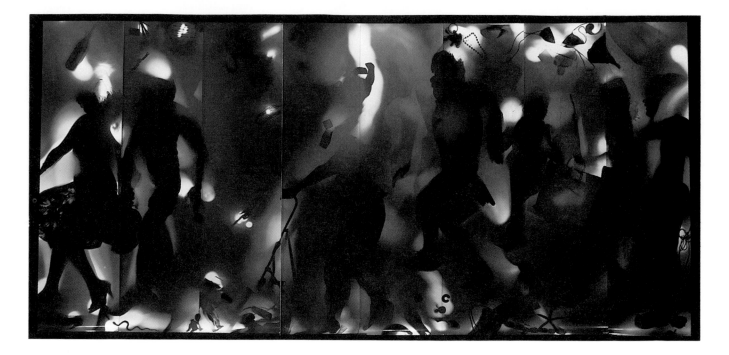

To get the feel and look of a frantic shopping spree Burchfield rehearsed and directed live models and various objects on eight pieces of Cibachrome paper. The photogram was created as Burchfield walked into and around the picture space exposing the paper with a penlite flashlight and colored gels for about twenty minutes.

© Jerry Burchfield "Art and Commerce, 1986" Cibachrome 8 × 16 ft.

•

A wide variety of tones and colors will be produced where translucent objects were placed on the emulsion and where partial shadowing occurred under opaque objects that were not totally in contact with the emulsion. Areas that were left uncovered will receive the maximum exposure and not record any detail.

A Concise History

The early explorers for a workable photographic process, Johann Schuluze in 1725 and Thomas Wedgwood and Humphry Davy in 1799, all began their experiments with cameraless images. The technique remained dominant until 1918, when Christian Schad, a Dadaist painter, used this method to make abstract images known as Schadographs. Man Ray followed with his Rayographs and then László Moholy-Nagy with what we now call Photograms.

Color Photograms

Color offers expanded possibilities for the creation of photograms.

Photograms can be made on any light-sensitive material. Color paper offers a starting place for beginning experimentation. Paper is easy to work with and it can be handled under a safelight, which enables one to see where to place the objects. It can be processed quickly so the results are immediately known.

The choice of objects to use in photograms is endless. Give it some serious thought and just don't use what happens to be in your pocket or locker. There are natural objects like plants, leaves, flowers, feathers, grass, sand, and rocks. Consider using manmade objects like colored glass, or make your own materials. These can include cut paper in a variety of colors and shapes. They may be either translucent or opaque.

Liquid-colored inks, such as Dr. Martin's, can be put on a piece of thin glass and exposed through onto the paper. The thickness of the glass will affect the outcome. Both inks and objects can be combined together.

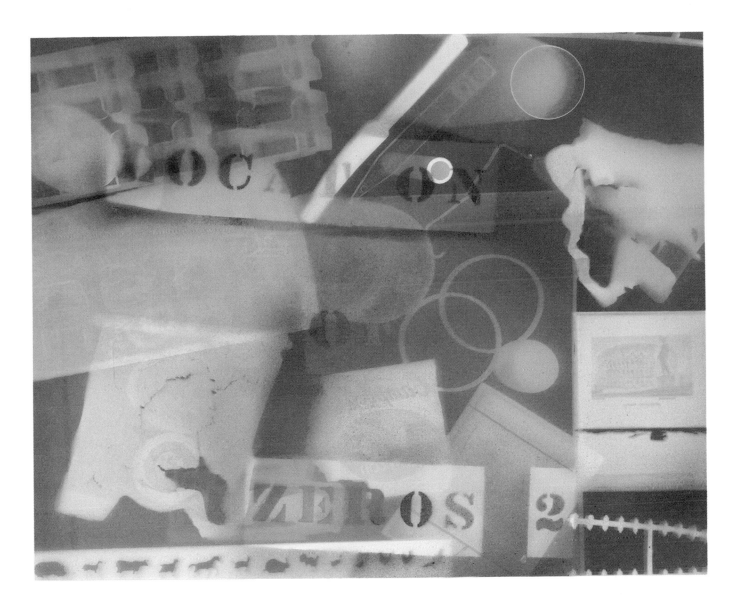

Different colored light sources can be used to make various color effects.

The color enlarger can be used as the source of exposure. Try changing the filter pack to produce a range of colors. Another effect is created when you expose an area with one filter pack and another area with a different filter pack. Also, try using an electronic flash, filters, or transparent plastic to color the light. Another technique is to employ a penlight as the source of exposure. It can also be used to draw with and to emphasize certain areas. Attach it to a string and swing it above the paper to make an unusual exposure effect. Filters can be placed in front of it to color the light too.

Combine a negative that has been made with a camera with one or more of the cameraless techniques.

Rephotograph the photogram and incorporate it with another camera or cameraless image.

Remember, all the regular guidelines for printing apply. This means areas may be burned and dodged during exposure.

Do not just plop some junk down on a piece of paper, turn on the light, and expect it to look good. Feel free to explore as many arrangements and uses of the materials as possible.

The photogram is used here by Barrow as a vehicle of inquiry into the nature of photography itself. The spray-painted colors on the image call attention to the fact that photography is not a depiction of reality, but an extension of our own private experiences and perceptions.

© Thomas Barrow "Location of Zeroes 2, 1981" Silver print with paint 16″ × 20″ Courtesy of J. J. Brookings Gallery, San Jose, CA

Cliché-Verre

Cliché-verre combines the handwork of drawing with the action of the light-sensitive materials of the photographic process to make a picture. Shortly after Henry Fox Talbot made public his Photogenic drawing, three English artists and engravers, John and William Havell and J. T. Wilmore, devised this method of working. In their technique a piece of glass was covered with a dark varnish and allowed to dry. A needle was then employed to etch through the varnish to the glass. The glass was used as a negative and contact printed onto photographic paper. They exhibited prints from their process in March 1839, making it one of the first spin-off methods to come from the invention of the photographic process.

In France the process was "reinvented" in 1851 by Adalbert Cuvelier's using the glass collodion plate method. He introduced it to Corot who made it popular. It was employed by many other artists of the Barbizon School, proving to be an accurate, easy, and inexpensive way to make monochrome prints.

The process was revived again in the United States in the late 1960s and 1970s. At this time there was renewed interest in nontraditional approaches to the photographic medium that got a boost in part from the effects of the counterculture and its interest in alternative modes of expression.

Working Procedures for Making a Cliché-Verre

Begin making a cliché-verre by getting a piece of glass and covering it with an opaque paint or varnish. Black spray paint will work well. The glass can be smoked instead of painted to make a different type of visual effect by creating uneven densities. One method to smoke the glass is to hold it over the chimney of a lighted kerosene lamp. A sheet of film that has been exposed to white light and developed to maximum density can be used instead of glass. Scratching on a photographic emulsion will generally produce a more ragged edge line than that obtained with a coated piece of glass.

Once the glass is dry, a drawing is made with a stylus (needle, X-Acto knife, razor blade, piece of bone, or whatever you can imagine) by scratching through the coating to the glass. The glass can now be used as a negative to make a contact print or enlargement onto a piece of photographic paper.

Traditionally only black-and-white prints were made with this technique, but by using color photographic paper and dialing-in different filter pack combinations it is possible to achieve a wide range of colors (figure 21.12).

Alternative Color Methods

Color can be used in a variety of ways for different effects:

Use colored inks to opaque the glass. Applying a series of different colored inks and not scratching down all the way to the glass can provide a multilevel color effect;

Apply translucent colored inks to the glass or plastic negative as a way to introduce different colors into the final print;

Combine the cliché-verre method with a camera-made negative. Scratch directly onto the camera-made negative and then make the print;

Combine the use of colored inks and scratching onto a camera-made negative (figure 21.13).

Figure 21.12
According to the A.C. Nielson survey, American households watched a total of 224,372,599,000 hours of television in 1985. The cliché-verre technique is applied here to lampoon the influence that television has come to have in our society.

© Robert Hirsch "Television Land, 1986" Type C print 20″ × 16″

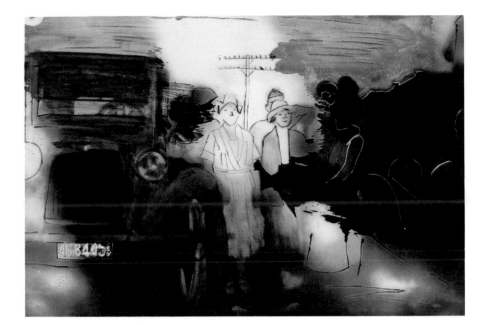

Figure 21.13
Miles has combined scratching on old negatives with the application of colored dyes to evoke a warm, pleasant sense of a passed era.

© Catherine Miles "Master Family #1, 1987" Type C print 16" × 20"

Stereo Cards

Sir Charles Wheatstone discovered the stereoscopic effect in binocular vision (using both eyes at once). In the 1830s he invented both the reflecting (mirror) and refracting (lens) stereoscopes for use with hand-drawn designs. Photography provided answers to many of the difficulties of these hand-drawn designs. Stereo pictures were tremendously popular from about 1854 to 1880 and again from about 1890 to 1919, with millions of cards and viewers being sold.

How the Stereo Effect Is Achieved

Stereo cards create a three-dimensional effect by taking separate photographs of a subject from two lateral viewpoints 2 1/2 inches apart, which is the average distance between the human eyes. This is accomplished with a twin-lens camera that has an interlocked double shutter which makes two images of the subject at the same time, side-by-side on the film. Stereo cameras can also produce a three-dimensional effect by interlacing the images with one another through the use of a lenticular screen.

It is also possible to produce stereo pictures of subjects that contain no movement with a regular camera. This is done by making the first exposure of the subject, then shifting the camera exactly 2 1/2 inches and making the second exposure. It may be moved to either the right or the left, but be certain to move it in the same direction every time. If this isn't done, it gets confusing as to which is the right-eye view and the left-eye view. If they are mixed-up the stereo effect will not work. There are also stereo devices that can be attached to the front of the camera lens that will permit simultaneous exposures with a conventional camera.

Figure 21.14
A model for making a stereo card that can be viewed in any standard refracting stereoscope. Both the left and right images must be of equal size. The left and right images are positioned so the distance between the center of each image is about 2½ inches. The distances to the top, side, and bottom borders surrounding the images need to be equal.

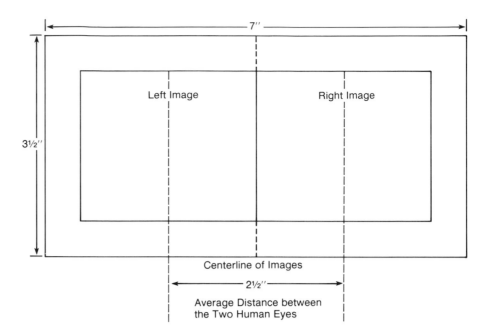

The Effect of Distance

The normal stereo effect starts at about five feet from the camera and is exaggerated at closer distances. Stereo infinity is the distance that the stereo effect ceases. This can range from 200 to 1500 feet and is dependent upon the number and variety of visual depth clues that are included in the view. The hyperstereo effect, in which the depth and size of the objects are exaggerated, occurs when there is too great a separation in between the picture-taking viewpoints. It is generally noticeable in the foreground of the picture. Improper separation of the images on the viewing card can also produce this effect. Pictures up to 2 1/2 inches wide can be mounted in a simple viewer with the proper distance between their centers. Larger images, having more than 2 1/2 inches between their centers, need to be viewed in a stereoscopic viewer with a lens or prism to compensate for this distance which is greater than that between the human eyes.

Standard Stereo Card Size

Following the model card in figure 21.14, make a standard 3 1/2″ × 7″ stereo card that is designed to be viewed in the basic refracting stereoscope. This style was devised by Sir David Brewster in 1849 and was improved into its current form by Oliver Wendell Holmes in 1861. It consists of a T-bar with a handle beneath the stereoscope body. A hood at one end of the bar contains two short-focus spectacle or prism lenses; a crossbar at the other end holds wire clips in which the card with the stereo photographs is inserted. The cross piece can be moved back-and-forth along the bar for focusing. An opaque divider extends part way along the T-bar between the lenses preventing each eye from seeing the opposite image. The stereo effect can be seen without a viewer. A simple opaque divider can be placed between the two images, maintaining the focus of the left eye on the left image and the right on the right image. Inexpensive twin plastic lenses, held up to your eyes, are also marketed.

Assignment

Guidelines for successfully making a stereo card include:

1. Thinking in three-dimensions. Consider how the objects in the foreground, middle-ground, and background will affect the final visual illusion. Provide the necessary visual depth clues to make the picture function in three dimensions. Use the depth of field to expand or contract the depth of the camera's vision.
2. Shift the camera exactly 2 1/2 inches for the second exposure.
3. Match the print density of both images.
4. Use a 3 1/2″ × 7″ support board on which to attach the images. Check to make sure the right image is on the right side before attaching the views to the card.

Figure 21.15
Rapier uses infrared film to capture part of the spectrum that is not visible to the human eye. Through her own split-toning process, in which more than one type of toner can be used and its location controlled by masking, earth colors are created to enhance contrast and the feeling of the work.

© April Rapier "Houston, 1981" Silver print 16″ × 20″

Toning for Color

Toning is a method of adding or altering the color of a black-and-white photograph. The following are three common commercially available ways of affecting the color of a print.

Development

The combination of paper developer and printing paper offers the most subtle way to control color through chemical manipulation of the emulsion. The age, dilution, temperature, time, and type of paper developer will all affect the final tone of the print. Silver bromide papers usually produce a cool neutral to green color while silver chloride emulsions make warmer tones. The combination of both the type of developer and kind of paper will also have an effect on the tones produced if any other method of toning is employed later.

Replacement

Process the print with a nonhardening fixer, like Kodak Rapid Fix, without adding Solution B. Now the silver compounds in the emulsions can be converted with inorganic compounds—i.e. gold, iron, selenium, and sulfur—to produce a wide range of muted and subtle colors (figure 21.15) Factors influencing the color are the metallic compound used, the degree of toner dilution, the type of paper and developer, the temperature of the solution, and the length of toning.

Dye Toning

Dye toning produces the most vivid and widest range of colors (figure 21.16). The dye base is usually attached to the silver in the emulsion through the action of a mordanting chemical. Mordants like potassium ferrocyanide act as a catalyst and combine with the dye to fix it in place. This prevents it from bleeding or migrating within the dyed area. The print is placed in the dye solution. The dye is deposited in the emulsion in direct proportion to the density of the ferrocyanide image.

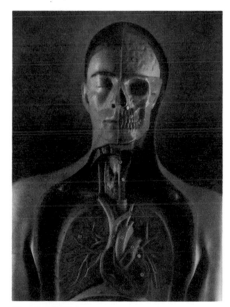

Figure 21.16
Owens made this color image using Edwal's Colovir process. The black-and-white print was first placed in blue toner and then into a red solution. Additional color was added by the local application of Marshall Photo Oils with a cotton swab.

© Ashley Parker Owens "From the Museum of Science and Industry Series, Untitled" Silver print with toners, dyes and oils 16″ × 20″

A variety of colors can be achieved by mixing dyes, immersing the image in consecutive baths of different dye, and selectively masking parts of the print with a frisket like rubber cement. There are also straight dye applications in which the silver is not converted, but the toner simply dyes all parts of the image equally. Dyes often lack long-term stability and will fade when exposed to any type of UV light. Dyes will often leave residues that can be seen in the base of the paper even after complete washing.

Safety

Many of the toning compounds are extremely toxic. Before using any toner read the directions and follow the safety procedures. Always wear rubber gloves and work in a well-ventilated space.

Additional Information

Further information is available from Kodak, Edwal, and in most black-and-white photographic texts. *Darkroom Dynamics,* edited by Jim Stone, and *Alternative Photographic Processes* by Kent Wade both offer sections on toning. If you are interested in making your own toners contact Photographers Formulary, P.O. Box 5105, Missoula, Mont., 59806, 800/922-5255. They offer a complete range of materials for the photographic chemist.

Hand-Altered Negatives and Prints

The first color photographs made their appearance in the form of hand-colored daguerreotypes. This was done to correct for the fact that all the early photographic processes lacked the ability to record color. The demand for color was greatest in portrait work. Miniature painters, who found themselves instantly unemployed by Daguerre's process, met the need by tinting daguerreotypes and painting over calotypes (the first photographic negative/positive system done on paper). In England the public seemed to have a preference for the "two penny coloured" pictures as opposed to the "penny plain." The hand coloring of black-and-white photographs continued to be widely practiced by commercial photographers for over the next one hundred years.

Why Hand-Alter the Work?

At present hand-altering the negative or print allows one to circumvent and explore ideas that would not normally find their way into current photographic processes. They let one introduce nonrepresentational colors, lines, patterns, and shapes into the photograph.

Methods to Consider

Some of the methods of modification of the negative and/or print include scraping or scratching with a stylus (figure 21.17); drawing or painting directly onto the image surface. This can be done with a brush, spray paint, an air brush, cotton balls, or other means of application. Colors can be either transparent or opaque. The medium can be acrylics, food-coloring, dyes, ink, oil paint, or watercolors (figure 21.18); heat can be selectively applied to distort or destroy part of the image; chemicals can be used to physically alter the appearance of the image (figure 21.19); optical distortion materials can be placed in front of lenses or light sources to dramatically change the image (figure 21.20); electronic signals can be employed to create a pattern on a screen which is photographed or used to directly expose the film or the paper (figure 21.21); combining the image with other media like engraving or one of the many forms of printmaking (figure 21.22).

Figure 21.17
Peven scratched the words "Slapping the Shore" into the actual print surface to serve two functions. First, they act as written symbols letting the viewer read what is happening. Second, their placement within the picture space provides a rhythmic repetition that visually adds to the movement of the waves in the original photographic image.

© Michael Peven "Slapping the Shore, 1980" Type C print 6" × 9"

Figure 21.18
Bailey utilizes acrylics, bronzing powders, enamels, ink, metal leaf, oils, pastel, pencil, and thread as expressive tools to manipulate the color and texture of her work.

© Alicia Bailey "Imaginary Fragrance, 1984" Mixed media 16" × 23"

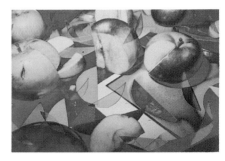

Figure 21.19
Triller achieved this monochromatic look by taking a normally exposed and processed Ektacolor print and altering it in exhausted E-6 chemicals. This is accomplished by reprocessing the print in the E-6 first developer, rinsing it with water, processing in E-6 color developer, rinsing, and refixing in Ektaprint fixer.

© Marie Triller "Untitled" Type C print 11" × 14"

Figure 21.20
Mitchell's references to illusions of real space are reinforced optically by the use of slide-projected imagery. The printing stage allows for corrections to compensate for the projection bulbs and extended exposures.

© Suzanne Mitchell "Illuminated Passage, 1984" Cibachrome 16" × 20"

Figure 21.21
From her collection of video graphics on tape, Cousins selects and plays a tape back on a VCR until finding the desired image. The pause button on the VCR is used to freeze the image on the television screen. Black paper, which has been cut into various shapes, is taped on the screen to further break up the video image. A kaleidoscope lens is mounted in front of the camera's normal lens and the exposure of the final product is made.

© Michele Cousins "Drifting Through the Night #2, 1987" Cibachrome 16" × 20"

Figure 21.22
Burchfield combined the center camera-made image with the outer photogram and strawberries to make a statement about John Lennon's murder. The photogram was exposed with a strobe and the center was masked and printed-in later. Strawberries were smashed and their juice allowed to interact with the paper, adding a sense of destruction and violence.

© Jerry Burchfield "From Second Degree: Still Life #43" Cibachrome 28" × 38"

Color Infrared Film

Kodak Ektachrome Infrared film is a false-color reversal film that originally was designed for camouflage detection by aerial photography. Our use of this material will not be concerned with its industrial, military, or scientific applications. We are interested in how the unusual color effects of this material can find an application in artistic, fashion, illustration, or pictorial photography.

Infrared film actually allows one to see things that are not visible to the human eye. Photographers have often abused the immediate bizarre and distorted colors that this film creates. It is easy to have it become a gimmick instead of a technique. For this reason it is important to understand the nature of this material and how it works.

What Is Infrared Film?

Infrared waves are electromagnetic radiation that are below the visible spectrum. It is made of wavelengths that are longer than those for red. The infrared range extends into the wavelengths that we associate with heat.

Characteristics of Infrared Film

Infrared color reversal film is made up of three layers of emulsion that are sensitive to red, green, and infrared instead of the standard sensitivity to blue, green, and red. When this film is processed the green layer responds to yellow, the red produces magenta, and the infrared makes cyan. All three layers are sensitive to blue, producing a magenta cast unless a yellow filter is used.

Infrared film can be used in daylight, artificial light, and even in total darkness to record the invisible infrared waves. Infrared waves will cut through haze and mist, making the use of this film effective to photograph scenes that include great distances.

Handling Infrared Film

Since this film is sensitive to waves we cannot see, it is a good idea to load and unload the camera in total darkness. Refrigerate this film before and after exposure, but let it reach room temperature before exposing or processing it. After rewinding the completed roll, return it to its container and process as soon as possible.

Filtration

With color infrared film, a Wratten filter No.12 (deep yellow) is recommended in daylight at all times. Without it the slides will look magenta. You can use other yellow filters to achieve different effects, but a deep yellow works best. The addition of a polarizing filter to the yellow filter can give foliage a deeper red or darken the sky dramatically. When working with tungsten light sources of 3200°K or 3400°K a CC 20 cyan and a Corning Glass Filter CS No. 3966 plus the yellow filter is the suggested starting place. For pictorial pictures CC 50 cyan and the yellow filter are recommended.

Changing the Color Balance

Suggested starting filtration places to change the color balance of infrared film: To increase magenta or decrease green add a cyan filter; to increase red or decrease cyan add a blue filter; to increase yellow or decrease blue add a magenta filter.

Orange or red filters can also be used to remove the magenta cast if you do not have a yellow filter. They will cause the other colors to shift in a different direction than the yellow. Infrared rays will record as red, red rays will record as green, and green rays will record as blue.

When high levels of infrared are present, as with chlorophyll-rich plant life, what appears to be green to the eye records in the infrared color (red) instead.

Enger has surmounted the problems associated with the color infrared E-4 process by shooting black-and-white infrared film. The color is controlled by subtly applying it by hand.

© Linda Enger Photography "Isolation of Thought, 1986" Silver Print with oils

Exposure

Since this film is sensitive to infrared, a regular film speed rating cannot be applied. Most meters will not even measure infrared. A preliminary daylight starting point is a film speed of about 160–200 with no filter. The film speed is about 80–100 with a No. 12 filter. Due to this uncertainty, bracketing is a good practice in one-half-f/stop increments. At shutter speeds of one-tenth of a second or longer reciprocity failure can happen. To correct for this, increase the exposure about one full f/stop and add a CC 20 blue filter.

Focusing

Infrared film does not focus at the same point as regular film. Most lenses have an infrared focus mark on their barrel, the most common being a red dot or a red 'r'. If the focus of the subject is ten feet, move the ten-foot spot on the lens barrel from its regular position over to the infrared one. Now the ten-foot mark is next to the infrared one rather than its normal place of focus. By using a wider-than-normal lens and stopping down the aperture to f/8 or f/11 you can generally compensate for this if you do not have the time or forget to refocus the camera to the infrared mark.

Chance

As you can tell, this process is not exactly precise. There are quite a few variables. Chance certainly enters into your calculations. Experimentation is in order. To begin to obtain repeatable results it is necessary to keep a written record of your exposure and filtration for each picture. Do make some pictures that include the following: foliage, sky, human skin, and water. See the effects this film produces on these subjects.

Processing

Infrared film processing is carried out with the E–4 process. No safelights or inspection equipment can be used. Be prepared to process the film yourself. Beware that some plastic developing tanks can be penetrated by infrared waves; stainless steel tanks continue to deliver the best results.

Infrared Film As a Negative

Criterion Photoworks, 119 East 4th Street, Minden, Neb., 68959, presently sells an infrared film that it processes as a negative. For more detailed information about this film, get the Kodak publication *Applied Infrared Photography.*

To obtain the Sabattier effect Burchfield's print was reexposed to tungsten light during development and then allowed to develop an additional minute. Processing was carried out in a tray to insure even results.

© Jerry Burchfield "Untitled, 1973" Type C print 11" × 14"

•

The Sabattier Effect

The Sabattier effect, also known as solarization, is the partial reversal of an image caused by exposing it to light during development. The result contains both negative and positive colors and tonalities.

This effect was first observed in the making of daguerreotypes in the 1840s. Armand Sabattier, a French scientist, discovered what caused this phenomenon in 1862. The process is one that is still not completely understood by scientists today.

The results of this effect are never the same. Many photographers have been attracted to this process because of the expressive uniqueness of each image, the influence that chance plays in the creation of the picture, and the mysteries that continue to surround, defy, and frustrate rational scientific explanation.

The Sabattier effect can be carried out on either negatives or prints. This section will deal only with prints since this process does not put the original negative at risk and offers many picture possibilities for someone attempting the method for the first time. Negatives that have been sabattiered do tend to produce more dramatic results than those made directly on a print from an unaltered negative. In order to preserve the original negative, those wishing to sabattier the negative will often make copy negatives from the original. The copy negatives are sabattiered at various times and distances in order to produce a wide variety of effects.

How the Effect Happens

The sabattier effect occurs when a burst of light strikes the paper or film during the development cycle. This fogs the paper or film and reverses the colors and tones. By controlling the duration and intensity of the burst of light, it is possible to control the extent of the effect. Giving too much exposure will produce black by converting all the silver halides to silver. Giving too little exposure will not change enough of the silver halides to produce the desired results.

Mackie Lines

A definite demarcation, known as a mackie line, is produced at the boundary between the reversed and unreversed areas. If it were not for these lines, the print would appear to be a positive version of a very dense and fogged negative.

What to Look for

Scenes that contain higher-than-normal contrast and possess a wide range of tonal differentiation are good candidates with which to begin experimentation. Images that have a strong sense of pattern or with distinct shapes will show noticeable changes. This will also make up for the loss of detail and subtlety of tone that accompanies this process. Since light-colored subjects contain more unconverted silver halides than darker ones, they will generally respond more strongly to reexposure. When this technique is successfully carried out, the image can appear more graphic with light glowing areas competing against dark mysterious spaces that contain a surreal sense of place, space, and time.

Sabattier Procedure

The sabattier effect can be produced without any special chemicals or equipment. The print should be developed in a tray as it offers the greatest control, but a drum can also be employed. Make the print on the highest contrast paper obtainable. Mix chemicals to regular strengths, but add a tray of water between the developer and the bleach/fix. Expose the print normally. Develop it for about one-half to three-fourths of the normal time. The print should contain essential shadow detail without full development of the highlights or midtone areas. At this point, remove the print from the developer and place it in a tray of water for up to thirty seconds with agitation. This dilutes the developer tremendously, but it does not completely stop the action of the developer. Next, take the print out of the water bath, drain it, and place it on a clean sheet of plexiglass, glass, or an unribbed darkroom tray. Squeegee the excess water from the print and put it and the backing under a light source for reexposure.

Sources of Reexposure

A variety of light sources can be used for reexposure. Plug the light into a timer for accurate reexposure control. A small light, such as an architect's lamp with a 15-watt bulb placed about four feet above the print works well. The enlarger can also be used as an accurate, controllable, and repeatable source of reexposure. It also presents the opportunity to easily work with either white light or, by dialing in filters, colored light. Coloring the light source will increase the range of effects that it is possible to achieve. Place a towel on the baseboard of the enlarger to catch any dripping water. Remove the negative from the carrier before reexposure. Refocus the enlarger if the negative is returned to make another print.

An electronic flash with a diffuser may also be used as a light source.

Harbison used colored gels during the reexposure process to produce even more dramatic results from the Sabattier process.

© Bob Harbison "Untitled, 1985" Type C print 8″ × 10″

Degree of Effect

The degree to which the sabattier effect takes place is determined by when the reexposure takes place and its duration. The earlier the picture is reexposed and/or the longer or brighter the light, the more intense the reversal becomes in the final print. Reexposure time is a matter of seconds or a couple of bursts from the flash. A digital timer will allow exposures to be made in fractions of a second, providing even greater control.

Procedure after Reexposure

After reexposure, the image can sit for up to thirty seconds. This can serve to improve the overall contrast and enhance the edge effects that are created along the borders of the different densities.

Now place the picture back into the developer and continue to process normally. The results cannot be judged until the entire process has been completed.

Trial and error is the rule. Nothing is predictable. Not all pictures are suited for this technique. Do not force the method onto a picture. Wait for a situation in which this technique can be used to enhance the statement. Some control can be gained by using a constant light-to-image distance from a timed light source, but careful record-keeping of exact working procedures, experience, and experimentation will provide the main guideposts.

Pictures from a Screen

Making pictures from a television screen or monitor offers the photographer the opportunity to become an active participant in the television medium instead of being a passive spectator. The camera can be used to stop the action on the screen or let the images blend and interact with one another.

Steps to Follow

To make pictures from a screen try following these steps:

Make certain the screen is clean.

Place the camera on a tripod. A macro lens can be used to fill the entire frame or to work with a small area of the screen.

Dim the room lights and avoid getting reflections on the screen.

Adjust the picture contrast to slightly darker than normal for an accurate, straightforward rendition.

Adjust the color to meet your considerations.

Set the shutter speed to 1/30 of a second. Adjust exposure by using the lens aperture. If 1/30 of a second is not used, the final picture will have lines in it because the shutter speed will not be synchronized with how the television forms a complete image.

Making Use of a VCR

Using a VCR gives the photographer the chance to be selective about the images on the screen and also provides the ability to repeat the image on the screen until it can be photographed in the manner that is desired.

Dougherty made this image directly from broadcast television. The black-and-white image was made and the color image double-exposed over it. The camera was set at an exposure time of 1/30 of a second and each shot was underexposed by two f/stops.

© Thom Dougherty "Bug-eyed, 1987" Type C print 8" × 12"

Alternative Modes of Working

Nonstraightforward representations from the screen are possible using the following methods:

Vary the shutter speed from the standard 1/30 of a second.

Adjusting the color balance of the screen from its normal position.

Vary the horizontal and vertical hold positions from their standard adjustment.

Use a magnet to distort the television picture. Be aware that this could put the television out of adjustment, requiring a repairperson to correct it. Try this on an old set that you no longer care about.

Make a series of multiple exposures from the screen onto one frame.

Put a transparent overlay of an image or color in front of the screen. Make your own using litho film.

Another possibility for incorporating images into a picture is to project a slide or slides onto a scene, rather than onto a screen, and then rephotograph the entire situation. A zoom lens on the slide projector can be useful in controlling the image size.

Movie theatre screens, including drive-ins, can also provide the photographer with a rich source of imagery to call upon.

Create images using computer graphics programs.

Slides As Negatives—E-6 at 1200

Amazing visual events can happen by taking color slide film and processing it to produce negatives. It is possible to push the film up to a speed of 10,000, dramatically increasing the color saturation, raise the level of contrast and create a pointillistic grain structure à la Seurat.

Gartel teamed up a Sandin image processor with a special effects generator and colorizing system to construct this image that is photographed directly from the screen.

© Laurence M. Gartel "Immaculate Mother of Technology, 1987" Cibachrome 30" × 40"

What to Do

Get a thirty-six-exposure roll of Kodak Ektachrome 200 Professional film. Set the film speed at 1,200. Bracket your exposures ½ f/stop and one full f/stop in both directions. If you push the film higher, you will need to be extremely careful in your exposures to retain acceptable shadow detail. You will be able to shoot in very low levels of light or use very high shutter speeds to stop action.

Look for Dramatic Changes

Contrast will be greatly increased, as in all push processes. A scene of low contrast will come out to be one of at least average contrast. A scene of high contrast will come out looking like it was shot on litho film.

There will be a noticeable increase in color saturation. Colors can begin to vibrate, look very intense, take on a "Day-Glo" appearance, and become deeper and more brilliant. The grain will appear quite oversized. You can literally pick out the different points of color.

Overall, the composition will tend to become more abstract, bold, impressionistic, and striking. The process is great for creating a mood. It is not suited for a situation that requires clarity and sharp detail. It should offer the opportunity to see things in a different manner. Predawn, after sunset, and night now become times that are accessible for you to photograph. This is not the time to go and shoot by the beach at noon. With these poster-like colors, the images tend to cry out to be printed bigger than normal. Consider getting some larger paper to print on if you find these images successful.

Development Procedures

After exposing the roll, the film will be developed twice, once for black-and-white and then again for color. After completing the black-and-white process you can either dry the film and carry out the color process at a later time or continue on and complete both processes in succession. Be certain *not* to use any type of wetting solution like Photo-Flo if the film is dried before doing the color process. At this point, watermarks will not matter as the film is going to be developed again and the wetting agent will muck up the color development.

Table 21.2
Black-and-White Development Chart

Solution	Time	Temperature	Agitation
1. Acufine (1200)	12 min.	75° F	30 sec.*
Acufine (10,000)	25 min.	75° F	30 sec.
2. Water stop	30 sec.	75° F	Continuous
3. Color film fixer	5 min.	75° F	1 min**
Remaining steps can be carried out under normal room lights.			
4. Wash	15 min.	75° F	
5. Bleach (C-41 or C-22)	15 min.	75° F	1 min.
6. Wash	30 min.	75° F	***
7. Dry		Room Temperature	****

*Agitate continuously for first thirty seconds and then for five seconds every thirty seconds.
**Agitate continuously for first fifteen seconds and then for five seconds every ten seconds.
***Water must be constantly flowing. If the wash is not complete it is possible to contaminate the color chemistry.
****At the end of this process your negatives will appear extremely thin and kind of a creamy-pink color. This is normal.

Color Development

After completing the black-and-white process develop the film following normal C-41 procedures. The color-developing process will add the color couplers and the density and color saturation will appear more normal. The entire process may be carried out under normal room lights. Be certain to maintain accurate temperatures.

Evaluation

After the film has dried inspect it. It will appear pink because the slide film does not contain the orange mask as do regular color negatives. Make a contact sheet to see exactly what you have to work with. The highlights should be fairly dense and bold and the shadow detail will look thin. The colors should be intense with the grain quite visible. Negatives with good detail in the shadow area and with highlights that are not blocked indicate proper exposure. You should have exposures at 600, 800, 1200, 1800, and 2400. Check to see which film speed worked best.

Printing

Since there is no orange mask you will probably have to add about 20–30 points of yellow to your regular starting filter pack. A low-contrast scene should print like a normal negative. A contrasty scene may require exposure times of over a minute. Although the colors will be much more saturated and the grain very noticeable, the overall color balance of the scene should remain the same as you saw it. This process does not create false colors like infrared, but it enhances what is already there.

Use this process to step into some new areas that you had felt were off-limits with your conventional use of materials. Normally you would use color materials to depict a scene. Now is your chance to open up and express your feelings and mood about a subject.

Hoy's image demonstrates the dramatic changes in contrast, grain structure, and increased color saturation that can be achieved when slide film is processed as a negative. The final work is printed on regular color paper.

© Bill Hoy "New Mexico Heartbreak, 1985" Type C print 11″)(14″

Write and Evaluate Your Own Assignment

This is the opportunity to make that picture you have been dreaming about and then measure the plan against what was accomplished.

Guide to Evaluation—Before Photographing

Before you go out to make any pictures, complete these three questions:

1. Write a clear, concise statement of the exact goals you hope to accomplish for this assignment.
2. Describe and list your objectives and how you intend to reach them.
3. What problems do you anticipate encountering? How do you propose to deal with them?

Guide to Evaluation—After Photographing

After making your pictures, answer the remaining questions:

4. Achievement: How many of the stated objectives were obtained? How well was it done? Are you satisfied? What benefits have been gained? Has new knowledge been acquired? Have new skills been developed? Have any attitudes been either changed or reinforced? Has the way in which you see things been altered?
5. The unexpected: What were the unforeseen benefits and problems that were encountered? Did anything happen to alter or change the original plan? How do you think you did with the unplanned events? Was there anything that you should have done to make a better picture that you did not do? How will this help you in the future to be a better image maker?
6. Goals compared to achievement: Compare the final results with the original list of goals. What did you do right? What did you do wrong? What are the reasons? What would you do differently next time? Were the problems encountered of an aesthetic or technical nature? Which were more difficult to deal with? What has been learned? How has it affected your working methods? Make yourself the teacher and measure how well the objectives of the assignment were met. What grade would you give a student on this project if you were the teacher? Why? Be specific.

Milk Carton

Photographs have become an automatic, unthinking part of our normal daily lives. They are simply there, inescapable, delivering messages in the most unlikely places, influencing our thinking. This in turn affects our decision-making process, which shapes the world. The once innocent milk carton has now become a mini-billboard sitting intimately with us at the kitchen table.

Confronting New Information

As we start each day, we are confronted with written and visual symbols on every available space of the milk carton. As we sit with our breakfast, we unconsciously look at it. What do we see? One side proclaims the brand and type of milk while another delivers its nutritional information and a third side

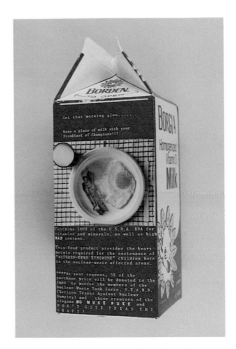

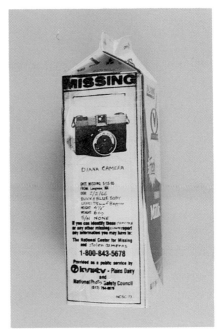

Barnard uses pictures and words on her milk carton to deliver a message protesting the proposal to dig a shaft in West Texas for the disposal of nuclear waste.

© Betty Barnard "Breakfast of Champions, 1987" Mixed media 9½" × 3¾" × 3¾"

Steele's milk carton pokes fun at the now discontinued toy Diana camera. This inexpensive plastic camera achieved a cult following and was used by serious photographers to purposely produce soft focus images.

© Tom Steele "The Missing Diana, 1987" Mixed media 9½" × 2½" × 2½"

announces some kind of mail-away product offer. All this seems rather straightforward and believable, until one encounters the fourth side. Here it has become fashionable to feature a barely recognizable picture of a child. The text tells us that this child has "disappeared," sometimes years ago, without a trace. The inference is that this child has been kidnapped. Reading on through this "wanted" poster, one discovers that the child was 16- or 17-years-old when the disappearance happened. Ask yourself, has this person been kidnapped or has this person run away from a situation that was intolerable? What should we believe? According to the 1987 Harpers Index, the number of missing American children who have been abducted by strangers is 1 percent.

We are confronted with conflicting information that in turn puts the validity of all the messages on the carton in doubt. Does this milk really contain the stated amount of Vitamin D or was the amount of Vitamin D determined in the same manner in which it was decided that the person was kidnapped? What should we think? Is the kitchen table the place for such a confrontation? What is public information and what is private? When should the line be crossed? What is the role of photography is all of this? What is the real issue being raised here? Could the truth be that a family conflict that has not been resolved in one house has, through the use of photographic methods, spilled over into someone else's house?

What Does It Really Say?

When encountering new information, be prepared to get beyond the surface and discover what is actually taking place. Do not be fooled by appearances and symptoms. In this instance, the message is being delivered in three different modes: photographs, words, and the interaction between the two media. Each has its own private independent meaning, but the juxtaposition creates an entirely new and different result. Be aware of how an anonymous voice of power is being used in both an economic and social framework to manipulate the viewer.

. .

Assignment

What is something that you feel strongly enough about that you would like to express it to millions of people in the privacy of their kitchen on a milk carton? Create such an image and attach it to a carton of milk. You may use text. Fill the carton with milk and keep it in your refrigerator. Use it in your normal household eating activities. See what reactions are generated by it during the course of a week.

∴

Non-Silver Approaches

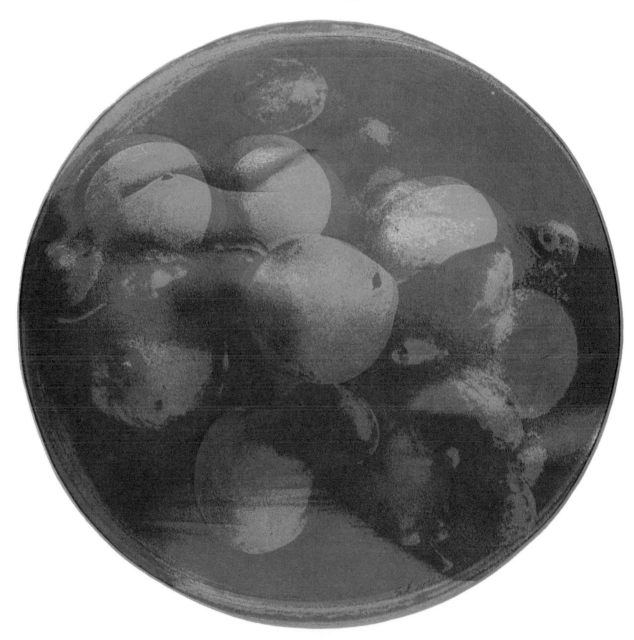

"Fruit 1967"
Scott Hyde
9½" diameter, Kwik-Print.
Collection of Museum of Modern Art, New York, NY.

·

Blueprints

Question: Is blue a color? Answer: Yes. This certainly qualifies blueprinting as a color process. The blueprint offers the photographer certain advantages over conventional image processes. Prints can be made without a darkroom, an enlarger, or special developing chemicals. Images can be put on all types of material. The final picture is quite permanent and it is fun to do.

Blueprinting is one of the easiest and most versatile of the non-silver approaches to working with color and a photographic process, but there are other processes, including Carbon, Gum, Kwik, and Van Dyke printing. It is possible to combine different nonsilver methods together, creating a new personal blending of the processes that can be tailored to suit your own vision.

History of Blueprints

The process known as cyanotype was invented in 1842 by the distinguished English astronomer and scientist, Sir John Herschel (1792–1871), as a way to make fast copies of his notes and sketches.

Herschel made a number of important contributions to photography, including the discovery that sodium thiosulfate would act as a fixing agent for silver-based photographs, the first photograph on a glass plate, and he introduced the terms "photography," "negative," "positive," and "snapshot" into our vocabulary. It was not until the 1880s that the cyanotype process caught on. It was at this time that precoated cyanotype paper became available for use by architects and shipbuilders who nicknamed the process "blueprinting."

How It Works

The cyanotype does not rely on silver salts, but on ferric salts to form an image. A salt is the result of the mutual action of an acid with a base. Some salts of iron are reduced to ferrous salts when exposed to light in the presence of organic matter. These ferrous salts act as powerful reducers of other metallic salts which are not affected by the ferrous salts. Ferric ammonium citrate gets broken down by the action of light to a ferrous salt. The ferrous salts react as reducers on the potassium ferricyanide. The areas which are not exposed to light remain in their ferric state and are washed away during development.

Paper

Cyanotypes can be made on a variety of paper surfaces and cloth. The Rives BFK paper is a good one to start with for general applications. Arches' watercolor 130 lb. paper will give a more textured image and you will lose more detail. Any type of paper from a grocery bag to typing paper offers possibilities. Improper paper selection will result in discouragement due to failure to produce good image quality.

Sizing

Sizing is not critical but some sizing is needed for this process. It supplies the organic material that is needed for the reduction of the ferric salts to ferrous salts and it helps to keep the image on the top of the paper, which prevents it from appearing flat. Many papers like the Rives BFK have enough

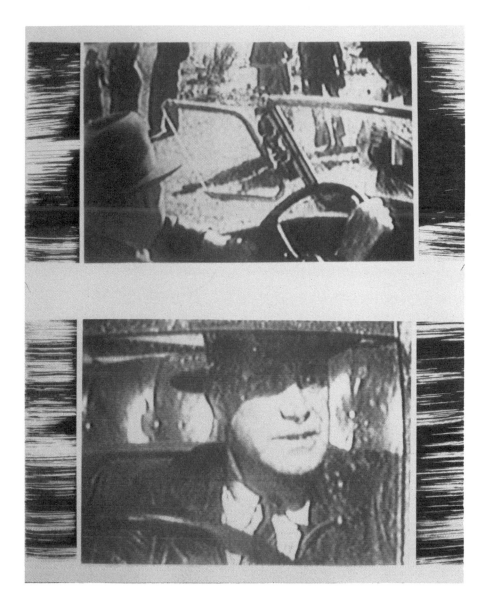

Dougherty made this blueprint by contact-printing six enlarged negatives in direct sunlight. The enlarged negatives were made on direct duplicating film from 35mm negatives shot directly from broadcast television.

© Thom Dougherty "El Rey de los Padrinos, 1985" Cyanotype 13" × 15"

•

sizing, but others may require additional sizing to produce a good print. Sizing can be applied and allowed to dry before the paper is coated. It is available in liquid form that can be brushed on or in the form of spray starch, and both are available at a grocery store (see Gum Bichromate printing later in this chapter).

Safety

Exercise care in the handling of all chemicals. Wear disposable rubber gloves. Use them once and throw them away. Avoid getting any chemicals on your skin. If this should occur, immediately flush the affected area with fresh running water. Work in a well-ventilated area. Avoid breathing any of the fumes. If you are sensitive to chemical irritants, wear a charcoal filter mask. Seek immediate medical attention if you have any type of reaction.

Sensitizing Solution

The sensitizing solution is made from two chemicals. Ferric ammonium citrate (the green granular form is the most sensitive and stable) is mixed 50 grams to 250 milliliters of distilled water. In a separate container mix potassium ferricyanide, 25 grams with 250 milliliters of distilled water. Be sure the potassium ferricyanide crystals appear bright orange before use. If they look rusty red they will not be effective. Mix only enough solution for your immediate needs. Store each separately in a dark brown plastic container with the air squeezed out. Combine the two solutions right before you are ready to coat the paper. Discard after use. Coated paper can be stored like regular photographic paper, but it is most sensitive right after it has been coated.

The Coating Process

The entire coating process should be carried out in a safelight darkroom if possible. It can be done in a dimly lit room, but some sensitivity will be lost. When you are ready to sensitize the paper, mix the two solutions together. There are two methods for accomplishing this.

In the first one, the paper is floated in a tray of solution for about three minutes. Tap the paper with a print tong very gently to dispel any air bubbles. Also use the tong to agitate the paper in the solution, taking care not to get any of the solution on the back of the paper. Use the print tong to carefully remove the paper, letting the excess drip into the tray, and hang the paper to dry with newspaper underneath to avoid staining the floor. Use a hair dryer on the low setting to speed the drying.

In the second method, the chemicals are applied to the paper with use of a polyfoam brush. Dip the brush into a tray of emulsion, press the brush onto the side of the tray to get rid of the excess, and apply it to the paper being careful to get an even coat.

Printing

Take the dry paper and place your negative over it (emulsion to emulsion) in a contact printing frame or cover with a piece of clean glass and a backing board. Take this sandwich outside and expose to bright sunlight. This non-silver printing-out process is fairly fast, but exposure times will vary greatly depending on how the material was coated, the time of day, time of year, and location. Exposure times can vary from as short as three minutes to as long as eight hours. Test strips can be made to determine exposure, but visual inspection is reliable and faster. The print is properly exposed when it appears about 20 percent darker than the final image is intended to be. The highlights will look glazed and possess a metallic sheen. The paper will change color from a yellow-green to a blue-gray as the image appears. Typical sunlight exposures are between three to fifteen minutes.

If artificial light is used for exposure, be certain it is an ultraviolet source such as carbon arc lamps, mercury vapor lamps, or sunlamps. The exposure times are usually longer than with sunlight.

After having properly exposed the print, remove it in dim light and wash in running water until the highlights clear (look white) and then dry.

Handle the paper from the back or the corners. If the surface is touched, it will leave fingerprints.

Anson's choice of subject and her direct, uncomplicated composition made good use of the blueprint's cool color and graphic nature.

© Sandy Anson "Blue Unicorn, 1987" Cyanotype 8" × 10"

Spotting

Cyanotypes can be spotted with watercolor, Prussian blue, or Marshall's photo pencils.

Storage

Cyanotypes are a stable process when kept in dark storage, but like any color process they will fade in bright sunlight. They should be stored in a dark and dry area.

Troubleshooting

If you get muddy blues or cloudy whites, try blueprint intensification. After the picture is processed, soak it in a 4 percent solution of fresh hydrogen peroxide and distilled water. Mix one ounce of hydrogen peroxide to twenty-five ounces of distilled water. Soaking time is determined by visual inspection, but it is generally brief. This should intensify the blue and make it richer and at the same time clean up the white highlight areas. When it looks good, rewash for at least five minutes.

Precoated Paper

Blueprint paper can also be purchased precoated from various sources. It is often called by a different name such as solar paper or sun paper. The quality and sensitivity vary greatly; check them out carefully before purchasing.

What to Shoot

When selecting subjects for this process remember the final image will be cool and that mid-tonal range details will tend to get lost. Simple, strong graphic images with a minimum of clutter will work well.

The Gum Bichromate Process

Gum bichromate printing is a simple process that uses a pigment (water colors or tempera), a liquid gum to carry the pigment, and a light sensitive chemical (Ammonium Dichromate or Potassium Dichromate) to produce a nonnaturalistic color image from a contact negative. The softening of the photographic image and the subjective use of color allow the photographer a great amount of freedom in the creation of the print.

The first workable gum process was developed by an Englishman, John Pouncy, in 1856. It was made popular in the 1890s by Robert Demachy and Alfred Maskell, who renamed the process Photo Aquint.

There are many different recipes for making gum prints. The recipe offered here is based on one developed and successfully used by Ken Pirtle and his students at Amarillo College. It is presented as a starting place and to show how the basic process works. Feel free to make adjustments and personalize the process. Much of what is discussed in the blueprint section can be applied to the making of gum prints, including the safety rules.

Using the gum process, Nettles extends the soft image quality that resulted from recording the original scene with a pinhole camera. The nonrealistic use of color contributes to the atmosphere of fantasy.

© Bea Nettles "Blue Waltz, 1982" Gum Bichromate

Paper Selection and Sizing

Pick a high quality etching or water color paper as it must be able to withstand being soaked and dried many times. Rives BFK, the Strathmore 500 series (2- or 3-ply) and Arches' water color paper offer good starting points and are widely available. The more texture the paper possesses, the less detail there will be in the final image. The selected paper must be sized to seal the pores of the paper. Sizing is accomplished by soaking the paper in hot water and then a solution of gelatin. This minimizes pigment staining in the highlight areas and preshrinks the paper to its final working size.

Knox Gelatin, available in most grocery stores, works well. Stir one packet into a quart of hot water until it is dissolved and then pour into a tray. Soak the paper in hot water for five to ten minutes, then put the paper into the tray of dissolved gelatin for two minutes. Squeegee the paper and hang it up to dry.

Preparing the Sensitizer, Gum, and Pigment

Mix one ounce of Ammonium Dichromate, which is twice as sensitive to light as Potassium Dichromate, to ten ounces of water and set it aside. The dichromate and dry gum can be purchased at a chemical supply company.

The gum is available in premixed lithographer's gum or dry powder Acacia Gum. The lithographer's gum can be obtained at a graphic or printing supplier. It will last a long time provided it has an anti-bacterial agent. The dry gum solution is made by mixing two ounces of dry gum to four ounces of water. Stir it until it is dissolved and set it aside.

Chapter Twenty-Two

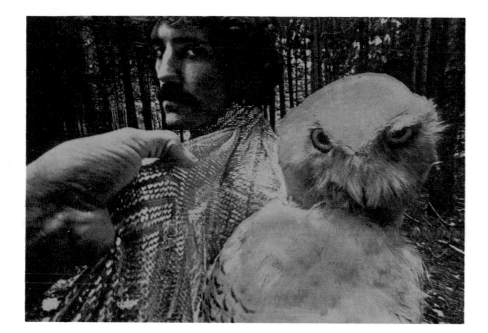

This gum bichromate image was printed by Fish eight to ten times with varying exposure times and color intensities. Certain lines in the print were later reinforced with delicate graphite drawing.

© Alida Fish "Untitled, 1978" Gum Bichromate 20" × 24"

Next place about one-half inch of pigment into a baby food jar and mix it together with one ounce of the liquid gum. Tube watercolors are easy to begin with. Put the lid on and shake until the solution is completely mixed. The amount of pigment used varies with the brand and color. Experience will guide you with future mixing. Now combine one ounce of the liquid dichromate to make a working solution. The gum and dichromate are generally mixed together in equal amounts.

Preparing the Paper for Printing

Tape the sized paper by its corners to a flat board. Brush the working solution onto the paper going in both horizontal and vertical directions. This can be done two to four times until the solution is evenly spread on the paper. Disposable polyfoam brushes work well. Do not oversoak the paper or let the solution puddle. Coat an area larger than the negative that will be used to make the contact print. Let the paper dry in a darkened room. It is not sensitive to light until it is dried. Drying time can be reduced by using a hair dryer.

Making the Print

Place the negative onto the dry-coated paper and cover with a clean piece of glass or place in a printing frame. A daylight photoflood or a sunlamp can be used to make the exposure. With the light source at a distance of twenty-four inches from the paper starting exposure time should be about 10 minutes. Different colored pigments will require different exposure times. Most of the exposures should be in the range of five to twenty minutes.

Using a blowing fan will lengthen the life of the light source and keep the print from getting too hot. Too much heat can produce a pigment stain on the print.

Developing the Print

After the exposure is made there should be a distinct image where the light has darkened the gum bichromate on the paper. Remove the negative and store it safely. Take the paper and place it face-down in a tray of water that is between 70° to 80° F. Let it soak for about four minutes. Turn the paper face-up and gently wash the loosened solution away. Hang the paper up to dry.

Multiple Printing

After the paper has dried, additional colors and coats of emulsion can be applied and the paper reprocessed. This can create depth, increase color saturation, and produce a sense of the surreal. One negative can be used for many different exposures. A wider variety of results can be produced by making negatives that possess different densities or by using entirely different negatives.

Additional Information

For more information on non-silver processes read *The Color Print Book* by Arnold Gassan, Light Impressions, 1981; *The New Photography* by Cathrine Reeve and Marilyn Sward, Spectrum, 1984; *Breaking The Rules* by Bea Neattles, Light Impressions; and *The Gum Bichromate Book* by David Scopick, Light Impressions, 1978.

History of the Dye Transfer Process

The invention of films like Kodachrome, Agfacolor, and Ektachrome provided solutions for an accurate, easy-to-use, nonscreen, and integral method for making color transparencies. A problem that all these processes shared was a way to make prints from slides.

Prints had to be made by a commercial lab that used the Carbo process, an improved version of Thomas Manly's 1899 Ozotype and his 1905 Ozobrome processes.

The Carbo process used carbon tissue in conjunction with a bromide print, not silver, to make an image of permanent pigment. In the Carbo process black-and-white prints were made from each of the three separation negatives made from the original transparency through red, green, and blue filters. The gelatin emulsions were stripped from each of the prints after development and dyed cyan, magenta, and yellow. They were then superimposed on a new paper base. The Carbo process offered excellent control in the making of the print, but was complex, costly, and not suitable for assembly-line production of photographs. The dye transfer process grew out of these techniques.

The Dye Transfer Process

Originally introduced in 1935 as the Eastman Wash-Off Relief process, it was replaced by the improved Kodak Dye Transfer process in 1946.

In the dye transfer process, separation negatives are made by photographing the original transparency or print on black-and-white film through red, green, and blue filters. These negatives can be archivally processed and used to make new prints at a future date, long after the original color image has disappeared. These negatives are used to expose special matrix films that will in turn transfer the dyes in printing.

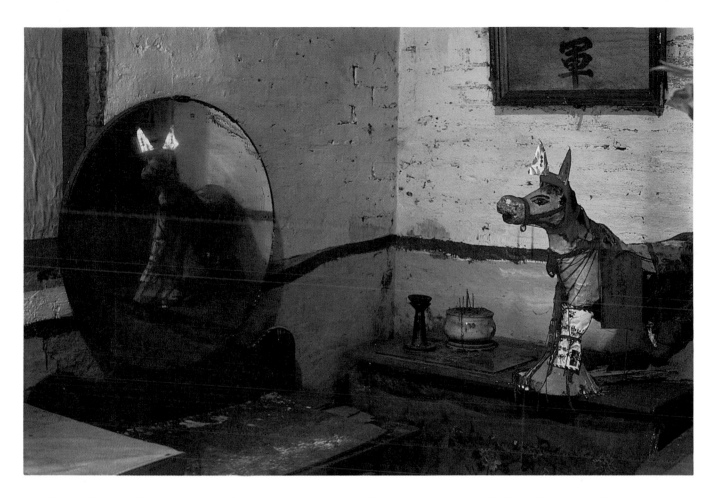

Dyes of any color may be employed, but the subtractive system (magenta, yellow, and cyan) is used when a normal full-color print is required. The matrix that has been made from the blue separation is dyed yellow, the matrix from the green separation is dyed magenta, and the matrix from the red separation is dyed cyan. The print is made on a special receiving paper, which is attached face-up on a smooth surface. Each of the matrices is squeegeed face-down against it and allowed to remain until the dye is absorbed. The dyes are transferred in the order of cyan, magenta, and yellow. Accurate registration of the images is required otherwise blurred outlines or color fringes will result.

It is a process that is technically demanding and requires careful attention to detail. When it is properly used it can produce a high-quality color print unattainable with any other process. It offers the widest range of latitude in print manipulation and it gives the photographer unequaled control over color, contrast, and density while making the print in full room light. The dyes used in this process are the most stable of any of the processes, making it the best choice for longest print life. Until recently, most color work was rejected as vulgar, gaudy, or too technically unstable for serious work. The use of the dye transfer process by such photographers as Eliot Porter have helped to legitimize the use of color in all areas of photography.

Eliot Porter's mastery of the dye transfer process can be seen in the range and subtlety of color feelings that his work emits.

© Eliot Porter "Temple, Shrine With Horse, Macau, 1985" Dye Transfer Print Courtesy of Scheinbaum & Russek Gallery, Santa Fe, NM

Additional Information

For detailed information about the dye transfer process contact: Coordinator, Dye Transfer Markets, Eastman Kodak Company, 343 State Street, Rochester, N.Y. 14650, 716/724–2540.

Keats' interest in atmosphere, light, and texture are revealed by the Fresson process's painterly, pointillistic, and tactile look.

© Doug Keats ''Ranchos de Taos Church, 1984'' Fresson print Courtesy of The Albuquerque Museum, Albuquerque, N.M.

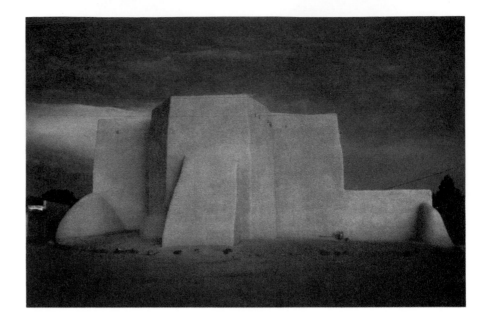

The Fresson Process

The Fresson process, invented by Theodore-Henri Fresson at the turn of the century, uses a ''secret'' carbon printing technique to create a pointillistic print from colored pigments. The Fresson Studio, in France, currently produces only about two thousand color prints each year. It requires about six hours to make each print. The Fresson process offers its own unique color look, excellent image control, and is said to be the most archival of any of the commercial procedures in use today.

How the Fresson Process Operates

To make a Fresson print, four color separations are made from an original color transparency. A separate exposure is then made for the cyan, magenta, yellow, and black separations, using a carbon arc light source, onto the special Fresson paper that is made up of pigments similar to those used in oil painting. The paper has to be coated, exposed, developed, and dried four consecutive times, once for each of the separations.

The Sawdust Developer

During the exposure, the pigment is hardened in proportion to the amount of light it has received. Now the print is ''developed'' using a solution of water and sawdust. During the development process, the pigment that has not been hardened by the action of light is softened by the water and removed with a mild abrasive, the sawdust. What remains after this operation makes up the final color image. This unusual developer permits local control of the image by pouring varying amounts of sawdust onto the print. It is possible to use this sawdust developer anytime in the future, after the initial image has been created, to make alterations to the print.

Chapter Twenty-Two

Color Electrostatic Processes

Using a electrostatic photocopier, such as a Xerox™, lets the photographer investigate a combination of manual, mechanical, and electric processes for image-making.

The Xerox™ System

The Xerox™ system works on a subtractive method. Magenta, yellow, and cyan pigments, similar to those found in acrylic paints, are coupled with a polymer resin in the toner. This makes a filmy layer of color which is electronically fused onto the paper producing a permanent image. The lens on the copier acts like a simple camera without a bellows so there is only one focal range possible, providing a limited depth of field.

This type of system offers the creative user great flexibility and many possibilities in the making of a print.

Options available on a machine of this type include duplication with accuracy, quick print production, conversion of three-dimensional objects into a rapid printout, transformation of a 35mm slide into a hardcopy, printing on all types of paper including archival and acetate, stability and permanency of the dyes, production of an image on transfer material enabling the picture to be moved onto other surfaces like fabric or glass, multiple exposure capability, color adjustment that will allow the operator to balance the colors in any direction including color from black-and-white, one- or two-color prints, and high contrast or normal full-color reproduction.

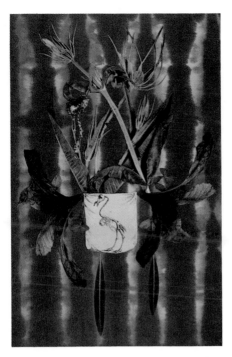

The flexibility of the electrostatic process is employed by Land-Weber to convert three-dimensional objects into a rapid hard color copy.

© Ellen Land-Weber "Untitled, 1984" 3M Color Process 22" × 14½"

Experiments to Consider

Consider using a Xerox™ photocopying machine to make these pictures:

Take a slide and have an enlarged Xerox™ color print made from it. This is performed by the copy machine with a special attachment for making prints from a slide.

Make a color copy of one of your regular color prints.

Now perform at least one of the following methods. Compare the results with original and note what changes have taken place.

Have a print made on a good quality drawing paper. Hand-color all or part of it with colored pencils, inks, or watercolor paints.

Cut out a series of images, arrange them on the copier glass, and make a print. Try combining both two-dimensional and three-dimensional objects.

Explore a theme such as food. Collect various items that are central to the theme—like beans, bread, fruit, grains, leaves, nuts, pastas, seeds, and spices. They may be whole, broken, or cut up. Compose them on the copier glass and explore their color and spatial and textural relationships.

Combine a series of electrostatic prints to form larger images. Start with a group of four prints that visually connect and expand it into a mural.

Place a live model on the copy glass. Pose the model so that the changes in the model's position on the copy glass can be combined to form a whole image. Sequence the prints as you proceed to insure that the visual mosaic being produced is coming together in the desired manner. Redo any prints that are not properly positioned. Try incorporating colored acetate and/or cloth into blank areas for added color, depth, and textural variation.

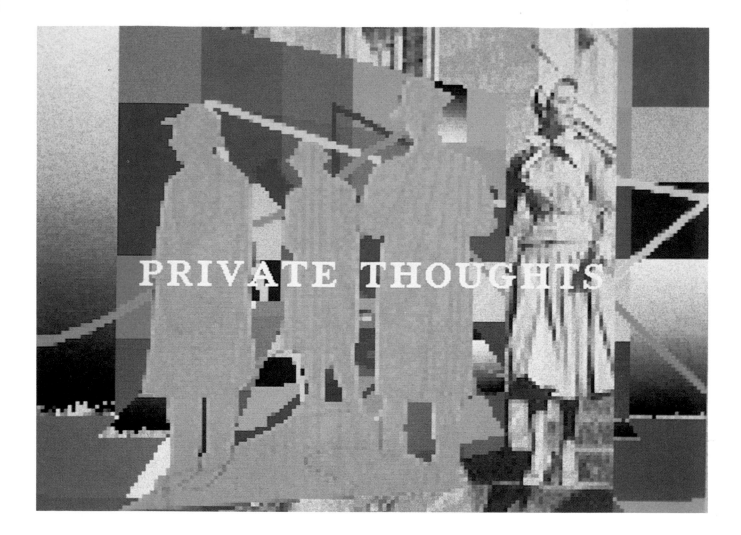

PRIVATE THOUGHTS

Manual, the team of Suzanne Bloom and Ed Hill, created this computer image using an ATT Targa graphics board and Island Graphic software. Color negatives were made directly through the use of a Rembrandt Graphics camera, which allows one to set separate exposures for the red, green, and blue video signals.

© Manual (Hill/Bloom) "Private Thoughts, 1987" Type C print 16" × 20" Courtesy of Moody Gallery, Houston, Texas

Electronic Imaging

The event that potentially could have the greatest effect upon how color photographs will be made in the near future occurred in 1981. Sony gave a demonstration of its still color camera that uses magnetic video discs instead of film to record a color image. The images can be displayed on a television screen or hard color copies can be made from a printer that operates like a photocopier. In 1986 Canon began to market a professional still video system designed to capture, store, transfer, and reproduce electronically created images based on these concepts.

The Electronic Revolution

This process could totally revolutionize the entire way in which all color pictures are made. The image is created electronically and completely dispenses with silver, along with the need for a darkroom. No specialized training is needed to process the film or to make a print. The time needed from idea to final product can be reduced to an electronic instant. Pictures made in Cameroon could be sent directly from the camera to the office back in New York through a telephone. Images from personal computers, Laserdisks, video

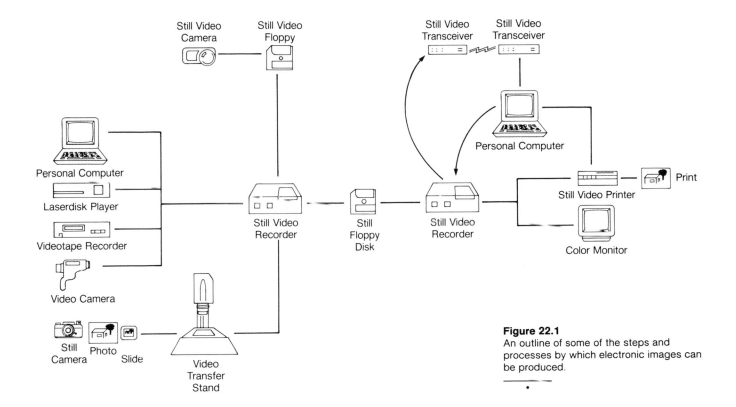

Figure 22.1
An outline of some of the steps and processes by which electronic images can be produced.

tape recorders, video cameras, and still video cameras can be immediately viewed on a monitor. Home-computer programs are now available that let the photographer electronically manipulate the images from all these sources. Hard copies can be made through a thermal printer that operates on the subtractive color principle. Silver-based photographs can be copied and used within this system too (figure 22.1). As picture resolution is improved, when a viable home use printing system is perfected, and systems costs are reduced, electronic imaging will take a wider and more active role in color photography.

Digitally Processed Photographs

An original color photograph can be converted into digital signals through a computer. A computer program enables the photographer to recolor, retouch, and even redesign by adding and subtracting objects from the original photograph. The resulting image, called a second generation original, is indistinguishable from the original photograph. Previously, all this type of work had been accomplished by hand. The implications of this process are staggering. It will drastically alter people's conception of a photograph mirroring and matching an outer reality.

Laser Research

Research is continuing to find practical and less expensive ways of using lasers to make color holograms (three-dimensional images) and to improve the quality of computer-generated photographs. For more information on this subject contact The Museum of Holography, 11 Mercer Street, New York, N.Y. 10013.

Gips used a video camera to put black-and-white photographs into an IBM™ PC. These images were then enhanced and modified by using a Number Nine graphics board and Brushwork software. This final image was photographed on the screen and printed as a Cibachrome.

© Terry Gips "Evening Garden, 1986" Cibachrome 11" × 14"

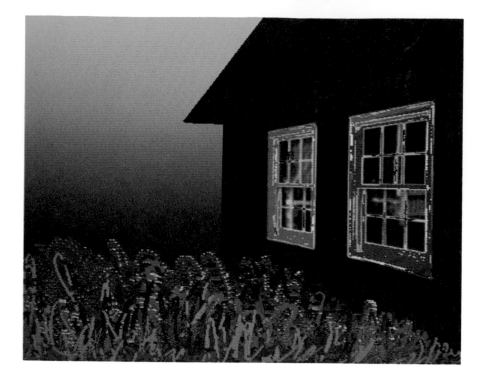

Future Developments

In the future students of photography will probably concentrate less on mastering its current chemical foundations. Energy will be devoted to learning more about computers, electrogenerated imaging, the elements of composition, and the interaction of color. As the technical barriers fall away, photography can become more democratic. People with a wide variety of backgrounds will be able to interact more easily with the medium, enhancing its aesthetic concerns and growth.

Technical advances are meaningless unless they are intelligently applied to the creation of meaningful photographs.

For additional information, see *Creative Computer Imaging* by Joan Truckenbrod (Prentice-Hall, 1988).

Additional References

Additional sources of information have been provided within individual section headings of the text for easy use. The following references are offered as a starting point for people who wish to obtain more knowledge in areas that this text has touched on.

History

Coe, Brian. *Colour Photography: The First Hundred Years 1840–1940.* London: Ash and Grant, 1978.

Deribere, M., ed. *Encyclopaedia of Colour Photography.* Watford, England: Fountain Press, 1962.

Friedman, J.S. *History of Color Photography.* Boston: American Photographic, 1944; reprinted, London and New York: Focal Press, 1968.

Gernsheim, Helmet, and Gernsheim, Alison. *The History of Photography 1685–1914.* New York: McGraw-Hill Book Co., 1969.

Green, Jonathan. *American Photography: A Critical History 1945 to the Present.* New York: Harry N. Abrams, 1984.

Mees, C.E. Kennoth. *From Dry Plates to Ektachrome Film.* New York: Ziff-Davis, 1961.

Newhall, Beaumont. *The History of Photography from 1839 to the Present,* 5th ed. New York: Museum of Modern Art, 1982.

Pantheon Photo Library. *Early Color Photography.* New York: Pantheon Books, 1986.

Rosenblum, Naomi. *A World History of Photography.* New York: Abbeville Press, 1984.

Sipley, Louis Walton. *A Half Century of Color.* New York: Macmillan Publishing Co., 1951.

Wall, E.J. *The History of Three-Color Photography.* Boston: American Photographic, 1925; reprinted, London and New York: Focal Press, 1970.

General Reference

International Center of Photography Encyclopedia of Photography. New York: Crown Press, 1984.

1986 Index to Kodak Information L–55. Rochester, N.Y.: Eastman Kodak Co., 1986.

Photo-Lab Index. Dobbs Ferry, N.Y.: Morgan and Morgan, 1982.

Contemporary Instructional Books and Texts

Bailey, Adrian, and Holloway, Adrian. *The Book of Color Photography.* New York: Alfred A. Knopf, 1979.

Current, Ira. *Photographic Color Printing, Theory and Technique.* Stoneham, Mass.: Butterworth Publishers, 1987.

Davis, Phil. *Photography,* 5th ed. Dubuque, Iowa: Wm. C. Brown Publishers, 1986.

De Grandis, Luigina. *Theory and Use of Color.* New York: Harry N. Abrams, 1986.

Glendinning, Peter. *Color Photography, History, Theory and Darkroom Technique.* Englewood Cliffs, N.J.: Prentice-Hall, 1985.

Hedgecoe, John. *The Art of Color Photography.* New York: Simon and Schuster, 1978.

Kodak Color Films and Papers for Professionals E–77. Rochester, N.Y.: Eastman Kodak Co., 1986.

Kodak Complete Darkroom Dataguide R–18. Rochester, N.Y.: Eastman Kodak Co., 1986.

Krause, Peter, and Shull, Henry A. *The Complete Guide to Cibachrome Printing.* New York: Ziff-Davis, 1980.

Life Library of Photography. *Color.* New York: Time-Life Books, 1970.

Nadler, Bob. *The Basic Illustrated Color Darkroom Book.* Vol. I and II. Englewood Cliffs, N.J.: Prentice-Hall, 1982.

Spencer, D.A. *Colour Photography in Practice,* Revised Edition. London: Focal Press Limited, 1979.

Zakia, Richard, and Todd, Hollis N. *Color Primer 1 & 2.* Dobbs Ferry, N.Y.: Morgan and Morgan, 1974.

Sources of Photographic Books

Hoffman's Bookshop, 211 East Arcadia Avenue, Columbus, Ohio 43202

Light Impressions, P.O. Box 940, Rochester, N.Y. 14603

A Photographer's Place, P.O. Box 274, Prince Street Station, New York, N.Y. 10012

Photo-Eye Books, P.O. Box 2686, Austin, Tex. 78768

Photo Jax Books, 5491 Mantua Ct., San Diego, Calif., 92124

Printed Matter, 7 Lispenard Street, New York, N.Y. 10013

Visual Studies Workshop, 31 Prince Street, Rochester, N.Y. 14603

Index